enactments

EDITED BY RICHARD SCHECHNER

To perform is to imagine, represent, live and enact present
circumstances, past events and future possibilities. Performance takes
place across a very broad range of venues from city streets to the
countryside, in theatres and in offices, on battlefields and in hospital
operating rooms. The genres of performance are many, from the arts to
the myriad performances of everyday life, from courtrooms to
legislative chambers, from theatres to wars to circuses.

enactments will encompass performance in as many of its aspects
and realities as there are authors able to write about them.

enactments will include active scholarship, readable thought and
engaged analysis across the broad spectrum of
performance studies.

THE AVANT-GARDE

RACE RELIGION WAR

MIKE SELL

LONDON NEW YORK CALCUTTA

Seagull Books 2011

© Mike Sell 2011

ISBN-13 978 1 9064 9 799 6

British Library Cataloguing-in-Publication Data
A catalogue record for this book is available from the British Library

Typeset by Seagull Books, Calcutta, India
Printed and bound by Hyam Enterprises, Calcutta, India

contents

acknowledgements

The shortfalls of this volume are purely mine. However, I owe its successful completion to the friendship, generosity, constructive criticism and knowledge of my friends and colleagues, especially Sarah Bay-Cheng, Margo Crawford, David Downing, Jody Enders, Penny Farfan, LeAnn Fields, Alan Filewod, Robert Fink, Patricia Gaborik, Jean Graham-Jones, James Harding, John Harris, Kimberly Jannarone, Maurice Kilwein Guevara, Don McAndrew, Janelle Reinelt, Rosaly Roffman, Cindy Rosenthal, James Smethurst, Graham White and Michael Vanden Heuvel. More targeted assistance was provided by Ibrahim Ashour, Paul F. Berman, Stephen Bottoms, Dominika Buchowska, Jools Gilson-Ellis, Tony Farrington, Dighton 'Mac' Fiddner, Martin Harries, Stewart Home, Fawzia Afzal Khan, Don La-Coss, Peter Middleton, Adnan Musallam, Judith Rodenbeck, Craig Saper, Abdel Soliman, Jindrich Toman, John Westbrook and Dan White. As a faculty member at a teaching-focused university, the help of research assistants is crucial and I have had excellent help from Eric Meljac, Christine Pristash, Kevin Sanders, Gabriel Smith and especially, Ben Roberts, who has single-handedly obtained the rights for the many illustrations herein. The American Society for Theatre Research has provided space and time for seminars on the avant-garde at its annual conference for the last nine years. The faculty, students and staff of Dartmouth University, Indiana University and the University of Louisville's department of English; the University of North Carolina, Chapel Hill's Communication Studies Department and the University of Wisconsin–Madison's biannual Lorraine Hansberry Project provided a chance to present and debate the book's presumptions. Indiana

University of Pennsylvania (IUP) as an excellent library staff, and I have relied on the labour and patience of the Interlibrary Loan Department, Carol Connell, Joann Janosko and, in particular, Joyce Kensey. Support was also provided by IUP's Department of English, the IUP Research Institute (which provided funding for the illustrations), African-American Cultural Center, the College of Humanities and Social Sciences and faculty senate. In many direct and indirect ways, this project has benefitted from the staff of IUP English Department, including its student workers and full-time staffers Esther Beers, Cathy Renwick (now retired) and Jackie Rohrabaugh. The students in my sections of Research Writing at IUP have provided good ideas, new directions and a testing ground for my work. Individual students who had a more specific influence are cited in the text. Special thanks go to the students in my Summer 2006 and Spring 2007 graduate courses on the avant-garde, among the most fruitful teaching experiences of my career. Portions of this book have appeared, in different forms, in *The Drama Review (TDR)* 51(2) (Summer 2007), *African American Review* 42(3–4) (Fall/Winter 2008), *Theatre Survey* 47(2) (November 2006) and *Modernism/Modernity* 18(2) (Spring 2011); my thanks to the editors and review readers for their rigorous criticism. I thank Richard Schechner for his unconditional support.

But the most profound support has come from my family. Tom Sell, my dad, has taught me much about the challenge of being decent in the midst of bureaucratic in-fighting and our long-ago discussion about jazz combos at the Lexington Narcotics Hospital was one of the sparks that led to this project. Roy and Carol Trifilio have provided not only a comfortable bed, plentiful wine, great food, far-ranging conversation, one of the best views a writer away from home could ever ask for but also, most importantly, love. This book simply would not exist without Kate Trifilio. As a faculty member carrying a seven-course load and as a father of three young children, the ability to pursue serious scholarship requires significant sacrifice of time and energy. The hours I have spent researching and writing these pages were paid for by her labour as mother, financial manager, homekeeper and her unwavering, deliciously prickly, moral support, patience, passion, scepticism, loyalty and love. This book is dedicated to Brando, River and Dylan. Their presence in my life has pressed me to do everything I do better. I hope the lessons of this book—and the history it describes—will help them make the world a better place in some small way.

towards critical vanguard studies

More than airliners and office buildings fell on 11 September 2001 and more ended than the 'American holiday from history' (George Will, quoted in Žižek 2002: 388). So did the avant-garde—at least a certain understanding of it.

When 19 hijackers handed their tickets over to gate attendants at Logan, Dulles and Newark, and, a few weeks later, American Special Forces soldiers made their initial contacts with tribal leaders in northern Afghanistan, tectonic shifts were set off in the field of avant-garde studies. The events of 9/11 and their aftermath show that it is time to do away with the disciplinary and historiographical assumptions that have shaped avant-garde studies for the last half century. This book is an analysis of the changes signalled by 9/11 and an effort to repair, reorient and retheorize the field of avant-garde studies in light of those changes.

To be clear, I am not implying that a crisis in an academic discipline equates on a historical, political or moral level with the violence wreaked on Manhattan, Washington DC, south-western Pennsylvania, the mountain passes and city gates of Afghanistan, the interrogation rooms and perpetual prisons of the War on Terror. Likewise, I am not sounding any disingenuous proclamations of a 'loss of innocence' or throwing accusations at my colleagues of know-nothingness or amorality. None of that is here. The field of avant-garde studies is hardly a place for the naive, apolitical or unreflective; indeed, one of the things I have learned from my fellow scholars is how complex and variable the power of avant-garde art

can be. Those scholars are, on the whole, theoretically rigorous, histori-
cally attuned and (most importantly) attentive to forms of creativity that
are both rebelliously imaginative and intellectually unsettling. My col-
leagues had been criticizing the avant-garde on theoretical and historio-
graphical grounds long before the September attacks. Since the 1970s, at
least, they have definitively established that the avant-garde is
Eurocentric, sexist, racist and homophobic, not to mention informed by
dubious notions of subjectivity and historical progress. Feminist theory
has been especially important in this effort. Mary Ann Caws, Teresa de
Lauretis, Susan Rubin Suleiman, Kristine Stiles, Elin Diamond, Lucy
Lippard, Rosalind Krauss, Rebecca Schneider, Peggy Phelan and others
have deconstructed the patriarchal myths nested in the avant-garde con-
cept, manifested in its history and affirmed (unwittingly or otherwise) by
its scholars.

In addition to identifying occulted power dynamics in the avant-
garde, scholars have also been rethinking the avant-garde's relationship
to media. Over the last 30 years, scholars and critics have torn their eyes
away from painting and literature to take a look at performance, new elec-
tronic media and perennially looked-down-upon forms, such as puppetry
and textiles. In the process, attention has gravitated towards formerly
marginal vanguardists, both those of the past like Dadaists Emmy
Hennings and Sophie Taeuber-Arp and more contemporary figures such
as Carolee Schneeman and Yoko Ono. In the process, the whole question
of how art can be political has been revised (see Harding 2010).

Thus, long before 9/11, those who studied vanguard activism have
known that studying the avant-garde is itself a political endeavour. As
Antoine Campagnon puts it, 'Avant-gardism belongs to both the critic and
his subject, for it is the critical viewpoint integrated into artistic practice
that gives the term "avant-garde" its meaning' (quoted in Stiles 2000:
269–70).

Nevertheless, 9/11 did initiate a crisis in the field—perhaps better
said, *should* initiate one. Ascertaining how it did (or should) brings to
light a deep shortfall in the field's commitment to rigorous theorizing,
self-consciousness of the gaps in, and presumptions of, its historical nar-
ratives and attentiveness to the ways that the field's institutional bases
inflect the interpretation of radical cultural acts. Ascertaining the nature
of that impact while continuing to incorporate the methods and per-
spectives of feminism, critical race studies, postcolonial and subaltern

theory, environmentalism, performance studies and queer theory is not only necessary for the field if it wishes to be both comprehensive and self-critical but also relevant to the broader effort to describe and understand our own historical moment and its possible futures. David Cunningham writes that a passionate, critically focused, attentiveness to the works of the avant-garde need not 'be a nostalgic mourning for an irrecoverable lost object, but may, in its engagement with the question of an avant-garde, produce [. . .] a repressed futural potential within the present' (2006: 254). 'All concrete manifestations of avant-garde-ness,' he continues, 'practically inscribe a response to and a repetition of the question: what is avant-garde *now*?' (ibid.: 274). I fully agree, and the spirit of Cunningham's inquiry is one I have tried to sustain in these pages.

What is avant-garde now? That does not have to be a question about who is making the edgiest art right here, right now. In fact, this volume is a call neither for a new avant-garde nor for cutting-edge accounts of the newest, coolest, most radical art from some hitherto unnoticed enclave. To ask what is avant-garde now is to delve into the past. To that end, I try here to expand the framework of avant-garde studies in order to bring in the story groups, individuals, ideas, genealogies and implications that have been ignored or overlooked. I investigate what constitutes cultural activism at varied times and places, including my own and my children's.

This volume is not a comprehensive history, not even of avant-gardism as it relates to my primary concerns: race, religion and war. There are many, many things that should have, might have and almost did receive discussion herein. My goal as a researcher was never to be comprehensive but wide-ranging. By doing so, I'm able to work out the kind of 'concrete, yet skeptical utopianism' that Rustom Bharucha advocates in *The Politics of Cultural Practice* (2000), a utopianism that obtains even in the face of 'those very realities that would seem to annihilate the imagination—poverty, hunger, homelessness, ethnic cleansing' (156, 161). And though I disagree with Richard Schechner when he asserts that the term 'avant-garde' 'really doesn't mean anything today', and 'should be used only to describe the historical avant-garde', I very much agree that any consideration of the tendency must account for the fact that,

> there is no area, be it Micronesia, the Pacific Rim, West Africa, the Circumpolar Region, or wherever, which does not have artists actively trying to use, appropriate, reconcile, come to terms with, exploit,

understand—the words and political tone vary, but the substance doesn't—the relationships between local cultures in their extreme, particular historical development and the increasingly complex and multiple contacts and interactions not only among various cultures locally and regionally, but on a global and interspecific scale (2002a: 352, 354).

Since being founded in the early twentieth century, the field of avant-garde studies has always focused on the possibilities and actualities of cultural politics but Schechner is right to criticize us for not paying enough attention to the avant-garde's cultural and historical specificity and for its belated response to trends beyond the borders of Western Europe and the US. 'Avant-garde' is a limited term culturally and historically—a point we must never forget—but it can be a highly solvent and analytically useful term when thought of in more critical-theoretical ways. Indeed, what I would suggest is that the term 'avant-garde' be considered as a set of questions rather than a canon of artworks and anecdotes.

In that spirit, I have written a history—more like fragments of a history, a cluster of genealogical lines—that is conscious of the institutional bases of avant-garde activism, is cross-disciplinary in approach and global in scope. My approach to the avant-garde implements, synthesizes and contributes to the critical-theoretical tendencies of the last three decades, while also responding to the paradigm-shattering developments of the post-9/11 moment. This approach frames the avant-garde less as a substantive entity in history—*the* avant-garde, the canonical avant-garde of countless syllabi—than as a critical-theoretical perspective from which we might examine a wide variety of sites, moments, creations and critical methods that produce a culture that is 'political' in some fashion, that challenge in some way the structures and flows of power. This is another reason I will call my approach 'critical' (that is, 'critical vanguard studies'), as I will often examine things that are not normally examined in books on the avant-garde.

In conjunction with an expansive sense of the term 'avant-garde', I will often take the reverse approach of most scholars and critics. Conventionally, a scholar begins with a novel, play, a dance, score, performance, event, etc., and then works out the—aesthetic, social, psychological, institutional, historical, etc.—challenges of that work. In contrast, many of the works I will discuss and quite a few of the longer case studies in this book were chosen first because of the *social* dimension of their revolt: their material position vis-à-vis some other, more powerful or

larger group or established structure of power. Having established the minority, subaltern or elite status of the group, I will then proceed to how they confront (or fail to confront), alter (or fail to alter), the relations and structures of power around them by way of their representational strategies. In this fashion, I try to respond to the challenge raised by Raymond Williams in *The Sociology of Culture* (1982), where he complains that '[n]o full social analysis of avant-garde movements has yet [been] undertaken' (quoted in Watten 2003: 152).

Art often plays a role in that revolt but not always. To ground analysis in the 'social', I consider modes of expression that have not received enough attention from scholars and critics. For example, I affirm the value, if not the priority, of performance-based approaches to the avant-garde. This is done, first of all, to respond to the 'antiperformative bias in the theorizing of the avant-garde', as it has been put by James Harding and John Rouse (2006: 1). This bias has marginalized the performing arts—theatre, performance art, dance, opera, cabaret—in favour of more object-oriented media such as painting, sculpture and literature. Thankfully, that bias is in the process of being corrected. Along with Harding and Rouse, a small group of scholars are recognizing that performance is 'a *pivotal* category for defining the avant-garde itself' (ibid.). This does not mean that the performing arts will be placed at the top of a pecking order or that object-focused media will be ignored. As an English professor I value texts highly. Though I dedicate a significant amount of space here to the live arts (particularly theatre and experimental performance), the issue raised by Harding and Rouse isn't really about what media we focus on in our work. It is about what happens to the media chosen by the cultural activist and what that choice does to the world around the artist. The turn to performance, as I see it, is one way to respond to Williams' challenge, the failure to do so being, in Watten's words, 'one of the major obstacles to renewed interest in the avant-garde' (2003: 155). Performance-based approaches can overcome the general 'lack of an adequate connection between avant-garde negativity and the larger social logic' in which vanguards and their creations circulate (ibid.).

By focusing on performance, we are able to better understand that connection. Following Watten, I agree that while 'the politics of form' is the central concern of avant-garde studies, the question of form is not an exclusively aesthetic question (ibid.: 154). Though art often provides superior insight into the power dynamics of a particular situation, that is

not always the case. This is why I will discuss topics that have limited or nonexistent aesthetic dimensions, such as British counterinsurgency oper-ations in Malaya during the 1950s; the South African secret society that helped implement and sustain apartheid; the Jewish fundamentalist Gush Emunim organization of Israel; the epidemiological practice of the French medical corps in Algeria and Liberation Theology, to name just a few. That said, one of my goals in writing this book is to complete a kind of intellectual *Bildungsroman*. Though I wander far from art and literature in these pages, in the end I have returned to the fold with a renewed sense of the value and importance of literature and art and a refined sense of the singular power of aesthetic expression in all its forms.

Finally, this volume—and the broader project of critical vanguard studies that it consolidates and furthers—affirms the importance of avant-garde studies to the humanities and social sciences and values the diversity of minoritarian tendencies that have engaged and produced culture in illegal, alternative or subversive ways to challenge the powers of their times and places. Avant-gardes have profoundly shaped the world we live in and continue to shape it as I write these words. We should defend, conserve and constructively criticize vanguard tendencies that, in the past or the present, have expanded the scope of social justice, improved the general welfare of the planet and empowered imagination, creativity and expression. Just as surely, we should work to identify, assess, criticize and undermine those avant-gardes that intend to curtail justice, degrade the planetary ecosystem or enslave and exploit the power to imagine and enact a better tomorrow.

'DISSENT FROM THE HOMELAND' AND THE COMFORTS OF THE EULOGY

Despite the staggering violence, I doubt that too many in the field of avant-garde studies were surprised by the 9/11 hijackers' motives and methods. The attack intertwined the symbolic, the performative, the economic-infrastructural, and the ethical, in a style straight from the rule book of the avant-garde. This was 'propaganda by deed' at its most audacious, terrifying and, dare I say it, traditional—no different in intent or effect from, say, the bomb detonated by the French anarchist Émile Henry at the Café Terminus in Paris on 12 February 1894. (Asked by the judges why he had wished to harm so many innocent people, he replied, 'There are no innocent bourgeois.') Like the radical actors,

poets, writers and performers of the Living Theatre, the performance artists associated with Fluxus and Happenings and the activist-intellectuals and artists of the Black Arts Movement (BAM), this was a small group of activists challenging political power through illegal, alternative or subversive means. They materially altered the status quo by shattering the conventions of perception. Like Pablo Picasso or Georges Braque, scanning with a Cubist eye a newspaper and guitar arrayed on a small table, the hijackers were imposing their ideological perspectives on reality, using spectacular action to exploit the links between aesthetics and politics and reshaping reality. Like the Surrealists loitering on the avenues of Paris and gathering in the classrooms of Fort de France, the hijackers knew that the right word or the right gesture at the right time could produce cataclysmic change. They were not artists but what they did on 9/11 resonated profoundly with what vanguard artists have done for the last century and a half.

That disturbing sense of familiarity was intensified for me by the video manifesto Osama bin Laden created on the eve of the first US air strikes on Afghanistan. 'Here is America,' bin Laden boasts, 'struck by God Almighty in one of its vital organs, so that its greatest buildings are destroyed. Grace and gratitude to God. America has been filled with horror from north to south and east to west, and thanks be to God. What America is tasting now is only a copy of [what] we have tasted' (*New York Times* 2001). Though the religious trappings of the declaration were off-tasting, as I discuss in Chapter 2, with some notable exceptions such as theatre historian, Christopher Innes, the role of religion in the avant-garde has been severely underestimated by scholars—the Manichaean terms in which those grievances were posed ('these events have divided the world into two camps, the camp of the faithful and the camp of infidels'; ibid.) were as familiar to this scholar as Andy Warhol's soup cans, Marcel Duchamp's mustachioed Mona Lisa or Luis Buñuel's scatological movies. So were the accusations of hypocrisy directed towards world leaders and bin Laden's recasting of the ideological myths of liberal progress into a repetitive knell of dehumanizing violence. A dozen avant-garde manifestos come easily to mind that take a similar tack.

What else would one expect? The avant-garde is premised on the notion that the modern world—its institutions, its social relations, its art, its cuisines, its economies—is terminally out of joint. Moreover, it presumes that solutions to the ills of modernity can come—indeed, must

come—from those who accept neither the status quo nor the methods assumed capable of redressing the endemic problems of the status quo. Its scholars presume, as Renato Poggioli did in his groundbreaking *Theory of the Avant-Garde* (1968; *Teoria dell'arte d'avanguardia*, 1962), that viable alternatives can come from those alienated from modernity but fully committed to alternative forms of community and to innovative use of the methods, assumptions and dynamics of aesthetic creation and reception. In other words, viable models of change can come from artists, from contrarian painters, poetic seers, queer performance artists and dancers (ibid.). Scholars in the field presume that art can play a moral role in society, can catalyze society to develop viable alternatives to systemic evil. So, while I doubt there were too many in the field who sympathized with the hijackers or approved of their methods, I doubt just as much that there were too many who didn't feel a creeping, disconcerting sense of recognition for what emerged from the flames and dust.

Within a few days of the attacks, I realized I was not alone in seeing the avant-garde 'signaling through the flames', to recall the iconic language of Antonin Artaud (1994: 13). On 16 September, experimental composer and electronic music pioneer Karlheinz Stockhausen held a news conference promoting his newest composition. Doing his best to make sense of what had happened a few days before, he invoked one of the dustiest conceits of the avant-garde—the blurring of art and life—characterizing the attack on the World Trade Center as 'the greatest work of art that is possible in the whole cosmos' (quoted in Lentricchia and McAuliffe 2002: 350). He went on to bemoan the impotence of artists like himself, who couldn't 'even dream in music' such an act, nor the fantastic idea of an event for which 'people practice like crazy for ten years'—as was the case with the jihadists—'totally frantic for a concert, and then die' (quoted in ibid.).

Stockhausen must have had some presentiment of the trouble his remarks would earn him; he asked the journalists to take his comments off the record since most people 'might not understand this' (quoted in ibid: 253). Unfortunately for him, several of the hijackers hailed from Hamburg, where the remarks were made, and it was a delicious opportunity for newspapers to indulge popular resentment towards elitist, self-righteous, just plain weird artists such as Stockhausen. The philistines got their wish; not only were the concerts that prompted the press conference cancelled but for a time Stockhausen became something of a *persona non grata*. The backlash

even rippled into academic departments. That December, two junior scholars of my acquaintance were asked about the remarks at screening interviews for entry-level university positions. Both were given the impression that they had to defend the field itself—and their interest in it—against the composer's tasteless comments.

Fortunately, this kind of speculation became slightly less *verboten* once the initial mourning period passed and the War on Terror began to show its contradictions. Several of the commentators in 'Dissent from the Homeland: Essays after September 11', the Spring 2002 issue of *South Atlantic Quarterly* edited by Frank Lentricchia and Stanley Hauerwas, explicitly invoke the avant-garde to make sense of the moment and its unfurling future. For this scholar, the willingness of those writers to challenge the solidifying consensus and invoke the avant-garde in so doing was bracing. Their responses—and the assumptions about the avant-garde that inform them—illustrate both the insights that come from applying the avant-garde concept to moments of terror and political crisis that aren't obviously 'artistic' as well as the limits of a certain understanding of the avant-garde.

Slavoj Žižek, for one, marvelled at how the moment uncannily recapitulated the titillating terrors of movies like *The Matrix* (1999), in which a small group of super-conscious, super-violent ex-slaves challenges their robotic overseers in lyrical sequences of super-slow-mo martial arts havoc (2002). Žižek writes that the pleasures of that film show that 'the unthinkable that happened was thus the object of fantasy', that 'in a way, America got what it fantasized about, and this was the greatest surprise' (ibid.: 387). If this is so, then, given the salvational role played in the film by a small group of specially talented people, they also longed for the avant-garde.

Complementing this view, Jean Baudrillard reads 9/11 as certain evidence that the avant-garde is dead except as fantasy and simulation. For Baudrillard, the clearest symptom of that death is the defunct status of the event in respect to moral judgement. Shocked that acts by officially designated terrorists were quickly matched by those of officially sanctioned nations, he concludes, 'Terror against terror, there is no more ideology behind this' (2002: 406). In place of the vanguard event, we have a meandering, hopeless precession of meaningless, horrifyingly violent, non-events (ibid.: 415).

A more historically minded appraisal comes from Fredric Jameson, who, after pondering the hypocrisy of the vested interests that used 9/11 to justify tax cuts and smear critics of globalism, expresses some sympathy for Stockhausen. He argues that the composer was 'not wrong to insist on the essentially aesthetic nature of the act', given that the motive of terror has always been 'a desperate attempt to address and even to expropriate the media' and insert some sense of 'ethical critique' into 'this other aesthetic and image-society-oriented dimension' (2002: 303). Jameson reminds us that Stockhausen's comments are grounded in a far older history, their origins to be found not just among angry Arabs but among desperate Europeans fighting for social and economic justice: 'As for terrorism,' he writes, 'its prehistory—propaganda by deed—lies in the failures of late-nineteenth-century anarchism, as well as in the "successes" of 1960s activism, whose program called for efforts to force the state to disclose its true repressive and "fascist" nature' (ibid.: 303–04).

But among the contributions to the special issue, Frank Lentricchia and Jody McAuliffe's 'Groundzeroland' is the most thorough and overt engagement with the history and theory of the avant-garde. The hijackings, they argue, were the offspring of the vanguardist urge to transgress the boundaries between art and life, to make claims to authentic consciousness against those of the philistine and to press society forcibly into a utopian future. They see the links between Mohamed Atta et al. and Percy Bysshe Shelley et al. as evidence of an insoluble flaw in modernity, not least the abiding belief that aesthetics can somehow provide a viable solution to economic and political dysfunction. The attacks punched through the spectacle of American hegemony in a fashion not unlike that of, say, a performance artist estranging a gesture from its nest of banality, producing 'a rupture in the perceptual field' (Lentricchia and McAuliffe 2002: 349). Though the costs of the rupture engineered by the jihadists are clearly unacceptable, it achieved something very important. As Žižek acidly put it in his piece, 'The United States just got a taste of what goes on around the world on a daily basis, from Sarajevo to Grozny, from Rwanda and Congo to Sierra Leone. If one adds to the situation in New York snipers and gang rapes, one gets an idea about what Sarajevo was a decade ago' (2002: 388). Stockhausen thus seems perfectly justified in finding parallels between 9/11 and avant-garde art.

That said, the attacks and the patently envious response of artists such as Stockhausen, demonstrate the logical consequence of the avant-garde's

long-held belief that consciousness should not merely be influenced by art. Rather, transformed and empowered by the radical community, art should enable 'the emergence of a New Man and a New World', with the artist him or herself the exemplum (Lentricchia and McAuliffe 2002: 355–6). This kind of belief ties Romantic rebellion to 'the Warholian conflation of violent, tragic, mass media news with the patriotic glory and glamour of death' (ibid.: 359) to 9/11. It might be said that the vanguard artist is father to the terrorist.

Looking back, what strikes me most about this brief flowering of avant-garde discourse is how closely it stuck to the script. Lentricchia and McAuliffe admit as much, characterizing Stockhausen's comments as 'a banality of avant-garde thought [. . .] an especially insensitive example of *épater le bourgeois*' (ibid.: 354). One might characterize Lentricchia and McAuliffe's essay in the same way, variations of which can be found in scores of articles and books. First, it invokes the avant-garde's Romantic origins, with the obligatory nod to Shelley. Then it identifies basic contradictions in the Romantic critique, illustrating them with examples of artists who embraced both radical art and inhumane politics. Finally, it indicts the avant-garde as such and then writes the eulogy. For Lentricchia and McAuliffe, the issue is how the patently virtuous idea of social, political and cultural resistance to unjust power turns into egomaniacal totalitarianism (ibid.: 354–5). Their illustration, and it is a good one, is Richard Wagner, worshipped by effete Symbolists and Nazis alike. Wagner sought to unite the audience (in the theatre and in the nation) into an invulnerable spiritual unity, while at the same time erecting a 'mystic gulf' between it and the guy lines, glue and glissando propping up the metaphysics (ibid.: 357). But such a gulf no longer exists—in the postmodern era, everything is ideology, so the mystic gulf is a tough trick to pull off. For the postmodern vanguardist who would resist the allure of authoritarianism while still holding on to the conceit that art can change the world, there must be a relinquishing of certain ambitions. The world-historical gambits of the past are no longer viable, so the only possible alternative is personal transgression. Unfortunately, this draws the artist into a perilous tète à tète with madness, criminality and nihilism—all the more so given art's general 'cultural inconsequence' (ibid.: 356). For proof of such peril, we have the violent inanity of postmodern performance (Lentricchia and McAuliffe's characterization, not mine): Chris Burden's performance piece *Shoot* (1971) in which the artist had himself shot in the arm by a .22 rifle (see Image 1.1).

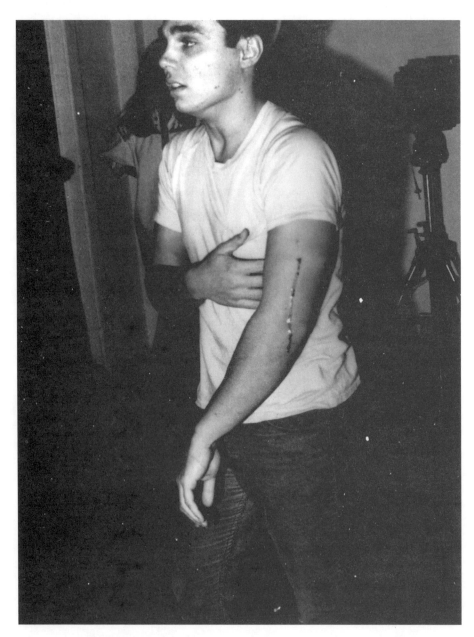

IMAGE 1.1 Chris Burden's *Shoot* (1971). © Chris Burden. Courtesy: Gagosian Gallery.

The Satanic laughter and crowd-stirring orations of vanguards' past have devolved into the self-referential mumblings of the navel gazer and the spectacular horror of mass destruction. In the end, all are trapped in Warhol's Factory, unable to find a way out of the hall of mirrors, unable to distinguish between political engagement and the glamour of death. At such a point, suicide bombing starts to make a certain amount of sense.

All due respect to the hallowed vanguard tradition of 'making it new', there's nothing inherently wrong with telling a story told many times before. However, the story in 'Groundzeroland' isn't the only one that can be told. It does have a respectable provenance though, being the favoured storyline of the 'Eulogist School' of avant-garde studies, one of the longest-lived in the field. Charles Baudelaire set the style back in the 1850s, anatomizing the ramifying blemishes of morbidity in the supposedly cutting-edge salons and poetry magazines of his day (1950: 188–9). This funereal tradition even hooked the Italian Futurists, whose founding manifesto of 1909 concludes with a description of themselves hiding in an abandoned airplane hanger, warming themselves around a fire fed by their own books while a new generation of vanguardist youths circle, ready to tear them limb from limb. But better death, they declare, than the decadence of the academy or 'the catacombs of the libraries' (Marinetti 1992: 148). Eulogizing got a bit more complicated after the Second World War when those who saw real social problems that could be addressed by art, faced a situation in which the conventional wisdom overtly denied that innovation, historical change and personal transformation were even possible. This was the situation in which the gadfly playwright Ed Bullins found himself in the early 1960s. Well aware of the banalized brutality, marginalized beauty and grassroots rebelliousness of the African American multiculture, he castigated the supposed avant-garde drama of his time (Eugene Ionesco, Samuel Beckett, Edward Albee and other so-called Absurdists), characterizing the whole bunch as hopelessly neurotic and either incapable or unwilling to address the social, economic and political grievances of African America in the 1960s. To Bullins, the 'so-called Western avant-garde' was emotionally dead, historically irrelevant, geopolitically isolated and racist (2006). Baudelaire, the Italian Futurists and Bullins show us that eulogy is a handy weapon in the internecine battles of position that every self-proclaimed avant-garde must wage.

Thus 'Groundzeroland' falls short not in its desire to define a position for critical creativity in the post-9/11 situation; this is a vital, necessary

effort. Instead, the shortfall is in the particular representation of the history of the avant-garde, the story they tell to make their point. Despite its postmodern trappings, Lentricchia and McAuliffe's essay repeats a storyline devised by intellectuals in the US and Europe in the early 1950s. Though written a decade after the fall of the Soviet Union, 'Groundzeroland' shares its presumptions with a remarkable group of critics—Hilton Kramer, Hans Magnus Enzensberger, Irving Kristol, Daniel Bell, Leslie Fiedler, Roland Barthes, Michel Foucault, Andreas Huyssen, Clement Greenberg and Peter Bürger, to name the most prominent—whose work emerged from and engaged with the ideological end game between bureaucratic communism and laissez-faire capitalism—the Cold War. It is hard to imagine any other topic that could earn such unanimity—it boggles the mind to imagine Kramer and Lentricchia agreeing about anything. But they agree that the avant-garde has been neutralized by the affluence-inspired tolerance and style-consciousness of the haute bourgeoisie. They agree that Stalinism, National Socialism, Maoism and the mass-murdering regimes of Pol Pot and other despots demonstrate the inevitable consequence of the vanguard logic: its obsession with Manichaean dualities, its compulsively totalizing logic, its absolutism, its aestheticization of politics. They also agree that the avant-garde's power as a catalyst for social transformation has been permanently disabled by the split between radical art and radical social movements institutionalized during the era of High Modernism. The failure of the French Surrealist group's efforts to collaborate with the French Communist Party typifies a problem that only worsened in the 1950s as self-styled avant-garde artists created poetry, paintings, dances and other works that were more and more difficult to understand and more and more dependent on the effete discourses of experts. Meanwhile, it is said, the working class grew fat with the assistance of trade unions that no longer believed in the historical destiny of the proletariat—and kicked out anybody who did.

But this is not the only story to tell. Theirs is bound to culturally, historically and geographically specific understandings of historical transformation, social struggle and aesthetic radicalism. It is a story that is not very good at handling subaltern and minority artists and communities creating radical culture and theorizing it as a historical and critical tendency. Though we can argue about the political efficacy of the feminist performance art of Carolee Schneemann and Marina Abramović, the poetry of Sonia Sanchez and Charles Bernstein, the border art of Coco Fusco and

Guillermo Gómez-Peña, the genre-bending choreographies of Bill T. Jones, the political strategy of the Zapatistas of Mexico and the Naxalites of India or the sociopolitical significance of the deconstructed, foam-speckled *tapas* of Spain's Nueva Cocina cooking movement, it would be nonsense to characterize any of them as trapped in the mirror halls of Warholian death glamour or as, in any fashion, patriotic. And if the story of the avant-garde can't make sense of these, then that story needs to be told differently.

But it is not enough to simply trot out counter-examples to prove an eulogist wrong. Cunningham has argued that any effort to historicize the avant-garde must contend with the fact that there is something 'essentially problematic about the notion of presenting particular works as "illustrations" of *the* avant-garde in general' (2006: 256). All research on the avant-garde inevitably struggles with 'a problem which [. . .] involves something to do with the *time* of the avant-garde, the distinctive modes of historical temporalization that its *concept* implies and which are not reducible to the ultimately homogenous time of (art or literary) historicism' (ibid.: 256). If the avant-garde is always in some fashion a response to modernity, then the emergent and diverse narratives of modernity and modernization coming from minority communities within the US and Europe and from regions traditionally excluded from the story of the avant-garde—Eastern Europe, Africa, Latin America, Asia and the Caribbean—would suggest distinct understandings of the avant-garde.[1] As scholars have shown, the last three decades of avant-garde activity and scholarship have demonstrated that we need to be very sensitive to the shifting nature of cultural politics, especially in the global era, and to the diverse ways that cultural power can be deployed.

THE HISTORICAL CONTINGENCY OF THE HISTORY OF THE AVANT-GARDE

Revisionary histories of the avant-garde have generated some of its most remarkable and far-reaching reconsiderations. Cedric Robinson, Fred Moten, Walter Kalaidjian, Kimberly Jannarone, Rosalind Krauss, James Harding and John Rouse, to name just a few, have not only shown how much we have to learn about the avant-garde but have also demonstrated that the very act of writing that history is necessarily a response to political contigencies of place and moment. Whether challenging deeply embedded Modernist myths that prop up masculine bias (Krauss 1985); demoting the white elite in favour of an argumentative, precociously postmodern

multiculture (Kalaidjian 1993); showing how the concept of the avant-garde has led to the marginalization of grass-roots and popular movements in the African diaspora (Robinson 1983); establishing the deep conceptual and affective links between the avant-garde and fascism in the 1920s and 30s (Jannarone 2010), or asserting the foundational role of transnational collaboration in the formation of the European avant-garde (Harding and Rouse 2006), these scholars have affirmed Foucault's notion that our understanding of historical developments need not depend on a transcendent concept—in this case, a substantive notion of 'the' avant-garde—that somehow exists outside of that concept's particular deployments in time and place. Each of these scholars show how the history of the avant-garde is still *in effect*.

The contingency of our understanding of the avant-garde is apparent when we take a closer look at how a canonical figure's significance alters when approached in light of, say, the history of globalization, transnationalism and interculturalism. In such a light, neither the prodigious proto-Surrealist Isidore Ducasse (aka the Comte de Lautréamont) nor his influential novel *Le Chants de Maldoror* (1868) can be considered simply 'French' or a milestone in a peculiarly 'European' story of avant-garde literature. Ducasse was born and spent his childhood in Uruguay; he frequently wrote letters to his father, a French Consular Officer who remained in Uruguay while his son studied and wrote in Paris; and he was multilingual, speaking French, English and Spanish. Even on the basis of this spare evidence, it is difficult to maintain the notion that Ducasse was a 'French' writer, nor, for that matter, that he was a strictly 'Latin-American' writer. His influence on key Surrealist writers—André Breton, for one—raises some interesting questions. Fernando J. Rosenberg sees a revised understanding of Ducasse as sure evidence that it is time to rethink avant-garde history altogether (2006: 18).

Rethinking that history needn't be limited only to questions of geography and geopolitics; we might consider, say, the institutions through which Ducasse passed as a young adult. After a year back in Montevideo, where one presumes that his aptitude for math and his future career plans were regular topics of conversation with his father, Ducasse enrolled in Paris' prestigious École Polytechnique. By the year of his enrollment, 1867, the École was a well-established incubator of the technocratic elite that was quite literally engineering the French empire. Moreover, it was one of the three French educational institutions (along with the École Supérieure de

Guerre and the École de Médecine de Paris) that had embraced the mandate of modern leadership described by Henri de Saint-Simon in his seminal writings on the avant-garde. The Écoles were hotbeds of Saint-Simonianism (as I shall discuss in Chapter 1).

How did this brief residence in the pipeline of the French empire's managerial elite (he dropped out after a year) inform his later explorations of literary evil? It is intriguing to juxtapose, rather like the 'chance encounter of an umbrella and a sewing machine on an operating table' (to recall one of Ducasse's infamous phrases), the novel's eponymous anti-hero with the École's ideal student. What if we read Ducasse's work in light of the rhetorical strategies typical of the École's graduates? Regardless, however we pursue our inquiries into the historical record, it is certain that, *pace* Cunningham and Foucault, there is an inherent polyvalence to the events, lives, sociocultural situations and works of even the most conventional figures of the avant-garde.

Is the avant-garde dead? That's a question that can't be answered except by first recognizing how little we know about the very past we thought we knew so well and how contingent our understandings of that past are. The history of the avant-garde is as historical as anything else.

And that includes the history we don't know. As I mentioned, on the eve of the US invasion of Afghanistan, bin Laden recorded a video, hailing as heroes the 19 jihadists who engineered the attacks. What I did not mention was that the parallels between al-Qaeda and the avant-garde weren't just tacit. On that tape, bin Laden characterized the hijackers as 'a blessed group of enlightened Muslims, the vanguard [*taliah*] of Islam' (*New York Times* 2001: B7). I initially disregarded the reference as in all likelihood a cavalier translation, of which there were plenty at the time. However, after reading Paul F. Berman's feature article in *The New York Times Magazine* on the radical Egyptian theologian Sayyid Qutb (2003), I began to suspect that the translation had been right on target. In the article, Berman describes the abiding interest Qutb showed for the most radical tendencies in European literary modernity and political vanguards, Lenin's Bolsheviks and the Spanish Falangists in particular (ibid.: 24–9, 56, 59, 65–7). After contacting Berman and following that up with the writings of Gilles Kepel (2002), Adnan Musallam (1998 and 2001) and others, my suspicions were confirmed.

More than just an apropos translation, the term *taliah* is the tell-tale of a relationship between Islam and the avant-garde that is long-lived, complex

and virtually unremarked by critics and historians. This relationship casts in a new light the role of Romanticism in the development of the avant-garde. It is generally agreed that Romanticism is one of the roots of the avant-garde. What is less often acknowledged is that Islam was a pervasive inspiration for British and French Romantics. Though that inspiration was most often a cognate of Orientalist fascination with the 'mystery' and 'exoticism' of the Arab world, it was occasionally the result of serious and respectful engagement with its religious practices and history, particularly the flight of Muhammad and his Companions from Mecca to Medina (called the 'Hejira'), and the subsequent guerrilla war that brought him to power.

As I will argue in more detail in Chapter 2, by restoring the Arab world, especially Islam, as an active, productive agent in its history, Eurocentric narratives of the avant-garde and declarations of its death are far less convincing. No less surprising are the implications that unfold from the history of military special forces, as I will discuss at length in Chapter 3. And these are only two of the many histories that have yet to be properly acknowledged and integrated into the story of the avant-garde. The attacks of 9/11 are merely the most dramatic and, for our times, the most relevant. Indeed, if 9/11 means anything to the field of vanguard studies, it is exactly how far the history of the avant-garde is from being settled—and how unsettling that history can be.

THE POLITICS OF INSTITUTIONALITY

Harding has argued that one of 'the crucial problematics' scholars and critics of the vanguard are facing today 'grows out of their own institutional discursive practices as critics and theorists and out of the relationship that these practices have to the analysis of radical, experimental communities that, while not anti-intellectual, have frequently defined themselves in a hostile relationship to academic institutions and their scholarly method' (2000: 4). On this point, scholars in the humanities lag far behind those in business and technology, as Silviya Svejenova, Carmelo Mazza and Marcel Planellas, have noted in their analysis of institutional innovation in the work of vanguard Spanish *haute cuisine* chef Ferran Adrià. Indeed, they would argue that even scholars and theorists in those fields have fallen short when considering the role of individual and small-group agency in the process (2007: 541).

Of course, anybody who works in avant-garde studies has to be aware of the politics of her position. Open hostility towards scholars, critics and journalists is as much a chestnut of the avant-garde as the eulogy. Italian Futurist Umberto Boccioni, in his short play *Genio e cultura* (1916; for the English translation, see Boccioni 2001), portrays a critic accidentally stabbing a young artist in the neck with a paper knife; then, in lieu of giving assistance, writing a monograph. Crouching 'like a raven', near the corpse, he pulls out a tape measure and intones, 'Toward 1915, a marvelous artist blossomed [. . .] Like all the great ones, he was 1.68 meters tall, and his width . . .' as the curtain falls (2001: 198). And there's that memorable moment in Beckett's *Waiting for Godot* (1952), when Estragon grievously wounds the feelings of Vladimir by calling him a 'Crrritic!' (1954: 48). The academic version of this hostility is the eulogistic notion of co-optation, bemoaning the appropriation or mass-marketing of formerly radical art and artists. But the relationship between avant-garde and academia is far more complex than knee-jerk hostility, stereotypes and declarations of death allow.

Indeed, despite the recognition that the relationship of avant-gardists to institutions is fundamental to our understanding of the avant-garde, there is a dearth of scholarship about how actors within institutions create change. Among the exceptions, Diana Crane has described how, beginning in the Cold War, the role of the so-called radical artist in the US 'underwent a major transformation', and how, 'while the organizational infrastructure for avant-garde art was changing, so was the social and occupational role of the artist'. Crane describes in particular how dissident artists—dissident primarily in terms of the form of their work rather than its politics—became members of the academic system, benefitting from the increasingly 'large, varied and complex' art world, and traces this process into the 1980s, with special attention paid to the behaviour and attitudes of art dealers and museum curators (1987: 9). Taking their analysis into the world of business and marketing, Patricia H. Thornton, Candace Jones and Kenneth Kury note that what they call 'institutional entrepreneurs' still pose a problem to organizational theorists: 'the source of their entrepreneurial ideas and how these ideas are associated with institutional change remains unclear' (2005: 127).

In their discussion of Adrià, Svenjenova, Mazza and Planellas ponder over this lack of clarity, noting that organizational theory has little to say

about how a self-taught chef copying classical and nouvelle cuisine at a restaurant in a remote spot of northern Spain managed to break free of those traditions to became the poster boy for an international wave of ultramodern haute cuisine and the founder of a line of food and other lifestyle products for those with neither money nor interest in the rarified climes of molecular gastronomy. The case of Adrià points to the fact that not only has theory as such been underserved by criticism as an agent of institutional change (Adrià's creativity is high flying but grounded in careful record-keeping, rigorous self-reflection and incisive elaboration of categorical structures) but creative people, too, have been underserved. '[A]ttention has been placed mostly on the role of specialized actors and gatekeepers—critics, journalists, art historians—as theorizers' (ibid.: 4). In contrast, they draw attention to 'essential and understudied initial steps that shape the potential for change, such as creativity, theorization, reputation and dissemination' (ibid.: 5).

As Paul Mann has shown, the avant-garde can be productively understood as an *economy* of discourse, a dynamic circulatory system of 'reviewing, exhibition, appraisal, reproduction, academic analysis, gossip, retrospection', and so on, in which scholars, critics and curators play the role of preservationists and middlemen, regardless of the attitudes of vanguardists towards them. With this in mind, a different way of investigating the avant-garde's political effects is possible: '[T]he hypothetical totality of such exchanges, willing or unwilling, voluntary or conscripted, voiced or even suppressed, would provide a map of the discursive economy within which the avant-garde operates and which services and is managed by the wider systems of circulation and exchange that constitute the culture at large' (Mann 1991: 7). Of course, scholarship, criticism and curatorial practice must be understood as more than just a material process. Duchamp suggested in works such as *Fountain* (1917) (see Image 1.2) and *The Bride Stripped Bare by Her Bachelors, Even* (1915–23) that the evaluative methods of art appreciation are tied up with forms of scatological, linguistic and erotic fetishism. These are hardly the only forms of bias one finds in the history of avant-garde scholarship and criticism. As I will discuss in Chapter 2, the field's constitutional antipathy towards religious belief has hampered consideration of avant-gardes premised on religious belief or indebted to religious models of activism. This is the other side of the story of Islam's erasure from the history of the avant-garde, a complement to the field's Orientalism.

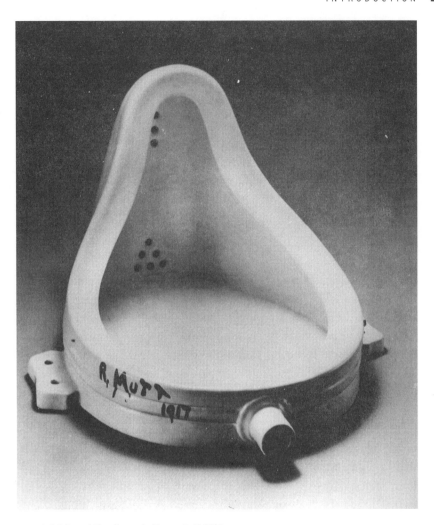

IMAGE 1.2 Marcel Duchamp's *Fountain*(1917).

The recognition that academic research is anything but a neutral player in avant-garde history troubled my smug scholarly certainty in the days following 9/11. It was one of the themes of the book I was writing at the time, *Avant-Garde Performance and the Limits of Criticism* (2008), a work that approached three avant-garde tendencies in the American counter-culture of the 1960s: the Living Theatre, early performance art (that is, Happenings and Fluxus events), and the BAM. What set these tendencies apart was the way they highlighted, played with and altered the relationship not only between artists and audiences (a well-worn strategy of art vanguards) but also between themselves and the journalists, critics and

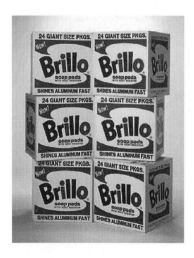

IMAGE 1.3 Andy Warhol's *Brillo Boxes* (1969).

scholars attracted to their works. Each delved into aspects of aesthetic, interpersonal and existential experience in such a way that criticism and scholarship were politicized. The Living Theatre's production of Jack Gelber's *The Connection* (1959), for example, foregrounded the addicted body, the specific forms of transvaluation that occur when one becomes addicted and fears such change. Happenings and Fluxus events raised challenges to memory, aesthetic value, objectivity and the past-oriented focus of scholarship. And the works of the BAM directly targeted the racism of scholarly institutions and emphasized the profound experiential divide between African Americans and white Americans. Further, each of these politicized scholarship and criticism through live performance, a form of aesthetic expression that is particularly good at situating the act of perception in a palpable social framework. In these situations, objectivity and ideological neutrality were disabled, purposefully and with varied goals in mind.

It was in this same period, the 1960s and early 70s, that we find the first efforts to theorize the avant-garde as a historical (rather than sociopolitical) tendency. This was due, as Arthur Danto has argued, to the general 'ascent to a new level of consciousness' on the part of artists, scholars and curators concerning art's relationship to its own past, 'a notion of strategy and style and agenda' that marked 'a certain kind of closure [. . .] in the historical development of art' (1997: 9). This closure, typified by the Brillo boxes of Warhol (see mage 1.3), revealed 'that there is no further direction for the history of art to take. It can be anything artists and patrons want it to be' (ibid.: 36). Bürger's *Theory of the Avant-Garde* (1974) emerged in this

moment as an explicit reaction against the 'Neo-Dadaist' frivolities of artists like Warhol. Against the 'post-historical' tendencies of 1960s art and scholarship, Bürger calls for a return to the classic works of Marxist theorists—Walter Benjamin, Theodor W. Adorno, Herbert Marcuse and Georg Lukács—and for the prioritization in avant-garde theory of self-reflexive, historically attuned, materialist approaches. For Bürger, the Dadaists and Surrealists were the first avant-gardes to ascertain the historicity of aesthetic categories and develop new methods for achieving 'metahistorical knowledge' (1984: 15). This was especially true for artists in the orbit of the communist movement such as John Heartfield and Bertolt Brecht, who decried the hypocrisy of the art-for-art's-sake position, began the work of analyzing and determining the pressures on art by the institutions and infrastructures of the art world and devised methods to thematize and divert those pressures, often depending on alternative institutions constructed by political activists and radical parties. These vanguardists were 'historical' in the sense that they recognized their own relative positions vis-à-vis the art styles and movements of the past and systematically critiqued the idealism that had formerly characterized avant-garde art in favour of a materialist class-consciousness.

Brecht's '*Verfremdungseffekt*' ('alienation effect') is an excellent example of the efforts of the 'historical avant-garde' to assess and engage its historical position. Brecht was suspicious of mainstream theatre's reliance on emotionally moving plot and acting devices as well as its efforts to disguise its constructed nature. He viewed both as enabling the ideological obfuscation of the real grounds of history, which, as a Marxist, he saw in terms of class struggle and economic development. To avoid this kind of obfuscation, Brecht instructed his actors to perform in a way that would always make the audience aware that they were watching an actor performing rather than a character living. In this spirit, the actor would break character from time to time and comment on the actions taken or dialogues spoken. Bürger asserts that the emergence of this kind of technique requires a radical shift in how we undertake scholarship and criticism: 'If aesthetic theories are historical, a critical theory of art that attempts to elucidate what it does must grasp that it is itself historical. Differently expressed, it must historicize aesthetic theory' (ibid.: 15). Indeed, Bürger argues that the effort to thematize and volatilize the relationship of artworks to their institutional and infrastructural bases is the primary function of a theory of the avant-garde.

However, Bürger overlooks the fact that, if the avant-garde's recognition that aesthetic theory is historical means that avant-garde scholars need to recognize the historicity of their work, then the avant-garde's recognition of its own institutionality means that scholars ought to assess their own institutional connections and the ways those connections inflect their scholarship. In that vein, we can consider, for example,

(1) the active participation of US academics in vanguard and anti-vanguard initiatives

(2) the canonization of the avant-garde in the post-Second World War university and museum system, and the politicization of the same in the 1960s and 70s by those historically excluded from their staff, collections and curricula.

These intersections of the avant-garde and the academy demonstrate that any effort to write a history of or devise a general theory of the avant-garde is a contingent, essentially political operation.

1. Academics in the (Anti-)Vanguard

Collaboration between vanguards and academics has been going on for as long as the avant-garde has existed. As Sally Banes puts it, '[L]ike most myths, the romantic legend of the anti-institutional nature of the avant-garde is both true and false' (2000: 217). By 'stressing the ingenuity, non-comformism, and agonism' of the tendency, we can lose sight of two facts:

> One is that the avant-garde has regularly formed its own alternative institutions, which in turn have been co-opted by the mainstream to become establishment schools and venues. The second is that, particularly in post-World War II America, intellectual and religious organizations—in particular, colleges, universities, and churches—have played a central role in the development of [the avant-garde], serving as research-and-development centers, venues, catalysts, and patrons (ibid.).

Alan Moore sees the connection between avant-garde and academia as a natural one; the urge towards collectivity that is so common among vanguards has a natural affinity with the structured collectivity of workshops, academies, utopian communities, and (for all their warts) university departments. He traces the links as far back as 'the reorganization of the great machinery of the French Royal Academy under Jacques-Louis David to serve republican rather than monarchical ends' (2004). He continues,

'David's students, the "Barbu," or bearded ones, lived a neoclassical moral ideal' and pioneered 'that special self-segregated community of creatives' (ibid.) that inspired not only the so-called bohemias of the mid-1800s and the remarkable flowering of utopian-minded workshop formations in the arts and crafts but also the more complex and provocative groupings that we find in the twentieth century.

Among the latter, one would count the socialist alternative schools that sprouted across Western Europe and the US in the early decades of the century; the legendary Residencia de Estudiantes founded in Madrid in 1910 and fostering the growth of future luminaries Federico García Lorca, Luis Buñuel, Salvador Dali, Ramón del Valle-Inclán and others; New York's New School for Social Research, founded by John Dewey (1918), which hosted John Cage's highly influential courses on composition in the late 1950s; Germany's Bauhaus (1919–33); the College of Sociology founded by Georges Bataille (1937–39); the Study Group for Human Phenomenology organized by Tristan Tzara, Jules Monnerot and Roger Caillois (1935–36); Black Mountain College of Asheville, North Carolina (1933–57), whose faculty included several former Bauhaus instructors; and the many consciousness-raising collectives and alternative schools that flowered across the global counterculture of the 1960s. A similar conjunction of radical ideology, collective cultural production, scholarship and pedagogy was characteristic of post or potentially revolutionary national situations such as those in the Soviet Union and Mexico in the 1920s; Cuba, Senegal and China in the 1960s and so on. Pioneering American performance artists Allan Kaprow, Robert Watts and Geoffrey Hendricks were all affiliated with Rutgers University starting in the late 1950s, Watts and Hendricks remaining on faculty for 31 and almost 50 years respectively (see Marter 1999). Kaprow later taught at the California Institute of the Arts and the University of California, San Diego. Joseph Beuys was a professor of monumental sculpture at the Staatliche Kunstakademie Düsseldorf from 1961 until his dismissal in 1972 for admitting those students to his class that the school had previously rejected. The next year, he founded the Free International University for Creativity and Interdisciplinary Research, where he continued to develop innovative, critically self-reflexive forms of pedagogy. (On Beuys' pedagogy, see Ulmer 1985: 225–64.) Former Harvard art historian T. J. Clark was a member of the British section of the Situationist International and later, the King Mob.

As John Westbrook has put it, all these, to a greater or lesser degree, formed in 'the intersection of two historically disparate fields—the avant-garde and academe'—were situated in the volatile terrain between the 'wake' of vanguard movements and 'the margins of the university' and other academic institutions (2008: 146). Structured to ensure a dynamic collaboration among radical ideology, heightened aesthetic productivity and rigorous scholarly exploration, these kinds of collaborations provided to their participants physical space, a degree of economic security, alternative discursive structures, opportunities for new kinds of pedagogy, situations to explore and enact alternative understandings of the historicity of aesthetic expression and opportunities for socializing.

Though the demands of critical probity and academic structure will rarely be in synch with each other, the effort to bring them into productive relationship has resulted in incisive and important forms of critical-creative work that have welded scholarly inquiry to innovative forms of social organization. Westbrook writes about that kind of innovation in the orbit of the French Surrealist movement. Almost from the start, Breton's group was committed to exploring the intersections of Surrealist creative technique and the social sciences—the first official effort housed in the Bureau of Surrealist Research, opened in 1924, directed by Artaud—but it was Bataille, Caillois, Tzara and Monnerot who took this exploration to its most radical conclusions, finding the efforts of Breton and his cohort far too unscientific. Concerning these, Westbrook writes: 'The avant-garde group and journal provided the forum to develop, experiment with, and experience [a] performative conception of intellectual practice. The group was not only a forum for individual and collective expression, but became itself the practical focus of transformative intellectual experimentation in which theories imported from the social sciences played a crucial role' (ibid.: 3).

The legacy of this effort should be a familiar one to humanities scholars. The critics and theorists associated with the journal *Tel Quel*—and post-structuralism more generally—emulated the approach of Bataille et al., mined for their critical scholarly potential the compositional techniques of Maurice Blanchot, Beckett, Artaud and other vanguard Modernists and responded enthusiastically to the theories of cultural revolution that had guided decolonization struggles in the Caribbean and Asia. The work of Foucault, Barthes, Julia Kristeva, Jacques Derrida and others would, in turn, exert a small but palpable influence on the student rebellions and transient groupuscules that sparked across the West in 1968

and, more broadly, enable 'a renewed look at the politics of the group-subject,' in Emily Apter's words, 'as they informed, and continue to inform, radical agendas for freedom and justice' (2004: 8). Another standout is James Clifford, whose remarkable efforts to integrate Surrealist research methodologies into anthropology and incisive critique of the modernist museum will be discussed at some length in Chapter 1.

Lest we presume that the fruits of the rapprochement between vanguards and scholars are wholly to the benefit of the Left, it behooves us to consider the role of academics in the exploitation, monitoring, harassment and disruption of vanguards. The case of anthropology is a good case in point. David H. Price recounts a moment a half century ago when the Central Intelligence Agency (CIA) covertly funded a wide range of social science research projects to support its efforts to disrupt nascent military and political vanguards (2007: 8). The top secret MK-Ultra project, designed to develop innovative forms of interrogation and behavioural modification, created a number of 'funding fronts designed to look like legitimate academic research institutions' in order to promote research on topics as diverse as role conflict in Burma, the 'psychological effects of circumcision', cross-cultural comparisons of child-rearing practices, self-image in conditions of isolation, 'craniological racial analysis' and small-group behaviour (ibid.: 11). Price makes clear that many of those who received funding from the CIA were unaware of the source of their funding but he also identifies a handful for whom this was not the case.

This kind of collaboration between anthropologists and the military has a long history. The French medical corps' role in the conquest of Algeria in the early 1800s was both epidemiological—identifying systemic health problems, responding to epidemics, providing care to the colonized—and ethnographic. As I will discuss in Chapter 1, French doctors produced the first thorough, if biased, ethnographic descriptions of North African Arab and Kabyle (Berber) communities. During the First World War, anthropologists used their academic credentials as cover to spy on German officers in Central America (González 2007: 15n7). In the early 1940s, British anthropologist, social scientist, linguist and cybernetic theorist, Gregory Bateson, designed top-secret propaganda campaigns for the Office of Strategic Services (OSS), the forerunner to the CIA, to identify and dampen nascent vanguard and grass-roots movements in South East Asia as part of the Allied war effort (Price 1998). In the late 1960s, several prominent US anthropologists participated in a

secret research project sponsored by the US Defense Department that aimed to assess the causes of civil war and prescribe actions that would allow governments to subvert any efforts to destabilize them. Intended to assist counterinsurgency operations in South East Asia (including the ongoing conflicts in Vietnam, Laos and Cambodia), it built on an earlier, short-lived project focusing on civil unrest in Latin America (Wakin 1992).

Such collaboration between anthropologists and the military continues even today. In 2006, the US Army released a new counterinsurgency manual, the first in over two decades. Though the Army had long understood the unique challenges posed by small-group insurgency, *FM 3-24* is notable for its unprecedented emphasis on the role of 'cultural knowledge' in those fights, proclaiming in its first chapter, 'Cultural knowledge is essential to waging a successful counterinsurgency' (quoted in González 2007: 14). Roberto J. González has examined how the culture concept is deployed in the manual, concluding that, 'in anthropological terms, [it is] not innovative', being 'essentially a primer on cultural relativism and social structure', some of whose concepts, 'notably the culture concept', are 'incomplete or outdated' (ibid.: 15). What concerns González more is the direct involvement of an academic anthropologist in the development of the manual, the implications of that concerning long-standing ethical standards in the profession and the impact such collaboration might have on future research.

Anthropologists are not the only academics who have collaborated with anti-vanguard initiatives. Katherine Eban has described the role psychologists are playing in the current War on Terror, both as a source for interrogation techniques and in medical consultation to ensure that interrogations of alleged terrorists are, as official documents of the American Psychological Association put it, 'safe, legal, and effective' (Eban 2007). In *Perform or Else: From Discipline to Performance* (2001), Jon McKenzie has raised troubling questions about the methodological, institutional and ideological links between performance studies and other performance-based fields such as organizational theory, computer engineering, marketing and product development, even missile design. This confluence of critical aesthetics and technical evaluation and implementation leads him to conclude that performance is an emergent 'onto-historical formation of power and knowledge' (ibid.: 25). Scholars and artists—particularly those who claim the cutting edge or to represent subaltern communities—inevitably contribute to this 'new and emergent arrangement of power-forces' (ibid.).

A similar development may be in the offing in other areas of the humanities and social sciences. In the conclusion to Chapter 3, I will discuss how the academic study of narrative, popular culture, religious iconography, the historical imagination and other forms of symbolic thought and expression are garnering the attention of the Pentagon, which has come to understand their value in making sense of the cultural terrain across which military interventions, particularly counterinsurgency operations, occur. Finally, it bears remembering that one of the first publications in the field of avant-garde studies—and one of its few bestsellers—was Max Nordau's *Entartung* (1892), translated into English as *Degeneration* (1895), a book indebted to racist criminology and intended to provide to authorities practical advice on how to undermine the unhealthy influence of avant-garde painters, poets, dancers and fashionistas on white, middle-class, European youth and, by extension, Europe itself. Quite practical, indeed—Nordau's epidemiological theory of the avant-garde proved useful for Nazis and neoconservatives alike. More disturbing still, his methodologies bear a disconcerting resemblance to some of the best and most provocative work in the field of avant-garde studies today. (See Chapter 1 for further discussion of Nordau and his legacies.)

2. The Canonization of the Avant-garde and the Politicization of Avant-garde Studies

Following through on Bürger's directive to historicize and thematize the institutional dimensions of the avant-garde, a critical theory of the avant-garde should be cognizant of the avant-garde's changing status as a subject of academic discourse. Of special relevance to that effort is the situation following the Second World War, when academic criticism, scholarship and curatorial practice concerning the avant-garde entered a more complex, ambivalent, institutional dynamic than had existed in the 1920s and 30s. During that period, Modernist works, including those conventionally understood to be 'avant-garde', were rapidly incorporated into museum collections and academic curricula in the US and Western Europe, their paradigms becoming the standard model around the world. In the US, the process was most visibly signalled by the Museum of Modern Art (MoMA) and the Art Institute of Chicago's Picasso retrospective of 1939–40, organized in celebration of MoMA's acquisition of *Demoiselles d'Avignon*. The exhibition introduced the artist to a remarkably receptive mainstream audience and instituted the scholarly periodizations by which Picasso's

work is generally understood (for example, Blue, Rose, African, Analytic Cubist, Synthetic Cubist). Three years later, Peggy Guggenheim opened her influential *Art of this Century* exhibition, designed by former De Stijl architect, Frederick Kiesler. Kiesler's approach established a tradition of housing modern art in a distinctly modern setting, and the exhibition provided critical, moral and financial support to artists who had fled the war in Europe, including Breton, Duchamp, Piet Mondrian and Max Ernst. In subsequent years, major museum retrospectives were organized around movements that had expressed nothing but contempt for museums.

The field of avant-garde studies in the English-speaking world came into its own at the same time, spurred by Clement Greenberg (his classic 1939 essay 'Avant-Garde and Kitsch' republished in the 1961 collection *Art and Culture*), Anna Balakian (*The Literary Origins of Surrealism*, 1947; *The Symbolist Movement*, 1967), Maurice Nadeau (*The History of Surrealism*, 1965), J. H. Matthews (*An Introduction to Surrealism*, 1965), Robert Motherwell (*The Dada Painters and Poets*, 1951), Hilton Kramer (art critic for *Arts Magazine*, 1955–58; *The New York Times* and *The Nation* beginning in 1965), Renato Poggioli (*Teoria dell'arte d'avanguardia*, 1962, *Theory of the Avant-Garde*, 1968), Hans Magnus Enzensberger ('The Aporias of the Avant-Garde', 1962), Lucy Lippard (whose anthologies of Surrealist and Dada documents were published in the late 1960s and early 70s), Donald Drew Egbert ('The Idea of "Avant-Garde" in Art and Politics', 1967; *Social Radicalism in the Arts*: *Western Europe*, 1970), small presses such as Grove Press (founded in 1951) and journals such as *The Evergreen Review* (1957–73) which exposed the literature of the avant-garde to a new generation. Surrealism, Italian Futurism, Dada, Constructivism and the like found their way onto museum walls, theatre repertoires, dance bills, syllabi and coffee-table books.

Jameson writes of this development:

One cannot too often [. . .] underscore the moment (in most US universities, the late 1950s or early 1960s) in which the modern 'classics' entered the school system and the college reading lists (before that, we read Pound on our own, English departments only laboriously teaching Tennyson). This was a kind of revolution in its own way, with unexpected consequences (1991: 313).

This moment was marked by 'a mutation in the sphere of culture' (ibid.: 314) that rendered antique the 'passionate repudiation' (ibid.) of Modernist

works, disabled their 'ugly, dissonant, obscure, scandalous, immoral, subversive, and generally antisocial' (ibid.) qualities. Though this mutation and repudiation was distinct across media—it played in architecture in a very different way than it did in theatre, for example—it did seem that their rebellious charge was lost, 'like former radicals finally appointed to the cabinet' (ibid.). This shift was one of the catalysts for the emergence of the postmodern, 'since the younger generation of the 1960s' would 'now confront the formerly oppositional modern movement as a set of dead classics, which "weigh like a nightmare on the brains of the living", as Marx once said in a different context' (ibid.: 4). Danto adds, in line with Jameson, that this period saw the rise of a new generation of politically engaged and aesthetically dissident artists who had 'the whole inheritance of art history to work with, including the history of the avant-garde, which placed at the disposition of the artist all those marvellous possibilities the avant-garde had worked out and which modernism did its utmost to repress' (1997: 15).

The avant-garde may have found its way onto the cabinet but the cabinet itself looked and sounded pretty much like it had before the radicals arrived: white, male, a speaker of one of the hegemonic European languages and enamoured of the fine rather than the vernacular arts. Its members held distinctly Modernist, Eurocentric and masculine perspectives that favoured the rigorous exploration of medium rather than sociopolitical circumstance (Guilbaut 1983). The 'marvelous possibilities' of artists and critics of colour, women, the queer, non-Europeans, vernacular artists such as sign painters and fashion designers and, following the heydays of the House Un-American Activities Committee, socialist and communist artists and intellectuals were still difficult, if not impossible, to find. (On sign painters and other vernacular artists, see Lorenzo 2000.) Also missing from the ranks were the new national subjects emerging from the revolutionary crucibles of China, India, Algeria, Cuba, Ghana, Guinea-Bissau and elsewhere—subjects that carried with them distinct experiences and understandings of cultural, technological and economic modernity. For those vanguards and scholars representing the 'new subjects of history'—as Jameson calls them (1989: 181)—not only did new characters, places and moments need to be introduced into the story of the avant-garde, but the story and its enabling institutions were also part of the problem.

The reform of those institutions came only after a prolonged, quite often violent, struggle that has impacted the way we think about the very

vanguards that fought the fight—often distorting the historical record as a result. Illustrative of this is the role of the BAM in the founding of academic 'Black Studies' programmes in the US. Radical artists and academics were in collaboration from the start. In 1965, Aubrey LaBrie, one of the editors of 'the first major Black Arts literary publication', *Black Dialogue*, taught a course at San Francisco State University (SFSU) on black nationalism. Nearby, workshops on related topics were hosted by Black House, a cultural-nationalist organization that had grown out of Black Arts West, a self-styled vanguard theatre project whose members included playwrights Bullins and Marvin X and community activists Huey Newton and Bobby Seale. Their desire to fully integrate activism, critical creation, pedagogy and community outreach led them quickly to the offices of the SFSU administration, where they demanded the full integration of their programme into the SFSU curriculum and faculty.

In response to those demands, SFSU hired sociologist Nathan Hare to coordinate its formerly ad hoc Black Studies programme, though without giving the programme official departmental status or full-time faculty. The hiring of Hare was a remarkable achievement in and of itself. Hare had earned national notoriety for 'The Black University Manifesto' (1967), which lambasted the administration of the historically black Howard University for its plans to make Howard '60 per cent white by 1970'. The manifesto affirmed the need for educational institutions that catered to the specific needs of African America and for the overthrow of the Negro college with white innards and to raise in its place a black university relevant to the black community and its needs. The subsequent student uprising at Howard gave the administration plenty of reason to push Hare to the exit.

Hare's move to SFSU did not dampen his radicalism. His far-reaching 'Conceptual Proposal for a Department of Black Studies', penned shortly after his arrival in early 1968, was deemed 'too political' by the administration, though it would become a model for ethnic studies programmes across the country. Administration foot-dragging further fanned student anger; tensions increased in April when Martin Luther King Jr was assassinated, setting off a wave of urban riots. In May, new demands were presented by a coalition of activist groups, including an end to the SFSU Air Force–ROTC programme, the admission of 400 poor, minority students from the area and the hiring of nine full-time faculty specialists in ethnic studies. That Fall, in response to the demands of the California state-system trustees (under pressure from Governor Ronald

Reagan), the administration suspended English instructor (and Black Panther Minister of Education), George Murray.

Incensed by this and the slow pace of reform, LaBrie, Hare, Amiri Baraka (at SFSU as visiting professor), the Black Student Union (led by James 'Jimmy' Garrett, whose enormously popular play *We Own the Night*, 1968, was workshopped nearby at Black House), the multicultural coalition organization Third World Liberation Front, Students for a Democratic Society, and the Progressive Labor Party began organizing for a major action and presented a list of 15 demands concerning the status of students of colour, ethnic studies and other matters of race and racism at SFSU. These included the consolidation of all Black Studies courses and faculty under a degree-granting Black Studies Department, with Hare as a tenured professor and chair, the complete autonomy and full financial support of that department, the reinstating of Murray, the admission of all African American applicants, and the stipulation that state trustees not be allowed to dissolve Black Studies programmes either on or off the SFSU campus. Predictably, the administration rejected the demands, setting off a five-month student strike.

Russ Castronovo believes that the most important outcome of the strike, aside from the creation of the first Black Studies Department in the nation, was that those involved 'overstep[ped] boundaries between campus and community, higher education and political consciousness and passive learning and activism' (2000: 782). Predicting performance studies pioneer Dwight Conquergood's work with the Latin Kings' street gang in Chicago and the Hmong ethnic group both in Thailand and the mid-western US (discussed in more detail at the conclusion of Chapter 1), the strike 'participate[d] in a transdisciplinary ethic of interrogation that question[ed] the university's configuration of knowledge as apart from public interest and unrelated to social justice' (ibid.). The radical organizations that spurred and developed from the strike mobilized, Castronovo continues, 'an interdisciplinary perspective upon systemic connections between institutional racism, capitalist production, and the social reproduction of knowledge' (ibid.: 781–2). This approach was enabled by the active involvement of individuals whose work had long crossed the lines among art, scholarship and activism; in other words, the African American vanguardists of the BAM.

Their efforts are exemplified by the Black Communications Project (BCP), described by one of its creators, Baraka, as rooted in 'Black Traditions', 'Mixed Media', 'People's Forms' such as rhythm and blues and

popular dance, 'energizing of existing structures and facilities', 'community organization', 'social utilization—bars, etc.', the performance of drama at 'points of general agitation' and 'cultural events' such as a 'mass Swahili Wedding Ceremony' (1968: 54–5). The shape and success of the BCP was due to the efforts of Sanchez (probably the key figure in the SFSU action); the many Afrocentric and politically radical study groups in the Bay region (such as Black House), many of which also functioned as art, music and literary workshops; and the writings of prodigious critic, poet, theorist and activist Larry Neal and the Revolutionary Action Movement's Max Stanford (now Muhammad Ahmad), who had long advocated a theory of cultural revolution. The BCP was the fruit of a sustained and self-conscious collaboration of artists, scholars, and activists who sought to define a new relationship among cultural production, scholarly inquiry and social responsibility. But the BCP was not just a means to an end—it was the very model of a militant Black Studies: critical, creative, collaborative and performative.

The actions at SFSU inspired similar actions across the US and the model proposed by Hare, practiced by LaBrie and Black House, and enacted by the BCP, became something of a standard. By the end of 1968, Black Studies courses, programmes and undergraduate and graduate majors could be found at some 640 colleges and universities, almost all making the changes in response to student, faculty and community unrest (Bass 1978: 2). Predictably, these changes drew the ire of traditional academics who were especially scandalized by the most radical demand of the activists: the critique and partial dismantling of academic credentialing systems. Such dismantling was necessary, the radicals argued, for truly self-reflexive, interdisciplinary, activist and democratically based scholarly and creative work. After all, Black Studies at SFSU came about when students, faculty and community members learned, created and fought together—and it was relevant to them only insofar as it remained focused on the most disadvantaged and marginalized members of the population. Thus, the birth of Black Studies in the US marked a shift not only in curriculum but also in faculty demographics and town–gown relations. Activists, artists and countless self-educated intellectuals were not only claiming a rightful place among the PhDs but loudly declaring the equality—if not the superiority—of their knowledge, a tendency actively emulated by an already unruly student body. Predictably, a backlash occurred.

The Ford Foundation's report on ethnic studies programmes, *Widening the Mainstream of American Culture* (1978), authored by Jack Bass, tells the story of this backlash, not only in its explicit support for conventional scholarship and credentialing rituals but also in the specific story it tells about Black Studies. It states quite frankly, that 'the introduction of black studies to American campuses began with conflict between academic substance and political purposes' (ibid.: 4). Just as candidly, the report admits that many schools instituted Black Studies out of fear of student radicals, creating programmes as a stop-gap measure 'to avoid further confrontations or to keep the students quiet' (ibid.: 2). But the report is far less candid about its ideological disagreements with the black nationalists who pressed the fight, instead presenting as inherently wrong-headed demands such as courses taught only by and for blacks, separate dormitories and campus centres for black students and required student approval of faculty and curriculum. Regardless of whether one agrees with such notions, one must admit that they are notions to be *argued*—not simply dismissed or ignored.

Equally disturbing, the report presumes that administrations took a wrong step when they hired instructors lacking conventional academic credentials. But rather than document the putative degeneration of the intellectual community at universities and colleges that had hired such faculty (or, on the contrary, acknowledge the benefits provided by such' faculty), or assessing the positive impact on faculty artists who had gained long-sought-after job security, the report focuses on intra-faculty relations and the bad blood between the young Turks and the old school. As the report puts it, 'Strident demands that sacrificed intellectual substance provided faculty members and administrators who might be hostile or indifferent to Afro-American studies with justification for destroying them, and in some cases that happened' (ibid.: 3). Attempting to avoid such stridency and keep the traditionalists happy, the Ford Foundation advocates that colleges and universities renew their commitment to 'academic integrity' while continuing to address the needs of those traditionally excluded from its corridors and classrooms.

I do not wish to argue for or against the demands of campus agitators, for or against standards of academic integrity or for or against the validity of segregative practices in university environments. There is no doubt that some truly unqualified people were hired by Black Studies programmes in their rush to appease angry students, faculty and other

community members. Just as surely, there were those more noted for 'civil rights protest' who had the intellectual chops to stand with the best and brightest, Hare and Murray among them. Regardless of the qualifications of specific individuals, the categorical assumption of the backlash was that activist experience, art and innovative combinations of cultural production and scholarly inquiry were less academically valuable than conventional, academically specialized scholarship. For radicals like Hare, such an assumption resonated with the most deeply rooted racism, a racism disguised—as most racism is—as a set of value-free criteria; in this case, 'academic integrity'. The reassertion of those criteria enabled a rollback on the kinds of progressive boundary-crossing and transdisciplinary approaches described by Castronovo.

The backlash purged and routinized the black vanguard—and apparently justified its forgetting. The foundation report does not mention the two-year organizational effort at SFSU nor what led to it: theatre, performance, elite–mass collaboration and other modes of critically conscious action developed by the artist-activists of the BAM. Rather than the community workshops, town and gown collaborations, innovative modes of pedagogy and other forms of radically democratized cultural production, the report cites only the assassination of the King and the anger of African Americans with their condition as the catalyst for Black Studies. Black nationalism is reduced to a hysterical demand for segregated facilities rather than being acknowledged as a valid intellectual position with a long history and remarkable roster of thinkers. The contribution of artists is ignored and the particular challenges facing artists when it comes to academic credentialing, is not addressed. Finally, the intellectual sources of the Black Studies' model are denied a hearing: C. L. R. James, Harold Cruse, Queen Audley Moore, John Henrik Clarke, Langston Hughes and Malcolm X, not to mention the hundreds of study groups, neighbourhood workshops and church committees who had spread their ideas. Granted, the Ford Foundation's liberal imperatives and corporate obligations provided plenty of good reason to have done with the likes of Baraka, Sanchez, Neal and their ilk. But the exclusion of black nationalists and black nationalism from the story, the shoring up of disciplinary boundaries and the denial of the critical-creative implications of black radicalism directly undermined the spirit of academic inquiry that is necessary for an understanding of the politics of academia.

At the very least, the backlash has impacted our understanding of the BAM. As Harry Elam Jr, Robinson, Moten and I have argued, the BAM is

not just one avant-garde among others; it calls into question the conceptual and historiographical bases of the field (Elam Jr 2006; Robinson 1983; Moten 2005; Sell 2005). Indeed, this book would not have been written were it not for the lessons I've learned from studying the movement. But these lessons have been hard to come by until quite recently. In 1991, David Lionel Smith rued the fact that 'we do not have a single book, critical or historical, scholarly or journalistic, devoted explicitly to the Black Arts Movement' (1991: 93). Times have changed, and there is a remarkable body of excellent work, now available on the movement. But that body of work was written in the face of the persistent hostility of leading figures in the field of African American studies. While not losing sight of the many shortcomings of the movement's theory and practice, Smith is right to point out that 'most criticism regarding the Black Arts Movement has been deeply partisan, for or against. The fierce polemics surrounding the movement have discouraged careful and balanced scholarship' (ibid.: 102).

Among those who have been most partisan and most polemical is Henry Louis Gates Jr. He has repeatedly and publicly insulted the movement and its scholars. He characterized a 1977 Modern Language Association-sponsored conference on the BAM at Yale as 'an attempt to take the "Mau-Mauing" out of the black literary criticism that defined the "Black Aesthetic Movement" of the '60s and transform it into a valid field of intellectual inquiry once again' (1987: 44). In a column he contributed to a *Time* magazine cover story on African American art and culture, he pronounced the BAM the 'shortest and least successful' movement in African American cultural history (Gates Jr 1994: 74–5). But the irony is, as Smith notes, that 'though Gates Jr often assaults Black Aesthetic critics for having an ideological agenda, the real struggle is between one ideology that rejects the institutional status quo and another that embraces it' (1991: 106). Moreover, once we get past the polemics, one notes the profound and abiding influence of the BAM on his work. (I, for one, hope that future editions of Gates Jr's seminal *The Signifying Monkey*, 1988, will include proper and prominent acknowledgment of Neal).

The care and balance called for by Smith is evident in recent work by Fanon Che Wilkins (2001), Robin D. G. Kelley (2003), Donna Murch (2003), Jeffery Ogbar (2005), James B. Smethurst (2005), Lisa Gail Collins, Margo Natalie Crawford (Collins and Crawford 2006), Peniel Joseph (2006a, 2006b) and others. That work is marked by a strong historical

consciousness, a sophisticated understanding of the role of medium and discipline in the articulation of 'blackness', and a self-reflexive reading of the impact of institutions on the construction of the discourse. Salutary to this development is the recognition of the centrality of performance and performativity to the movement. Anna Scott (1997), Kimberly Benston (2000), E. Patrick Johnson (2003), Fred Moten (2006), Lorrie Smith (2006), Rod Hernandez (2006), Cherise Smith (2006) and others have ensured the presence of performance as both medium and critical perspective in BAM studies (see also Sell 2001). Benston's book *Performing Blackness* is a vital intervention against the caricatured assumption that the BAM was 'a dangerously closed system of doctrines and fashions, and, in particular, as a self-deceived discourse declaring itself unambiguously to be a mode of authentic being unprecedented in African-savvy American history' (2000: 3).

Of course, this extraordinary wave of BAM scholarship has been enabled by scholars such as Gates Jr. My own understanding of the movement has been inspired and guided by his work and has benefitted profoundly from Black Studies programmes and curricula that may have been fought for by the radicals but survived because of tough-minded, institutionally savvy liberals like Gates Jr. Finally, the sophisticated approach of these scholars is possible only in academic settings that have come around to recognizing the value of interdisciplinary methods, artistic creation and identity-based scholarship. But I think it is fair to say that, given its entanglement with the politics and performativities of Black Studies, the BAM will continue to pose a challenge to the discourses and disciplines of academic scholarship and those who study it. As Benston warns us, '[T]he tactics we employ in decoding and recoding modern black art still turn in some measure on our interpretation of the artistic revolution whose origins stand now at a generation's remove, on our attitude towards the programmatic declarations and practical performances which carry the Black Arts Movement's freight of aesthetic, ontological and political visions' (ibid.: 6).

The case of the institutionalization of BAM and its impact on our understanding of the movement is, of course, unique. But it shares characteristics with similar efforts around the world by groups and individuals marginalized by the canons and institutions of the avant-garde. In an extraordinary account of a battle she waged with the organizers of an exhibition of women's performance-art photographs, Stiles has described the difficult negotiations that must be attempted in situations where 'value

judgments', 'personal expectations about the ethical behaviour of avant-gardes', and the 'experience of writing about them' (2000: 248) clash with those who believe themselves to be sustaining the critical force of the avant-garde, yet unwittingly subverting it. The dispute concerns the *Body as Membrane* exhibit organized by Kristen Justesen and Valie Export in 1995. Stiles raises three objections to the show and its catalogue. First, she objects to what she sees as uncritical representations of the serial-surgical alter-ations of performance artist Orlan and the reproduction of photographs of performances by Annie Sprinkle, Joan Jonas, Heli Rekuli, Elke Krystofek and others that, in her words, replicate the 'terrible, gnawing psychophys-ical self-doubt, self-hate, self-revulsion, and annulment' of women typical of male-intended pornography (ibid.). Second, Stiles objects to the absence in the exhibition and catalogue of pioneering feminist performance artist Carolee Schneemann, both her groundbreaking work of the 1960s and 70s and the innovative critical position she developed and summarized in 'Istory of a Girl Pornographer': 'I WAS PERMITTED TO BE AN IMAGE/BUT NOT AN IMAGE-MAKER CREATING HER OWN SELF-IMAGE' (quoted in ibid.: 251). Finally, she objects to the fact that Justesen and Export cut from their cat-alogue a commissioned essay by Stiles detailing these objections.

The germane issue here is not the content of Stiles' objections, but the lack of willingness of her colleagues to provide space for the articula-tion of those objections. A greater willingness to foreground such dis-agreements, Stiles argues, would promote 'a pluralistic accountability' and greater attentiveness to impact that, the positions and institutions of those who study radical art exerts on our understanding of that art (ibid.: 245). 'To be radical,' Stiles writes, 'requires responsibility, a quality that may be impossible to transmit from generation to generation', but it helps when those in the field commit to rigorous self-examination (ibid.: 275). 'No real theory of avant-gardes,' she concludes, 'may be written until the tastes and ambitions of critics themselves have been explored' (ibid.: 270). The absence of such exploration has impacted more than merely our under-standing of the BAM and feminist performance art. Banes writes:

> That the university now provides a protected haven—however ran-dom or small-scale—for experiments in performance; that it ani-mates in the next generation of young artists ideas—however embat-tled—about innovation and originality; that it literally feeds those who make iconoclastic, deviant, or alternative art and that it supplies dissident voices within the university system itself; all these aspects

are crucial politically as well as culturally—not to mention pedagog-
ically (2000: 235).

To quote Campagnon again, '[A]vant-gardism belongs to both the critic
and his subject, for it is the critical viewpoint integrated into artistic prac-
tice that gives the term 'avant-garde' its meaning (quoted in Stiles 2000:
269–70).

THE AVANT-GARDE AS CRITICAL METHOD AND GENEALOGY

This volume marks my own effort to consolidate the achievements of crit-
ics and scholars like Stiles, the activists of SFSU, those whose work I have
cited here, those who will be discussed in the chapters that follow and
those for whom room could not be found (or that, with apologies, I've
missed out), in other words, those who have studied the avant-garde in a
theoretically rigorous, ethically self-reflexive, historiographically dexter-
ous and institutionally conscious way. Likewise, it marks my effort to effec-
tively respond to the challenges facing the field after 9/11, both the
genealogies 9/11 intruded into the field (that is, of Islam and military spe-
cial forces) and the renewed consciousness of the contingency of avant-
garde studies it has provoked. To those ends, I have worked under partic-
ular assumptions about the avant-garde that others in the field may not
share, that need specification and inevitably raise issues of their own. I will
begin with the two most consequential: my definition of the avant-garde
and the tropological approach that structures the three chapters.

1. Defining the Avant-garde

Sarah Bay-Cheng once remarked to me that anyone who writes about the
avant-garde defines it in a fashion that neatly fits the material they have
chosen to write about. I find her comment both inspiring and frankly
depressing. On one hand, these kinds of bespoke definitions reflect the
diversity of the tendency and the dexterity of our critical traditions, speak
to the many 'futural potentials' of vanguard cultural production and the
multiple configurations of power within which vanguards manoeuvre. On
the other, it reflects a chronic lack of rigour and theoretical self-
consciousness in the field and, perhaps, our inability to resist the heady
scent of radical chic, making it an irresistible tagline for hedge funds,
clothing boutiques, graphic designers and, last but not the least, scholars
wishing to advertise the radicalism of their favourite artist or artwork.

My definition of the avant-garde responds to this contradiction. It is a working definition for sure, but it opens some space for the assessment of both familiar people and works and those that fall outside the conventional storyline. Counterbalancing this expansiveness, the definition provides some fairly rigid criteria to guard against uncritical, impressionistic uses of the term.

The avant-garde is a minoritarian formation that challenges power in subversive, illegal or alternative ways, usually by challenging the routines, assumptions, hierarchies and/or legitimacy of existing political and/or cultural institutions.

Perhaps the parts of this definition that will surprise readers the most are, first, the stipulation that the avant-garde be 'a small-group formation' and second, that there be no specific mention of art or aesthetics. As I mentioned earlier, this book attempts to respond to the challenge raised by Williams in *The Sociology of Culture*.

By prioritizing group status, my definition not only ensures that social analysis be given priority in our efforts to theorize and historicize the avant-garde but also provides the most concrete approach possible to the specific politics of a given vanguard. The definition orients our scholarship and criticism towards *relationships* and detailed, concrete and historicized descriptions of the 'politics of form'. As Fred Orton and Griselda Pollock have put it:

An avant-garde does not emerge 'readymade' from virgin soil to be attributed à la mode. It is actively formed and it fulfills a particular function. It is the product of self-consciousness on the part of those who identify themselves as, and with, a special social and artistic grouping within the intelligentsia at a specific historical conjuncture. An avant-garde is a concrete cultural phenomenon that is realized in terms of identifiable (though never predetermined) practices and representations through which it constitutes for itself a relationship to, and a distance from, the overall cultural patterns of the time (1981: 305).

Again, this does not mean that art falls out of the picture. In fact, by attending to practices, representations and relationships in a more general way—as opposed to those that concern only art and aesthetics—we are better equipped to understand why the avant-garde has been associated at some times and in some places more with individuals than with groups or with some forms of cultural production (such as art), rather

than others. In this vein, Alan Filewod, in a recent series of papers on radical theatre in Canada, argues that it is best not to consider the avant-garde as a set of specific techniques. Given that specific modes of aesthetic radicalism lose or gain political charge and efficacy depending on their temporal, geographical or social situation, it is more useful to consider the avant-garde as a shifting 'domain of reception and patronage in cultural industries' (Filewod 2006).

One immediate objection to the emphasis on group identity is that 'vanguards of one' such as the Polish *wunderkind* Stanislaw Witkiewicz, the motile chaos factory Elsa von Freytag-Loringhoven, Beckett, or shooter-of-Andy-Warhol Valerie Solanas would appear to be categorically excluded. This is not the case. A definition of the avant-garde that gives priority to social relationships, social action and the ways that people imagine and organize themselves can be as sensitive to individual identity as it is of social groupings. This is why significant portions of this book are dedicated to individuals—Henri de Saint-Simon, René Crevel, Suzanne Césaire, Melvin Tolson, Emmy Hennings, Emile Nolde, Max Beckmann, Ernst Toller, Frantz Fanon, Max Nordau and others. In a setting where the institutional and cultural pressures for group identity threatens to destroy the individual, individuality and individualism are valid, viable bases for activism. That said, I very much agree with Kalaidjian when he criticizes the field for generally fetishizing the individual artist—particularly, the white, European artist—at the expense of collectivist, multicultural or populist models of cultural production (1993).

An emphasis on group identity and social action also provides tools for considering the career arc of avant-gardes, allowing scholars to chart the shifting status of a group as it adjusts its relationship to power. All apologies to the eulogists and the Romantics, but the 'co-optation' of an avant-garde by a mainstream institution or a patently non-revolutionary social class is not necessarily the end of the story. Quite the contrary, the moment of co-optation—always a transformative moment—can provide much valuable information. Such moments generally compel the avant-garde in question into a process of thorough self-assessment, allowing it to achieve a higher level of self-consciousness and, in the process, revealing a new set of tasks to carry through its efforts to alter power relations. Emilio Gentile has explored this process in his excellent study of the debate pursued by Italian fascists over the status of autonomous fascist groups within the fascist Italian state (2003). A similar story will be told,

in Chapter 1, about the South African Afrikaner Broederbond, the secret organization that designed and implemented apartheid. Over the course of its eight-decade existence, the Broederbond transformed from a marginalized party representing a despised minority to the most powerful organization in the racist South African state. But this incorporation into a bureaucratic state spurred the development of an avant-garde within its ranks, the infamous Security Branch. Very different kinds of negotiations of avant-garde hegemony can be traced in Mao's Red Army as it assessed the future of the revolution during the crisis years in Yenan; among French officers in Algeria who abandoned the army's long- standing tradition of political neutrality and nearly launched a coup against the French government; and in the Gush Emunim organization in Israel as it insinuated itself throughout the Israeli government during the 1970s and 80s. All of these and others will be discussed in the chapters that follow.

This raises a related matter: the ideological range of avant-garde studies. Scholars and critics of the avant-garde freely admit to the right-wing associations of some of its key figures and movements—Richard Wagner, Friedrich Nietzsche, Italian Futurism, Ezra Pound and Wyndham Lewis being the most obvious. Indeed, they may be a little too ready to make such admissions; Günter Berghaus (1996a), Emilio Gentile (2003) and Patricia Gaborik and Andrea Harris (2011) have shown that the relations of Marinetti and his Futurist cohort to the fascist movement in Italy are far more nuanced and problematic than is usually admitted. In other fields—such as political science, the sociology of organizations and history—right-wing vanguards are an accepted subject with a healthy body of work around them. That the case is not so in the humanities is surprising. Recent work on the avant-garde informed by feminism, critical race theory, queer theory and postcolonial theory has challenged any notion of the avant-garde as a purely radical agent in history given its Eurocentrism and diverse chauvinisms. From these perspectives, the avant-garde as such is a right-wing tendency. Thomas Crow (1983) and Manfredo Tafuri (1992) have made compelling cases that avant-garde cultural production—Neo-Impressionist painting and Modernist architecture, respectively—has served, for all intents and purposes, as research-and-development laboratories for capitalist development. Jacques Attali has made a similar case for music, reading the formal experiments of composers such as Erik Satie, Arnold Schoenberg, John Cage, Karlheinz Stockhausen, etc., as modelling new social formations

and modes of political economy that have no necessary relationship to progressive ideology (1992). Jannarone reads Artaud's writings, especially *The Theater and Its Double (Le Théâtre et son Double*, 1938), alongside the similarly mystical, totalizing and anti-intellectual writings of proto-fascists, troubling the common association of Artaud's works with liberatory, anti-authoritarian politics (Jannarone: 2010). There is some provocative work available on right-wing punk movements (see White 2011). And Serge Guilbaut, in his classic work on Abstract Expressionism in the Cold War-era, *How New York Stole the Idea of Modern Art*: *Abstract Expressionism, Freedom, and the Cold War* (1983) details how avant-garde art was deployed by the US as part of an ambitious, psychological warfare campaign.

Right-wing vanguards, subvert, avoid and challenge power in complex and contradictory ways, making it all the more vital that they be fully brought into the fold of avant-garde studies. Klaus Theweleit has examined the role that the paramilitary Freikorps played in the creation of the fascist revolution in Germany. The Freikorps were heroes to the German middle classes, embodied many of the most cherished myths of German masculinity and were often well-paid agents of the German state (the embattled government of Friedrich Ebert sent them to quell communist uprisings in several German capitals in 1920). This makes their vanguard status vis-à-vis the political and cultural institutions of their moment especially complex. A similar problem emerges in the relationship of institutionalized racism and police brutality in the US. Steve Martinot and Jared Sexton have raised a difficult question concerning how we conceive the agents of such violence. As they show, 'splinter groups' and 'bad apples' provide a useful scapegoat for authorities, distracting from the structured racism and economic inequality of the state (2003: 171). They ask, 'Of what are such groups the avant-garde?' and they argue that community efforts to monitor, investigate and punish police brutality must, in a tragic paradox, assent to the legitimacy of the very institutions designed to defend the structures of race and class. They conclude that the 'avant-garde of white supremacy' reveals 'a twin structure, a regime of violence that operates in two registers, terror and the seduction into the fraudulent ethics of social order' (ibid.: 172). While I do not believe that such vanguards are by any means paradigmatic of the avant-garde as such, they raise issues of general import to the field.

Finally, a sociologically based definition of the avant-garde gives scholars a significant advantage when they're trying to work through a

historiographical analysis of their topics. A focus on group identity allows us to sidestep the problem of having to define this or that avant-garde as 'in advance', a rhetorical obligation of the field that is long overdue for the dumpster. By emphasizing how a given vanguard relates to other social groupings around it and how it relates to and distances itself from broader cultural patterns and infrastructures, we can trim away some of the modernist mumbo-jumbo surrounding the term and restore an element of the original, function-focused meaning of the term: the military corps that goes in advance of the main army. We should always remember that, before it is ever 'in advance', the military avant-garde is a small group that distinguishes itself from a larger group by identity and position. Rather than having to invoke dubious historiographical meta-narratives, the scholar can dig instead into belief systems, discourse economies, institutional formations, rhetoric, etc. As a result, the analysis of artworks—still, to my mind, the most interesting dimension of the field—can speak much more concretely to politics and power. Establishing how, say, a particular style of painting or dance or film is ahead of its time is not an especially interesting or relevant thing to do as far as I am concerned. A more interesting question is to ask why a particular medium and/or style came to function as a marker of social difference and how such difference came to be understood in essentially temporal ways, came to be associated not just with social difference but also with a presentiment of things to come.

In addition to leavening the modernist bias of the field, a focus on group status gives us some very useful tools to address the fact that the avant-garde—both the tendency and its academic discourses—are, in Harding and Rouse's words, 'haunted by a Eurocentric specter' (2006: 3). Moten agrees: 'The idea of the avant-garde is embedded in a theory of history. This is to say that a particular geographical ideology, a geograph-ical racial or racist unconscious, marks and is the problematic out of which or against the backdrop of which the idea of the avant-garde emerges'. For Moten, the Eurocentricity of avant-garde theory 'produces the social, aes-thetic, political economic, and theoretical surplus that is the avant-garde' (2003: 31). Moreover, it props up a certain way of thinking about the avant-garde that reproduces that very economy, a point he makes clear in his discussion of African American jazz. Harding and Rouse, among others, have shown that 'existing histories of the avant-garde have privileged a Eurocentric framing of practices that were always already present in a

variety of unacknowledged forms across the spectrum of world cultures' (2006: 3). Working against that kind of framing, we can extend the focus on relationships and distances described by Moten and Pollock to the geopolitical field. In this way, avant-garde studies can participate in the broader 'reassertion of space in critical social theory' that was first described by Edward W. Soja (1989: 12ff.)

Soja notes that the 'nineteenth-century obsession with history [. . .] did not die in the *fin de siècle*'. On the contrary, 'an essentially historical episte-mology continues to pervade the critical consciousness of modern social theory' (ibid.: 10). Challenging this epistemology, he invokes the notion of a 'triple dialectic', in which space, time and social beings interact, poten-tially in a transformative fashion (ibid.: 12). When we turn to vanguard ten-dencies outside of Western Europe and the US, we do not just expand the scope of the field; rather, the triple dialectic rebounds on the very discur-sive structures of the field. As Harding has made clear, understanding the avant-garde as a transnational phenomenon does not mean we just fold the 'other avant-garde' into the existing storyline, add a few new names and texts to the anthologies, or hang a few new paintings in the galleries. Rather, a globalist approach demands that we shake off the historically inflected connotations of the avant-garde as a 'cutting edge' in favour of other, more relational metaphors such as 'contested edges, simultaneous articulations, and apostate adaptations' (Harding and Rouse 2006: 24).

Although my definition challenges scholars and critics to pay greater attention to the sociology of the avant-garde, one thing that it does not challenge is the idea that the avant-garde is political. Indeed, I presume that its very *raison d'être* is to challenge power. However, I also presume that the nature of that challenge is varied. More importantly, vanguards often reconfigure the very concept and nature of political struggle. Perhaps the best example of this are the feminists and black civil rights workers of the 1960s who came to recognize the multiple sites of oppres-sion that could not be touched by legislative and criminological action. Their notion that the 'personal is political' addressed that gap, upended the conventional wisdom about how to fight oppression and unleashed a wave of theory and practice that is still rippling. Similar effects can be seen in military history; the history of irregular warfare is the history of small groups exploiting the insufficiencies and gaps in the strategic concepts and capacities of more powerful armies. Avant-garde art is polit-ical not just because it is a force within the art world and other cultural

institutions—indeed, in that realm, the avant-garde's power would appear to be only declining in recent decades—but also because it reforms the human sensorium, directs our attention to aspects of experience that we might otherwise ignore or discount or intrudes into the aesthetic realm, forms of knowledge or experience normally understood as belonging to other, putatively non-aesthetic realms.

Thus, though I declare that the avant-garde is 'political', I don't presume a particular 'politics of form', to recall Watten again, as necessary or superior to another. Avant-gardes often exploit the loopholes, exclusions and blindspots of official institutional and cultural power. The avant-garde challenges power in subversive, illegal or alternative ways. By that definition, there can be no 'liberal avant-garde', in the sense that the avant-garde would be seeking to simply reform existing political or cultural institutions. As we saw in the case of the BAM and Black Studies, even when fully engaging institutions, the avant-garde demands and produces fundamental restructurings and reconceptualizations.

2. The Avant-garde as Critical Method

One of the things that sets this volume apart from other studies is its tropological approach. Each of the chapters is dedicated to a word—race, religion, war—that serves as a key term, theme and principle of coherence for a wide-ranging exploration of vanguard tendencies. Each term provides a distinct perspective on the history, meaning and 'futural potential' of the avant-garde. Readers may be familiar with Frank Lentricchia and Thomas McLaughlin's *Critical Terms for Literary Study* (1995) or Raymond Williams' earlier *Key Words: A Vocabulary of Culture and Society* (1976) (both of which, by the by, do not include the term 'avant-garde'). My book is in their spirit. In these pages, race, religion and war provide a terminological and associational thread binding people, places, actions, art and ideas from across history and around the world, enabling not only a revised historical sensibility concerning vanguard activism, but a set of critical concepts with which to continue the work of telling the history of the avant-garde in a more complex, more complete way.

This tropological approach responds to Foucault's critique of conventional historiography in his essay 'Nietzsche, Genealogy, History' (1984[1971]) in which he calls for the abandonment of historiographical methods premised on 'ideal significations', 'indefinite teleologies' and the 'search for origins' (1984: 140). By situating the historical development of

the avant-garde in the realm of struggle, accident, discursive formation and situation, we can tell a story organized around the 'myriad events through which—thanks to which, against which—' historical formations, agents and concepts exist (ibid.: 146). Rather than charting the development of a single avant-garde—*the* avant-garde—a history that emphasizes its conjunction with racialized power, spirituality, religion and warfare (or, for that matter, cuisine, drug use, sexual practice and so on), can demonstrate not only that the avant-garde is an extraordinarily diverse phenomenon but also that the multiple configurations of power in the modern era—what Foucault refers to as 'capillary power'—have been shaped by vanguards. As Watten puts it, '[t]he avant-garde is a central example of [an] "emergent" cultural form, and as such its implications are not confined' to any one form of activism (2003: 153). In this respect—and cognizant of vanguardism as a viable mode for both Left and Right—one might posit the history of the avant-garde as the very history of power, of power's expansion and insinuation, centralization and fracturing, reformation and radical revisioning. It is, if you will, the history of power's imagination; the history by which, to quote Arjun Appadurai, '[t]he imagination is now central to all forms of agency, is itself a social fact, and is the key component of the new global order' (1996: 31).

I have always tried to convince my students that it is a far less interesting question to ask, 'Is this avant-garde?' than to ask, 'What are the benefits of considering this subject in terms of the avant-garde?' 'What kinds of perspectives on power can we open if we view this person, produced thing, event or social group as avant-garde?' 'How does a research agenda informed by the theory of the avant-garde help you to discover new things about this topic (be it the history of the Hilton hotel chain, the work of photographer Ilse Bing, Puerto Rican nationalism, or whatever)?' 'How does it provide insight into the internal and external power dynamics that shape it?' 'How do those power dynamics provide some sense of the individual or group's self-definition and articulation as a social entity (minority, elite, subculture, grass-roots tendency) and the challenges it poses to the institutions, discourses and folkways surrounding it?' Then it is time to return the favour: 'How does your topic help us to better understand the avant-garde?' The tropological approach affirms Foucault's point that '[t]he isolation of different points of emergence does not conform to the successive configurations of an identical meaning, rather, they result from substitutions, displacements, disguised conquests, and systematic reversals' (Foucault 1984: 151).

This approach informs each of the chapters in this book, so a brief summary can both illustrate and give the reader some sense of what is in the pages that follow. Chapter 1 is about race. At the heart of this chapter is the story of how the avant-garde shook off its early, technocratic associations to become a broad-based cultural tendency. This is the story of bohemianism in Paris during the middle decades of the nineteenth century, its complex collusion with racism and racialist thinking and what I call the 'cultural turn' of the avant-garde. The first wave of bohemian cultural production marked a critical phase in the evolution of the vanguard concept, pioneering multiple forms of radical cultural production and social alterity but at the expense of a persecuted minority, the 'gypsy' (properly called 'Roma'). That discussion of the cultural turn of the avant-garde is prepared by an exploration of a key, though persistently underserved concept in the field of avant-garde studies—minority.

Understood in two ways—naming both those marginalized by power (that is, racialized, sexualized or economically disadvantaged subalterns), as well as those vested in it (that is, the minority party in a parliamentary body)—the term can be deployed to comprehend subtle nuances in the practices of avant-garde movements. For example, it provides a comparative basis for considering the work of both the white French Surrealist, Crevel and the black, anti-colonialist activists who articulated a distinctively Caribbean form of Surrealism in the 1930s and 40s. This discussion of minority carries into an analysis of the Afrikaner Broederbond and the racist roots of Saint-Simon's coinage of the modern meaning of 'avant-garde' and its role in both the colonization of Algeria (by way of the French medical corps) and its decolonization via another French- educated medical man, Fanon. Within a critical genealogy of avant-garde racism and racist avant-gardes, Italian Futurism's obsession with blackness and dependence on racialized forms of performative embodiment can be related both to Modernist and Postmodernist primitivism as well as to the almost forgotten work of Nordau, whose book *Degeneration* was not only the first book-length study of the avant-garde but also an inspiration to Nazis to confiscate and destroy avant-garde works in the 1930s, and to right-wingers in the US such as Jesse Helms to deny funding to queer performance artists in the 1990s. Perhaps most disturbing, Nordau's explicitly racist methods depend on techniques and assumptions uncannily similar to those of a putatively Postmodernist approach to avant-garde studies. As alternatives to the 'Nordau effect', I try to derive some useful lessons for the field from the

performances of Latin American critical-creative activists Fusco and Gómez-Peña, the sociopolitical interventions of the WochenKlausur collective and the collaboration of performance studies pioneer Conquergood and members of the Hmong community at the Ban Vinai refugee camp in 1985.

Chapter 2, dedicated to religion, also argues a controversial point. Against conventional wisdom, I posit that the avant-garde is a non-European, non-Modernist concept. It is here that I fully develop the notion that the avant-garde, rather than being the invention of Enlightenment-era European activists, emerged in the wind-blown terrain between Mecca and Medina during the Hejira of Muhammad and his Companions in AD 622. But the chapter begins not with a critique of the Eurocentrism of the field but with its anti-religious bias. Avant-garde studies, thanks to the pervasive influence of Bürger's *Theory of the Avant-Garde*, is dominated by Marx's critique of religion, emblematized by his oft-quoted bon mot, 'religion is the opiate of the masses' (1970: 131). Going against the grain, I explore not only the many overtly religious movements and individuals who fit my definition of 'avant-garde' but also religion's proven ability to mediate the social, cultural and political tensions surrounding small-group activism.

Within such a genealogy, the religious fanaticism of the military Junta that waged Argentina's 'Dirty War' during the 1970s can be comprehended as a point of emergence in conjunction with Saint-Simon's obsession with metaphysics and bad habit of characterizing avant-garde intellectuals and technocrats as a priesthood; as can Nietzsche's atheism and the diverse vanguards that practised mysticism, occultism and spiritualism in the nineteenth and early twentieth centuries. As I show, the 'Janus-faced' nature of religious belief and practice in the French Symbolist and German Expressionist movements can be usefully situated within a genealogical line that includes left-wing political movements in Guatemala and African America and ultra-violent right-wing movements in Kosovo and Mozambique. Finally, I move into a discussion of three religious fundamentalist vanguards in the US, Israel and Egypt, the latter the wellspring of al-Qaeda, each exemplary of the troubling ambivalence of religious vanguards vis-à-vis established state and cultural powers. The chapter concludes with an exploration of Zen Buddhism—its role in support of Japanese Imperial aggression during the Second World War, its influence on US avant-garde art and the lessons it teaches concerning the sacred–secular split in Western society.

To what degree can culture be used as a tool for military aggression or resistance? How has the culture of war shaped the way we think about the relationship between culture and politics? These two questions are the catalysts for the opening section of Chapter 3, an investigation of the history of special forces and other irregular military corps. After a brief discussion of military strategy in the art of the Italian and Russian Futurist movements, the instrumental, metaphysical, existential and aesthetic dimensions of warfare are illustrated by a comparative discussion of Melvin Tolson's epic poem 'The Bard of Addis Ababa' (1944) and the courageous resistance of Las Madres de Plaza de Mayo, who helped bring Argentina's Dirty War to an end but failed to adequately ascertain the entanglements of their work in the telecommunications revolution that provided critical support to the Junta that stole their children from them.

A revisionist history of Dada and Surrealism follows, showing the benefits of situating art within military history. Specifically, by emphasizing the controversial strategy known as 'revolutionary defeatism', the often misunderstood work of Dada chanteuse Emmy Hennings and the troubling inactivity of the Surrealists in occupied France have an important political dimension restored. Interculturalism and transnational collaboration, typically applied to artists and art collectives, are traced through the history of the sapper, the military engineering corps that provided an innovative concept of vanguard activism to Honoré de Balzac and played a major role in the insurgencies in Vietnam and El Salvador. The efforts to theorize and institute flexible forms of small-group praxis are explored through a lengthy discussion of counterinsurgency in Malaya, in Mao Zedong and Amilcar Cabral's respective theories and praxes of cultural revolution and in the so-called Revolt of the Colonels that almost toppled the French government during the Algerian War for Independence. The chapter concludes with an examination of three recent trends in the avant-garde of war that materially impact the field of avant-garde studies and, more broadly, the liberal arts: the military takeover of the public sphere, the generalization of the special forces model in militaries around the world and the push by the American military to educate all its soldiers in cultural studies.

* * *

Although I have benefitted greatly from the advice of experts in the many disciplines I explore in this book and have laboured to acquire the 'chops' necessary to write in those disciplines, I must admit that I am by no means an expert outside of my homebene fields of theatre, performance and dramatic studies. I have had to digest a daunting amount of material and familiarize myself with a great many discourses—an invigorating experience for me but specialists will find gaps, blurred details and idiosyncratic perspectives. That said, I trust that any discrepancies will be minor and not undermine the spirit of my inquiry. Indeed, I can only hope that my work inspires critical response across disciplines.

A similar weakness might be found in my response to the globalist imperatives of the field. Readers may have already detected in these pages a tension between my advocacy of global approaches and the examples that I have used to make the case. I have done my best to ensure the broadest geographical spread possible. However, in the interest of scholarly and critical rigour and because of my limits as a scholar, I have often depended on avant-garde histories with which I am most familiar and that have scholarship in the languages that I read. Again, my hope would be that, whatever gap exists between my intentions and my execution, this work will inspire others to do better.

I am far more confident about the challenge I have posed to the historiographical paradigms of avant-garde studies, particularly its wilful blindness to the nineteenth century. For far too long, the field has been dominated by Bürger's notion of the 'historical avant-garde', a notion that has consigned to 'prehistory' the rich and problematic vanguards that preceded Dada, Surrealism and Constructivism. Such assumptions are well worth abandoning. Indeed, I am tempted to call for a decade-long moratorium on any new theories of the avant-garde and the full investment of scholarly and critical energy into historical research, particularly in the eighteenth and nineteenth centuries. It is all too clear that the history of the avant-garde is not the one we find in the history books.

Notes

1 Among the many scholars problematizing notions of modernity (and, thereby, postmodernity) through the lens of globalization and the emergence of new national and regional subjects are Okwui Enewezor (1999), Geeta Kapur (2000), Jonathan Hay (2001), the contributors to Jan-Georg Deutsch et al. (2002) and Wu Hung (2004).

race

THE FUTURE OF THE RACE

Ten men, dark skinned, gather around a formal dining table, each with a luminous white lily in hand. They're aware of an ocean nearby, but the room is sequestered, so it's more of a feeling, a certain quality to the atmosphere. And it's dark. The light is so low that only the table is visible, and only barely so since it is made of smoked glass. Indeed, the men can hardly see themselves; their dark skin doesn't provide adequate visual contrast with the room's shadowy perimeter. They're hungry, ravished in fact. Signalling the arrival of the first course, a woman enters, also dark skinned, with a platter of 20 fresh, but curiously weightless, white chicken eggs. The men each take one and inhale deeply the delicate, ephemeral almond-and-vanilla scent of acacia flowers whose essential oils have been injected into the empty shells. A tureen follows, brim-full of cold milk, tiny mozzarella *bucconcini*, and white grapes bobbing on the surface, the whole having an unctuous, motile whiteness even in the low light. No one eats the soup. The woman enters a third time, this time carrying a platter burdened with rich truffles of butter-wrapped coconut nougat arrayed on a bed of white rice and whipped cream. Again, the men do not eat; rather, they sip anise, grappa, or gin, as they might choose, the burning sensation in mouth, oesophagus, and stomach quickening the appetite even more. Drawing the feast to its conclusion, an incandescent globe of frosted white

glass descends from a hidden alcove in the ceiling, casting all in a gentle white light. As a parting course, another *amuse-nez*: the scent of jasmine—a night bloomer, familiar with darkness—fills the air with its tantalizing, elusive sweetness.

Though to make full sense of 'The Dinner of White Desire' one requires consideration of the history of cuisine and culinary theory in the avant-garde—a topic for another book—it also quite clearly requires consideration of the history of race and racism. But make no mistake, bringing race into the conversation shakes foundations, suggesting a genealogy of the avant-garde that brings together—around the same table, if you will—Italian Futurists and Zionist cultural critics, white supremacist secret societies and left-wing performance ethnographers, colonial medical men and impoverished bohemians, black Caribbean poets and white utopian socialists. In the following pages, I will try to describe some aspects of that genealogy and suggest the rather unsettling conclusion that not only are race and racialized thinking ubiquitous in the history of the avant-garde but also that the avant-garde has been an agent of that ubiquity, at times altering the terrain of racialized power in favour of the disempowered, at times for those already enjoying the benefits of the myths, institutions and folkways of race and racism.

There is perhaps no better place to begin such a genealogy than with the Italian Futurists. Conventional wisdom places the origins of a full-fledged artistic avant-garde almost alongside those obnoxious, audacious, hilarious and profoundly influential propagandists of modern life whose ranks included 'aeropainter', co-author of *The Futurist Cookbook* (1932) and *chef de cuisine* of 'The Dinner of White Desire', Fillìa (aka Luigi Combolo) (see Marinetti 1989). Though Fillìa's work doesn't get much attention these days, it's hard to imagine a course syllabus dedicated to the avant-garde that does not include his friend Filippo Tommaso Marinetti's 'The Foundation and Manifesto of Futurism'. It has been on all of mine, often close to the semester's start. First published in the winter of 1909 by the leading French daily *Le Figaro*, it has proven to be an enormously influential document. That influence isn't usually considered racist, but closer examination reveals that it is, in many respects, a manifesto of white power.

The document opens with a description of Marinetti and his gang of hyperactive male poets nervously grinding their ennui into the rich Oriental rugs of their deluxe poetic garrets, then leaping behind the wheels of enormous automobiles, vehicles compared successively to hungry

beasts, centaurs, funeral biers, guillotines, a smoking hot flatiron and frenzied dogs. They race through the streets of the city, then out to the industrial suburbs, where Marinetti nearly flattens a couple of cyclists. Reacting quickly but unable to control the clumsy Bugatti he's driving, Marinetti crashes into a factory runoff ditch. And in that ditch he encounters a sublimely unctuous blackness. 'O maternal ditch!' he apostrophizes, 'almost full of muddy water! Fair factory drain! I gulped down your nourishing sludge; and I remembered the blessed black breast of my Sudanese nurse.' Eventually pulled out by a crowd of fishermen and 'gouty naturalists', the Futurists, 'faces smeared with good factory muck [. . .] celestial soot', declare their 'high intentions to all the living of the earth'. At this point, the reader is presented with a proper manifesto: eleven points, a final coda glorifying speed, the machine and the future and a call for the destruction of museums, rot-stinking professors, anti-quarians and the Italian Futurists themselves, if they should ever lose their nerve (Marinetti 1992: 145–9). Bookends of Italian Futurism, these two works by Fillìa and Marinetti, were published at the opening and closing of the movement.

Recent research and criticism have explored Italian Futurism's ties to fascism and right-wing sociopolitical tendencies more generally. As is widely known, Marinetti was an indefatigable cheerleader for the up-and-coming Mussolini. Quite a few Futurist groups across Italy's boot shared that fervour, campaigning for fascist parties in their cities. Ultimately, the relationship did not work out as well as either had hoped but it demonstrates that understanding the shared sympathies of the Futurists and the fascists while also recognizing their differences is nec-essary for understanding the politics of Italian Futurism. As scholars have demonstrated, it is all a great deal more complicated than most of those throwing accusations at 'Futurist Fascism' would admit (Berghaus 1996b; Hewitt 1993 and Gaborik 2007: 210–32). Distressingly, despite the grow-ing scholarship on Futurism's right-wing politics, race is still more or less absent from the conversation. Indeed, only two scholars to my knowledge have discussed at any length the racism out of which the Futurist crusade exploded, Emilio Gentile one of them. And only Laura Winkiel has addressed the specifically *black* muck, the *black*-breasted Sudanese wet nurse or the fact that these artists felt emboldened enough to proclaim their programme only when their faces were *blackened*, only when they were able to cloak themselves in 'figures of racial alterity' (2006: 66).

But race is no incidental matter. It is right there in front of us: the 11 points and thrilling coda *are delivered in blackface*. The sludge may be more viscous than burnt cork, true, but that does not make it any less an act of racial drag than those witnessed by, say, the Broadway audiences of Cohan and Harris Minstrels in 1909. Industrial-grade blackface gave the Futurists supernatural powers, allowing them to recognize themselves as a group capable of collective exhortation and superhuman feats of aes-thetic derring-do. 'We are black and different,' the 'Manifesto' declares between the lines. That greasy, stinking blackness gave them a new kind of body, one specially suited to the demands of the modern industrial era. And it empowered them to write, to manifest, to declare, to take a stand against the corruption and effeminacy of modern Italy. Winkiel argues that, through documents like the 'Manifesto', 'the racial contradictions of Enlightenment discourse [. . .] animated new, aestheticized forms of mod-ern political communities, subjectivities and by extension, also political citizenship', contradictions that 'continue through the rhetoric of violence to function as a regulatory force to discipline bodies into modernity and modern democratic politics' (2006: 66).

Racism and racialized notions of vanguard power in the Italian Futurist movement extends far beyond the 'Manifesto' (and, for that matter, 'The Dinner of White Desire'). The Futurists not only embraced the car, the train, the plane and the gun to forward their programme of modernist hygiene and nationalist awakening but also the technologies of race. Eugenic themes and imagery permeate the writings of Marinetti, Mina Loy and other Futurists. Leading eugenicist Nicola Pende praised the Futurists for their forward-looking thoughts on cuisine, getting public thanks for the gesture from Marinetti.[1] In addition to their enthusiasm for eugenics, Futurist groups across Italy were active in matters of race on a geopolitical scale. Many lobbied and demonstrated for the invasion of Ethiopia in the 1930s; the 50-something-year-old Marinetti volunteered to serve in the front ranks.

THE DREYFUS AFFAIR AND THE RACIALIZATION OF INTELLECTUALS

In order to fully comprehend the role of race in the avant-garde, we need to be attentive to not only direct references such as those found in works like 'The Dinner of White Desire' and 'The Foundation and Manifesto of Futurism' but we should inquire also into more subtle dynamics: for

example, into the changing understandings of the role of the body that emerged in the late 1800s in European political culture, particularly in respect to intellectual participation in the public sphere (see Habermas 1989). Such changes are especially apparent during the Dreyfus affair, the political scandal that rocked France and other European nations in the 1890s and catalyzed a shift in the ways that intellectuals imagined themselves and their work. At the same time, the response of intellectuals to the affair illustrates the characteristic slipperiness, opportunism and contradictoriness of avant-garde racism and racialism.[2]

Captain Alfred Dreyfus, an up-and-coming artillery officer, was convicted of treason in 1894 for passing secrets to the German embassy. He was a remarkable figure. A product of the military-industrial complex championed by Saint-Simon—he had degrees from both the École Polytechnique and École Supérieure de Guerre—he would have seemed to Saint-Simon the very model of the vanguard European. But he was also the scion of old Jewish money, a class that struck terror in the hearts of *goyim* everywhere. And if that did not complicate matters of identity and allegiance enough, his family was from the Alsace region, a territory traded back and forth between the French and Germans for centuries, though the family was wholeheartedly 'French', having chosen to move to France after the annexation of the region following the French defeat by Prussia in 1871. In the autumn of 1894, Dreyfus was arrested and charged with trading military secrets with the German embassy in Paris. Two months later, he was publicly cashiered and shipped off to the infamous Devil's Island prison in French Guiana. Émile Zola's explosive 1898 editorial 'J'accuse!' (published in the newspaper *L'Aurore*) brought to light the many errors, oversights and deliberate flouting of legal process in the trial—and made crystal clear that Dreyfus was convicted not for any crime but for being a Jew. The affair brought to light the nationalist and racist prejudices festering within the French military and industrial communities and widespread among the French citizenry.

There were broader implications to the trial than the disturbing revelation of widespread anti-Semitism among France's technocratic elite. The Dreyfus case changed the way that intellectuals imagined their role in society and, more significantly, the way they presented their ideas and performed their role as intellectuals in the public space of civil society. It also altered the performative dynamics of intellectual work. This alteration, we should note, occurred decades before the Surrealists discovered, in Walter

Benjamin's words, that 'the collective is a body' and revolutionary action must be a form of 'bodily collective innervation' (1985: 238). Though lacking the Surrealists' understanding of the labyrinthine psychosocial dimensions of such embodiment, intellectuals of the Dreyfus era were well aware of and responsive to the collapse of 'traditional oppositions between action and contemplation, individual and collective, mind and body, technology and nature', well aware, as Raymond Spiteri has put it, of the 'political physiognomy' of the vanguard challenge (2003: 53).

To understand the revolutionary changes of the intellectual body as it relates to Italian Futurism and, more broadly, twentieth-century avant-garde, we can turn to Gentile, a scholar who has thoroughly explored the impact of the Dreyfus case on Italian political culture, suggesting that the crisis produced new understandings of the intellectual as an embodied being. These new understandings, underwritten by explicitly racialist concepts, spurred intellectuals across the political spectrum to new kinds of intellectual praxis. Gentile argues that

> the myth of modernity was the main theme that, either directly or
> indirectly, was at the center of the considerations of Italian political
> culture regarding the Dreyfus case. The French crisis was interpreted
> as a global conflict between opposing concepts of man and politics, a
> conflict in which were at stake not only one man's fate but also the des-
> tiny of humanity during a period of rapid changes that were threat-
> ening to shatter the pillars of traditional society, dragged through the
> vortex of modernity (2003: 12).

Regardless of their political sympathies, all agreed that the Dreyfus case had exposed a rottenness within European civilization, a kind of bio-political degeneration, 'an immense national disease', as Guglielmo Ferrero put it in an editorial in *Nuova Antologia* in 1899 (quoted in ibid.: 17). Ferrero asserted that a 'powerful energy' was needed 'to combat' the 'degeneration of politics' (in ibid.).

The metaphor of biological degradation was commonplace in the political discourse of the time (and in aesthetic philosophy too, as I will discuss in the conclusion to this chapter), so there is nothing especially new here. What was new was the concern with the physical status of intellectual work, the physiognomy of critical thought. The Dreyfus affair altered the way the public sphere worked. The true test of the active citizen after Dreyfus, particularly if he claimed to be in the vanguard, was

to take a stand, quite literally, in public and do so before an aggressive, ideologically opposed crowd that was perfectly willing to respond with violence. As Gentile summarizes it, Dreyfus implicated all

> men of thought and education who had abandoned the serenity of meditation and by throwing themselves into the conflict had challenged the fury of the mob imbued with anti-Semitic hate, chauvinism and superstitious devotion to the army as the sole sacred guardian of the nation. [. . .] The confrontation between the rationality of the individual and the irrationality of the crowd was a very important part of the drama (ibid.: 14).

A cartoon by Caran d'Ache captures the irresistibly physical nature of the controversy (see Image 2.1). Whether pro- or anti-Dreyfus, to take a stand before the mob was to take a stand for history, for human agency in time, to take a stand for—and this was quite explicit—the race. The intellectual on his feet, shouting, bare-knuckled—the *performing* intellectual—was the future of the race.

Gentile's description of the ethical obligation of the intellectual, one of the necessities to take on the ignorant mob in an act of physical confrontation, captures the élan of many avant-gardes in the early twentieth century. The rejection of nervous, isolated meditation in favour of provocative public action is evident in the first lines of Marinetti's 'Manifesto', where the poets abandon the garret, ennui and poetry and take to the streets. And then there is the Futurist *serate*. A typical evening with the Futurists might feature the declamation of manifestos—perhaps several at the same time—a performance by Luigi Russolo on his cacophanous noise machines, the recital of Futurist poetry and display of Futurist paintings and all kinds of audience-baiting shenanigans, including the spreading of glue on seats, double or triple-sold seats, the generous dissemination of itching dust, etc. The gesture was returned in kind—scuffles broke out regularly and rotten fruits and vegetables thrown at one event made Carlo Carrà cry out, 'Throw an idea instead of potatoes, idiots!' (quoted in Goldberg 1988: 16).[3] There is a critical difference here, however; the Futurist did not stand for reason before an unruly mob; he stood for the elite and for the irrational against the democratic, sheepish masses addled by cheap talk of equality and feminism. But the ideological differences are beside the point: both the Dreyfusard and the Futurist understood that the moment of confrontation with an aggressive mob empowered

IMAGE 2.1 This cartoon of a French family dinner by caricaturist Caran d'Ache illustrates the divisions in French society during the Dreyfus affair. In the top panel, the host says, 'Above all, let us not speak of the Dreyfus affair!' The bottom panel shows the dinner party in disorder: 'They have spoken of it.' Courtesy: Wikimedia Commons.

the body in special ways. Such confrontations physicalized thought and manifested the body politic.

The emergence of this new body politic wasn't just the consequence of the Dreyfus affair, of course. Broiling around the Dreyfus incident were all kinds of new disciplines and discourses concerning the body's power, productivity and fragility. The body was the focus of efforts to modernize the military, the factory, the prison and public schools, as Foucault has demonstrated (1995). In addition were the continuous alterations of daily life in the modern urban city as it became not just a place to live and work but to be seen, a space that became undeniably theatrical, 'a stage', to go by Roger Shattuck's description of Paris during *la belle époque*, 'where the excitement of performance gave every deed the double significance of private gesture and public action' (1968: 6). But these broader shifts are not sufficient to explain why public declarations of outrage and public calls for liberty were, for Left and Right alike, the prodigy of 'a *homo novus* who can live in a new society,' to recall Mussolini's description of the true revolutionary (quoted in Gentile 2003: 21).

To be clear, the declamation of manifestos, the insulting of an audience, the assaulting of ears with the brash cacophony of noise machines or violent scuffles in the aisles cannot be considered in any way racist. Where race comes into play is in the sense that intellectual work required a particular kind of performance, a particular style of *political embodiment*. The Dreyfus-era activist and the Futurist performer shared a common practice of public intellectuality, a performative strategy that welded belief, identity and action into a moment of intense, activist sociality. They shared a belief that embodied activism, promised something bigger, more authentic, something hygienic for all the people of Europe and the world. To stand up for an idea was to stand up for one's race.

How we think about Italian Futurism—and by extension, more generally the twentieth-century avant-garde art—changes when race is in the discussion. Marinetti's 'Manifesto' makes clear that the supernatural, oratorical and creative power of the Italian Futurists was acquired only after

(1) the decline of European culture was met with a physical response, a shock-force regeneration of the race by way of public performance, and

(2) Marinetti took a header into blackness, took a big gulp, smeared it across his brow and cheeks and sang praises to his beloved black-African nanny.

Whether participating in public demonstrations or consuming the very *haute* of *haute cuisine*, the Italian Futurist was acting for the future of the race, embodying a whiteness undermined by liberal democracy, a whiteness that could channel the new powers unleashed by modern industry, industrialized warfare and the enormous economies of scale built to support racist imperialism. Whatever else it may be, 'The Foundation and Manifesto of Futurism' is a proclamation of white desire and white power. To play with a phrase, the Futurist moment is a racist moment (Perloff 2003).

PRIMITIVIST MODERNISM

Marinetti and his gang were not alone in their racist nostalgia; the longing for the ancient and the authentic, especially when larded with exotic otherness, was endemic to the artistic and intellectual scene. European Modernists were fascinated by the objects brought back to Europe from Africa, Oceania and the Americas to be put on display in museums such as Paris' Palais du Trocadéro, where Picasso spent hours looking over cases brimming with weapons, worship objects, masks and the like (see Flam and Deutch 2003; Rubin 1984). Though we cannot ignore the conditions that enabled the encounter of European artist and non-European object—colonialism—there is nonetheless a progressive edge to be found in this troubling, perverse fascination. The visits by Modernists to the ethnographic, anthropological and natural history museums of Europe inspired a changed conception of those things and to some degree, the people who made them. Jack Flam and Miriam Deutch explain:

> The earliest European interest in primitive art was strongly related to a drastic shift in conceptions of representation and of form at a time when advanced artists were moving away from the Renaissance tradition of verisimilitude and naturalism. The post-impressionists, especially Cézanne, had played an important role in opening the eyes of the younger artists to the possibilities of non-mimetic representation and of using 'distortions' from naturalistic norms for expressive ends. In doing so, the younger artists saw themselves as being very modern and also as making contact with ancient traditions—such as Egyptian, archaic Greek, and medieval European art—that had not only eschewed naturalism but seemed to be involved with deeper, more spiritually compelling kinds of expression (2003: 3).

Maurice Vlaminck, André Derain, Henri Matisse and Pablo Picasso, among others, perceived these African objects with a sense of both surprise (finding unprecedented qualities in the objects they encountered) and familiarity (confirming formal and theoretical concerns codified in Post-Impressionist art and criticism).

The impact of this encounter went beyond making and thinking about art, extending into larger questions about subjectivity, identity, history and community—the kinds of questions asked by Paul Gauguin in his monumental 1897 painting *Where do we come from? What are we? Where are we going?* (see Image 2.2). Indeed, if Primitivist Modernism displays an 'unremitting hostility to contemporary civilization,' as Christopher Innes has put it in his comprehensive exploration of European avant-garde theatre, then it behooves us not to give into the lure of seeing primitivism as merely an escape or as something that can be waved away for its bad ideological odour. Innes writes, 'The point of borrowing from African sculpture or Balinese dance is that, in being "primitive", [one] embodies an alternative value scale. In the same way, the point of exalting the unconscious and emotional side of human nature is to provide an antidote to a civilization that almost exclusively emphasizes the rational and intellectual' (1993: 9–10). 'Primitive' objects suggested to the Europeans not just another way of looking at the world but also another way of being in it. However, though we must not overlook the critical and political leverage primitivism provided the first generation of Modernists, neither should we overlook the many prejudices that were left in place. Hal Foster writes, 'Like fetishism, primitivism is a system of multiple beliefs, an imaginary resolution of a real contradiction, a repression of the fact that a breakthrough in our (that is, European) art, indeed a regeneration of our culture, is based in part on the breakup and decay of other societies, that the modernist discovery of the primitive is not only in part its oblivion but its death' (1985: 386).

Those contradictions have proven remarkably sturdy. James Clifford found them in effect as late as 1984, among the very people who could quite justifiably claim the cutting edge of scholarship and criticism and the most nuanced political correctness. That year was a banner one in the history of primitivism, as it witnessed not just one but several groundbreaking exhibitions dedicated to the subject in the US, heralding a widescale rethinking not only of primitivism but of Modernism as such. The time was certainly ripe for a reconsideration. Black nationalism (particularly the BAM, robust in New York City), feminism, queer and Third

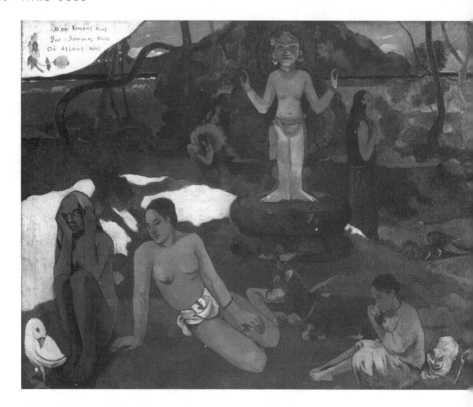

IMAGE 2.2 Paul Gaugin's *Where do we come from? What are we? Where are we going?* (1897). Courtesy: Museum of Fine Arts, Boston.

World consciousness had carved out a beachhead on the highest echelons of the art world, successfully pressuring collectors, directors, curators, agents and scholars to reassess the histories of their professions. But plenty of old prejudices were left in place, sometimes in ways that seemed perfectly commonsensical and inoffensive.

Clifford finds a curious atavism in the Museum of Modern Art's mega-exhibition of that year, organized by William Rubin and Kirk Varnedoe. He criticizes in particular the way the exhibition failed to provide adequate historical and authorial information for almost all the non-European works; for its display strategies (lucite plinths, dramatic pools of light, works floating as if by magic in mid-air) that gave to the works the impression of magical self-sufficiency; and for the lack of pieces that did not fit the Modernist aesthetic favoured by Rubin and Varnedoe, such as works created for European tourists or works by non-European artists

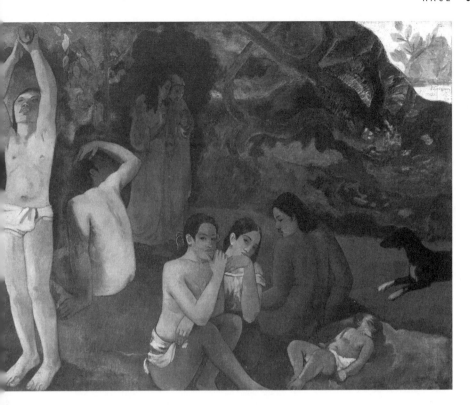

inspired by European art. In response, Clifford wonders how Primitivist Modernism might be presented differently, more critically, more attuned to the political and institutional history of racism. How, he asks, might the great works of European Modernism be displayed so that they are no longer cloaked in Modernist magic but appreciable as a group of cherished objects among other cherished objects, curiosities that might be examined so as to reveal, say, the psychosexual appeal of blackness to white male Modernist artists. To this end, Clifford suggests a juxtaposition of the 'elemental, "magical" power of African sculptures' and the fetishes of early twentieth-century white *négrophilie*, including 'the jazzman, the boxer (Al Brown), the *sauvage* Josephine Baker' (1984: 357).

An apt addition to Clifford's counter-exhibition might be Fillìa's 'Geographic Dinner' (1938). In it, the diner encounters a 'shapely young woman dressed in a long white tunic on which a complete geographical map of Africa has been drawn in colour; it enfolds her entire body'. Dishes corresponding to 'a gastronomic orientation inspired by continents, regions, and cities' would be served according to the personal preferences

of each man. The proverbial 'breast man' gets Cairo and a dish featuring little pyramids of pitted dates in palm wine, the largest one surrounded by cubes of cinnamon-scented mozzarella stuffed with roasted coffee beans and pistachios. He who prefers the sublime pleasures of the right knee gets Zanzibar and the 'Abibi Special', 'half a coconut, filled with chocolate and placed on a base of very finely chopped meat and steeped in Jamaican rum' (Marinetti 1989: 129). What Clifford and Fillìa highlight—and what Rubin and Varnedoe obscure—is the intimate relation between Modernist form and racialized (and gendered) desire and how the effort to produce a line, a shape, a sound that transcends the contingencies of time and place cannot be extricated from the denigration, exploitation and fetishization of human bodies.

RENÉ CREVEL AND SURREALISM'S 'REVOLUTION AGAINST WHITENESS'

Not all European vanguards (or curators, for that matter), were seduced by the 'Abibi Special' of Modernism; in the front rank of these resistant Modernists were the Surrealists. Indeed, one of the things about the Surrealist movement that sets it apart from other European avant-gardes of its time is its persistent focus on the 'white mystique' and the 'repressive machinery that props it up', as members of the Chicago Surrealist Group put it. Further, Surrealism invented 'not only a revolutionary critique of whiteness but also new forms of revolutionary action against it' (Chicago Surrealist Group 1998: 3). That said, the critical race theory and anti-racist activism of the Surrealists did not spring forth without struggle or embarrassing mishaps. As Franklin Rosemont points out, 'that individual Surrealists in the 1920s did not wholly elude the lure of exoticism is no more surprising than the fact that some of their references to race reflect their inexperience and naiveté' (in ibid.: 20). It took experience—particularly, the experience of the revolutionary events that rocked the colonial system in the twentieth century—and it took long hours of frank and mutually critical discussion between the European Surrealists, non-European artists and activists like Jules Monnerot, Aimé Césaire, René Ménil and C. L. R. James for their 'treason to whiteness' to be put into full effect.[4] The Surrealists understood that such research must be pursued in ways that reflect critically upon the very structures that produce the racialized relation, the recognition of Otherness and the cherished illusions of selfhood armoured in the myths of whiteness. A close examination of

Surrealist anti-racism will, as Amanda Stansell describes in her nuanced discussion of Surrealist Primitivism, not only reveal 'the contradictions between the Surrealists' ideals and their practice and thus [. . .] the ways they both challenged and replicated the discourses of their time' but also, more generally, the challenges and opportunities of anti-racist activism in the early twentieth century (2003: 112).

René Crevel was a dashing figure, movie-star handsome and among the most audacious of the first generation of Surrealists. The leader of the group, Breton, listed him in the 'First Surrealist Manifesto' among those possessing the spirit of 'absolute Surrealism'. He is an especially fascinating figure in that not only was he the most consistently political of the group (taking his comrades to task during their periodic retreats from the turmoil of political activism) but he was also an—and openly critical—bisexual in a movement that was as homophobic as the bourgeois society it so vocally despised. In a movement with more than its share of sycophants, Crevel took public stands against Breton. And he was much more sanguine than his fellows about Paris, that singular cultural ecosystem that provided so much fodder for revolutionary creation. Paul Cooke, exploring this divergence through three of Crevel's novels, notes the absence in them of that singular feature of Surrealist writing about the city: Dali's '*realizations de desires solidifies*', those locales of strange affective intensity such as the arcades in which Louis Aragon and Benjamin spent so much time mining for revolutionary contradictions (2005: 621–2).[5]

Why? Crevel knew the ways that the margin served at capitalist imperialism's pleasure. His second novel, *Mon Corps et Moi* (1925), explores the small dance halls of déclassé Paris. The *bal musette* was a place where female performers belted out the jaunty music of France's ethnic minorities while landlords, drug dealers and pimps collected profits, tourists got a taste of the 'real Paris', upper-class show-offs ruminated the yummy thrills of cultural and sexual transgression and gay men cruised (including more than a few closeted bourgeois). But it was not all fun and games. Crevel 'was disturbed by the economic realities that could accompany the fulfilment of sexual fantasy. He suggested that the *bal musette* has become as much a part of the Parisian tourist trial as Notre-Dame, though a place where, instead of buying pendants or lighting candles, visitors get tipsy and pick up rent boys' (Cooke 2005: 622). Crevel's approach to the modern urban environment reflects a distinct social consciousness, particularly concerning the politics of sex.

And race. As with his fellow Surrealists, Crevel's anti-racism did not emerge full-blown. His first efforts to deconstruct racist desire followed a line typical among white radicals of the 1920s: playing the conventional tropes of racist exoticism to a putatively more 'radical' end. Crevel's trance-induced extemporization in the autumn of 1922 of a 'long and breathless story about a "Negress in white stockings,"' larded with insults for the wealthy hostess providing the board and bar for him and his fellow poets, is hardly critical enough about its racial, gender and sexual signifiers. (It reminds me a bit of how white radicals in the 1960s used terms like 'nigger' and 'spade' around their African American friends.) The gist of Crevel's extemporization, though, holds water in one respect: race, gender and heterosexual desire are deeply implicated in each other, in white subjectivity and in the sexual theatre of commodified sex. Fortunately, Crevel's insensitivity to certain self-serving dimensions of theatricalized blackness did not last anywhere near as long as his commitment to social justice.

This was true of Surrealism more generally. A year after *Mon Corps et Moi* was published, the Surrealists took a collective stand against French colonialism, joining the communists in their support of the Rif rebellion in Morocco and calling for French soldiers to fraternize with the rebels. In 1921, the 18,000 Berbers living in Spanish-controlled Morocco declared their independence. Led by Muhammad Abd al-Krim, they battled the Spanish for several years in guerrilla style, eventually provoking a combined Spanish–French military expedition. Nineteen Surrealists signed the petition 'Appeal to Intellectual Workers', published in the communist newspaper *L'Humanité*, and the group published several other statements in the same spirit. Colonialism, Surrealists like Crevel discovered, integrates the lives and imaginations of colonizer and colonized alike, at all levels. They learned that the everyday moments of convulsive beauty and blocked desire that were, according to Surrealist theory, the elusive keys to revolution, had to be situated in a broader, essentially global context: colonialism. Crevel's singular contribution to this move was to understand how it was enabled by forms of theatricality, what Crevel called 'the scenic organization of venal love, the object of desire [. . .] an object in the décor of desires' (1996: 356).

Crevel played a leading role in Surrealism's transformation into an anti-racist, anti-imperialist movement. He served as a liaison for and contributed two essays to Nancy Cunard's still-underappreciated and explosive anthology, *Negro* (1934). He co-authored one of those essays,

'Murderous Humanitarianism' (1932), the Surrealist group's collectively signed indictment of French liberalism's failure to take on racism and colonialism. But his most remarkable contribution was 'La Négresse aux bordels' ('The Negress in the Brothel', 1931). During a period in which Surrealism was experiencing what Breton called, the 'crisis of the object', a crisis that inspired dozens of found and modified objects such as Méret Oppenheim's fur-covered tea cup and saucer, *Object* (*Le Dejeuner en fourrure*) (1936), Crevel extended his earlier exploration of sexual politics by examining and indicting racist capitalism's fetishization of the black woman's body. Doing so, he revealed how, in Myrna Bell Rochester's words, 'the patriarchy of the church and the white male power structure (that is, capitalism), had reduced all women to objects of desire. By the same process, it had objectified and oppressed people of colour and manufactured for its use the most debased *object of entertainment*: the black woman prostitute' (1998: 55).

Predicting by a half century a basic premise of queer and feminist film, theatre and performance studies, Crevel describes the 'scenic organization of venal love' savoured by both sex tourists and primitivist moderns as a way of arranging bodies, eyes and objects in space ('the object of desire [. . .] an object in the décor of desires') so as to titillate and lubricate the circulation of pleasure and money. Crevel's familiarity with the way that radicals rationalized their homophobia, his experience with the sexual tourism of the *bal musette*, his alienation from heterosexist European commodity culture and his ongoing contacts with non-European intellectuals, provided him a rich lens with which to seek evidence of a deeply embedded and tendentiously pornographic orientation to Eurocentrism.

'The Negress in the Brothel' begins with a wickedly precise anatomy of the French literary establishment's willingness to proclaim the wonders of 'love' in the midst of a militaristic, capitalist 'France meditating colonial expansion and reprisals and, once a week, after a quick Mass, the charms of her estate' (Crevel 1996: 354). French love, Crevel declares, is no more than a love of things, its idealism a scrim for the most venal possessiveness. Paris is a city for lovers because it is a city for capitalists. Bourgeois love is nothing more than 'an act of annexation' and the 'instinctive articulation of sexual pleasure in such an affirmation as "You are mine" or "I possess you" and in such an acquiescence as "I am yours" or "Take me" makes clear that the "final and definitive admission by and between the elements

of the couple" is an acquiescence to "the idea of inequality" ' (ibid.). There is, therefore, nothing at all surprising in the dovetail between the male chauvinist's pleasure in insulting the feminist and the pleasures he might take with a black sex worker. Crevel writes, 'In the Brothel: Sexual intercourse. In the Drawing-Room: Social intercourse. "Using" prostitutes translates only one aspect of masculine complexity: establishing foci of contempt and respect in the hierarchy of blue stockings translates another' (ibid.: 355).

It was not only the reactionaries' fault. Crevel indicts Surrealist hero Charles Baudelaire for the way he divided his affections between on the one hand, the Afro-French prostitute Jeanne Duval and on the other, his social muse and patron, the 'chairwoman' and former artist's model, the white European courtesan Appolonie. Ultimately, Crevel's critique applies to all those who derive 'apology or justification' in 'the very considerable epithelial advantages' of cross-racial dalliance and exploitation. Around them all we discover a common 'scenic organization of venal love' that finds its perfection—its very emblem—in the favoured style of posh Parisian whorehouses where one finds an idealized vision of white femininity, cast in bronze, holding a lamp to illuminate the comely black prostitute descending towards the wallet-wielding, wool-and-leather-bound bourgeois Priapus wandered in from some plush arrondissement.

THE DUAL MEANING OF MINORITY

Before exploring in further detail the relationship among race, desire and vanguard practice in the Surrealist movement, I need to clarify a key term. Notwithstanding the fact that many avant-gardes are 'vanguards of one' (for example, Surrealist hero Jacques Vaché; the Polish *wunderkind* Witkiewicz; the rogue Dadaist Kurt Schwitters; 'I Shot Andy Warhol' fame Solanas), the vast majority of avant-gardes are small groups that are in a variety of ways and for a variety of reasons, marginal to the institutions and folkways of hegemonic power because of some shared characteristic that defines them as different. In other words, the avant-garde is a *minority*. As I explained in the Introduction, this volume gives priority to the sociological status of vanguards over their aesthetic or cultural products, presuming that such prioritization can provide useful insights into the art and culture of the dissident, the radical and the resistant marginalized. Thus, the interdisciplinary approach taken here is inconceivable without

the sociological concept of *minority* to guide the selection and grouping of topics. But there is a slipperiness—a useful slipperiness—to the term 'minority'.

'Minority' does not have one but two definitions. In its most common usage, 'minority' means a 'small group of people differing from the rest of the community in ethnic origin, religion, language, etc.; now, sometimes more generally it suggests any identifiable subgroup within a society, especially one perceived as suffering from discrimination or from relative lack of status or power.' The second meaning is 'a group or subdivision whose views or actions distinguish it from the main body of people; [originally] a party voting together against a majority in a deliberative assembly or electoral body'.[6] This second definition situates the small group within a very different political order than the first one defined by conventionalized political protocols and institutions designed to ensure some degree and continuity of power to those who lack numbers. This second kind of minority plays an acknowledged, legitimate role in any liberal, parliamentary society both in large-body debates and small-group discussions such as a presidential cabinet. Unlike the first minority, whose hands are never allowed to hold the reins of power, the second is what we might call a *vested* minority. They are sometimes procedurally disempowered (as is the case in most parliamentary groups, where the group with fewer numbers loses key positions and the ability to deploy certain procedural manoeuvres). But sometimes just the opposite is the case.

Some might resist the idea that the second, vested kind of minority can be characterized as 'avant-garde'. How, they might ask, can those vested in power, those fully legitimated by the discourses and disciplines of power, be avant-garde? But if we rule out the idea that there can be no 'vested vanguards', then we are faced with three problems. First, we are going to have to rule out most of the avant-garde tradition as we know it today on the basis of simple comparison. Next to the negress in the brothel, the Surrealists are a vested vanguard. Or compare the young Picasso with, say, Korean labour organizers in Japan. I do not wish to imply any specific evaluation here—that is, that the Korean labour organizers are somehow superior to the European painter—but the differences cannot be dismissed. Picasso elected to be a minority and had the guts and social network to move against the tide. Korean organizers lead the charge against economic, cultural and linguistic oppression because they must; they have no other option.

Secondly, without a concept of 'vested vanguard', we risk losing track of groups that use their vested position to implement minoritarian programmes. This is the case with Christian Evangelicals in the US, a small percentage of the total population, who exercised in the late 1990s and early 2000s considerable influence on all levels of government and culture—in part, by their proclamation of threatened minority status. Finally, we risk losing track of one of the most important and interesting dynamics in avant-garde history, the transformative dynamic that has often occurred between the disempowered and the vested. André Lepecki has called our attention to the keystone role that women have played in the history of Western dance, particularly 'women who advocated [. . .] a *becoming-minoritarian*—becoming woman, becoming black, becoming Indian, becoming child, becoming animal, molecular imperceptible'. He argues that, within the transformative dynamic between the vested and the disempowered, we might find new scholarly perspectives with which to approach, say, Isadora Duncan's fascination with children and their movement styles or Martha Graham's exploration of 'Indian' and 'Negro' dance (Lepecki 2007: 123). In sum, a sociology of the avant-garde that can evenhandedly assess both marginalized and vested minorities, alone and in relation to each other, can provide useful insights into the history and theory of the avant-garde more generally. But just as importantly, it can provide subtle instruments for the analysis of specific avant-gardes. I'll attempt precisely this in my analysis of transatlantic Surrealism and the Afrikaner Broederbond.

THE SURREALIST ATLANTIC

Crevel's minority provided incisive perspectives not only on European hegemony but also on Surrealism. However, the contradictions of minority played very differently for those who fought racism without the 'very considerable epithelial advantages' of people like Crevel. The minority of the French Surrealists, for example, was of different cause and consequence than that of the small community of elite black intellectuals who betrayed their class, refused their destined role as diligent mediators of French colonial rule and mounted a revolution in reason and representation that would ultimately impact the political history of the Caribbean. Those intellectuals, artists and activists inspired in part (though it is contested to what degree), the international Négritude movement (Edwards

1999); the interest in 'cannibal modernism' widespread in North, Central and South American artistic and scholarly circles; the grassroots movement that brought to power Haiti's first non-mulatto president; and Fanon. The movement continues to raise, in Michael Richardson's words, 'subtle and complex ideas that have rarely been addressed and [. . .] continue to raise important questions with multifarious implications for current debates concerning alterity and communication between cultures' (1996: 1).

Richardson situates the encounters between francophone Caribbean writers and French Surrealists in three larger tendencies: French colonialism's self-serving myth of cultural superiority; the perturbations of identity caused by cultural colonialism among the indigenous elites who helped manage and mediate French hegemony; and the unique social structure in which white European and black Caribbean Surrealists became friends and collaborators. Unlike the British, who presumed their superiority and governed by the rule of divide and conquer, the French, in Richardson's words, were 'far more responsive to aspirations of the colonial peoples for integration into the body politic of the "mother country", making this integration an element of their colonial policy. This was based not so much on biological as on cultural racism' (ibid.: 2). This was no 'more generous and enlightened than that of the British, it was in fact just as much an instrument to ensure the smooth running of empire and contained within it exactly the same measures of contempt and racism' (ibid.). In many ways it was even more insidious, given that it was based on the myth of assimilation, a myth that caused an identity crisis among those who were invited to assimilate yet were constantly reminded of their inferiority. Fanon writes in *Black Skin, White Masks*, 'There is a fact: White men consider themselves superior to black men. There is another fact: Black men want to prove to white men, at all costs, the richness of their thought, the equal value of their intellect. [. . .] For the black man, there is only one destiny, and it is white' (1994: 10–11).

The disruption and denigration of the culture of the colonized can volatilize a culture's intellectuals. Groomed for middle management, security, education and civil-service jobs, colonized intellectuals typically do the kind of purposefully banal work that keeps the colonial machine working. At the same time, their very existence marks the colonizer's need to keep some of the most volatile resources of the colony—knowledge, education and imagination—under discipline. In the case of knowledge workers in Martinique, most were entranced by the 'one destiny' described by Fanon;

indeed, they were often described as 'more French than the French'. But, regardless of the degree of their seduction, they were responsible for mediating between the colonizer and the colonized in a range of sites (schoolrooms, holding cells, factory floors, shipyards, etc.). As a consequence, these 'cultural middlemen' were privy to forms of knowledge and possibilities of radical praxis that others outside of their class were not. Of course, most acted on this knowledge in only the most self-serving ways; further evidence—as if it were needed—of the power of greed, the survival instinct and the glamour of cultures that enjoy military supremacy. But some acted in a far more egalitarian fashion.

Most of the black students at the Sorbonne and École Normale Supérieure were perfectly willing to leave behind their native cultures and embrace the culture of the metropolitan capital. But regardless of their attitudes towards their home cultures, their very being implied a critique of colonialist superiority. As Brent Hayes Edwards puts it, 'When soldiers, artists, migrant laborers, and students settled in the metropole after World War I, their presence challenged easy assumptions about the primitivism of "natives"' (1999: 84). A few would commit themselves to a deeper and more thoroughgoing kind of challenge, exploring their conflicted positions and rejecting the warmed-over stuff of uplift and assimilation in favour of militancy, pan-Africanism and transnational affiliation, doing so in tandem with the coalitions, unions and reading groups that were building momentum towards decolonization. These activist-intellectuals pioneered a critical response to European hegemony and capitalism based on the notion that the struggle against Eurocentrism cannot be fully addressed in the conventional vocabulary, syntax and logic of the European radical tradition. In search of an alternative, they started with the specificity of their existence as subject-employees of the French empire and with their role in the 'progress of civilization'. And they collaborated with the Surrealists, who responded in kind.

Edwards describes Surrealism as part of 'a complex field of influence and debate, in which Surrealism is only one term, and a hotly contested one at that' (ibid.: 128). Without presuming that Surrealism was the only current of European radicalism that appealed to African-diasporic activists, it is nevertheless true that Surrealism appealed to them for several reasons. The first reason was quite a superficial one, akin to the intrinsic challenge of black students at the Sorbonne. The Caribbeans heard 'white people themselves cogently accusing their own culture of a

barbarism that surpassed anything in the history of the so-called primitive peoples' (Richardson 1996: 5). The French Surrealists were public and persistent in their support of anti-colonial, anti-Eurocentric movements and artists around the world. The Caribbeans were also impressed by the rigourous, non-pietistic Marxism of the Surrealists, who had already showed their willingness to stand up to the Communist Party even as they sought engagement with it. They appreciated the attention the Surrealists were paying to the work of Hegel. Alexandre Kojève's highly influential lectures of the 1930s sparked a widespread return to the German philosopher among the French intelligentsia, especially the Surrealists. His emphasis on the master–slave dialectic had an obvious appeal to a black population only a few generations out of bondage. Finally, the Caribbeans understood the broader implications of the Surrealist critique of the human sciences, illustrated both by Surrealist actions in protest of the 1931 Colonial Exhibition and the dissident Surrealist journal *Documents* (1929–30), which explored the possibility of a non-Eurocentric sociology.

Transatlantic Surrealism began in 1931 when Jules Monnerot, Pierre Mabille, Simone Yoyotte, Etienne Léro and a few other students at the Sorbonne, began discussing the possibility of a Caribbean Surrealist Group. Ultimately, nothing came of the plan—disagreements about Surrealism itself contributed to the loss of momentum—but they did publish one issue of a magazine titled *Légitime defense* (1926). Its Surrealism is proclaimed in the title, borrowed from Breton's pamphlet of the same name. But the Surrealism is of a distinctly *positional* nature, as is signalled by the allusion. Breton's *Légitime defense* castigated the French Communist Party for its philistinism, greed and inability to dream (Breton 1978). The student magazine's allusion to this internal critique of the Left suggests a similar position that the Caribbeans were forming in relationship to their own class and to Surrealism.

Though the errors of the magazine have been thoroughly enumerated—the stereotypes it uncritically reproduced, the limited Marxist practices it advocated, the weaknesses of the poetry it presented and demanded—it also raised issues of lasting importance. In Ménil's introduction to the 1978 reissue, he claims their most important achievements to include 'the political and social liberation of colonial peoples; the problem of a Caribbean culture taking account of race and history; the problem of an aesthetic to be worked out on the basis of what is particular about life in our islands' (1996: 38). The magazine also initiated a rethinking of

Surrealism as such. Breton complained, in a 1935 lecture in Prague, that Surrealism had entered a period when all kinds of 'vulgar abuses' and 'misunderstandings' were being committed in its name (Jean Cocteau's lovely but ultimately apolitical spectacles especially offend Breton) (see Breton 1972: 257). These emphatically *black* Surrealists, to the contrary, proclaimed that 'as traitors to [our] class [we intend] to take treason as far as it will go' (Richardson 1996: 3) and to maintain Surrealism as first and foremost a poetics of the political.

Though the specific ways in which the Caribbeans engaged with Surrealism were varied and contentious and though there is still an argument over specifics, this is, without doubt, a remarkable group of activist-artists and intellectuals: the Martiniquan Yoyottes and Césaires, Ménil, Monnerot and Léro; and the Haitians Paul Laraque, René Depestre, Clément Magloire-Saint-Aude, Jean Price-Mars, Jacques Romain and Jacques Colére. Publications written in response to Surrealist developments would include another one-issue journal, *L'Étudiant noir* (1934), which Aimé Césaire published along with the Senagalese Léopold Sédar Senghor and the Guyanese Léon Damas, a foundational work in the development of Négritude, which many see as a direct response to the shortcomings of the earlier magazine. Price-Mars, the Haitian champion of Négritude and Les Griots, the group founded by fellow Haitians, Carl Brouard, Lorimer Denis and François Duvalier, aimed 'to probe and recover the African values that had been denied in the dominant Haitian culture' through the development of alternative scholarly research and writing methodologies grounded in indigenous forms of knowledge and expression (ibid.: 13). Damas's *Pigments* (1937) was published with an introduction by French Surrealist poet Robert Desnos. In 1949 Pierre Naville translated into French and wrote an introduction to James' magnum opus *The Black Jacobins* (1938). There was also the singular *Cahier d' un retour au pays natal* (1939) by Aimé Césaire, praised by Breton as 'nothing less than the greatest lyric monument of our time' (quoted in Richardson 1996: 6). And there is Wilfredo Lam's masterpiece *The Jungle* (1943, see Image 2.4), described by Mabille, one of the French Surrealists, as an expression of

> total opposition between this jungle where life explodes on all sides, free, dangerous, gushing from the most luxurious vegetation, ready for any combination, any transmutation, any possession, and that other sinister jungle where a Führer, perched on a pedestal, awaits the

departure, along the neo-classical colonnades of Berlin, of mechanized cohorts prepared, after destroying every living thing, for annihilation in the rigorous parallelism of endless cemeteries (1996: 212).

Mabille's take on Lam's painting is proof that transatlantic Surrealism rejected every essentialism, freely inverted all categories and, in so doing, comprehended that the grid-like structure of an European cemetery (so reminiscent of Modernist abstract art) and its neoclassical surrounds can itself be understood as a primitivism, one that has turned inward, perverse and deadly. Richardson argues that Mabille and Lam were exploring a distinctly *relational* approach to primitivism, seeing it not as some essential characteristic of non-Europeans but as 'a way of thinking that is appropriate to all people but [. . .] denigrated in the West' (1996: 23). In other

IMAGE 2.4 Wilfredo Lam's *The Jungle* (1943). Courtesy: Artists Rights Society, New York.

words, the primitivism of Mabille and Lam is understood as a universal tendency that was deformed, disciplined and denigrated by Western racism, pressed to the margins where reign the grammar school teacher, the psychiatrist and the patriarch.

The work of Suzanne Césaire marks another highwater mark of the Surrealist Atlantic. As Rosemont puts it, she was 'one of Surrealism's most penetrating thinkers, whose intellectual influence on Breton—and on the entire movement—was considerable'. Rosemont goes further, describing her as 'one of Surrealism's major theorists' (1998: 21) and citing her manifesto '1943: Surrealism and Us' for its efforts, in her words, to 'finally transcend the sordid antinomies of the present: whites/blacks, Europeans/Africans, civilized/savages will be transcended. [. . .] Our value as metal, our cutting edge of steel, our amazing communions will be rediscovered' (Césaire 1996: 126). Kelley sees Césaire as one of those who linked Surrealism 'to broader movements such as romanticism, socialism and Negritude' (2002: 170). The published works don't tell the full tale; one must also acknowledge the deep friendship Césaire shared with Breton, who expressed his admiration for her in his poem 'For Madame Suzanne Césaire' (1942). She intervened in the Surrealist tendency at all levels, contributing important theoretical works as well as pointed criticisms of the day-to-day behaviour of the Surrealists that remind one of Crevel. She took Breton to task for publicly stating that he could not find black women sexually attractive, patiently explaining to him that this was a symptom not only of prudishness and intellectual ineptitude but of an inability to imagine black women as whole beings—in other words, a complete betrayal of Surrealism. This convinced him. Césaire's intellectual and interpersonal derring-do perhaps informs the concluding line of her 1943 manifesto, 'Surrealism—the tightrope of our hope'.

In 'From Cutting Edge to Rough Edges: On the Transnational Foundations of Avant-Garde Performance' (2006), Harding describes a basic problem with the way the avant-garde has been understood. He argues that, unless we pay close attention to the entanglements of avant-gardism and colonialism, we risk 'turning a blind apologetic eye [. . .] or, if we only see the entanglement and dismiss the idea as another ideological conduit for European cultural hegemony, then we have failed to recognize the extent to which [. . .] the avant-garde is not a European but a fundamentally global phenomenon' (ibid.: 3). Instead, it can be understood as a series of 'contested intercultural exchanges' that can potentially rethink

and recast 'processes of global hegemony and [. . .] counter-hegemonic resistance' (ibid.). Harding suggests the metaphor of 'rough edges' to describe a way of thinking about the avant-garde that emphasizes it not as 'subsequent to the moments of intercultural exchange' but rather 'in the exchanges themselves' (ibid.: 8). By focusing on the 'sites of cultural exchange and contestation', the avant-garde appears like a 'plurality of edges devoid of an identifiable center, a plurality that the rectilinear center-to-edge/edge-to-center convention in scholarship on the avant-garde has obscured' (ibid.: 9–10). That is certainly the case with the Surrealist Atlantic.

It is at this point that the dual meaning of 'minority' proves particularly useful. In line with Harding, Richardson writes of Caribbean Surrealism that 'what is at issue here is not a one-way process of objectification of the other, but the basis for a genuine recognition of the other's own subjectivity, albeit always framed by the aims of Surrealist aspirations: mankind's liberty in its most general form and the resolution of contradictions' (1996: 25). The Surrealist Atlantic emerged out of a self-reflexive critique of the avant-garde mythos itself, a critique that never lost sight of the specific agency (or lack thereof) of minorities and the differential practices of minoritization across the colonial system. The Surrealist Atlantic was forged by two minority communities that had very different histories, experiences and statuses. They came together to explore desire, imagination, language, art, power, identity, capitalism and the imperial prison house. Theirs was a community that invented new kinds of communication in the face of daunting social, political, cultural and personal obstacles. And they created art.

The encounter did not go perfectly. Ménil, one of the Martiniquans who participated in the collaboration from the start, was acutely aware of the intra- and interpersonal dynamics that could derail such an effort. His description deserves to be quoted at length:

> One notes the ambiguous attitude of an emotional type among white (European or American) critics. Their approach is generally affected by a strong coefficient of subjectivity (feelings of guilt, a need for atonement, seeking evasion and exoticism, masochism, etc.). With some we note a reserve, a discretion, and a fear of squarely tackling the question: 'It is an issue for blacks, they are the ones who must undertake the critique . . . if they think it is worthwhile and say what they think of it.' This is quite natural, but . . . does it not simply represent

a repression of racism not to wish to consider a Negro philosophy as one human philosophy among others? Equally, Negritude is not merely a matter between blacks, since its object is the relation 'black–white' and it styles and defines whites correlatively and antithetically in relation to blacks. Finally, [because] Negritude situate[es] itself from the start within the framework of progressive and anti-colonialist ideologies, the most liberal white critics have difficulties in surmounting the following problem: how to effect, without complacency, the progressive critique of a progressive ideology that contains errors? They are afraid that by submitting Negritude to such a critique they could be accused of paternalism, or even racism (quoted in Richardson 1996: 16–17).

As Richardson sums this up, 'What is essential, then, is to keep open the paths of communication while respecting questions of otherness and exoticism' (ibid.: 17). This required real intellectual dexterity, a studied lack of dogmatism and a refusal to abide by the conventional rules governing interaction between French and colonial elites. The frank and mutual criticism that we see in the work of Mabille, Monnerot and Suzanne Césaire (not to forget Crevel) reminds us of the critical role played by face-to-face encounters between those who proclaim themselves the avant-garde and those whom they supposedly lead.

THE AFRIKANER BROEDERBOND

A very different kind of vanguard minoritarianism is apparent in the history of the Afrikaner Broederbond. The Broederbond was a secret society whose members were exclusively white, Afrikaans-speaking, financially secure, male, Protestant South Africans over the age of 25 and of 'unimpeachable character' (quoted in O'Meara 1977: 164). It played an important, perhaps central, role in the theorization, implementation and enforcement of apartheid, the system that, with the utmost violence, empowered and enriched whites at the expense of non-whites in South Africa from 1948 to the early 1990s. Terry Bell has called the group 'the effective brain of Apartheid. [. . .] This secret society to which every president, prime minister, senior parliamentarian, military and police officer belonged, together with most senior church and education leaders, was the primary think-tank of the system and the major influence on policy' (Bell with Ntsebeza 2003: 5). Some would dispute this characterization

but all agree that the brotherhood was a major player in South African politics for half a century. The historical record may never be able to settle matters. True to its motto—'Our strength lies in secrecy'—it was able to ensure 'that, unlike state records, its history—the history of the system called apartheid—was never under threat of disclosure' by the Truth and Reconciliation Commission that has helped manage South Africa's transition from racist to democratic rule (ibid.: 36).

In addition to the powerful loyalties fostered within it, the organization was also held together by a watertight racist ideology, with hellfire as collateral. As its chairman put it in 1944, 'The Afrikaner Broederbond was born out of the deep conviction that the Afrikaner *volk* has been planted in this country by the Hand of God, destined to survive as a separate *volk* with its own calling' (quoted in O'Meara 1977: 176). This belief in the righteousness of their minority (whites have never comprised more than a tenth of the South African population) helped the organization to grow from a desperate little culture club into an elite world power and to maintain that elite status for almost half a century. I will consider here two moments in the Bond's history, each marked by a distinct model of minority-based vanguardism:

(1) 1918–48, which takes us from the Bond's founding by a small group of railway clerks, clergy and security guards to its rise to national hegemony and the official institution of apartheid in 1948 and

(2) 1962–92, dating from the first crisis in the Bond's leadership— the botched trials of anti-apartheid activists, the Sharpeville Massacre and the Mpondo rebellion in Transkei—to its official end as a national power broker in 1994.

The Bond began as little more than a feverish fantasy of three Afrikaner youth stargazing on a hill outside Johannesburg in 1918. Clerks on the British-managed national railway system, they were part of a colonized class valued by the British colonizers for their discipline, on-the-ground knowledge of the region and white skins. But they were also marginalized, their denigrated status 'a constant reminder of the defeat of the Boers by Britain in the war of 1899 to 1902' (O'Meara 1977: 28). They were angry, isolated and tortured by guilt for letting down their grandparents, the legendary Voortrekkers who colonized the interior of southern Africa. The idea these three men had for a club was a 'refuge for those who wished to preserve and strengthen their language and culture' in the

face of their British colonizers (ibid.: 29). A few months after the first
meeting, Jong Suid Afrika (Young South Africa) was founded, a name
changed shortly after to the Afrikaner Broederbond. The members were
provided with buttons for their lapels signalling their commitment 'to
defend the Afrikaner and "return him to his rightful place in South
Africa"' (ibid.). On the face of it, this is not much of a challenge to British
hegemony, but imperialism manages power at least in part by managing
cultural matters, so any emphasis on culture by the colonized is tacitly
political. Even the Broeders' commitment to culture would take an overt
and active political turn, a move prodded by Dutch Reform Calvinist
Reverend Johannes Naude (ibid.).

In addition to language and customs, the first Broeders were the safe-
keepers of a cultural myth that was well-worn by the time they got their
hands on it.

> Like so many Afrikaners before and since, they had been raised on
> an intellectual diet of myth and potted history which pitted heroic
> Boer against perfidious Briton in a struggle that impacted on the
> cosmos itself. They saw the Afrikaners as players in the unfolding of
> the Book of Revelation, upholding the light of Christian civilization
> against an advancing wall of darkness promoted by the Beast himself.
> It was God's will that the 'Afrikaner nation', in reality a recent amal-
> gam of Dutch, French, German, Scots, Indonesian, Malay, and
> African ancestry, linked by language and a narrow Calvinism, had
> been placed on the southern tip of the African continent. His will
> should be done (Bell with Ntsebeza 2003: 29).

In that spirit, the Broeders took the dust-covers off an old military strate-
gy of the Voortrekkers that provided a kind of spatial map—what Mikhail
Bakhtin would call a 'chronotope', an imaginative matrix of time and space
that shapes storytelling and self-image (1981)—for their vanguard fan-
tasies: the laager. The laager will be familiar to fans of American Western
movies: a defensive circle of wagons within which the settlers would make
camp and protect their supplies and livestock (see Image 2.5). But the
Voortrekkers did not just use the laager defensively; it was a kind of semi-
permanent settlement from which could be launched 'raids into the hostile
territories [. . .] led by heroic soldiers [. . .] and directed by farsighted,
tough, and essentially benevolent leaders' (Bell with Ntsebeza 2003: 29).
The laager was a keystone of the Bond's self-concept. 'The soldier-hero
icon was everywhere,' Bell writes,

IMAGE 2.5 'The laager'. Courtesy: Corbis Images.

It ratified the broad acceptance of the cult of the leader, an accept-
ance that Afrikaner Broederbond-inspired educational theory would
later try to mould into a permanent feature of 'white' youth in gen-
eral and Afrikaner youth in particular. It certainly provided much
of the inspiration for the many starry-eyed young men who volun-
teered to fight 'on the border' or to join one or other of the state's
security divisions (ibid.).

The Broederbond's version differed from the Voortrekkers' not only in its
secrecy (a conventional circle of wagons is hard to miss) but also in its
emphasis on culture, which made the laager not just a sociopolitical strat-
egy but an icon of ethnic separation. Ultimately, the laager provided the
Broeders a *weaponized concept of culture*, a way to fight a political fight on
cultural grounds and a practical method to segregate themselves within
the neighbourhoods, congregations and factory shop floors of the South
Arican community and, thus, constitute themselves a vanguard of white-
ness (for 'weaponized culture', see Apter 2004).

Though the myth was put in place fairly early on, the membership
was not. The 1921 Bond was a very different bunch from the originals of
1918. Efforts to recruit the railroad clerks and cops who comprised the

majority of the 1918 youth association, as well as the financially secure artisans and manual labourers 'of unimpeachable character' who made up the bulk of urban Afrikaners, failed. The Bond's cultural twist on the laager myth attracted teachers, preachers and civil servants (Bell with Ntsebeza 2003: 29); thus, the brotherhood was 'a purely petty-bourgeois organization, rooted in the northern provinces of the Transvaal and Orange Free State, and concerned with the particular effects of the trajectory of capitalist development on the Afrikaans-speaking fraction of the petty bourgeoisie' (O'Meara 1977: 158). Part of the problem was that the Bond's myth of whiteness was directed not against black Africans but other whites, the British. But the threat from British whiteness—whether imperialist or liberal-cosmpolitan, both terrifying to the Broeders—was not simply felt as acutely by urban, working class and farm-working Afrikaners, who were in high demand in the rapidly expanding pre-Depression economy (Dubow 1992). Culture was not an issue because the money was good. Because 'they devoted their energies during the first three decades of the twentieth century to issues like republicanism, language equality, and the poor white question [. . . it] was markedly slow to address directly the relationship between black and white South Africans' (ibid.: 210).

This was to change. In the 1930s, the Bond found its appeal to white workers, both urban and rural, growing (ibid.: 215). It was then that white farmworkers started to feel the sharp end of the industrialization of South African agriculture. In addition, the global economic crisis displaced hundreds of thousands of white workers in field and factory alike. The myth of whiteness cultivated by clergy, teacher and academic was an effective balm to those who could not get their heads around the idea that their fellow Afrikaners might be responsible for their suffering (ibid.). A new scapegoat was ready at hand, too, one with deep roots in the nationalist fantasy and legislative history of Afrikanerdom. Industrialization in South Africa 'resulted in a massive influx of African workseekers who came to be perceived as posing a major threat to the privileged position of largely Afrikaans-speaking unskilled and semiskilled labour in metropolitan areas' (ibid.: 211). In such an environment, fantasies of minoritarian power became increasingly appealing. Supported by trade union action, boycotts, strikes and other acts of civil disobedience, the growth of black industrial labour 'prefigured a new challenge to white power on the part of urban Africans' (ibid.) not least, by infiltrating spaces that had been

previously dominated by the Afrikaaner ethos. The laager myth blossomed in such conditions—memories of Zulu terror, it seems—and the vanguardist fantasies of the Broederbond became a sociopolitical reality.

After the victory of the National Party in 1948 and the first sweeping measures instituting apartheid, 'few if any policy decisions taken by any cabinet were not first approved by the executive of the [Bond]—if they were not Broederbond policies in the first place' (Bell with Ntsebeza 2003: 27). This leads to some difficult questions about the status of the Broederbond as an avant-garde, questions that bring us back to the two meanings of minority. The integration of vanguard and state apparatus always requires radical shifts in the nature of the vanguard in question, as is clear from other cases where that kind of hegemony was achieved (such as Maoist China, the Soviet Union, Fascist Italy and Argentina during its so-called Dirty War). An avant-garde cannot go unchanged when it changes from minority to hegemony. But this movement into hegemony does not necessarily mark the 'death of the avant-garde', as so many scholars of the avant-garde have tended to see it, but is instead a moment when various negotiations of status, function and self-image occur. This makes such moments especially interesting to the historian and critic—a 'rough edge' well worth considering. In the case of the Broederbond, though the sociological, economic and political bases of its vanguardism were either dissolved or mired in organizational in-fighting, the brothers moulded the state itself to its paranoid self-image, unleashing not only a 'breathtakingly extensive' body of legislation (Cole 2010: 7) and an effective police force but also a bureaucracy that would enable the Bond to continue to exert control outside of parliamentary pressures. After the victory, the Bond was no longer a *functional* vanguard but the *myth* of the vanguard—the 'potted history' of Voortrekker, laager, victory against both odds and the Zulu horde at Blood River in 1838 and destined whiteness—was never far from hand.

During the 1940s and 50s, the South African state was transformed into a kind of geopolitical laager, both symbolically and practically. If, as Marx noted, the French chose for their own post-revolutionary state the apparel of the Roman Republic (Marx 1963), for apartheid-era Afrikaners, it was circling wagons, fanatic militias, last-ditch Boers and patriotic preachers. I suspect that all this played with at least a shade of irony for the company vice president sinking a ten-foot putt on a green outside of Cape Town. During the 1940s, the Bond put the finishing touches on a concept of Afrikaner whiteness that was especially appealing

to the businessmen who flocked to the club in great numbers. This new-and-improved, fully legalized whiteness gave the Broeders the intellectual, rhetorical and bureaucratic weaponry to keep alive the feeling, even on the seventeenth green, that the Afrikaner elite were the true sons of the Voortrekkers.

But behind the scenes, a great violence was in the offing, and a new vanguard of white power was coming into being. To protect white entitlement, the golfer needed the cop, the spy and great quantities of cash and blood. Security became the *raison d' être* of the laager, supplanting culture as the litmus of white destiny—and it was in security that the Bond's vanguardism was revived as more than just a myth. Within the Bond, a group of men committed themselves to the protection of white power. They deployed, in secrecy, great numbers of intensely loyal double agents, assassins, private eyes and later, death squads and guerrilla military forces into the Zulu-infested darkness of modernity. Two of the major figures in the shaping of this new avant-garde were Broeders John Vorster and H. J. Van den Bergh, the former a prime minister (1966–78) and president (1978–79). Together, they helped create an efficient, innovative infrastructure of terror and surveillance that would add years to the life of a political system in crisis—as well as restore a true vanguard status to the Bond.

According to Bell, in 1962, Vorster, then Minister of Justice, approached Van den Bergh, a high-ranking police officer, about being head of Security Branch. This position carried not only the responsibility of managing national security but also of initiating major reforms to the branch so that it could meet the new challenges to the white power that were emerging (2003: 27). Among these challenges there was, first, the specifically cultural challenge revealed during the politically disastrous series of high-profile trials of anti-apartheid activists staged between 1956 and 1964. While denying the anti-apartheid movement its leaders, the trials galvanized the grassroots and demonstrated the power of public demonstration and cultural performance for black South Africans. Catherine Cole summarizes the unprecedented challenge faced by white authorities:

> As the musician Abdullah Ibrahim stated, South Africa's may well have been the first revolution ever conducted in 'four-part harmony'. The state obsessively [. . .] record[ed] and document[ed] its non-white population through passbooks, and Africans responded by setting the passbooks on fire. The state passed repressive laws, and

Africans broke them. When Africans broke the law, they were put on trial. Yet, in Nelson Mandela's view, 'Our appearances in court became the occasions for exuberant political rallies' (2010: 8–9).

She continues,

> In the face of state repression and censorship, the anti-apartheid struggle cultivated a rich and multifaceted repertoire of resistance. Embodied expressions, songs, gestures, dances, and speech acts were its weapons (ibid.: 9).

The cultural firewall of apartheid and the geopolitical isolation of the township system had unintentionally enabled black Africans to develop approaches to activism that the Afrikaners did not know about or understand.

The shootings in the township of Sharpeville on 21 March 1960, marked another turning point for apartheid—and was further evidence that security strategy had to be modernized. Cole notes that 'even at the time of the shootings, many recognized Sharpeville as an historic watershed' (ibid.: 8). Paul Sauer, a senior member of the South African Cabinet, said two weeks after the shooting, 'The old book of South African history was closed at Sharpeville' (quoted in ibid.: 8). Assembling to protest the increasingly oppressive effects of the Pass Laws, which required all non-white South Africans to carry documentation at all times, between 5,000 and 7,000 people gathered at a local police station to be arrested, since none of them were carrying their passbooks. Efforts to disperse the crowd took a turn for the worse when the police opened fire, leaving 69 dead and over 180 injured, including large numbers of women and children. After the massacre, a State of Emergency was declared, prompting mass arrests and detention without trial. Cole writes, 'Among anti-apartheid activists, the years before 1960 were called "the legal days"; afterwards, everything was illegal' (ibid.). As a result, the prison population exploded, the anti-apartheid movement saw more and more of its members abandoning nonviolent resistance and anti-apartheid organizations such as the African National Congress develop military wings. Embracing violence and moving underground, the anti-apartheid forces demanded from their oppressors innovative, insidious countermeasures.

Though the incidents at Sharpeville have received the most attention from historians, Bell believes that the Mpondo uprising in the Transkei homeland is just as important. As he describes it, 'that rebellion [. . .] was

against the very traditional authorities with which the Apartheid government had hoped to build their segregationist dream' (2003: 22). Random acts of sabotage against government projects, the punishment of those who continued to pay taxes and the burning of collaborationist leaders' homes gave way to a full-scale guerrilla war that was brought to a close with heavy armour, aircraft and a full-scale police assault on the rebel stronghold in June 1960. The Mpondo Revolt cast into doubt a basic presumption of apartheid. Transkei was intended to be a model of the benefits that autonomous cultural development could provide people of different races. Transferring power to traditional tribal authorities in the spirit of 'home rule' was intended to promote that kind of cultural, political and social empowerment. But it was mere smoke and mirrors; these so-called Bantustans possessed only the most meagre self-control, their 'leaders' the same self-serving elites who arise wherever oppressive power needs collaborators. The homelands were essentially labour farms for distant factories and the whites-only country clubs and gated neighbourhoods. In addition, the idea of 'cultural authenticity' was a fiction, as basic alterations in economy and social structure had been made. As a consequence, traditional avenues for the empowerment and self-esteem of youth were concretely blocked; land was scarce and the conventional methods for transferring authority between generations obliterated by Afrikaner rule.[7] The revolt in the Transkei further ratified the primacy of culture in the South African race war and prompted the most insidious, ubiquitous and devious response from white power.

Van den Berg and Vorster were the right men to restore vanguard mobility to the apartheid bureaucracy in the 1960s not only because they were willing to torture and terrorize but also because their sense of white identity—and their sense of being in the vanguard—was distinct from most Bond members. For them, the trajectory from hinterland laager to Cape Town golf course took a detour through the vicious modernity of the concentration camp. In 1943, Vorster was a lawyer and youngest 'chief general' of the outlawed Oxwagon Guard (*Ossewabrandwag* in Afrikaans), a far-Right organization that rivalled the National Party for the sentiments of white South Africans, counting as many as 350,000 members by 1941.[8] They were a mean bunch, friends with the Nazis, who affirmed for their South African brothers the political efficacy of fist and pistol and taught them how to build an efficient cell structure and manage mass sentiment. Violently opposed to South African support of the British

during the Second World War and legally marginalized by Jan Smut's pro-British government, the Guard chose to become, in Bell's words, a 'paramilitary pro-Nazi underground' (ibid.: 41) with a storm division that carried out extra-parliamentary acts of terrorist violence including murder. The experience of minoritization—one that was chosen by the members, driven by their commitment to the 'true' South Africa—in a white-dominated system enabled them to develop a keen sense of how to hold an extremist line in a parliamentary political system.

Van den Bergh was one of several hundred Guard members who spent a hard time in a Koffiefontein prison camp for terrorist acts, a camp no different to him than those in which independence-seeking Boers had been thrown a half century before, many to starve to death. Wandering among the 'corrugated iron huts set on concrete slabs and watched over by machine-gun nests in wooden watchtowers', he and Vorster began to form plans that they would put into effect in the 1960s (ibid.). In the meantime, Van den Bergh served as counter-intelligence chief, his job being 'to seek out and expose the government agents sent in to spy on the internees' (ibid.). The laager for these men was less 'potted history', more Foucault's *Discipline and Punish* (1977). The vertiginous realpolitik of the camp—where loyalties were always in question, violence always close at hand, a sense of destiny a sure antidote to hopelessness—would typify Vorster's years at the top of South Africa's power elite.

Van den Bergh dismantled the 'hopelessly antiquated' security administration. Instead of the meritocratic, professionalist, bureaucratic and increasingly directionless system in place, the new regime cohered around a tight circle of 'men we know and can trust (quoted in Bell with Ntsebeza 2003: 42). Van den Bergh's plan responded to the Bond's increasingly hide-bound and fractious nature, which was causing it to lose response speed and ideological focus. The Security Branch was envisioned by its head as being more powerful than the Bond itself, 'an all-seeing, all-knowing agency that would select the right people for the right jobs and not only set the course for the ship of state but steer it too, in splendid anonymity' (ibid.). It would recover the brute momentum of trek, skirmish and assassination from the plodding, intellectualized and politically compromised Bond and a national government that had been forced to make unacceptable concessions to international pressure. The laager was occulted in the corridors of secret office complexes, in bare-knuckle interrogation rooms, secret training camps and in the field

with right-wing counter-revolutionary guerrilla soldiers undermining neighbouring regimes.

But the ironies of race ultimately outdid this new vanguard. Bell notes that, in addition to consolidating the circle of tough men at its core, there were two other priorities in the reorganization of Security Branch: 'The others were to create a network of undercover agents and to recruit infiltrators from the black community who could be sent abroad to join the [African National Congress, the most threatening opponent to apartheid] in exile' (ibid.). To promote their agenda, they developed an extensive network of double agents, including the so-called Askari, guerrilla fighters who were captured and converted to the apartheid cause by threat, brainwashing and ideological conversion. In conjunction with the use of undercover agents, infiltrators and blackmail, the Security Branch's efforts to turn the enemy illustrate how profoundly performative the avant-garde of whiteness had to become in South Africa in order to sustain its power. Indeed, the Bond's efforts to reconcile the contradictions of their minority forced them to develop a common culture with blacks who, according to apartheid ideology, shared absolutely nothing in common with them. The deployment of these double agents traced one of the faultlines in the ideological infrastructure of apartheid.

Security Branch also cultivated and exploited one of the unforgivable sins of the Afrikaner cosmology: miscegenation. Sexual activity was among the most legislated activities during the apartheid era and, as one would expect, interracial marriage and sexual relations were outlawed. Thus one of the favourite methods of the Security Branch was the blackmailing of those who had acquired, 'as the police coyly put it, "illicit carnal knowledge" across the colour bar', often through police entrapment (ibid.: 45). Because such crimes carried such a potent mix of legal and social penalties, the victims tended to be especially willing to play along. There is nothing especially odd about the politicization of sex in colonial situations, but the implications of racist sex laws and their exploitation by Security Branch implicate Afrikaner whiteness in unique ways. Security Branch embarked on a project that evokes less the militant purity of the laager than Foucault's description of nineteenth-century sex-research centres like Jean-Martin Charcot's hysteria ward at the Salpêtrière hospital:

> Capture and seduction, confrontation and mutual reinforcement: parents and children, adults, and adolescents, educator and students, doctors and patients, the psychiatrist with his hysteric and his per-

vert, all have played this game [. . .] These attractions, these evasions, these circular incitements have traced around bodies and sexes, not boundaries not to be crossed, but perpetual spirals of power and pleasure (1990: 45).

The purity of whiteness—with its apotheosis in the apartheid state—was the sacred imminence of a Creator-ordained historical purification, one that was spiritual, linguistic, cultural and racial. To guarantee that purity, the sons of the Voortrekkers pursued a careening descent into ever more elaborate hygiene rules and dedicated men's professional lives to leering surveillance of the Afrikaner citizenry's sexual practices. Harding's 'rough edges' took on an undeniably sensual, sadistic and voyeuristic charge during the final years of Bond hegemony.

The assassination of African National Congress lawyer Bheki Mlangeni in February 1991 brought to light other kinds of subversive cross-racial desires. Mlangeni was assassinated by a set of exploding head-phones after he had become involved in the defence of Dirk Coetzee, a former commander of the death-squad training centre at Vlakplaas, outside Pretoria. Coetzee had put himself at mortal risk when he broke the Bond's vow of secrecy and confirmed the death-row confession of Butana Almond Nofemela, a black African and former agent of Security Branch, sentenced to death for the murder of a white farmer in 1989. Upon learning that he, unlike other agents of his ilk, would not be spirited away under cover of a fake execution, Nofemela testified not only to what happened at the training centre but also to hacking to death a civil rights lawyer in 1981. Horrified that a loyal agent was being hung out to dry, Coetzee not only confirmed the testimony but also festooned it with details about mass murders, kidnapping, torture, the disposal of corpses, weapons running and other acts of terrorism. In response, then-Prime Minister F. W. de Klerk lambasted Coetzee as an agent of an independent group 'determined to plunge into anarchy the careful settlement process established by men and women of good faith on both sides of the apartheid divide' (Bell with Ntsebeza 2003: 13). Complementing South Africa's officially sanctioned sadomasochistic sex show, Nofemela, Coetzee and De Klerk's mutual betrayals are symptoms of the Bond's final, fatal crisis as an avant-garde of whiteness.

If the Surrealist Atlantic demonstrates the vital role that intimate interpersonal relations between differentially minoritized communities can play in collective vanguard struggles against racism, the case of the

Afrikaner Broederbond demonstrates how those same kinds of relations can both serve and undermine the efforts of one minority group to secure power and hold it against such efforts. But the critical issue here is not the relationships. Rather, the transatlantic collaboration of radical artists and activists and the shifting status of the Broederbond's minority demonstrate that a more nuanced understanding of power relations can provide a more sophisticated sense of how avant-gardes negotiate the structures and myths of power. As Schechner aptly puts it, 'At present, categories like "Left" and "Right" have lost much of their meaning; they are useful only in very particular historical circumstances, not as general principles' for the consideration of the political challenge posed by vanguard movements (2002a: 343). A concept of the avant-garde informed, in this case, by a dualistic notion of racialized minority can open analysis to subtle gradations of power and the nature, the efficacy of movements across them and the critical role race can play among vanguard tendencies.

HENRI DE SAINT-SIMON AND OTHER RACIST UTOPIANS

In addition to refining our sense of the power dynamics that inform how and why avant-gardes do what they do as minorities, a concept of the avant-garde that is attuned to race can spur new ways of thinking about how we periodize it. Probably the dominant model these days is Bürger's concept of the 'historical avant-garde', which, to summarize quickly, prioritizes early twentieth-century movements such as Futurism, Dada and Surrealism and, by extension, dismisses nineteenth-century vanguard formations as little more than naive precursors or misdirected appendices of the true avant-gardes. But Bürger's position is indefensible both in theory and in fact. For sure, Bürger has saved scholars a lot of headache by scaring them away from the nineteenth century. A full reconsideration of the 'prehistoric' avant-gardes dredges up all sorts of complications and paradigm-shattering moments while still allowing us to make use of Bürger's still eminently useful litmus test concerning the avant-garde's reflection on and engagement with its infrastructural and institutional dimensions. That the paradigms and precedents of the nineteenth century were wrapped in race and racism makes a discussion of them all the more pertinent and an abandonment of the conventional scaffolding of avant-garde history all the more necessary.

This leads us to Saint-Simon. I agree that we should not fetishize the man, notwithstanding the fact that he coined the term in its truly modern sense (indeed, in two distinctly modern senses, as I will discuss ahead). The boundaries of the avant-garde are by no means set by the limits of his thought and writings. But there's a historical interest here—and a genealogical line that carries into our own times—that is well worth our attention. Saint-Simon's theory of the avant-garde, implemented in varied versions as part of a constantly evolving utopian programme (often driven by whatever access he had to money or influence at the time), has impacted sociology, positivism, Marxism (Engels said, 'Almost all the ideas of later socialists that are not strictly economic, are found in him in embryo'; 1945: 12), socialism and even capitalist reformism. His presence in the history of modern warfare, as I will be showing in the chapter on 'War', is large. Despite the fact that many of his principles and presumptions have been discredited, quite a few of the issues that energize the field of avant-garde studies today were first identified and explored in Saint-Simon's circle in the 1820s, including the belief that ways of knowing are inextricable from social milieu; that there is a significant and manipulable relationship among culture, identity and power; that media, institutions and social groupings play a key role in that relationship; the utility of hierarchical organization in the pursuit of justice and social progress; the significance and role of Europe in global culture and history; the cultural impact of technical and cultural production; and the mediating role played by social classes in intellectual history. Apologies to Bürger and those who have chased us away from the nineteenth century but I find it difficult to consider the Saint-Simonians as anything more than a blind appendix or naive precursor.

Though most scholars of the avant-garde are aware that Saint-Simon coined the modern concept of the avant-garde, less well known is the fact that it was a *racist* coinage. Saint-Simon placed the 'man of imagination' at the head of what Egbert has described as 'an administrative elite trinity consisting of artists, scientists and industrialists-artisans' (1970: 121). 'In so doing', Egbert continues, 'he gave rise to the conceptions both of an artistic avant-garde and of a social vanguard—conceptions with enormous importance for the history of art and of social radicalism alike' (ibid.). For anyone with even a whit of enthusiasm for the arts, it is hard not to be thrilled by the words spoken by the artist in Saint-Simon's *Opinions littéraires, philosophiques, et industrielles* (1825, probably co-written with Olinde Rodrigues):

It is we, artists, who will serve you as avant-garde: the power of the arts is in fact most immediate and most rapid: when we wish to spread new ideas among men, we inscribe them on marble or on canvas, [. . .] and in that way above all we exert an electric and victorious influence. We address ourselves to the imagination and to the sentiments of mankind; we should therefore always exercise the liveliest and most decisive action; and if today our role appears nil or at least very secondary, what is lacking to the arts is that which is essential to their energy and to their success, namely a common drive and a general idea (quoted in Egbert 1970: 121).

But this quote has always been taken out of context; specifically, the context of Saint-Simon's racist metaphysics. Saint-Simon persistently worked, in Egbert's words, to 'arrive at the laws governing the science of man as Newton had discovered the scientific law of the universe' (ibid.). The Newtonian comparison is apt; Saint-Simon at one point advocated a strictly Newtonian, essentially mathematical theory of the universe, viewing it as a perfect mechanism in which existed imperfect creatures. This view led him and others to spearhead the call for the grand civil engineering feats of modernity, such as the Panama Canal, in order to impose upon humans the material conditions for their own perfection. However, he gradually moved away from that constrictive constructivist theory towards 'one that was essentially historical, evolutionary and organismic, rather than mechanistic' (ibid.: 120).

Though his metaphysical speculations changed over the years, his attitude towards non-Europeans did not. For example, while trying to nail down the details of his metaphysics and refining his plan for the organization that would best serve the avant-garde, Saint-Simon took the time to publicly praise and justify Napoleon's decision to keep slavery legal in Martinique, Tobago and St Lucia and pressure the revolutionary government of Haiti to maintain conditions of abject poverty for black workers that were really no different from slavery—and just as profitable. Though the years saw him change from a Newtonian to an organicist, Saint-Simon never lost faith in the theory of polygenesis—a theory 'that the color-coded races were separate and unequal species of the genus *Homo*' (Frederickson 2002: 66). Polygenesis gave Saint-Simon a way to think about global relations in synch with the leadership demands of European modernity. Black slaves were necessary to the progress of civilization and black Africans were well-suited to the trade. Frederickson summarizes Saint-Simon's position:

The revolutionaries had made a mistake, Saint-Simon wrote a year after the rescinding of emancipation, when they 'applied the principle of equality to the Negroes'. If they had asked the men of science, 'they would have learned that the Negro in accordance with his formation, is not susceptible under equal conditions of education of being raised to the same level of intelligence as [the] European' (ibid.: 67).

Though Saint-Simon believed in the inevitability of progress and the 'perfectibility of races', he also believed in the superiority of the European line. Domination in ratio to enlightenment was the rule for him.

We might be tempted to erect a firewall between Saint-Simon's theory of the avant-garde and his racism, but that is not so easy. The racialized body played a key role in Saint-Simon's speculations from the start. Egbert writes, 'Quite early, he found in history the same critical ages, the same changes of taste, as in the history of the individual human being, with history therefore developing through periods of adolescence, maturity, and decay like the life-cycle of a living organism' (1970: 120). This notion informed his theory of the avant-garde, too. Art, industry and science—the vanguard triumvirate—were not career options for Saint-Simon but a kind of physiological obligation. Saint-Simon based his speculations about the body—both the individual body and the social body—on the work of anatomical pathologist Xavier Bichat (Staum 2003: 21). What Saint-Simon found most compelling about Bichat's theory was that 'variability in organic disposition became a signal that no one person would excel in all capacities. The only answer for a productive society, therefore, was specialization in which the naturally talented would rise to the top' (ibid.). As Martin Staum puts it, 'Saint-Simon [. . .] contended that the different capacities of the human mind could not each be simultaneously developed. Saint-Simonians believed in the proper education of the three distinct talents within society. The rational would become scientists and scholars; the emotive, artists, poets and preachers; and the active, muscular types, workers, administrators, or entrepreneurs' (2000: 457). Michael A. Osborne explains that Saint-Simon extended Bichat's theory so that it could speak coherently to both individual and group: '[W]hereas Bichat had written of the body as composed of some twenty-one different tissues (each with its own specific functionality and kind of life) and of intelligence as being separate from organic life, the social scientists drew comparisons between the well-functioning biological individual and the

well-constructed society' (2004). What Saint-Simon added to this mix was sociology, leadership and engineered modernity. Specific institutions had to be developed to promote the powers amplified by such specialization, while unifying the individual and the group into a historical power. Once properly organized, 'on a world scale, Europeans would be the global brains at the head of economic development, while other peoples might attain guidance to climb the ladder of being or advance through the several stages of development. In a harsher view, however, some would always remain uncivilizable' (Staum 2003: 21). In Saint-Simon's system, the artist, the industrialist-artisan and the scientist were biologically destined leaders of a biologically superior civilization.

Having said that, it would be inaccurate to paint all Saint-Simonians as racist. Though they all thought about the avant-garde in terms of race, the ends of Saint-Simonian racial speculations were not always nor consistently the denigration and disempowerment of others. Staum points out, first of all, that

> at least one Saint-Simonian, [Olinde] Rodrigues [again, a likely co-author of *Opinions littéraires, philosophiques, et industrielles*], refused to correlate the distribution of capacities with racial ancestry. A tireless advocate in the 1840s of mutual aid societies, easy credit, and profit-sharing for workers, Rodrigues also invoked the work and example of Olympe de Gouges in an appeal for citizenship for women (2000: 457–8).

The racialist basis of the Saint-Simonian system allowed its users to justify all kinds of perspectives on the 'race question'. This is illustrated by the concept of 'perfectibility of races' as it circulated in the pioneering Ethnological Society of Paris (1839–48), which would eventually collapse over deep disagreements about slavery. In April 1847, a debate was initiated in the Society concerning the proper 'mode of association between the races', a debate that was understood as part of a larger discussion in French society about whether to abolish slavery. Rodrigues' contribution to that discussion was to hold 'that all human races had an "equal aptitude for civilization in suitable circumstance", just as, "women will one day conquer equality without any restriction"' (in ibid.). On the other hand, banker Gustave d'Eichthal turned the functionalist organic metaphysics of Saint-Simon to the service of racist hierarchy. Eichthal felt that 'many blacks, including Oceanians and Australians as well as Africans, are in a

"primitive state" with no sciences, no systematic religion, no developed fine arts, literature, or administration. If abandoned, they would have no "civilizing initiative of their own" (ibid.: 459). Like Rodrigues, Eichthal considered the question of gender as a related issue, insisting in support of his pro-slavery argument that women are not equal to men 'in the absolute sense' but have a functional 'role of the same importance in the organization of the couple'. Thus, the 'happy and benevolent dispositions' of Africans would give them, 'a special role in the new peaceful age' (quoted in ibid.: 459).

The racialized contradictions in utopian movements do not just concern Africans or card-carrying Saint-Simonians. Robert S. Wistrich has examined the relationship between the eighteenth-century Enlightenment, the emancipatory categories and tendencies of the late nineteenth century and anti-Semitism, arguing that 'it would be no exaggeration to say that [post-1870 anti-Semitism] was essentially an offshoot of left-wing ideology' (1995: 109). Louis-Auguste Blanqui, the revolutionary socialist associated with both the 1830 revolution and the Paris Commune of 1871, called the Jews 'the horror of the nations because of their pitiless cupidity, as they had once been because of their enmity and war to the death against the human race' (quoted in ibid.: 119). Charles Fourier and his followers, perhaps the biggest rivals to the Saint-Simonians, were convinced that Jews were evil and not afraid to tell others about it. The Fourierite Alphonse Toussenel used the term 'Jew' as a general signifier of the evils of commodity capitalism; the 'elasticity' of the term allowed him to characterize the Protestant Christian nations of Western Europe as 'Jewish' (Frederickson 2002: 114). The popularity of his work was due not only to his ability to tap into a popular tradition of using the word 'Jew' to describe non-Jews (a bit like how some people these days claim to use the word 'gay' as an insult without being homophobic) but also his appeal to popular fears of elite cosmopolitan Jews such as the Rothschild's. Fourier himself was far less subtle (notwithstanding Toussenel's use of phrases like 'the people of Satan'), harshly criticizing the French revolutionaries for granting Jews citizenship, given that they were, in his words, 'the leprosy and ruin of the body politic' (quoted in Wistrich 1995: 115, 116).

THE FRENCH MEDICAL CORPS IN ALGERIA:
FROM SAINT-SIMON TO FRANTZ FANON

The École de Médecine de Paris, one of the other anchor schools of the French empire and another hotbed of Saint-Simonianism alongside the École Polytechnique and École Supérieure de Guerre, is perhaps the single most instructive example of how an avant-garde moulded by Saint-Simonian ideas of race could use those ideas to conceive, lobby for and implement large-scale civil projects; expand European hegemony; and establish a place for themselves in the modern order. This was a vested minority if ever there was one and obsessed with a man with race. In a fascinating article on the role of French military doctors in Algeria during the French colonial takeover (1830–70), Patricia Lorcin describes how graduates of the École enabled it, among all other French institutions, to '[throw] the longest shadow over the medical corps in Algeria' (1999: 658). Most of the doctors serving in Algeria got their training there and the school became a prototype for those built in the provinces. Lorcin expands on this:

> Not only did it hold pride of place as the center of medical innova-
> tion in the first half of the nineteenth century; of equal relevance was
> its link to Saint-Simonianism. [. . .] The value placed by Saint-
> Simonians on the role of science and individual scientists in shaping
> an improved society, and on the necessity of a hierarchical order to
> achieve this end led to the association of the Utopian philosophers
> with scientific and military establishments (ibid.: 658–9).

Saint-Simonism was lingua franca for French medical men, not least Auguste Warnier who would become 'the foremost spokesman of the colony', prefect of Algiers in 1870 and deputy for Algeria in 1871 (ibid.: 664). He was especially fond of Saint-Simon's idea that civilization was 'a ladder up which people progressed in accordance with the degree of social harmony and political or scientific development in their society' (ibid.: 659). Further, he cheerfully 'advocated the achievement of well-being through economic endeavour, efficient technology, and industrial develop-ment', believing that the 'ideal society was a paternalistic hierarchy in which a natural elite (of scientists, technocrats, and industrialists), guided the masses to improved living standards and higher states of civilization' (ibid.). Dreams of this sort danced in the head of many a young physician crashing across the Mediterranean Sea towards the Algerian coastline.

Race and ethnicity were the rhetorical firepower doctors deployed in their efforts to establish epidemiological science as a fully funded concern of the French state. Racial upliftment and the benefits of peaceful co-existence in the service of Paris justified the measures and costs of modernizing the Algerian infrastructure. The strategic utility of the corps had been demonstrated by Napoleon's Egyptian campaign, which saw 'the triangular relationship of military activity, medicine, and imperialism [. . .] truly established' (ibid.: 658). The 23-volume *Description de l'Égypte* (1809) is only one of the monumental accomplishments of Saint-Simonian physicians 'looking beyond the immediate demands of their patients to the appraisal not only of the local population but also of the flora, fauna, and topography of the area in which they practiced' (ibid.). In Algeria, these kinds of approaches enabled French doctors to insinuate themselves not only in the highest echelons of civil and military power in the colony but also in the kitchens and toilets of the Algerians. Far in advance of modern academic ethnography and performance studies, Saint-Simonian doctors conducted detailed surveys of the everyday lives of the Algerians, delving into the most intimate details and providing 'scientific' justification to public health administrators and civil engineers interested in disrupting traditional folkways deemed unhealthy or socially destabilizing. The doctors' work helped trace a kind of capillary map of the Algerian multiculture, one that proved eminently useful to military authorities as the French transitioned from an expeditionary force to a permanent bureaucracy managing colonial development.

Algeria was (and remains) a multi-ethnic society. The two largest ethnic groups, the Arabs and Kabyles (Berbers), were the subjects of multiple French surveys, not surprising since they were the only two groups who had resisted the French invasion, the Arabs not surrendering until 1847, the Kabyles holding out for another decade. As a consequence, 'underlying all ethnological research was the need to discover which were the most subversive elements of the population and which, if any, were those most likely to cooperate with French rule' (ibid.: 667). One of the first full-length studies, *Considérations sur l'Algérie*, written by physician Eugène Bodichon, was published in 1845. Bodichon's book focused 'on the character traits, morality and religion of both Arabs and Kabyles, discussing them in the light of the French occupation and its civilizing capacities' (Lorcin 1999: 654). Those capacities were directed by the medical corps towards two goals, both of which are reflected in the book:

(1) eradicating diseases

(2) providing evidence 'whether ethnicity or race could be disease
specific' or, 'more important, [if . . .] lifestyle, culture and moral-
ity influence the transmission of diseases and epidemics' (ibid.).

Achieving those goals would allow the French to control Algeria without
threat of resistance groups forming in their midst.

As the primary agents for new methods of colonial development, the
medical corps also showed real adroitness with the unprecedented kinds
of authority that emerged during the Napoleonic era, authority that could
be wielded outside the parliamentary structures and processes of the post-
revolutionary French state—and very much in the spirit of Saint-Simonian
technocracy (which was never a democratic notion to begin with).
Algerian physicians were elites in the spirit of Saint-Simon's vision of the
avant-garde; for them, medicine was not just a technical practice but a
philosophical, sociological and moral index of civilization. The medical
corps capably exploited the unprecedented

> politics of the French Revolution and the ensuing Napoleonic era.
> [. . . T]he Revolution initiated the politicization of French physicians.
> Medical involvement in French politics continued throughout the
> nineteenth century, and political activism in the colonies was its logi-
> cal extension. This activism was to place physicians among the
> movers—and in some cases, the prime movers—of the colony (ibid.:
> 656–7).

Their historical impact is hard to overestimate. By making 'themselves
[. . .] a cultural, social and political presence in Algeria, the members of
the medical profession made an important contribution to the develop-
ment of a French colonial identity and to the creation of a French intel-
lectual space in the colony' (ibid.: 655).

Ironically, the same approach provided an experimental, rhetorical and
operational basis for the creation of a distinctly *post*-colonial identity in
Algeria. Compounding the irony, that approach was developed by another
French-educated physician assigned to serve the colonial imperative but
this one a transplanted Martiniquan, educated and mentored by Aimé
Césaire no less. Frantz Fanon's stature in pan-African and revolutionary
thought is monumental and his accomplishments in psychiatry, philosophy,
sociology and literary theory the topic of a dauntingly extensive body of
commentary. His two major works, *Peau noire, masques blancs* (1952; *Black*

Skin, White Masks, 1994[1967]) and *Les Damnes de la Terre* (1961; *The Wretched of the Earth*, 2005[1963]), are major documents of the anti-colonial struggle and wellsprings of postcolonial theory, inspiring heated argument to this day. His contributions to the Algerian independence struggle are, likewise, exemplary of engaged intellectual work. But despite his contributions to revolutionary praxis, the sociology of colonialism and its enemies, the role of culture in insurgencies and the politics of race and representation, and despite the fact that those who have written about non-European vanguards often depend on his writings, Fanon's place in scholarly histories of the avant-garde is marginal at best. His position vis-à-vis the vanguard medicine men who healed the wounds inflicted by the very French colonialism they abetted has received almost no attention, despite his remarkable essay 'Medicine and Colonialism', written during the initial stages of the Algerian revolt.

It is difficult to understand why more has not been written about Fanon himself as vanguardist. The Césaire connection, for one, is compelling. Fanon was a lifelong friend and mentee of Césaire's, going way back to his student days at the *lycée* in Martinique (where Ménil and Suzanne Césaire also taught). Césaire's influence is easily apparent in Fanon's work, not least in his belief that intellectual work must interrogate and be interrogated by concrete political work. Kelley goes further, identifying four specific implications of the mentoring Fanon received from the elder statesman of postcolonial Martinique, including

(1) the notion that, in Fanon's words, 'Europe is literally the creation of the Third World';

(2) that the Third World would pave the way to a new society (2002: 178);

(3) that Africans are not primitive or degenerate but the sons and daughters of a 'valid historical place'; and

(4) in Kelley's words, that 'the "colored" world not [. . .] follow in Europe's footsteps, and not go back to the ancient way but carve out a new direction altogether' (ibid.: 176–80).

Like the Caribbeans who critically engaged primitivism and ethnography as both a discourse of colonialism and a wellspring of intellectual community, Fanon understood that knowledge, power and sociality are inextricable; that the ability to critique a specific system of knowledge and power requires a thorough understanding of, indeed education *within*,

that system; that any change to the system will therefore require change from all parties involved; and lastly, that any criticism of that system will implicate the critic's own personal and professional identity. Fanon's efforts to describe and intensify the pathology of a dying colonialism should therefore be traced, at least in part, to Surrealism's critique of the humanities and social sciences in France and elsewhere and its insistence that dynamics of desire and identity, usually relegated to the psychotherapist's office, in fact impact all levels of social being. It fits the tradition of highly personal, ruthlessly frank internal criticism exemplified by the French Surrealists' relationship to the French Communist Party and by Crevel, Suzanne Césaire and others to identify and surpass the limits of Surrealism in order to empower it.

Fanon's work as a physician also brings to mind Bürger's litmus test of the avant-garde: that the critique of a particular system of representation must also be a critique of the institutional supports of that system of representation in order to enable subsequent representations to effectively thematize that critique. Not only did the colonial medical corps construct new (that is, 'scientific' and 'ethnographic') representations of race in opposition to those of the church and popular folkways, they also developed institutional and organizational infrastructures to further the work of modernization and forward the cause of Universal Reason. In line with Bürger, we find in the corps not simply changing concepts of race but also the recognition that the existing institutional bases of racism were hampering the full unfolding of a 'science' of race. Thus, Fanon's most significant link to the history and theory of the avant-garde may not be what he is best known for, his writings on colonialism and his contributions to the Algerian revolution, but, rather, his membership as a racialized minority in the vested vanguard of colonial medicine.

Fanon's consciousness of institution and sociality wasn't merely due to the time he spent with Césaire. Fanon served a residency in Paris with the legendary François de Tosquelles, the Catalan nationalist who pioneered the field of institutional psychotherapy, an approach that explicitly attends to the 'articulated spaces' of the institutional and social setting in which therapy occurs (Macey 2000: 144–8). After serving for another year in Paris, Fanon was commissioned to head the Blida-Joinville Psychiatric Hospital where he served until 1956, at which time he committed himself completely to the Algerian insurgency. Following through on the critique mounted by both Surrealism and Tosquelles, Fanon used the insights of his

discipline—psychiatry—to criticize colonialism, deeming it *the* public health crisis of the twentieth century. This he argued in his groundbreaking *The Wretched of the Earth*, whose chapter 'Colonial War and Mental Disorder' summarized his work as a psychiatrist who treated both French torturers and tortured Algerians. Even before he committed himself full time to revolutionary struggle, Fanon instituted changes in psychotherapeutic practice at Blida-Joinville, including varieties of sociotherapy that addressed mental and emotional disorders as integral to the larger social setting (Vergès 1996: 86–7). As part of his efforts to 'open the hospital, to humanize it, to make the patient a man among other men [*sic*]', Fanon organized workshops to provide opportunities for work-skill development; allowed patients to earn money, form theatre groups, and run a newspaper; and held twice-weekly meetings with patients and staff (ibid.). Like the Caribbean Surrealists, Fanon never lost sight of what he called the 'persistent and irreducible *sociality*' of the subject, his mental representations and his desires (quoted in ibid.: 87).

Fanon always understood that 'in the colonial situation, going to see the doctor, the administrator, the constable, or the mayor is identical' (Fanon 1967a: 130). Long routinized by an extensive but inefficient and patronizing colonial medical system, those visits 'helped administratively to transform the native into the colonized, self-determining people into colonial subjects. The information licensed by medical, bureaucratic, political or police visits fuel colonial governmentality just as the information they release is framed [. . .] by the colonial imperative' (ibid.). Fanon felt that this introduces an 'ambivalent attitude' in the colonized who finds it difficult 'to separate the wheat from the chaff' and, as a consequence, tends to reject medical help because of the concomitant humiliation that it entails. Whatever 'good faith' there is is almost always 'immediately taken advantage of by the occupier and transformed into a justification of the occupation' (ibid.: 123). In his letter of resignation from Blida-Joinville, Fanon wrote, 'If psychiatry is the medical technique that aims to enable man no longer to be a stranger to his environment, I owe it to myself to affirm that the Arab, permanently an alien in his own country, lives in a state of absolute depersonalization' (ibid.: 53). But Fanon also came to view his efforts to radicalize that system as insufficiently attentive to their broader representational and institutional context. Looking back at his work at Blida-Joinville, Fanon ultimately deemed it a failure, believing, as Vergès puts it, that

language and cultural barriers raised methodological difficulties; theater activities were irrelevant if they were seen [by the largely male inmates] as a 'feminine activity'; a newspaper was worthless if patients were illiterate; the presence of an interpreter underlined the gap between the patients and the psychiatrists; [and] group therapy was doomed to fail if speaking one's feelings and emotions was not part of the 'local culture' (1996: 93).

But what is perhaps the most intriguing—and, frankly troubling—dimension of Fanon's critique of colonial medicine is how much it duplicated its practices. The patron saint of the wretched of the earth held assumptions about the colonized and practiced a methodology that would likely have met with the approval of Warnier and the other Saint-Simonians in the medical corps. Like his precursors in Algeria, Fanon believed that psychology was not just a matter of the individual but also of people. Vergès calls colonial psychiatry the 'heir of the *psychologie des peoples*, which emerged [. . .] as a discourse whose goal was to define a relation between race, culture and the psyche' (ibid.: 87). Though Fanon would, of course, disagree with the racist presumptions of a Gustave Le Bon or Léopold de Saussure, he would agree to a large extent with their 'notion of the radical heterogeneity of beliefs of the racial groups', an idea 'opposed to the philosophical idea of Reason, and to the dogma of the moral unity of humankind' (Antoine Bouillon, quoted in ibid.: 88). Their methods also show striking similarities. During his time at Blida-Joinville, Fanon travelled across Algeria to study the cultural and psychological lives of Algerians, spending most of his time in the Kabyle region, a perennial seedbed of resistance and vanguardism. As with his colonialist precursors, those surveys enabled both more effective medical care by identifying obstacles to its successful delivery and provided important strategic information to political leaders and the military, though, of course, Fanon's discoveries were channelled not to the colonial authorities but to the revolutionaries. Fanon even expressed sentiments about Algerian traditional culture which echo his colonialist precursors. In 'On National Culture', an essay in *The Wretched of the Earth*, Fanon warns the anti-colonial movements not to fall into the pitfall of romanticizing cultural tradition, which he sees as threatening the development of a truly modern, secular Algeria. But he also sees modernity as having distinct implications and contours for the Algerian, given their differences from Europeans. Echoing the medical corps' differential analysis of Arab and Kabyle in

order to identify possible threats to colonial unity, Fanon highlights differences within the Algerian community that he believes will materially impact the anti-colonial struggle. He particularly takes to task the Algerian bourgeoisie for their indulgent nature and the nationalists for being both overly centralized and consistently failing to ensure 'the fruitful give-and-take from the bottom to the top and from the top to the bottom which creates and guarantees democracy' (Fanon 2005: 170).

Though of an entirely different ideological orientation, in many ways Fanon is in line with medical men like Warnier who also found in traditional Algerian cultures resistance to the economic and political development that would usher them into modernity. The difference, of course, is that Fanon's end of the line runs to the Left. Just as the Caribbean Surrealists inverted the principles of colonialist anthropology to create a critical practice of ethnography and an effective intervention strategy in the Surrealist movement, Fanon inverted the principles of the Saint-Simonian public health official, turning an epidemiology oriented to heal and control into a weapon for the colonized, or as Vergès puts it, into an imperative to cure and to free (1996: 85).

TSHEMBE'S PARADOX

Thus far, I have shown how a focus on race can help us better understand the relationship of the avant-garde to shifts in the function and power of intellectuals and technocrats in the nineteenth century, to the media and institutions of primitivism in the twentieth century, to the dual meanings of minority and to the construction and dismantling of the European colonial system. I will turn now to a theme that has circulated throughout these pages but has not been directly addressed: the theatricality of race and anti-racist struggle. Lorraine Hansberry, in her play *Les Blancs* (1970), creates an elegant and incisive image of the challenges facing those who would destroy the spectacle of race (1994). In it, a black Afro-British intellectual reluctantly puts on the mantle of revolutionary anti-colonialist warrior after returning to his homeland from a long, self-imposed exile. Its most remarkable scene has Tshembe Matoseh laying out swaths of traditional African fabrics on the ground, gracefully weaving a shimmering web of shifting colour and pattern to fend off a liberal, white American journalist whose most annoying quality is his certainty that everyone would get along just fine if they cleared their heads of racialist nonsense.

Tshembe avers that race is just a 'device', a fiction to justify oppression and exploitation, an utterly unempirical, completely fantastic idea. However, he makes sure that his agreement comes with a claw-sinking paradox: 'A device is a device,' he tells the journalist as he continues to weave his brilliant mosaic, 'but [. . .] it also has consequences: once invented it takes on a life, a reality of its own'. The black man in Mississippi shot by racists, he sardonically concludes, 'is suffering the utter *reality* of the device' (ibid.: 92). Race is fundamentally theatrical, a mercurial hybrid of bone-marrow reality and smoke-and-mirrors theatricality. This is what I call 'Tshembe's Paradox'.

BOHEMIANISM, THE 'GYPSY,' AND THE CULTURAL TURN OF THE AVANT-GARDE

Tshembe's Paradox is at the heart of what is perhaps the single most important moment in the history of the avant-garde. As I discussed earlier, the nineteenth century saw the development, in France, of racist theories of white superiority grounded in a Saint-Simonian model of technical and cultural activism. But the era also saw the rise of a very different way of being avant-garde, one that has inspired innumerable anti-racist movements and provided security and expressive power to those marginalized by racism, misogyny, epidemiophobia and other kinds of essentializing prejudices. This way of being veered wildly between the poles of Tshembe's Paradox, sometimes embracing essentialist notions of identity, at others putting on the most overtly performative and theatrical trappings of the racial device. Thus, it is only fitting that we begin our exploration of bohemia and bohemianism in the front row of a Broadway theatre in the mid-1990s.

The rousing finale of *Rent*'s (1996) first act takes place in a stylishly déclassé restaurant, at which place a multicultural, multi-gendered, variably doomed and destined clique of artists, intellectuals, upwardly mobile con artists, cross-dressers, activists and slumming trust-fund kids belt out 'La Vie Bohème'. Raising their glasses, they pay rock-'n'-roll homage to an alternately inspirational and titillating rogues gallery, including Gautama Buddha, Langston Hughes, Lenny Bruce, Allen Ginsberg, Maya Angelou, Carmina Burana, 'emotion, devotion [. . .] causing a commotion', leather-clad dildos and, last but not least, 'wine and beer'. It is an undeniably thrilling moment when knocked out with the right mix of high

decibels and youthful energy, a number seemingly designed to carry the audience to the theatre bar already buzzing.[9]

Part of the thrill of the number is the rapid-fire memory required of the audience member. In addition to those already named, 'La Vie Boheme' tosses out almost two dozen other references at 4/4 tempo, making it at once pop anthem and pop quiz. Jonathan Larson is obviously a big fan of the bohemian genre; he packs the show with its relics: the romantic up-and-down narrative, the tried-and-true punchlines, sure-fire comic and tragic generic tricks, outré costumes and, of course, hip cultural references. In the process, he manages the tough trick of being at once innovative and utterly traditional. In this respect, the number is like the show as a whole, *Rent* being both rock opera and memory theatre. (On 'memory theatre', see Yates 2001.) Indeed, despite all the popular press about *Rent* remaking the modern musical, it is in many ways a very old-fashioned show. I was especially charmed at a production in Chicago where I had the opportunity of witnessing a bourgeois couple right out of the pages of Marx and Engels' *Communist Manifesto* (1848)—in matching furs, no less— stomping down from the balconies in a huff. I had seen the bourgeois insulted—the legendary *épater de la bourgeoisie* described in all those books and articles on the avant-garde!

Its invocation of memory makes *Rent* typical of works about bohemian life. Henri Murger's *Scenes de la Vie Bohème* (1845), Giacomo Puccini's *La Bohème* (1896), Jack Gelber's *The Connection* (1959–63), Baz Luhrmann's *Moulin Rouge* (2001)—to name only the best known in a very fecund line—are all memory texts, texts that are *about the struggle to remember* in the face of poverty, cultural marginalization and epidemic and *are a form of memory*. This memorial combination of form and content is an important characteristic of the bohemian genre—and of the milieu it represents. Those who live the bohemian lifestyle are noted for their passion for the unprecedented—the shocking, the outré, the newest import or freshest hybrid—but they are romantic in their lasting love for the antique, for first editions, dusty paste jewellery, forgotten vinyl recordings and passionate, doomed love affairs. But the bohemian also forgets, and what has been forgotten and how it has been forgotten prove, on close inspection, to be of great significance to our understanding of the avant-garde. In the following pages I will be describing what and how the bohemian forgets even as she proclaims a most radical form of remembering.

Bohemia and the avant-garde came into being around the same time and place, Paris in the 1820s, where technocratic proto-futurist military engineers from the École Polytechnique walked the same streets as neo-medievalists and professional conspirators. What bound them then (and binds them even today), is a common obsession with *history*, particularly the belief in the *authenticity* granted by critically positioned cultural conscious-ness, history-minded activism and the intentional flouting of middle-class rules of decorum and good taste. In this respect, both the bohemian and the vanguardist are part of a broader trend of historicist thought, a trend that includes pioneering historiographers like Jules Michelet, Alexis de Tocqueville, Leopold von Ranke and Jacob Burkhardt (those who helped forge the 'grand narratives' of European historical thought during the nine-teenth century) as well as those who actively criticized such historiography, Hayden White (1975) and Jean-François Lyotard (1984) coming immedi-ately to mind.

While vanguardists often bought into the tales of the historiographers, bohemians more or less resisted the urge. The bohemian tends to believe that history is not to be found in the grand narrative movements of European conquest, liberal progressivism and proletarian revolt but, rather, in unexpected and seemingly banal places and moments: in the greasy remains of a low-budget banquet, for example, or the sensuous friction of flesh across sacrosanct sexual, racial or class boundaries. Even so, the bohemian is still fundamentally a creature of the modern moment and always something of a Modernist. Regardless of where history is to be found, the bohemian assumes that authentic existence is historically conscious existence, undeniably *present* being. To be bohemian is to be a memorialist who lives life fully in the present. To remember in a bohemian way is to be authentic in a certain way—to be authentically modern.

While there is an astonishing and daunting amount of writing about bohemians and bohemianism, what is generally missing from most of the conversation is the vehicle of the metaphor. Bohemian is a metaphorical designation, after all. The avant-garde artist is like a 'gypsy', compelled to wander, to live on a prayer but creating art and loving passionately at whatever cost. But the vehicle of the metaphor carries a history that is ignored at peril, 'bohemian' being derived from one of the French words for 'gypsy', *bohemian*. Those terms, by the way, have been generally rejected by the 'gypsies' themselves, who prefer their own name, the 'Roma', over the other, pejorative one. For this reason, I will refer to the radical

subculture, the one described in *Rent*, as 'bohemian' and to the ethnic group as 'Roma'. The links between the bohemian and the Roma are deep but, for the Roma, being in the 'avant-garde' has almost never been a choice. An ethnic group that lives in all areas of the world and as a legend of literature and folklore, their harassment by authorities and neighbours in Eastern and Western Europe compelled them into a nomadic existence. The historical record is dismal. They were the object of five centuries of persecution and enslavement in Wallachia and Moldavia, a human rights crime drawn to a close only in the late 1800s. 'Gypsy hunts' were popular in Switzerland, Holland and Denmark starting in the sixteenth century and awards and honours were given to participants. In 1835, one hunt covered four districts in western Denmark and resulted in the murder of over 260 men, women and children identified as gypsies (see Duna 2007). Anti-Roma immigration laws were common in the late 1800s, as was the case in the US. The Roma was the one other ethnic group explicitly targeted for extermination by the Nazis, who murdered them by the thousands and made their genocide official policy in the occupied territories. For the Roma, being avant-garde was always a compulsion, a condition of flight. Unlike the artistic avant-gardes of Europe and the US, the Roma's struggle for expressive and political liberty was not just a consequence of philistinism, mass-media hypocrisy or the malign neglect of federal funding agencies but also of 'gypsy hunters', Nazis and skinheads.

Describing the Roma 'presence' in bohemia and the bohemian presence in the history of the avant-garde provides yet another perspective on how the sociopolitical formation of race underwrites not just the disempowerment of certain kinds of people but also enables certain aspects of anti-racist critique. Specifically, it allows us to understand how Tshembe's Paradox can lead both to forms of consciousness-raising irony (that is, the déclassé son of a factory owner playing 'gypsy') and to actions motivated by true belief (that is, the gypsy hunter). But getting to that point of understanding is not easy. The Roma exist in a representational conundrum comparable in some ways to the African American in the US literary tradition, a condition described by Toni Morrison as 'unspeakable things unspoken' (1989) and by Peggy Phelan as the 'unmarked' (1993). The Roma, not unlike the African American, is an 'invisible thing' that is 'not necessarily "not-there"', a 'void' that is 'empty, but [. . .] not a vacuum' (Morrison 1989: 11). Their history is inextricable from the centuries-long smear campaign against them, the legends spoken of them by

sympathetic white youth and their iconic status in art. And yet, despite this crush of representation, the Roma's role in the history of the avant-garde has been ignored and almost forgotten.

The bohemian myth helped satisfy an unprecedented desire among white urban Europeans for a concrete sensibility that would allow them to *feel* that their lives were related in some essential fashion to the cataclysmic changes occurring around them, to *feel* that they belonged to a history, a secret history of sorts, that was not wholly encompassed by capitalist modernity. Parisians excluded from wealth, the public sphere and civil and national decisionmaking looked for significance and control in lives that, after the revolutions of the late 1700s, were no longer organized by the agricultural cycle and the punctual arrival of sabbaths and holy days but by other rhythms and experiences: meals, lovemaking, debate, creation, ducking authority, scrabbling for money. Bohemians developed a diverse and mercurial performative discourse, what Diana Taylor calls a 'repertoire' of gestures, intonations and oratures as distinguished from the written 'archive' (2003). As Mary Gluck puts it, bohemia's 'alternative vision [of self and modernity] cannot be found in any literary text or ideological tract produced by members of bohemia. It was, rather, performed through gestures, clothes, lifestyle and interior decoration' (2000: 356). This repertoire was comprehensible and meaningful to a diverse population, including ostracized single mothers, those stricken with tuberculosis, painters, Eastern European immigrants, déclassé middle-class kids and the Roma. All of these benefitted from the new ways of living that became possible in post-revolutionary Paris, lifestyles that confronted and/or avoided authority in new, surprising and interesting ways. Paris' bohemian districts were floating islands in a sea of violence, exploitation and boredom.

But this turn to the politics of lifestyle was hardly by choice. Rather, it was part of an effort by those energized by the promises of the revolution and disappointed by its realization to retain some kind of progressive agency in a period of profound revolutionary disappointment and counter-revolutionary backlash. César Graña, in his classic book on bohemia, describes the impact of the multiple waves of political devolution that took place in the early 1800s in France:

> Popular suffrage in France before the revolution of 1848 had actually reached its peak immediately after 1789, when something less than half a million had been given the vote. By introducing tax

qualifications, the Bourbon restoration had brought the figure down to 100,000, chiefly landowners and wealthy merchants and manufacturers. The Orléans monarchy reduced the electoral tax to accommodate the middle businessman and certain professional groups, but no one beyond that. In 1846, out of a population of 35,000,000, the 'legal nation', the electorate of France [. . .] was 250,000 (1964: 13).

Affording a kind of 'imaginary solution' to the increasingly intractable problems and hardening authoritarianism of the French liberal state, the bohemian 'lifestyle' served at least somewhat effectively to protect the interests of those marginalized by the modernizing, capitalizing, counter-revolutionary nation-state. The idea that the 'personal is political', that there was a 'culture' that could withstand terror, was a lifeline to those so marginalized.

Interestingly, the 'discovery' of cultural politics by the bohemians occurred at a time and place that possessed only the most rudimentary academic, criminological and popular discourses on culture. A. L. Kroeber and Clyde Kluckhorn have shown that the term 'culture' was identified as an object of scientific study not until about 1843, around the time that bohemia's first wave had already peaked and shortly after the founding of the Paris Ethnographical Society. The coinage was largely in order to describe a set of social and aesthetic practices not covered by the concept 'civilization', which 'refers primarily to the process of cultivation or the degree to which it has been carried' (Kroeber and Kluckhorn 1952: 13). The concept of culture, on the other hand, described an 'extraorganic or superorganic' state or condition 'in which all human societies share even though their particular cultures may show very great qualitative differences' (ibid.: 13–14). The unity of aesthetics and ontology that is the hallmark of bohemia—the old saw about blurring the line between art and life—was, in the early decades of the avant-garde, about *achieving* that kind of organic unity (as opposed to breaking it, which is the rule today, particularly among performance artists). Not surprisingly, French intellectuals and academics of the nineteenth century openly resisted the notion. As a result, what we now call 'culture' (as well as quite a few of the methodologies that we associate with the humanities) was initially and almost exclusively a discourse of the cops.

And it stayed theirs for some time. Even by 1952, the year Kloeber and Kluckhorn's book, *Culture: A Critical Review of Concepts and Definitions*, was published, 'in French, the modern anthropological meaning of

culture had not yet been generally accepted as standard, admitted only with reluctance in scientific and scholarly circles, though the adjective cultural was sometimes so used' (ibid.: 11–12). Claude Lévi-Strauss' first significant works on structural anthropology were not published until later in that decade and the radical ethnographic project of the Surrealists had been largely eclipsed by the Second World War and Existentialism. Our rightly cherished ability to recognize, remember and revolutionize the field of activities, gestures, beliefs and expressions that is 'culture' was pioneered by bohemians in a situation in which the 'expert' discourse on cultural politics went no farther than police harassment and editorial-column disdain. Thus bohemians *defined* a field of struggle, not merely reacted within one; in fact, it was the academic and criminological institutions that reacted to them. What we call 'culture' was (and is) that field. In the absence of any substantive communication between bohemians and the French academic, governmental and criminological establishment (I will discuss the work of Cesare Lombroso below), the bohemians' turn to local vernaculars was inarguably radical.

But if culture was a foil to political disempowerment, it was in danger of becoming nothing more than what we would now call a 'lifestyle choice', easily appropriated by those with neither sympathy for nor experience of the crushing poverty and danger suffered by many in the gutters of Paris. Culture was inadequate without an ideological supplement, some kind of symbolic, performative fortification that could provide a sense of groundedness, a kind of chthonic authenticity amid the chaos of European modernization. What was needed, as it turns out, was blackness.

The Roma symbolized that blackness—more than symbolized it, *lived* it. Ian Hancock notes that the Roma themselves have long depended upon a system of black/white imagery to differentiate themselves from non-Roma. Hancock writes,

> [T]his distinction has always been a part of the Romani world view. Another term for 'non-Gypsy' is *goró*, which in India means 'light-skinned', while a Romani self-ascriptive label found in Northern and Western Europe is *Kaló*, which means 'black'. One Romani term for Eastern Europe, where the highest concentration of Romani lives, is *Kali Oropa*. [. . .] These are boundary-maintaining labels which persist in culture while no longer having any manifestation physically (1998).

It is not coincidence that entry into the bohemian lifestyle is usually the consequence of things that are not chosen but that are compelled (or at least compelling), that are felt as somehow *essential*: love, the compulsion to paint or sculpt or write, chronic illness, addiction, single motherhood, migrancy, homelessness, being queer. Bohemian 'blackness' provided a sense of historical and political authenticity rooted in the body. The bohemian myth gave existential firmness to the day-to-day chaos in which many non-Roma Europeans lived, gave to them a kind of ontological repertoire with which to express popular memory, existential authenticity, cultural prerogative and political entitlement in a society that saw regular and legal violence and discrimination against women, the poor and political radicals, ethnic and epidemiological minorities. The myth of bohemia was the performative language with which those alienated by an unprecedented modernity could make sense of an existence chillingly close to disaster and derive from that closeness knowledge, pleasure and love.

The ironies of Tshembe's Paradox are not precluded by this desire for the essential and the authentic. After all, the rebellions of the bohemians, both petty and grand, are rebellions *on display*. The bohemians are at all the big events of the season. They hang out on street corners, loud, gaudy, wilfully incapable of minding the line between private and public. Murger describes the bohemians as those who have 'given evidence to the public of their existence' (Murger 1903: xxix). The bohemian 'hides in the light', to recall Dick Hebdige's description of 'spectacular subcultures' like the British punk scene of the 1970s and 80s (1989). Bohemians are rebels but attractively so. Recall Gluck's point that bohemia is fundamentally a performed identity. She notes in particular the nineteenth- century craze for dress inspired by 'gothic novels, fashionable romances, romantic dramas and melodramas, whose colorful images saturated the world of popular culture' (2000: 358). Perhaps the most famous bohemian act of radical authenticity occurred around the so-called Battle of Hernani, when a group of outrageously dressed French youth, led by Théophile Gautier, publicly supported their idol Victor Hugo against the philistine bourgeois hordes. As much was said of Gautier's long hair and bright crimson sash as the rules broken by Hugo's play, leading one to conclude that the invention of the bohemian marks, in part, the invention of *visibility politics*.

But to be theatrical was to put at risk the authenticity on which everything depended. Gautier, for one, made it a point of 'keeping it real' both in life and print, perhaps in part due to the theatrical celebrity that had

propelled him into the public eye. In an 1843 review of the dismal little melodrama *Les Bohémians de Paris*, he 'angrily objected to the application of the "charming" word to the dubious street people ('cranky ruffians', 'frightful villains', 'hideous toads who hop in the mires of Paris') who populated the play' (Brown 1985: 1). Not just ethnophilic, class-conscious elitism was at work here. As Marilyn R. Brown has shown, the deeper issue in Gautier's ire was his commitment to a radical form of transnational solidarity. To wit, Gautier backs up his critical authority in the review by describing a trek he took through Spain a few years earlier—no small accomplishment in an age before superhighways and personalized combustion engines—during which he saw 'the real bohemians' (ibid.). 'Along with the *gitanos* of Spain, the gypsies of Scotland, the *zigueners* [*sic*] of Germany, here are the only bohemians that we recognize' (ibid.). The claim of authenticity is ratified by both the 'real bohemians' and the Gautier group, who made sure to outfit themselves in 'authentic' nomad gear in preparation for meeting the 'authentic' nomads of the Spanish hinterlands.

Gautier's paradoxically 'theatricalized authenticity' is well represented in an illustration by Gustave Bourgain (1890, see Image 2.6). In it, we see a group of artists, specifically a group from the anti-traditionalist Barbizon school, painting a band of 'gypsies': three women huddled around a cooking fire and a man striking a provocative pose in front of a wagon home. Bourgain titles the image *Gypsies* and clearly intends some ambiguity with it: Who are the gypsies here, we might ask, the artists or the folks by the wagon? Well, both, of course. But there's a deeper irony here when we notice, following Brown, that the male bohemian in the image is not a 'real' bohemian at all but a surrogate in gypsy drag (ibid.: 5). The irony would be rich enough were he simply some anonymous actor looking to pick up a few *sous* and a hot lunch. However, the surrogate is rabble-rousing poet Jean Richepin. Born in Algeria in 1849, he had acquired, by the time of Bourgain's illustration, a well-earned reputation for stirring up the impoverished classes with his impassioned verse, for being a first-rank competitive drinker and for his full-time commitment to the life of the nomad. He was a bohemian of the first rank: ornery, politically conscious, iconoclastic and a dexterous drunk. One could not find a more apt illustration of Tshembe's Paradox than Bourgain's picture, which shows how, as Brown puts it, 'from its inception, [. . .] bohemianism was a "picturesque" response to, and sublimation of,

IMAGE 2.6 Gustave Bourgain's *Gypsies* (1890). Gautier's paradoxically 'theatricalized authenticity' is well represented here.

the failure of the revolutions of 1830 and 1848 and the recourse to art and attitude in order to allow the torch to be carried on' (ibid.: 9).

Lest we assume that Tshembe's Paradox was at play only among the bohemians, we should trace the perennial association of the Roma themselves with theatricality. As a term, 'bohemian' suggested to the French not just the nomadic Roma and the déclassé artist but also the peripatetic entertainers of the day—the *saltimbanques*, bear wrestlers, jugglers and the like—and a rogues gallery of other 'theatrical' types such as the congenital liar, the juggler, legend weaver, con artist, enthusiastic pub dancer and pickpocket. A concern with theatricality informed the legal status of the bohemian over the centuries: in addition to tracking the movement of Roma by their association with itinerant performers, European anti-Roma legislation specifically targeted their dress and language, long a favourite style for unruly non-Roma youth. Anti-Roma laws for the previous four centuries in France almost always targeted both the Roma and the entertainers in one fell swoop, as well as the wannabes who tagged along emulating their dress, dialect and jests. Paul Boudet, French Minister of the Interior, said in 1864, the *bohemièn* was 'vagabond', 'dangerous foreigner' and, as street performer, 'the natural auxiliaries of the

Socialist establishment' (quoted in ibid.: 24). For Richepin, that was a fair cop, being a radical North African who occasionally dressed like a marginalized Eastern European to serve as a model (in both a literal and figurative sense) for artists who wanted to believe that the very act of painting would grant them personal and historical authenticity. Bourgain's drawing and Richepin's performance suggests that any attempt to correct our historical understanding of the Roma—and, by extension, race and the avant-garde—must get in among the smoke and mirrors of gypsy camps in which were found not just Romani families but also revolutionaries, painters, jugglers, con artists and magazine illustrators.

Thus, I agree with Gluck when she argues that the biggest challenge to constructing a sociology of bohemia is the deeply embedded myths surrounding it. After all, with such myths in the way we will always fail to 'connect the social and the aesthetic dimensions of the bohemian and thus reestablish the historical specificity and concreteness of the figure' (2000: 352). I also agree that we scholars should ask questions that stabilize historically and sociologically the bohemian, questions such as: 'What were the historical preconditions that explain the emergence of the cultural bohemian? What were his characteristic features? What were the sources of his vision of modernity and how did he implement them within the historical world?' (ibid: 353). However, Gluck's timely advice takes no account of the Roma or the dynamic of theatricalized authenticity that has informed their racialization for the last half millenium. In other words, any discussion of the bohemian has to account for Tshembe's Paradox.

Alaina Lemon points out, in a nuanced analysis of race politics at the Moscow Teatr Romen, that there is a specific meaning to the idea of 'authenticity' in Russian Romani society, one rooted in theatrical performance, an idea that is common among all Roma, not just entertainers.

> One reason it is so difficult for Romani performers to contest what is or is not authentic in a production, to challenge tropes that have dominated up to now, is that being seen as authentic is much more problematic for them than for actors in other, non-ethnic theatres. Audiences and actors usually make a 'basic conceptual distinction' between a fictive 'staged role' and a real 'stage actor'. But this role separation does not apply to Romani performers in Russia—Roma are supposed to play themselves, as *Roma* (1998: 489).

Lemon continues,

> [T]he case for Roma in Russia is complicated precisely by the fact
> that the tendency to perform is located within the 'true Gypsy'.
> Indirectly, such tropes of performance affect even non-performers,
> who are expected simultaneously to be temperamental (expressive)
> and capricious (improvisational), as well as calculating (rehearsed)
> and dishonest (masking) (ibid.: 481).

Thus, theatricalized authenticity describes a common ontology—a way of
being—shared by bohemian and Roma alike, a sense that selfhood is not
possible except through a theatricalization of self, a making public of a
secret identity both in artistic declarations as well as public exhibitions of
pleasurable derring-do, an effort to 'hide in the light' and, in the very act
of hiding, achieve a real, though fragile sense of liberty. Bohemia marks the
'bodying forth' of the avant-garde, its emergence as a mode of ideologi-
cally motivated 'radical actuality' (Garner 2000: 530). It is with bohemia,
not Futurism, that the history of avant-garde performance really begins.

In addition to theatricalized authenticity, bohemians are self-con-
sciously exotic. Exoticism is defined rather tepidly by the *Oxford English
Dictionary* as a 'tendency to adopt what is exotic'; 'exotic' defined as

(1) outside, extrinsic, or foreign in character and

(2) as something 'of or pertaining to strip-tease and strip-teasers'.

But the definition is not a bad place to begin. Exoticism is a mode of
appropriation as well as a kind of theatricalized sexual behaviour and
sexual display. In this respect, there is perhaps no better emblem of
bohemian exoticism than the gypsy dancer, resplendent in cloth, coins
and—this is what sets apart the gypsy dancer—seductive ethnicity. She is
the obsession of Hugo's hunchbacked bell-ringer in *Notre Dame de Paris*
(1831) and she haunts Luhrmann's movie *Moulin Rouge*. Hugo's
Esmerelda was a dark beauty surrounded by vicious patriarchs, salvation
for a man lacking conventional beauty but possessed of a refined aesthetic
temperament. The courtesan Satine, played by the luminously pale
Nicole Kidman, is an uncanny Esmerelda, at once familiar and alien.
Satine's beauty is entirely denuded of the gypsy's 'blackness', and, rather
than coins, Satine wears diamonds. Her lover Christian, it so happens, is
a great deal lovelier than the hunchbacked bell-ringer Quasimodo's
physical ugliness replaced by the outré verse he presumably writes. In
terms of ethnicity, symbols of monetary exchange and the love of the

unconventional, Satine is a second-order displacement of the Roma: just as Kidman's paleness displaces the metaphorical blackness that displaces the Roma, the diamonds Satine celebrates displace the coin that, as Marx noted, displaces the material acts of production and exchange into the realms of fantasy and fetishism.

Tshembe's Paradox—manifested in theatricalized authenticity and performative exoticism—helps us better understand a critical period in the development of the avant-garde: the *cultural turn of the avant-garde*. This turn began almost immediately after Saint-Simon's coinage caught on, in the mid 1820s. That turn would be more or less complete by 1855, when the radical painter Gustave Courbet's 'Pavilion of Realism' flaunted aesthetic independence and ideological radicalism in the faces of the solid citizens enjoying the sights and sounds of the Universal Exposition. But, and this is no small qualification, the close of the cultural turn and the birth of painterly Realism happened just up the mall from the Colonial Exhibition, where all the 'goods' of colonialism, including gleaming black bodies, palm oil and exotic hardwoods could be contemplated in dazzling display. During the three decades that passed between Saint-Simon's death and Courbet's indy art show, the avant-garde underwent a signifi-cant change in character, transforming from an essentially technocratic and military concept to a more widespread and persistent model of arts activism. That this development should achieve its maturity just when European racism went global is a symptom of the complexity of racism and the strategies formulated by its opponents.

MAX NORDAU, *ENTARTE KUNST*, THE NEA FOUR AND THE PAST AND FUTURE OF AVANT-GARDE STUDIES

Scholars, teachers and historians are no less vulnerable to the ironies of Tshembe's Paradox and no less entangled in the history of race and racism than the avant-gardes they study. As I have shown, the avant-garde as both a subject of discourse and a form of radical cultural praxis, was, during its first decades, divided among three groups with very different motives, methods and languages to make sense of how activist minorities might substantially affect power relations in a given society. There were, first, those who deployed the concept as an utopian, organizational and technocratic lever to forward the cause of European modernity. Most prominent among these were the Saint-Simonians, whose work led to,

among other things, the Suez Canal, the English Channel tunnel and highly effective forms of colonial knowledge production in places like Algeria. Second, there were those who countered the tendentiously anti-democratic, technocratic tendencies of the utopians through diverse forms of racialized performance. Bohemian language, ways of thinking and styles of activism were radically different from the Saint-Simonians and their descendents. These were not technical elites by any means, though they did often claim to be culturally elite. They were members of subaltern multicultures who actualized a common sense of identity through gesture, fashion, cuisine, argot, displays of public affection and so on, often in overt rejection of the cult of expertise and the universalist pretensions of the academics and experts at the Écoles.

There was a third group, too, one that I have not discussed at any great length to this point, though they were a shadowy presence in my discussion of bohemia. This third group is not so much an avant-garde as an *anti* avant-garde, an authoritarian community whose theories and practices frame activist minorities, whether they be unruly subcultures at home (the bohemians and their ilk) or abroad (rebellious ethnic groups, for example), as an object to *control*. Related in function to the kind of instrumentalized ethnography used by the French colonial medical corps is the subfield of avant-garde studies which frames its subject primarily as a threat to civil, legal, military and epidemiological order. This is the avant-garde studies of cops, soldiers, up-and-coming politicians and security consultants. Unfortunately, though those who police and disrupt vanguards have deeply impacted the history of the avant-garde, they have received almost no attention from scholars and critics of the avant-garde.

That is not the case with the first two trends, of course, to which contemporary academic avant-garde studies can be easily traced. The first, utopian, technocratic tendency is the more obvious and fruitful. It gave rise to the disputatious, subtle and socially grounded debate in the 1920s among the Marxists Lukács, Adorno, Brecht and Benjamin. Antonio Gramsci's development of the concept of hegemony is also a highlight of the tendency. In the 1960s, this utopian, materialist and philosophically sophisticated tendency was further developed by writers who explored the tension between the utopian and the material in a fashion that was still, however attenuated it might appear, conscious of social class and political economy. Clement Greenberg and Daniel Bell were major figures in the neoliberal version of this tendency. One would also count Stuart Hall,

Hebdige and the other faculty at the UK's Birmingham School of Cultural Studies, the French journal *Tel Quel*, Kristeva, Foucault, Barthes et al.; and the critics involved with the art history journal *October*, including Foster and Krauss. Egbert, Bürger, Enzensberger, Lippard and Lauretis are sensibly situated within this line, too.

The second tendency, focusing on subaltern expression, has been no less influential, though its impact on the academic field of avant-garde studies came later and in a more roundabout fashion. The 'bohemian' tendency in academic avant-garde studies emerged in the 1960s and 70s in universities in New York City, Paris, Buenos Aires and other urban areas where one could find senior avant-gardists (whether established or impoverished), deeply rooted neighbourhood enclaves of radical, chic groups resisting the conditions of their minoritization and a robust and diverse cultural scene. In New York City in the 1950s, one found the tight, nomadic band of avant-gardists around Peggy Guggenheim; the far less well-off vanguard milieu of jazz musicians, communist poets, Garveyites and sign painters described so well by Lorenzo Thomas; the close-knit Greenwich Village bohemia, celebrating an astonishing half century of vanguard status; the remarkable academic nexus comprised of Columbia, New York University, the New School and the City College of New York; Modernist museums like the Guggenheim and the Museum of Modern Art; and of course, Harlem, still a Mecca for African America and the home of Malcolm X. New York City was by no means unique. During a period that saw tectonic shifts in the way that both the modern city and the modern university organize individuals and groups, knowledge and institutional development, the counter-cultural avant-garde enjoyed a rare level of cultural influence in urban centres around the world.

But those same urban centres were also crucibles for the methods that could discipline, manage and subvert the avant-garde. What are the connections between avant-garde studies, with its emphasis on radical art, dissident aesthetics and a wilful disregard for institutional and cultural authority and the patently authoritarian discourses of policing (whether beneficient or authoritarian), applied criminology, colonial management and counterinsurgency?

We can begin with one person and one very popular book. Though the police had monitored dissident cultural and political groups long before he arrived on the scene—as evidenced by the many sumptuary laws concerning the Roma-style ghettoization of immigrants and political

radicals and the attentive monitoring by police and priests of the saloons and garrets where artists hung about—the field of criminology became a proper science only with the publication of Cesare Lombroso's pioneering works of the 1890s. Lombroso was a positivist; his theory of crime assumed that criminality was neither a consequence of social and economic factors nor an essential aspect of human nature but, rather, an inherited defect, most commonly found among 'inferior' races like the Roma who supposedly displayed specifiable, identifiable physiological defects that reflected an essential criminality. Reflecting the Saint-Simonian roots of his activist, socially minded approach to the human sciences, Lombroso's theory of the 'criminal man' (the title of his groundbreaking 1895 book) not only detailed what he saw as a biological and cultural threat to social order, not only specified the methods that could effectively respond to that threat but also argued for the development of an elite force of scientists to lead the fight. Lombroso's racist criminology was backed by other cutting-edge researchers in racist 'science', including B. A. Morel, who tweaked Jean-Baptiste Lamarck's theory of acquired characteristics to argue that certain groups of people were evolutionary 'degenerates' (Morel is usually credited with coining the term 'degeneration'). There is also the criminologist Rafael Salillas, who, according to Lou Charnon-Deutsch, considered ethnic groups such as the Roma, 'by nature and occupation, [. . .] more akin to the delinquent than to the normal elements of society' (2002: 25).

Though Lombroso's theory of criminality has been discredited for some time now (not only for its racism but also for its inability to account for the environmental and social causes of crime), he and his followers established anthropological criminology as a current scientific field and developed methods still in use today, including the use of phenotypical markers to identify criminals, both actual and potential—among which is the phenomenon popularly known as 'racial profiling'. While tracking criminals by the shape of the skull or face (Lombroso was a pioneer in phrenology, too) may be out of fashion, so-called behavioural profiling which involves harassing those who wear a certain kind of clothing, flash certain gestures or engage in certain leisure pursuits is still accepted practice among police and soldiers. Such profiling, which recalls not just Lombroso but also the epidemiological methods of the French medical corps, is not an aberration but integral to criminology.[10] I shall return to the subject of 'behavioural profiling' again.

But Lombroso is not the pioneer who helped us understand the relationship between the police and the professor. That credit belongs to another, a man who worshipped Lombroso. This leads to a curious point: among the many ironies of the field of avant-garde studies is that the first book to survey and theorize the cultural avant-gardes—and one of its few bestsellers—was written by a man who despised vanguard art. Max Nordau's *Degeneration* is 'dedicated to the Italian criminologist 'in open and joyful recognition of the fact that without [his] labors it could never have been written' (1968: vii). Extending Lombroso's assertion that artistic genius is a form of biological degeneration, Nordau writes,

> Degenerates are not always criminals, prostitutes, anarchists, and pronounced lunatics; they are often authors and artists. These, however, manifest the same mental characteristics, and for the most part the same somatic features, as the members of the [. . .] anthropological family who satisfy their unhealthy impulses with the knife of the assassin or the bomb of the dynamiter, instead of with pen and pencil (ibid.).

His book is a veritable catalogue of *fin-de-siècle* cultural dissent, with chapters covering every major tendency on the European scene at the time, including the Pre-Raphaelites, Symbolists, Tolstoy addicts, the Richard Wagner cult, the Parnassians and Diabolists, Decadents and Aesthetes, Ibsen devotees and wannabes, avid readers of Nietzsche and Zola and the acidic Naturalists who followed in their wake. With this book, avidly read by anxious bourgeois parents, ambitious bureaucrats and police inspectors alike, Nordau cemented the connections between dissident cultural producers and racialized minorities and provided 'scientific' justification for the harassment of cultural activists.

The perennial association of the Roma and the bohemian served Nordau well. For Lombroso, 'Bohemians' (that is, the Roma) were the very emblem of the degenerate racial group. For Nordau, the 'bohemians' (that is, the urban counter-cultures of modern Europe), were the very apotheosis of degenerate culture. Culture, for Nordau was a biological matter, which is why he preferred not to use the term *fin-de-siècle*; the proper term would be, he writes, '*fin-de-race*' (ibid.: 2).

There are important differences between Lombroso and Nordau. Nordau's emphasis on culture reflects an understanding of race that is less essentialist than Lombroso's. That is not all that surprising—Nordau was

a Jew, if a thoroughly assimilated one, all too familiar with the anti-Semites of Budapest and Berlin. Though he would not become an advocate for the Jewish community until after the Dreyfus affair broke out—at which point he would become a leader of the Zionist movement second only in influence to Theodor Herzl—he knew all the 'scientific' justifications developed to support anti-Semitic legislation and excuse hate crimes against Jews. His divergence from Lombroso also stemmed from an interest in individual physiology and the belief that degeneracy was primarily an *epidemiological* as opposed to an anthropological problem, one that could be fought like a disease.

But though he rejected the overtly racist arguments of Lombroso, he also did not accept the strictly environmental arguments favoured by others. As George L. Mosse summarizes it, Nordau only partly accepted Morel's argument that degeneracy was caused by environmental toxins such as drugs and industrial byproducts damaging the nervous systems of urban dwellers (Mosse 1992). Nordau took culture seriously. The invidious effects of the modern city were exacerbated by self-proclaimed 'avant-garde' art and literature, the ubiquitous bohemianism of youth culture and the radical chic favoured by the *haute bourgeoisie*. Nordau writes, 'In an industrial society, not only does the individual have no time to assimilate new discoveries but these discoveries themselves make increasing demands on his labour. Above all residence in large towns leads to nervous excitement' (Nordau 1968: xxi). This, in turn, leads young people to adopt 'a compound of feverish restlessness and blunted discouragement, of fearful presage and hangdog renunciation', weakening them against the allure of those who are constitutionally averse to discipline and modesty and ignorant of the virtues enabled by the collective struggle for the progress of civilization—namely, the avant-garde (ibid.: 2, 5). Fatigue and bad company, two more links in the epidemiological chain, lead young, white Europeans to incessantly crave 'novel sensations', and avant-garde painters, poets and other so-called artists are on hand to offer just the thing. The consequence of this vicious cycle is that not only do individuals suffer from degeneration but the larger society degrades too. Those who have the talent and drive to produce culture, those who should be guiding European civilization towards higher things, instead 'crowd into a suburban circus, the loft of a back tenement, a second-hand costumier's shop, or a fantastic artists' restaurant, where the performances, in some room consecrated to beery potations, bring together the greasy *habitué* and the

dainty aristocratic fledgling' (ibid.: 15). Degeneration, as Mosse summarizes it, is 'caused by [. . .] a mixture of clinical, social, and moral factors [. . .] a certain lifestyle rather than simply as a bodily disease—a lifestyle which, by the 1890s, had become visible, practiced by men and women who were not afraid to call themselves decadent' (1992: 566). For Nordau, degeneration and its amelioration are primarily a cultural matter.

Culture had to be brought under control the way that disease had been brought under control. The bohemians were becoming too bold in their affronts to the solid citizen. The Paris Commune, the apotheosis of bohemia's 'critique of everyday life', had convinced many that a revolution in everyday life was the best answer to the greed and authoritarianism of the modern state. Courbet's participation in the toppling of the Vendôme Column was indisputable evidence of the threat posed by avant-garde artists to common sense, social order and European progress. But even more dangerous were the petty rebellions that could be witnessed everyday on the streets of Paris, Nordau's home town. Nordau knew those streets well. Though it is difficult to imagine him on the same avenues as the bohemians, the *haute bourgeoisie* and the demimonde or to picture him sitting in cafes eavesdropping on the disputations of Post-Impressionists and scurrilous teenage poets, he was there nonetheless, taking detailed notes. Against the rising tide of everday rebellion, Nordau calls for attention to be paid, by all levels of society, to the lifestyles of those especially susceptible to the siren's call of the avant-garde. To heal those who had succumbed to degeneration and to prevent further cases, he prescribes a return to the 'flexible and ductile' forms of classical Greek art, greater authoritarianism, increased concern for the social lives of 'nervous' and solitude-seeking young people followed by a robust programme of physical exercise and international cooperation to assist the 'inexorable fate' of those 'whose mental derangement is too deep-seated'; in other words, hurry them along towards death (Nordau 1968: 551). 'This book is obviously not written for them,' he continues, but *about* them, because they show 'the disease of the age "to its anatomical necessity" (to use the excellent expression of German medical science), and to this end every effort must be directed' (ibid.).

The majority of those who work in the field of avant-garde studies would certainly not support the idea that the ultimate goal of avant-garde studies is to provide scientific justification for denying artists their right of expression, for forcing kids to march through the countryside

and euthanizing holdouts. However, it has attracted its fair share. In addition to the thousands who purchased Nordau's book when it was first published, there were those who attended 'the century's most highly attended exhibition of advanced art' (Altshuler 1994: 136). From 19 July to 30 November 1937, over two million people visited the *Entarte Kunst* (Exhibition of Degenerate Art) in Munich, organized by the Nazis to give clear and alarming proof of the damaging effects of 'decades of cultural decadence', as the exhibition pamphlet explained to visitors, most of whom had never seen art like it (quoted in ibid.: 126). The attack on the artistic avant-gardes by the National Socialists reflected, as Bruce Altshuler puts it, the fact that Hitler, a 'spurned painter, took art very seriously, and Nazi functionaries followed his lead in creating an elaborate bureaucratic apparatus for its control' (ibid.). English art critic Herbert Read was probably not the only Modernist artist to feel guilty pleasure upon hearing that the leader of an advanced industrial nation had spoken for almost two hours about the role of art in the creation of a powerful nation—as Hitler had at the opening of the Haus der Deutschen Kunst, the first major building project of the Nazi regime.

Nordau's racist theory of art and culture and his prescription for combating degeneracy were the foundations of *Entarte Kunst*. Though the exhibition was assembled hastily, it was well prepared for by a series of attacks launched against critical-cultural producers and the German multiculture. The campaign began with Wilhelm Frick's address, 'Against Negro Culture—For Our German Heritage' in 1930. This is no footnote of Nazi history; Frick was the first Nazi to be appointed to high office in Germany. Close on the heels of Frick's pronouncement, the German legislature passed a general ban on 'subversive' and 'degenerate' cinema, theatre, performance and music. The Bauhaus, the legendary Modernist school, saw its 29 faculty members summarily ejected and the Modernist murals painted in the stairwells whitewashed. Degenerate art exhibitions were held across Germany for the next six years, though none compared to the Munich show in scale or in popular success. Thus, it was on the cultural front that the Nazis banked the coals of the Holocaust.

Nordau's racist theory of the avant-garde inspired the cultural ransacking of German modernity. The show's curator, painter Adolf Ziegler, and his staff pillaged museums and galleries across Germany, assembling, by Altshuler's estimate, 16,000 works by 1,400 artists (ibid.: 140). In addition to those by German artists like Emile Nolde, Käthe

Kollwitz, Karl Schmidt-Rottluff, Ernst Ludwig Kirchner, Otto Dix and Oskar Schlemmer, paintings, drawings, prints and sculptures by non-Germans such as Georges Braque, Paul Gauguin, Vincent van Gogh, Ferdinand Léger, Max Ernst, James Ensor and others were crammed onto walls and display cases. The galleries were festooned with 'graffiti' which mimicked the fonts and style found in avant-garde art journals of the time: (see Image 2.7) 'Insolent mockery of the Divine under Centrist rule', 'An insult to German womanhood', 'The ideal—cretin and whore', 'The Jewish longing for the wilderness reveals itself—in Germany the Negro becomes the racial ideal of a degenerate art' (see Barron 1991: 46). After the exhibition closed, the pillaged works were added to the private collections of Nazi bigwigs, though far more were sold for desperately needed foreign currency. Tragically, most were destroyed; the burning of over 1,000 paintings and 3,000 paperworks provided a fragrant counterpoint to the pyres of banned literature ignited across the country four years earlier (Altshuler 1994: 146–7). The year after the Munich show, the attention of those in the Haus der Deutschen Kunst turned to degenerate music (see Image 2.8) and the fires of the Holocaust were further stoked.

Though I do not mean to imply that the US Congressmen who attempted to destroy the National Endowment for the Arts (NEA) in the

IMAGE 2.7 Hitler and entourage tour the Degenerate Art Show (1937).

1990s and, with it, an increasingly visible queer art scene were genocidal maniacs (though I am sure more than a few readers will be perfectly happy with the comparison), they shared with both Nordau and the Nationalist Socialists assumptions about how art best serves the nation; about the threat to bedrock cultural values posed by leftists, homosexuals, multiculturalists and dissident artists (particularly performance artists); and about

IMAGE 2.8 Degenerate music poster.

the instruments of the modern state that might be effectively turned against the dismal tide. The decision in 1990 by NEA Chair John Frohnmayer to veto the funding of performance artists Karen Finley, John Fleck, Holly Hughes and Tim Miller (the so-called NEA Four) was part of a systematic campaign to bring both the agency and other publicly supported cultural outlets (such as public radio and television) under the control of cultural conservatives. Already embroiled in controversy for giving money to edge-bending artists like Robert Mapplethorpe, Andres Serrano and Robert Clark Young, the NEA was vulnerable to attack. But Frohnmayer's decision was not just an effort to censor certain kinds of subject matter: it was also an overt (and applauded) attack on the distinctly queer avant-garde that had emerged out of the AIDS crisis and among the so-called tenured radicals in university art departments who had managed to take over part of the state's cultural bureaucracy. The NEA's stated mission is 'to enrich our Nation and its diverse cultural heritage by supporting works of artistic excellence, advancing learning in the arts and strengthening the arts in communities throughout the country'.[11] But, believing that this mission was not being ful-filled—in fact, was being undermined by the radicals embedded in its com-mittees—ultra-right-wing North Carolina Senator Jesse Helms led the charge against the NEA, the most injurious effect of which was reducing its funding almost by half in 1996 and banning funding for individual artists. Pat Buchanan's primetime speech at the 1992 Republican National Convention would have been enthusiastically applauded by Nordau and Frick alike. Buchanan declared the moment ripe for 'a cultural war, as crit-ical to the kind of nation we will one day be, as was the Cold War itself' (quoted in Chapman 2010: 56).

English novelist Israel Zangwill was right: 'Whenever art goes crazy and letters lose touch with life, men will remember the prophet of *Degeneration*' (quoted in Nordau 1968: xv). Scholars of the avant-garde can remember Nordau to their benefit too—his influence is not only apparent among the fanatics of the Right. Indeed, it is ubiquitous to the field of avant-garde studies. Of course, there are few in the field who feel any sym-pathy with Nordau's paternalistic, phobic attitudes towards rebellious expression. The postmodernist, materialist, identity-based approaches that have revolutionized the field of avant-garde studies since the early 1970s are, in fact, explicitly posed against them. But there is a wicked irony lurk-ing in our field's efforts to defend critical art from right-wing fanatics and purblind formalism.

How so? For one, the methodologies that dominate avant-garde studies today recapitulate those used in *Degeneration*. Their scepticism, for example, towards what Lyotard calls 'metanarratives', those conventionally held stories that give coherence to history, stories that provide to the communities that tell them a way to mold events into shapely, generally self-serving narratives (1984). Before he gets to the degenerates—indeed, in the first pages of his book—Nordau expresses his contempt for the term *fin-de-siècle*, a word that 'has flown from one hemisphere to the other, and found its way into all civilized languages'. He judges it a rank absurdity 'only the brain of a child or of a savage could form', a 'childish anthropomorphism or zoomorphism' that refuses to recognize 'that the arbitrary division of time, rolling very continuously along, is not identical amongst all civilized beings' (Nordau 1968: 1–2). He cites the Islamic calendar as the most obvious refutation of the decadents' Eurocentric tendency to 'project externally its own subjective state' (ibid.).

In addition to scepticism towards metanarratives, Nordau condemns formalism. As opposed to the aestheticist critics of his day, he refuses to consider the artwork itself as the end of analysis. Like any good cultural studies scholar, he uses the artwork as a kind of lens through which sociological, geographical and political contexts might be spied, the generative conditions in which the art created thereby brought into sharper focus. Nordau would likely applaud our efforts to take interdisciplinary approaches to the avant-garde. Like us, Nordau viewed the avant-garde as a complex reaction within modernity which challenges the conventional categories of social, political and cultural analysis. Though he does not use the terms 'transnationalist' or 'intercultural', Nordau agrees with us that any effort to understand the avant-garde's challenge can succeed only if it is aware of the unprecedented conditions of cultural knowledge enabled by industrial colonialism. Industrial modernization enables one, if he 'but read his paper, [. . . to] take part [in] a continuous and receptive curiosity' that enables the consideration, in rapid juxtaposition, of 'a revolution in Chili, in a bush war in East Africa, a massacre in North China, a famine in Russia, a street row in Spain, and an international exhibition in North America' (ibid.: 39). The avant-garde is the monster born from the marriage of local fatigue and transnational exchange networks.

Like Judith Butler, attenders of drag balls, aficionados of certain kinds of performance art and many of those who advocate performance studies, Nordau believed that the avant-garde's most profound threat to

social order concerned the body. Nordau's theory of degeneration was intended, first and foremost, to battle the various mental and emotional side effects of rapid industrialization as well as the nervous disorders of the European bourgeoisie who managed it. To diagnose those ills, which affected both the individual and the society, Nordau often focuses on the the body, especially the performing body or body-on-display. Nordau trained himself to be as keen-eyed an observer of cultural performance as any student of the Frankfurt School, the Birmingham Center or the New York University Performance Studies programme. He attended varnishing days in all the European capitals and insinuated himself into the most fashionable salons and déclassé watering holes. His book is replete with vivid descriptions of edgy fashion and its milieu—the street, the home (Nordau is consistently attentive to interior design), the pages of journals. Performance is a kind of symptomology to him; it is a mark of their degeneration that degenerates 'strive visibly by some singularity in outline, set, cut, or color to startle attention violently and imperiously to detain it [. . .] to produce an effect at any price' (ibid.: 9–10). In his efforts to learn about those effects, Nordau shares with Butler et al. a belief in the power of performance to challenge power. And all understand the value of a certain kind of 'behavioural profiling', the detailed description of actions and contexts in order to comprehend the politics of performance.

In *Fascist Modernism: Aesthetics, Politics and the Avant-garde* (1996), Andrew Hewitt raises some tough questions about how scholars and critics in the humanities make sense of the politics of art and culture. He does this as part of an extended discussion of Benjamin's assertion that fascism puts into effect an 'aestheticization of political life'. Through their efforts to transcend the 'petty' issues of class inequity and the endemic crises of capitalism, fascists rely on an essentially aesthetic concept of racial purity and destiny to unify white people (Benjamin 1968). This puts the struggle against fascism on treacherous terrain. Hewitt observes that 'not only does fascism introduce the mechanisms of aesthetic control historically into the public and political realm', it 'likewise obliges political analysis to borrow its terminology from aesthetics' (1996: 68). Benjamin urges against the aestheticization of politics—the falsification of politics—and for the politiciziation of art. Scholars and critics have rallied to that call, especially in performance studies. A critic with a penchant for behavioural profiling can politicize aesthetics by juxtaposing the dress and speech patterns of a Second World War-era female ship-building foreman, the

robes and wigs of a British Lord Justice, the dances of a Havana carnival, a tourist performance by Maasai warriors in Kenya, a gathering of elderly people to tell stories in a Polish village, a Postmodernist staging of an Ibsen play and a car advertisement featuring an American football coach—as Schechner does in his *Performance Studies: An Introduction* (2002b: 143–5, 24).

While this kind of intellectual motility is an exciting and laudable development (and I do not doubt he knows a lot about all the things in that list), I would disagree with Schechner that the solubility of a term such as 'performance' is evidence of 'an increasingly performative world' (ibid.: 4). Likewise, I would resist Jon McKenzie's similar argument that the virtually ubiquitous concern with performance at the turn of the twentieth century—that is, efficiency, productivity, quantifiable activity and entertainment demographics—is the mark of an emergent and unprecedented 'onto-historical formation of power and knowledge' (2001: 18).

No, it started long before that. The rise of performance studies and the performance paradigm were set into motion more than a century ago, during the *fin-de-siècle*. They originated in a culture in which racialist conceptions of identity, power, morality and history were ubiquitous. It was in the whites-only salons and lecture halls of racialist Europe that one witnessed the invention of 'aesthetic taxonomies', a method of assessing identity by way of visible markers, usually biological but also (as in the work of Nordau) sartorial and behavioural. The first widespread application of such taxonomies came under the banner of 'decadence', a term commonly held as synonymous with 'degeneration', a term used by both Right and Left. Rather than being a post-racist development—as implied by both Schechner and McKenzie—the performance paradigm is a creature of European racism.

In his historical survey of the term 'decadence'—a notion with close, if complex relations to the term 'avant-garde'—Matei Calinescu shows how that term, in use for centuries, was given a peculiarly Modernist twist once it became a generally accepted notion that 'a historical period [. . .] should be perceived as a "totality", and that sociopolitical phenomena and artistic manifestations are organically interrelated' (1987: 159). By the late 1800s, this was conventional wisdom, thanks to the diligent work of the Saint-Simonians and the street-level gains of the cultural avant-garde. For intellectuals, pundits and advisers on both Left and Right, aesthetics was a kind of philosopher's stone of history, a solvent concept and

an arbiter of moral virtue and social justice. No doubt, the *fin-de-siècle* vanguards were 'conscious promoters of an aesthetic modernity that was, in spite of all its ambiguities, radically opposed to the other, essentially bourgeois, modernity with its promises of indefinite progress, democracy, generalized sharing of the "comforts of civilization", etc.' (Nordau 1968: 162). This was a valid, effective response to the deployment of neoclassical aesthetics by authorities who classified different groups along racial lines, including the 'degenerate' artists and their hang-about milieu. They did this, of course, to retain their power during a volatile moment in social history, a moment that demanded broad gestures to attract the bourgeoisie. One racist of the time, Victor Courtet de L'Isle, did his part by convincing others that one ought to compare 'how close the faces of each [racial] type approximated the Greek statues of Apollo' (see Frederickson 2002: 67–8) (see Image 2.9). In contrast, the 'degenerates' embraced an aesthetic of deformation, freakishness, ugliness and the most etiolated obliquity.

However, if the European cultural Left confronted and rejected a neoclassical aesthetic deployed to justify the superiority of white people, it did not challenge two other ideas:

(1) the fate of Europe depended on the right kind of aesthetic perception and judgement;

(2) the shape of history was most visible in the way that art was created and received.

Indeed, the nineteenth-century art vanguards by and large held both as basic principles of faith. With all due respect to Benjamin, the aestheticization of politics was not the invention of Nazis but of a community that shared little ideologically except a common belief in the virtue and historical significance of aesthetic production. This community included not only nineteenth-century racists defending imperialism and patriarchal entitlements but also bohemians embracing the performative possibility of ontological Otherness and aesthetes tracing European civilization's collapse in the nuances of an Alexandrine or the subtle lighting effects of an allegorical painting. Left-wing artists and cultural activists shared with their enemies a belief that aesthetic expression was implicated profoundly in the power dynamics of the modern state and that the struggle over aesthetic understandings and authority was the most effective way to interrogate and, ultimately, challenge unjust political authority. And the metaphor that governed all of this was race.

FIG. 339. — Apollo Belvidere.[533]

FIG. 340.[556]

Greek.

FIG. 341. — Negro.[554]

FIG. 342.[357]

Creole Negro.

FIG. 343. — Young Chimpanzee.[555]

FIG. 344.[558]

Young Chimpanzee.

(458)

IMAGE 2.9 Victor Courtet de L'Isle: 'How close the faces of each type approximated the Greek statues of Apollo.' Courtesy: The British Library, London.

As Hewitt describes it, avant-garde studies as it currently operates—that is to say, as a branch of fine arts, theatre and performance and literary scholarship—presumes, above all else, that the most incisive critical perspective comes from work that 'straddles [. . .] political and aesthetic discourses', and in some sense requires that ambivalent position 'to assess the importance of [. . .] our contemporary critical position vis-à-vis the avant-garde' (1996: 69). Dance historian and theorist Frédéric Pouillaude would agree with Hewitt, seeing little benefit to the either/or approach to the question of art's relationship to its time and place. Pouillaude wonders if there's another way for scholars to work out the choice between, on the one hand, viewing the artwork as a symptom of the zeitgeist (even, as with Lyotard, we understand it as no more than a representation of 'the impossibility of figuration [. . .] the fact that there is an unrepresentable') and, on the other, renouncing the notion that art has any power to speak to the history and actuality of power, seeing the 'abandonment or fading of its historical task' as evidence that we should turn instead to 'the crude exhibition of its factual and socio-economic functioning' (Pouillaude 2007: 126). Though Pouillaude does not invoke the racialist origins of the problem, his efforts to find another way of representing the politics of art is germane to thinking of the avant-garde in an authentically post-racist way.

THREE ALTERNATIVES TO A RACIST THEORY OF THE AVANT-GARDE

Bürger's litmus test may provide some help in this matter. If an avant-garde must both thematize (that is, make it a subject) and engage with its own enabling social and material conditions (that is, the institutions that keep it alive), then the effort to extricate the avant-garde from race and racism must marry theoretical critique with institutional consciousness. As I have discussed in the Introduction, the need to attend to the institutional bases of critical activity is not just a matter for artists but also for scholars. The power of vanguard expression—whether a dance, a building, a film or a poem—is, in part, its capacity to bring the relationship between form and function into its institutional contexts without renouncing the unique, imaginative power of art. Not only can art make us conscious of the 'reality of the device' (to recall Hansberry again) but provide *another* reality and *another* device, one that does not renounce identity and community but does not give in to the fetishistic temptations of xenophobia either.

How might scholars follow artists in this effort? For one, they need to deliberate carefully on the lines between avant-garde art and scholarship, a line that has been challenged in diverse ways over the last few decades, including by those many scholars who are artists. In the conclusion to this chapter, I will discuss three recent examples of anti-racist critical-creative performance: the 1992 performance provocation, commonly referred to as *The Couple in the Cage*, by Coco Fusco and Guillermo Gómez-Peña; some recent work by the European art-intervention collective WochenKlausur; and the collaboration between performance studies pioneer Dwight Conquergood and members of the Hmong ethnic group in Chicago and in the refugee camp at Ban Vinai in Thailand. These performances challenge racist power not only in direct and overt ways but, by dissolving conventional distinctions between avant-garde art and scholarship, they also highlight and challenge the institutional structures in which they work. As a consequence, they each suggest ways in which the racialist foundations of avant-garde studies might be more effectively assessed and addressed.

1. Coco Fusco, Guillermo Gómez-Peña and Two Undiscovered Amerindians

The Latina/o performance artists Fusco and Gómez-Peña have staged, both together and separately, works that uncover and volatilize the historical, social and aesthetic connections between cultural institutions and racism. They call themselves 'border artists', not only to identify their specific cross-border identities (Fusco is Cuban American, Gómez-Peña Mexican American) but also because they create art that crosses disciplinary, media and geopolitical boundaries in an effort to highlight issues of identity, location, racialization, sexuality, finance and power. Especially germane to a discussion of race and the avant-garde, their work also crosses the borderlands between art and critical scholarship and does so in a fashion that emphasizes their ambiguous position vis-à-vis the field of avant-garde studies. This was the case with the piece they composed and executed in 1992 in response to the five hundredth anniversary of Columbus' arrival in the Americas. At art and natural history museums in London, Minneapolis, Washington DC, Chicago, Irvine, New York City, Madrid and Buenos Aires, visitors encountered Fusco and Gómez-Peña inside a large golden cage, the artists dressed in grass skirts, feathers and bones and sunglasses. A sign explained that they were 'Guatinauis', an indigenous people from an undiscovered island in the Gulf of Mexico (see

IMAGE 2.10 Coco Fusco and Guillermo Gómez-Peña, dressed as 'two undiscovered Amerindians', pose with a visitor at a Madrid performance (1992). Photograph by Nancy Lytle. Courtesy: Coco Fusco.

Image 2.10). During the course of the day, the two performed 'traditional tasks', including lifting weights, sewing voodoo dolls, watching TV and working on a notebook computer. They were fed through the bars and a guard would lead them on a leash to the bathroom when need be. A box was positioned in front of the cage with a sign which explained that, for a small donation, the female would dance to hip-hop music, the male would tell stories in the Guatinaui language or they would pose for pictures with the visitors. At the Whitney Biennial, an additional choice was added: for $5, the visitor could peek at the male's genitalia.

Of course, this was all a joke, a serious one intended to restore to public view the shared history between art and natural history museums and the tradition of displaying abnormal and non-European people. As Fusco explains, by 'performing the identity of an Other for a white audience, sensing its implications for [. . .] performance artists dealing with cultural identity in the present [. . .]' they could 'unleas[h] those ghosts from a history that could be said to be ours'; specifically, the history of intercultural performance art, an art form intertwined with the 'ethnographic exhibition of human beings that has taken place in the West over the past five centuries' (1995: 37).

But beyond restoring institutional history, Fusco and Gómez-Peña had other goals: their interest in restoring this dimension of history to the institutions of cultural and aesthetic preservation and education was part of an effort to create 'a strategically effective way to examine the limits of the "happy multiculturalism" that reigned in cultural institutions [. . .] as well as to respond to the formalists and cultural relativists who reject the proposition that racial difference is absolutely fundamental to aesthetic interpretation' (ibid.: 39). Addressing simultaneously the oppressive history of the institutions that support their work and, just as importantly, the assumptions of those who claim to have moved beyond that history, *The Couple in the Cage* installed a profound and volatile irony in the presumptive certainties of postmodern theory and progressive curatorial practice. Fusco and Gómez-Peña demonstrate how, in the absence of historical consciousness and attention to the heated desire that circulates between viewers and the things they view, even progressive art institutions and art history can play into the hands of racism.

However, a number of issues emerged unexpectedly from their performance. First, they were astonished to discover that more than half of the visitors honestly believed they were seeing 'two undiscovered Amerindians': 'We did not anticipate that our self-conscious commentary on this practice could be believable. We underestimated public faith in museums as bastions of truth, and institutional investment in that role' (ibid.: 50). But that sort of literalism was not just the sin of ignorant visitors easily fooled by beads, body paint and official-looking signage. Their identities as artists were, in subtle ways, essentialized. As Fusco notes, while performing at New York City's Whitney Museum of American Art, they 'experienced the art world equivalent of such misperceptions: some visitors assumed that [they] were not the artists but rather actors who had been hired by another artist' (ibid.). Fusco believes that this was due, in part, to the fact that they were identifiable as 'artists of color', an identification compounded by the persistent prejudice against performers— whether actors, singers or performance artists as such—who, on the whole, have been marginalized by scholars and historians.

Compounding this misrecognition, docents insisted on intervening in the experience of visitors to 'didactically correct audience misinterpretation' (ibid.). Fusco and Gómez-Peña were especially concerned with the actions of the docents, which they feel undermined the interactive nature of the piece and the kinds of artist–audience communication that might

have called into question the authority of artists, critics and museum authorities—or, at the very least, provided food for thought. Recalling the value of the kind of face-to-face contact that gave life to the Surrealist Atlantic and doomed the Afrikaner Broederbond, Fusco writes, 'The literalism governing American thought complements the liberal belief that we can eliminate racism through didactic correctives; it also encourages resistance to the idea that conscious methods may not transform unconscious structures of belief' (ibid.: 54). While they do not by any means 'solve' this problem, Fusco and Gómez-Peña discovered the perfect method to manifest those unconscious structures in the squares and museums of major world capitals.

2. WochenKlausur and the Anti-aesthetic of Social Intervention

A very different way of addressing racism while, at the same time, sustaining a palpable politics relative to the embedded racism of art and its institutions has been assayed by the art activists known as WochenKlausur (WK). WK member Pascale Jeannée explains, 'develops and realizes proposals—small-scale but very concrete—for improving sociopolitical deficits' (2001: 7). By 2007, the group had developed 23 projects of this sort, from providing medical care to homeless people in Austria (Vienna Secession, 1993) to creating links between experts in various fields and students at schools across Japan (Museum City Project, 1999) to the construction of three small pavilions in Nuremberg, Erlangen and Fürth, Germany, to provide opportunities for political parties—whose disagreements had become supercharged by media coverage—to sit and work through their issues in a more objective, emotionally neutral way (Institut für moderne Kunst, Nuremberg, 2000). The prerequisite for every WK project is the invitation of an art institution, 'which provides WK with an infrastructural framework and cultural capital' (ibid.: 8). The time span of the intervention is 'the normal time span of an exhibition', including the development, realization and sustenance of 'a small but concrete measure' to improve some form of 'sociopolitical deficit' (ibid.). Organizers Wolfgangg Zinggl, Stefania Pitscheider, Katharina Lenz and Pascale Jeanée believe that 'artists' competence in finding creative solutions, traditionally utilized in shaping materials, can just as well be applied in all areas of society: in ecology, education, and city planning'. To them, 'there is no difference between artists who do their best to paint pictures and those who do their best to solve social problems with clearly fixed boundaries' (ibid.: 7).

WK is heir to the anti-art tendency of the twentieth-century avant-garde, presuming neither that the creation of art objects is necessary, nor that aesthetic perception as such is particularly important to the identification and solution of social ills. Zinggl, for one, sees WK as continuing the work (Saint-Simonian in inspiration) of politically engaged artists who believed that the most politically engaged art was art that worked, that had a function—for example, Soviet Constructivism, the Bauhaus, the Situationist International, the countless demonstrations of the 1960s, Joseph Beuys' concept of the Social Plastic and Karl Staeck's agitation-propaganda posters. He also links WK to less utilitarian tendencies in art, including Viennese Actionism and Neo-Dadaism, which emphasized the breaking of taboos and the achievement of social catharsis through performance. And, finally, he views WK as continuing the work of social movements such as feminism and educational activism whose primary goals are political and economic (Zinggl 2001).

WK works under the presumption that all art institutions are inherently conservative because of their inability to abandon the idea of the intrinsic value of aesthetic creation, to abandon 'the mastery of craftsmanship, a universal ideal of beauty, and the material art object' (ibid.: 129). In terms of the latter, WK's interventions are best understood as following through on efforts to invalidate the art object that one associates with Duchamp's 'Readymades', certain artists in the Fluxus and Happenings communities, and Conceptual Art (ibid.: 15).

Their simultaneous critique of the art object, art institutions and aesthetics is particularly relevant to WK's efforts to address forms of xenophobia. In 1995, the group exploited a loophole in Austria's patently exclusionary and demeaning employment and immigration laws. Noting the exception provided to those who could make claims to being artists, WK commissioned seven immigrants to produce forms of socially engaged art, thus assuring them legal residency. A year later, WK intervened to improve conditions for inmates detained pending deportation at the notorious Salzburg Police Detention Centre. As part of the 1999 Venice Biennalle, the group set up eight language schools for refugees in Macedonia and Kosovo. However, as successful as these projects may be, notwithstanding the theoretical validity of their critique of the institutions and assumptions of art, they remain open to the charge that, in their efforts to have done away with aesthetics, they have forgotten the often-times crucial role that representations play in people's attitudes towards

'others'. In response, WK has developed projects that intervene directly in representational politics. In 2003, they constructed a show at Sweden's Dunkers Kulturhus which, reminiscent of the 'reverse ethnography' practised by the Surrealists and James Clifford, 'focused on the dominance of the bourgeoisie in Helsingborg's cultural life, which leaves few opportunities for the wide diversity of cultural currents outside of the bourgeois norm to interact with the public'.[12] And with the invitation of e v+ a Bienniale in Limerick, Ireland, they implemented the Belltable Open in 2006 at a cinema specializing in films for Ireland's ethnic minorities.[13]

Another criticism is that, though it effectively erases the lines between art and sociopolitical activism, WK's work challenges neither the elite status of the art institutions that fund their work nor some patently Eurocentric notions of art and artists. Indeed, Zinggl freely admits that they depend on the 'mythos of art' and a concept of the artist that views him or her as essentially different from non-artists—his discussion of the 'psychology of the artist' and 'the abilities that differentiate him or her from others' dithers between 'basal causes' and the essential allure of art to 'unconventional minds and non-conformist[s]' (2001b: 133). Thus, for all of its rigorous theorization concerning the validity of representational art and its concrete achievements in improving social conditions, WK is finally dependent on institutions and identities bound to forms of aesthetic authority and essentialism, forms that are themselves entangled with the aesthetics and politics of race and racism. The imbrication of racism and aesthetic radicalism does not disappear in the WochenKlausur critique, but its economic and institutional dimensions are revealed and engaged.

3. Dwight Conquergood, the Hmong and Health Theatre at Ban Vinai

An equally incisive intervention into the sociopolitical realities of racialized power, one that not only altered the very institutions and practices that enabled the intervention but also sustained a commitment to the function and value of aesthetic representation, was developed and implemented by performance studies' pioneer Dwight Conquergood. Conquergood's take on performance studies was informed less by the history of avant-garde theatre and performance than by what he called in 1989 the 'performative turn in anthropology'. As he summarizes it, this turn began with the waning of positivism and the general rejection of 'dualisms and dichotomies such as subject–object and structure–function'

(ibid.: 82). The recognition that culture is 'an active verb, not a noun' (ibid.: 83) led, first, to a shift in focus towards performance and the performative dimensions of social life. Subsequently,

> [this] shift from thinking about performance as an act of culture to thinking about performance as an agency of culture has prompted a reflexive turning back upon the conduct of inquiry itself. Now, ethnographic research, the 'doing of anthropology', is discussed as performance. The progression from focusing on performance as a context-specific event to performance as a lens and method for conducting research has promoted a vigorous critique of research presuppositions, methodologies, and forms of scholarly representation (ibid.).

Mirroring the critical tendency in ethnography developed around the Surrealists in the 1920s and 30s, Conquergood presumes that 'the conduct of ethnographic research is absolutely embedded in power and authority' (ibid.: 84). Further, following Clifford Geertz and James Clifford, he argues that 'academic schools of thought are comparable to tribal villages and susceptible to ethnographical analysis' (ibid.). Conquergood was particularly influenced by Victor Turner's effort to rework the conventional 'participant-observer' model of anthropological research. Like Turner, he wanted to trouble the conventional lines between insider and outsider, expert and non-expert, but also deploy a number of Western aesthetic concepts (that is, performance, social drama, the presentation of self, etc.) as both analytical tools and opportunities for intercultural exchange between observers and observed.

The best example of Conquergood's efforts to deploy aesthetics in a fashion that enabled effective analysis, foregrounded ethical responsibility and portended basic alterations in the relations between authorities (including himself) and the people with whom they served was his work at the Ban Vinai refugee camp in Thailand in 1985. Ban Vinai was constructed primarily for members of the Hmong ethnic group. Great numbers of Hmong had fled Laos after the withdrawal of US forces in 1974, with whom the Hmong had fought against the communist-nationalist Pathet Lao for some 20 years. The Hmong's collaboration with American Special Forces earned them the enmity of communist authorities both in Laos and in Vietnam and added fuel to long-standing anti-Hmong prejudice across Southeast Asia. The Hmong continue to this day to be singled out for retribution.

Located on the border of Thailand, the Ban Vinai camp, as Conquergood describes it, housed not only the single largest community of Hmong in the world but also had, at its peak in 1986 (it was shut down by the Thai government in 1992), 'a population larger than any city in this remote area, [. . .] even Loei, the provincial capital. All of the approximately 48,000 residents [were] crowded onto 400 acres of undeveloped land' (Cohen-Cruz 1998: 220). Over 90 per cent were ethnic Hmong. Moreover, the land in the camp was 'intensively used because refugees [were] forbidden to go outside of camp without the express permission of the Thai camp commander' (ibid.).

As might be expected, one of the major challenges facing residents and organizers was health care, not only because of the high-density population and the 'grossly inadequate housing, latrines, and facilities for waste disposal' (ibid.) but also because of cultural differences and overtly prejudicial attitudes between the Hmong and the expatriates. Health workers in the camp, many of whom were evangelical Christians on mission, committed gross violations of cultural respect: for example, cutting sacred spirit-strings from the wrists of patients because 'the strings were unsanitary and carried germs', or removing neckrings that the Hmong believed 'held the life-souls of babies intact' (Conquergood, quoted in Fadiman 1997: 35–6). Hmong shamans were systematically discredited by nurses and physicians and their authority undermined.

Not surprisingly, the camp's sanctioned health care facilities were rarely utilized by residents. But there were pressing health-care issues that could not be addressed by conventional Hmong medical practice, including an outbreak of rabies among camp dogs and a garbage and sanitation problem that had reached crisis proportions. This was where Conquergood came in. Having earned a reputation for his work on shamanism, performance and health issues among the Hmong (that is, the high incidence of Sudden Unexpected Death Syndrome among Hmong immigrants in the US), he was invited to the camp by the International Rescue Committee to serve as an ethnographic consultant and help improve health conditions at a camp described by agency reports as the 'filthiest', most 'primitive' and 'difficult' in the country (Conquergood 1988: 176).

Upon arrival, Conquergood immediately challenged boundaries between experts and subjects, the powerful and the powerless, choosing to share a corner of a thatched hut with seven chickens and a pig rather than

live in the expatriate enclave an hour away, like all the other health work-
ers (Fadiman 1997: 36). Doing so, he 'hoped to break the pattern of
importing the knowledge of 'experts' and distributing it to the refugees,
who were expected to be grateful consumers [. . . and] demonstrate to
both expatriates and refugees that *dialogical* exchange between the two
cultures, the two worldviews and sensibilities, was possible' (Conquergood
1988: 182). Moreover, he established a relationship of equity between
himself and Hmong healers by bartering recommendations and practices
(ibid.). He personally used the services of Hmong healers during his five
months in the camp, getting help for persistent diarrhea and a badly cut
toe and getting free spiritual advice when he contracted dengue fever. As
a consequence, he was able to 'enact an example of dialogical exchange [.
. .] wherein each culture could benefit from the other, approaching health
care issues within a both/and embrace instead of an either/or separation
of categories; this approach was particularly important because the
refugees were accustomed to having expatriates undermine, even out-
rightly assault, their traditions' (ibid.).

During his first morning in camp, Conquergood observed a Hmong
woman sitting on a bench and singing a traditional song. When her per-
formance was over, she approached him and pressed a crescent-moon
sticker onto a page of his notebook. He noticed that her face was deco-
rated with stickers of similar little moons as well as little suns; he realized
that camp health workers used this method to inform illiterate patients
whether medicine should be taken at night or in the morning (1988: 175).
For Conquergood, the moment 'cathected the themes that would become
salient in [his] fieldwork: performance, health and intercultural exchange
between refugees and expatriate health professionals'. With the woman's
performance in mind, he started 'a refugee performance company that
produced skits and scenarios drawing on Hmong folklore and traditional
communicative forms such as proverbs, storytelling, and folksinging, to
develop critical awareness about the health problems in Ban Vinai' (ibid.:
176).

As Conquergood noted at the time, 'Camp Ban Vinai may lack many
things—water, housing, sewage disposal system—but not performance.
The camp is an embarrassment of riches in terms of cultural performance'
(ibid.). He recognized that the surfeit of performance was due not just to
the amount of time the refugees had on their hands but also to deeply
embedded traditions of oral storytelling and gestural communication,

traditions that gave the Hmong a sense of personal and community iden-
tity. This led him to conclude that 'any communication campaign that
ignored the indigenous cultural strengths of performance would be
doomed to failure' (ibid.: 180). At the same time, Conquergood did not
want to appropriate Hmong traditions 'as simply another means to get
refugees to do what bureaucrats think best for them' (ibid.: 181). Rather, he
'hoped that performance could be used as a method for developing critical
awareness as an essential part of the process of improving the health situa-
tion in the camp' (ibid.). In that spirit, the troupe, composed of both
expatriate health workers and camp residents, focused as much on 'the
process of developing the performance' as it did the final product: 'The
backstage processes of researching and developing culturally appropriate
materials along with the participatory involvement of the people are expe-
riential/processual dimensions as significant as any explicit 'message' com-
municated in a skit or scenario' (ibid.).

As a consequence, Conquergood and his collaborators were able to
develop informative events based in Hmong performance traditions;
construct costumes and masks that attracted crowds and spoke
convincingly to them; provide opportunities for feedback, including
critical advice from a Hmong leader on appropriate costumes, music
and chant prosody; and, even more important, prompt advice from
audience members about how certain characters, notably a tiger, inter-
acted with the audience, particularly children, who proved instrumental
to spreading the word about good health practices (see Image 2.11)
(ibid.: 184–5). In the end, Conquergood's work not only positively
impacted conditions at the camp but also altered relations between the
Hmong and health workers, restored a degree of esteem to Hmong
medical experts and their traditional cures, raised critical consciousness
among the Hmong refugees about differences between their traditional
lifestyles and the nature of camp life (especially as it concerned the dis-
posal of garbage), and ensured that the Hmong had a voice in at least
one aspect of their lives, lives whose conditions would progressively
degrade over the next seven years.

Perhaps just as significantly, the work raised consciousness among
the expatriate health professionals, disabusing many of them of their
racist tendencies to see the Hmong as dirty, difficult, backward people
(ibid.: 198–9). Indeed, when he looked back at his work in the camp,
Conquergood felt that more work of that kind was needed: 'Directing

IMAGE 2.11 Health Theatre in a Hmong Refugee Camp.

most of the performances to the Hmong resulted in a one-sided com-
munication campaign and subtly reinforced the prevailing notion that
the Hmong were primarily responsible for the bad conditions' (ibid.:
199). However, he did help develop one performance event for the
health workers, an evening that concluded with a truly 'radical move',
having a Hmong shaman enact a traditional soul-calling ceremony of
blessing and tying around the wrists of health workers the very spirit-
strings that they so often cut off of Hmong patients. Unfortunately, 'the
most dogmatic agency workers—for example, the Christian nurse who
refused to allow any Thai calendars in her ward because they had pic-
tures of the Buddha—did not even attend this event' (ibid.). And
Conquergood, too, admits to his prejudices; feeling it 'easier to identify
with the Hmong, the dogmatic Christians became the Other for' him
(ibid.). In the end, though, his work at Ban Vinai confirmed for him rad-
ical theatre worker Eugenio Barba's assertion that 'it is the act of
exchanging that gives value to that which is exchanged, and not the
opposite' (quoted in Conquergood 1988: 202).

THE UNFAITHFUL HEIRS OF RACISM?

The interventions of Fusco, Gómez-Peña, the WK collective and Conquergood speak critically to the history of aesthetic racism and racialist models of the avant-garde that I have described in these pages— a history that extends back through Nordau to Lombroso, the Algerian medical corps, the original generation of bohemians and the Saint-Simonians. Of course, they have bigger fish to fry than the idea that post-modernist research on the avant-garde may be informed on its deepest levels by racialist concepts of aesthetic politics. Regardless, their work provides useful lessons for scholars who are interested in, one, a history of the avant-garde that accounts for peoples, places and moments out-side of Europe and, two, a critical methodology that can productively account for its own institutional and historical entanglements with race and racism. Each understands that using art to act against racism requires not only audacity but a willingness to take on the very institu-tions, discourses and social structures that allow them to use art in that way. In addition, they each reflect on their own identities—on the kinds of investments they have in their roles as artists, scholars, knowers, as performers in front of audiences. And finally—and perhaps most impor-tantly—each demonstrates how critical to anti-racist activism is face-to-face contact between those who are bound within the structures, histo-ries and imaginaries of race.

So much of the history of race and the avant-garde has depended on that kind of simple intimacy—on the mixing of the marginalized in Paris' déclassé neighbourhoods, the insinuation of doctors into the kitchens and bedrooms of Algerians, the rogue relations fostered to maintain apartheid, the friendships that forged the Surrealist Atlantic, just to recall those I have discussed in these pages. Such intimacy is no panacea—indeed, some of the most horrific violence has been wreaked upon intimate friends, fami-lies and neighbours. However, this kind of contact has proven to be a powerful catalyst to political transformation. Scholars and historians of the avant-garde must, it seems, remain decadents, faithful believers in the idea that brush strokes, the taut lines of a dancer's legs, the edits that join film shots or the contours of a poetic line are the most certain symptoms of power shifts. But they must remain faithful as well to the profoundly social nature of aesthetic activism, believers in the power of gathering. In this faith, we remain the heirs to the aesthetics of race and racism. The ques-tion facing us then is: How faithful will we be to the family line?

Notes

1 On eugenic themes in the work of Mina Loy, see Aimee L. Pozorski (2005: 41–70). Nicola Pende's comments can be found in Filippo Tommaso Marinetti (1989: 41).

2 I use the term 'racialist' to describe a way of thinking in which biological, ontological and theoretical assertions based on race are made and contested. 'Racist' refers to those situations in which racialist discourse is used to promote the degradation and exploitation of persons defined by racialist discourse as racially other.

3 For a fascinating discussion of Futurist interactions with audiences with a focus on Futurist representations of the crowd (and including a thorough review of the literature on crowd psychology that arose contemporary with the Futurists), see Christine Poggi (2002).

4 'Treason to whiteness is loyalty to humanity' is the motto of the journal *Race Traitor*.

5 Instead, Paul Cooke finds a persistent sense of marginality, 'a concept that looms large in Crevel's perspectives on his home city, and [. . .] therefore add an important alternative dimension to the standard view of the Paris of the Surrealists'. See Cooke (2005: 621–2).

6 See 'Minority' in *Oxford English Dictionary*. Available at: www.oed.com (last accessed on 18 September 2007).

7 See Sean Redding (2006). Redding bases his argument on John Lonsdale's (1992) analysis of the role of 'civic virtue' in the so-called Mau Mau Rebellion in Kenya in the 1950s.

8 See 'Ossewabrandwag' in 'African History'. Available at: http://-african-history.about.com/library/glossary/bldef-ossewabrandwag.htm (last accessed on 19 September 2007).

9 Thanks to Molly Held, who first drew my attention to the importance of bohemianism to the avant-garde.

10 Andrew Perry confirmed this suspicion in a paper completed for my research writing class at Indiana University of Pennsylvania in Spring 2005. For comments on the use of phenotypical markers to police dissident groups, see Lee Edelman (1994).

11 See National Endowment for the Arts website. Available at: http://www.nea.gov/about/01Annual/annual01.pdf.

12 'Perception of Subcultures' in WochenKlausur website. Available at: www.wochenklausur.at/projekte/18p_kurz_en.htm (last accessed on 24 September 2007).

13 'A Cinema for Immigrants' in WochenKlausur website. Available at: www.wochenklausur.at/projekte/22p_kurz_en.htm (last accessed on 24 September 2007).

religion

AVANT-GARDE STUDIES AND THE CRITIQUE OF RELIGION

In early October 2001, Osama bin Laden appeared on US television networks. A videotape showed him celebrating the 19 men who had, a few weeks earlier, crashed airliners into the World Trade Center, the Pentagon and a fallow field in Western Pennsylvania. Bin Laden characterized the men as 'a blessed group of enlightened Muslims, the vanguard of Islam' (*New York Times* 2001: B7). His use of the term 'vanguard' (in Arabic, *taliah*) is striking given his intransigent stance against the decadence of the West and its philosophies—and what is more Western than the avant-garde?

At the time that I had such a thought, I dismissed the *Times* translation as a freak, typical of an American media establishment still scrambling for Arabic translators, but I dutifully filed the clip away. I later discovered that the translation was right on the money: the word *taliah* is properly translated as 'vanguard' and is a telltale of a long-lived, mutually influential relationship between Islam and the avant-garde, a relationship that, once we pay it its proper due, calls into question some of the basic presumptions of the field of avant-garde studies. (I will return to this later in a discussion of the writings and influence of Egyptian theologian Sayyid Qutb, Islamic fundamentalism and the implications of the revisionist history of the avant-garde he describes in his influential book *Milestones*, 1964.)

But radical Islamism is only part of a much larger history of the avant-garde of religion. A genealogy of the avant-garde that acknowledges this history will encounter the most pressing, impassioned concerns of modernity and its aftermaths: the standards of rational communication, the role of traditional culture within modernizing societies, the necessity of metaphysical speculation, the function of irrationality and aesthetics in politics, the tension between interculturalism and nationalism, the blurring of economics and cultural politics. But, despite that, the avant-garde of religion has received little attention from scholars and critics, an oversight that should worry us, considering that some of the most successful avant-garde movements have been explicitly religious in nature.[1] I will explore several of these vanguards in this chapter.

But there is a problem. To understand the avant-garde's religious dimensions, we will run up against antipathies that are both historiographical—how we tell the story of the avant-garde—and theoretical—how we conceptualize it. Indeed, as one discovers, the field of avant-garde studies is fundamentally hostile to religion and spirituality. Nordau's *Degeneration*, discussed in the previous chapter, was the first serious effort to survey avant-garde movements in Europe and it set the mark for how the field treats religion. The book's presuppositions (explicitly racist) and prescriptions (hard work, heterosexual marriage and conservative taste will save Europe) are hardly the style these days, thankfully, but his sociology of the *fin-de-siècle* avant-gardes mobilized both concerned parents and Nazis, and its legacies are found in the most cutting-edge, politically correct cultural studies today (as I discuss in the conclusion to Chapter 1).

But that is not my concern at present. What I'm interested in now is how, complementing its concern with racial degeneracy, Nordau's book launches a sustained polemic against religion. He characterizes 'mysticism' as 'a principal characteristic of degeneration. It follows so generally in the train of the latter', he continues, 'that there is scarcely a case of degeneration in which it does not appear' (1968: 45). As one of the leading Zionists of his day, Nordau was notorious for the antipathy he felt for mystical, religious-based approaches to Jewish nationalism, but his most potent vitriol was reserved for the 'degenerate mysticism' and 'Buddhist skepticism' that was rampant among the effete artists of Europe, infecting the youth with a love for Wagner's music, the ethereal visual art of the Pre-Raphaelites and Symbolist poetry. Echoes of Nordau's shrill voice could be heard a century later in the outcry against Andres Serrano's photograph

of a crucifix submerged in his own urine, *Piss Christ* (1989), and, more recently, against Chris Ofili's use of elephant dung and porn-magazine cut-outs in his collage, *The Virgin Mary* (1996), the latter drawing the personal ire of New York City Mayor Rudolph Giuliani and several strokes of white latex paint from a 72-year-old vandal.

A far more remembered and respected contributor to the theory and historiography of the avant-garde is Bürger. Though any self-respecting scholar should know Bürger's work backwards and forwards, I do not know of anyone who has questioned his assumption that any theory of the avant-garde must start with a critique of religion. In 'Ideology Critiques', one of the first sections of *Theory of the Avant-Garde*, Bürger gives theoretical priority to Marx's *Critique of Hegel's Philosophy of Right* (1843), the book in which one finds his memorable *bon mot*, 'Religion is the opium of the people' (Marx 1970: 131). What attracts Bürger most to Marx's critique is its ability to recognize the 'twofold character of ideology': illusion ('Man projects into heaven what he would like to see realized on earth') and truth ('It is "an expression of real wretchedness"'; Bürger 1984: 7). A critique of religion, according to Bürger, is not only a prerequisite for any theory of the avant-garde but it is also the very motive force of the avant-garde itself. It 'destroys the religious illusions (not the elements of truth in religion) in order to make men capable of action'. This is a paraphrase of Marx, who writes, 'The critique of religion disillusions man so that he will think, act, and fashion his reality as a man who has lost his illusions and regained his reason' (quoted in ibid.).

Marx's writings on religion serve an important function in Bürger's theory, which becomes apparent with his claim that the avant-garde's most important development came in the early 1900s, when artists angrily rejected the discourse of aesthetic autonomy (that is, art for art's sake) promoted by European vanguardist artists and critics in the middle and late 1800s. Bürger contends that what sets the so-called historical avant-gardes apart from their precursors—the Impressionists, Symbolists and their tepid Aestheticist fellows—is consciousness of how the art-for-art's-sake position depends on an economic infrastructure that fundamentally contradicts their aestheticism. Gautier argues in the preface to his novel *Mademoiselle de Maupin* (1835), 'Nothing is really beautiful unless it is useless; everything useful is ugly, for it expresses a need, and the needs of man are ignoble and disgusting, like his poor weak nature. The most useful place in a house is the lavatory' (see Gautier 2001: 758). But he fails,

Bürger might say, to acknowledge that those lavatories enable the creation of beauty. In contrast to Gautier's distaste for plumbing, a 1920 Dada exhibition had its visitors enter through a bathroom occupied by a girl in a communion dress and reading pornographic poetry. While this is further evidence of the intrinsic lure of potty talk and scandalous gestures to the avant-garde, the gesture also shows the effort to integrate the economic and social infrastructure of art into the work itself, avoiding the aestheticization of politics.

According to Bürger, it was the art-for-art's-sake tendency shaped by Théophile Gautier, Walter Pater, Edgar Allan Poe and others that set the cornerstone for the metaphysical edifice on whose ruins the 'historical' avant-gardes would tread. In the same way that Marx reads religion as the expression of a real need lacking any possible gratification or adequate consciousness of the material relations of production, Bürger reads the ideology of aesthetic autonomy as the expression of a real need (in this case, for a fully liberated subjectivity), lacking any possible gratification or adequate consciousness of the material relations that would enable liberation to occur for more than just a few enlightened artists. By thematizing the very institutions of artistic education, display and criticism and setting aside the religious 'lies' of *l'art pour l'art* while maintaining its 'truth', the 'historical' avant-gardes established the standards by which all other activist art movements would be judged. For scholars and critics, this also marked the impossibility of a critique and a history of the avant-garde that can do anything but dismiss religion as illusion.

Unfortunately, the baby was thrown out with the bathwater. The anti-religious bias of Bürger's theory gives no breathing space for avant-gardes that may be both conscious and critical of the institutions of aesthetic production and consumption, yet retain as part of their programme of critical activism elements that are properly considered religious. Among these, one might mention the Sillon movement founded in 1894 by Marc Sangnier, a devout Catholic and graduate of that hotbed of vanguard fantasy, the École Polytechnique, in order to explore ways to challenge the anti-Catholic bias of the French government. Out of that movement's progressive, activist study groups came Peter Maurin, co-founder in 1933 with Dorothy Day of the Catholic Worker Movement, the Christian anarchist organization whose journal regularly addressed aesthetic questions and voiced strong support for alternative craftmaking institutions (see Egbert 1970: 210–12). If the Sillon movement is banned

from avant-garde history, to name just one example, then one wonders, too, how to make sense of Surrealism's sustained engagement with alternative and non-Western religious traditions such as alchemy, Sufism and *voudon*. Indeed, the religiosity of Surrealism, particularly after the Second World War, remains one of the movement's more scandalizing features. Many academics consider it to be a symptom of the movement's collapse.

Nowhere is Bürger's incapacity to comprehend the relationship of religion and the avant-garde more apparent than in his treatment of Dada, Bürger's favorite example of a 'historical avant-garde'. Oddly, there is not to be found in his book any discussion of the *moral* critique mounted in Zurich and other capitals of Europe by the war-ravaged men and women of the movement. If there was anything that brought these angry young people together, it was moral outrage at the looming catastrophe of the war and the liars and con men who were letting it happen. One notes, in particular, the conspicuous absence of Dadaists Hugo Ball and Emmy Hennings from his book. This may be no accident; both Ball and Hennings turned to an ascetic spiritual life after the Cabaret Voltaire ended its brief, furious run down the street from Russian revolutionary Vladimir Lenin. The conventional story is that Ball and Hennings returned to religion after a brief, torrid affair with Dadaist iconoclasm. This is hardly the case: to them Dada was a religious moment. One finds a sustained, positive, substantive influence before the Cabaret Voltaire on Ball and Hennings: Wassily Kandinsky, whose paintings and performance compositions are not only difficult to see as anything but *l'art pour l'art* but also as anything but spiritual in reference and method. Though Ball and Hennings were not dominant voices at the Cabaret—there were no leaders there, only participants and spectators—and their religious views were not shared by many, it is nevertheless compelling to imagine that the Dadaist interest in the 'total work of art' is indebted as much to the spiritual holism of Wagner and Kandinsky as it is to the fragmentary anti-aesthetic of collage. And while it is fair to find the origins of Hennings' remarkable performances in her extensive experience as a cabaret chanteuse, it is hard not to see Ball's famous cyber-lobster suit (see Image 3.1) invoking the stiff, vertical lines of the nineteenth-century Lutheran minister's vestments (see Hoffman 2010).

Lest we presume that such problems are characteristic only of Bürger's treatment of Zurich Dada, there is Johannes Baader, a major figure in the Berlin tendency—the one favoured by Bürger. Baader is not

IMAGE **3.1** Hugo Ball's rainbow-coloured cyber-lobster suit, which recalls the clerical vestments of Lutheran ministers (1916).

IMAGE **3.2** Johann Baader's *Das große Plasto-Dio-Dada-Drama* (1920). Courtesy: Archives Nakov, Paris.

mentioned once in *Theory of the Avant-Garde*. Self-styled *OberDada* and 'Dada Prophet', Baader began his avant-garde career as a mortuary architect in Dresden before designing the 'World Temple', an interdenominational worship structure that mixed and matched a variety of sacred styles, both European and non-European. A year or so after he was declared legally insane by the Berlin police, he and Raoul Hausmann founded *Christus GmbH* (Christ Ltd.), which protected pacifists from the draft by certifying them as one with Christ. Baader's most significant work, *Das große Plasto-Dio-Dada-Drama: Deutschlands Grösse und Untergang oder Die phantastische Lebensgeschichte des OberDada* (The Great Plasto-Dio-Dada-Drama: Germany's Greatness and Decline or the Fantastic Life of the Superdada, 1920) (see Image 3.2), served as both model for Dada architecture and a medium for the exploration of his own, cosmically expansive sense of self. This remarkable assemblage is composed of all kinds of stuff: cogwheels, newspaper clippings, small models of conventional architectural elements, bits from Dada journals and Hausmann's sound poems. In an absolutely un-ironic way, Baader proclaims, on the aerial antenna that is the top-most element of the work, 'the final redemption from suffering and death' (Baader, quoted in White 2001: 587). Equally un-ironic is Baader's interpretations of the war, grounded firmly in the biblical book of Revelations. These kinds of antics earned Baader stinging rebuke from fellow Berlin Dada and dedicated atheist Richard Huelsenbeck, who characterized him in 1920 as a 'comfort-loving Swabian pastor [who] attempts to exploit his mania for godliness simply in order to line his pocket' and, in *Memoirs of a Dada Drummer* (1974) as 'an itinerant preacher, the Billy Graham of his time, a mixture of Anabaptist and circus owner' (quoted in White 2001: 587). Notwithstanding Huelsenbeck's distaste for Baader's religious leanings, it should be obvious that, without an understanding of Berlin Dada as a community in which passionate debate about religion occurred frequently, there is little possibility of understanding Berlin Dada at all. Any responsible discussion of the avant-garde has to be able to think about the avant-garde in ways other than that provided by, first, the Marxist critique of religion and, second, routine academic scepticism of things irrational. (Such a critique is apparent in the essays collected by Goldstein 2006.)

The benefits that come from being attentive to the role of religion in the development of activist minorities is apparent when we turn to the 'usual suspects' of avant-garde historiography. But it is all the more

significant when we turn to those who have not been on our radar. Consider the work of Cedric Robinson, a fellow traveller of the BAM of the 1960s and 70s and a key player in the efforts of African American historians to recast the history of African diasporic radicalism. Though religion plays a minor role in Robinson's magisterial *Black Marxism* (1983), there are moments worth mentioning. In a lengthy analysis of slave revolts in the Americas and Africa, Robinson argues that as a consequence of the transport of African labour to the Americas, 'African ontological and cosmological systems; African presumptions of the organization and significance of social structure; African codes embodying historical consciousness and social experience; and African ideological and behavioural constructions for the resolution of the inevitable conflict between the actual and the normative' were motive forces behind the black radical tradition (1983: 174).

Obeah is a magical and shamanistic tradition that was a long-lived source of anxiety for African kings. H. Orlando Patterson has described the role of Obeah in Africa, where, in a series of Gold Coast insurgencies, the 'Obeah-man was essential in administering the oaths of secrecy, and, in cases, distributing fetishes which were supposed to immunize the insurgents from the arms of the whites' (quoted in ibid.: 136–7). Obeah was carried by enslaved Ashanti and Dahomeyans to Jamaica, Trinidad and Tobago and other Caribbean islands, where it provided critical perspectives, resistant cultural practices, bodily experiences that imbued the suffering of black labour with a broader significance and an intercultural medium for the diverse ethnic populations within the slave community. Not surprisingly, priests were major players in slave rebellions, particularly in Brazil, and in the founding of the Windward and Leeward Maroon communities.

Robinson concludes by noting that, despite efforts to wipe it out, Obeah never disappeared but 'continued its mutational adaptation and development in Jamaica (and elsewhere) over the centuries, successively manifesting itself in the societies of Myalism in the eighteenth and nineteenth centuries, the Pocomania movement of the late nineteenth, and the Rastafarians of the present' (ibid.: 137). Indeed, Michael Craton writes, 'Obeah (like the Haitian *Voodoo*, or the Jamaican variant, *Myalism*, or Trinidadian *Shango*) sought ritualistic links with the spirit world beyond the shadows and the sacred trees, providing a mystical sense of continuity between the living, the dead, and those yet to be born' (quoted in ibid.:

136). Consciousness of the simultaneously backward- and forward-looking quality of these battle-tested cosmologies led many black radicals of the 1960s to embrace West African religious belief; at one point, Amiri Baraka was a Yoruba priest. West African cosmological, ethical and aesthetic traditions were also important to the Muntu reading group of North Philadelphia, which included James Stewart and Larry Neal. The Muntu group helped shape not only the BAM but new scholarly methods for the study of the African diaspora (see Sell 2005). The restoration of Obeah and other West-African-derived religious traditions to the history of African diasporic resistance has implications beyond the specific point that Robinson intends. Robinson's research calls into question Marxism's tradition, as he puts it, of 'neglect and miscomprehension of the nature and genesis of liberation struggles which already [have] occurred and surely [have] yet to appear among' 'peasants and farmers in the West Indies, [. . .] sharecroppers and peons in North America, [and] forced laborers on colonial plantations in Africa' (1983: xxx). In addition, Robinson challenges a tendency in Black Nationalist ideology to ignore the 'new, syncretic cultural identities' developed within and across African-diasporic, Native American and European slave communities (ibid.: xxxi). Obeah, in particular, evinces that kind of 'mutational adaptation and development' (ibid.: 137). The 'critique of the critique of religion' that I will pursue in the following pages should enable avant-garde studies—as it enables Robinson in the case of Marxism—to open up the conventional story line to new connections, new implications and perhaps a revised understanding of the avant-garde itself.

FIVE ASPECTS OF RELIGION

In order to better understand the avant-garde's relationship to religion, I need to specify what aspects of religion I find most significant. As I use it, the term 'religion' covers five interrelated topics:

1. Religion as a Way of Thinking

First, religion is a *way of thinking*, an epistemology. The basic idea of this way of thinking is that apparent reality is not true reality. Religions generally describe a set of beliefs and practices that establish the relationship between two (or more) realities and suggest ritualistic methods to bring them into unity or, in some cases, ensure their separation. Religion is

fundamentally concerned with that which is both here and not here, present and absent. In this respect, all religion is fundamentally utopian. (One notable exception to this rule being Zen Buddhism, an influence on avant-garde art and activism in the 1950s and 60s, which I will discuss later in the conclusion.)

Nevertheless, the avant-garde is about action and efficacy, about enacting the perspectives and powers of a minority or an elite in order to change the world. Rather than marking a contradiction, the overt presence of metaphysical, utopian thinking in a tendency committed to action provides an entry into broader issues, especially what might be called the 'metaphysics of effect'. To recall, many artists and critics have taken to task the Symbolist movement of the late 1800s for its commitment to art for art's sake, its elitism, its hamstrung understanding of the relationship of art to its enabling institutions and its mysticism. In large part, this disdain has to do with Symbolism's lack of sociopolitical efficacy. How can the sociopolitical 'uselessness' of art actually be a valid political stance? Neither is it obvious how a group of effete poets and painters gathering in private to explore mystical experiences and smoke hash could be considered in any way 'activist'.

But if there's one lesson to be derived from the history of the avant-garde then that is to never underestimate the political efficacy of a quiet gathering of like-minded rebels. This is probably no more apparent than the Seder celebrated by a small group of dissident Jews in Jerusalem two thousand-odd years ago. The Last Supper shares many of the traits with much later dissident gatherings such as Hugo's bohemian literary salon, known as the Cénacle. 'Cénacle' is the French word for Jesus' final meal with his most important followers. Like all such gatherings, secrets were shared, as was simple food and drink, with plenty of discussion of political and metaphysical matters. Cenacles (the English spelling of an unfortunately uncommon word) always includes the performance of a composition by one or more of the members. Jesus delivered his Farewell Discourse and torrents of awful and epic poetry were the case at Hugo's Cénacle. The tradition of toploading metaphysics into acts of everyday communality is a constant in the history of the avant-garde. There is perhaps no more common act among activist minorities than the ritual sharing of food and intoxicants. Anyone who's spent time in the impoverished and déclassé student subcultures of any major US university will recall discussions around potluck dinners verifying the ethical virtues of the dishes

being served and the clothing of the eaters. The sanctification of bread and wine by Jesus and its replication in the *agape* feasts of early Christians were just a more overtly political version of this tradition.

The positive relationship of spirituality to political efficacy is not just for 'escapist' art like that described by Gautier or the putatively 'escapist' modes of vanguardism like the cênacle (escapist because they recede from view, gather in private). Describing a series of performances offered in Austin, Texas, in 2000, by Holly Hughes, Peggy Shaw and Deb Margolin—three of the most politically engaged artists of our time—Jill Dolan audaciously argues that the critical perspectives, theoretical concepts and performative interventions intended by those artists to short-circuit the patriarchal, white, heterosexist, Christian logic of US culture are themselves deeply enmeshed in spiritual questions. Describing what she calls the 'utopian performative', Dolan explores the feelings inspired by Hughes', Shaw's and Margolin's work—work clearly intended to undermine the brutarian spiritual certainties of the 'American era' but also tending to preach to the converted. Dolan concludes that, precisely because of its contingency, uncertainty and fragility as performance, even the most closed-circuit, coterie-crowd performance can find firm ground for acts of moral and ethical obligation, for the imagining of alternatives and for commitments based in intense forms of generosity and fellow feeling: 'communitas' (2001: 457).

There is little doubt that, for artists, especially visual and performing artists, religion's perennial concern with the boundaries between the seen and unseen is everywhere. In theatre, for example, exploring and rupturing those boundaries is fundamental to the craft. As David Savran puts it, because theatre always creates a convincing reality out of a congeries of memories, conventions, smoke, and mirrors, it must 'remember what, in effect, was never there' (2000: 585). The modern dramatic tradition, in particular, because it is founded on a radical break with the past, is 'haunted by that which it believes it has displaced, that 'tradition of all the dead generations' (ibid.: 584).

Artists who utilize photography and younger digital media have also shared this obsession, especially since technological innovations in art and culture seem to produce oddly spiritual consequences. Alison Ferris makes interesting work of this tendency in the recent 'Disembodied Spirits' exhibition at Bowdoin College, which shows that

artists' recourse to the ghostly often functions as a by-product of tech-
nological advances—primarily photography and the telegraph in the
nineteenth century and the computer in the late twentieth century.
Like ghosts themselves, these dematerializing technological innova-
tions produced both anxiety and optimism in their times, while
simultaneously altering, quite dramatically, received notions of rep-
resentation and vision (2003: 47).

Ferris quotes scholar Mark Cousins: 'What is characteristic about ghosts is
not that they are seen or not seen, but that they transform the relation
between what is normally seen and what is not seen'. James VanDerZee's
composite photographs of the 1920s exemplify this transformation.
Portraits such as *Daddy Grace and Children*, which superimposes Bernhard
Plockhorst's classic—and classically kitschy—painting *Christ Blessing the
Children* on a portrait of the pastor of Harlem's United House of Prayer
for All People, or *Future Expectations* (*Wedding Day*) of 1926, in which we
find ghostly, intertwined hearts and an infant, 'bend the parameters of
time and make visible an anticipated future' (ibid.: 47, 49, 52–3). Though
I would not characterize VanDerZee as a vanguardist—I think it better to
characterize him as a grass-roots Folk-Modernist—he does provide ocular
proof for his viewers to think and feel across the gap separating the banal-
ity of everyday life from a realm of heightened sentiment, significance and
temporality.

2. Religion as Institution

In addition to being a way of thinking, religion can be understood as an
institutional phenomenon with organizational structures, graded levels of
authority, land holdings, publishing networks, lay communities and the
like. This is a dimension of the avant-garde that, as Bürger showed, must
be attended to both consistently and with a high degree of self-reflexivity.
Without a doubt, institutional (or 'established') religion has been a regular
object of avant-garde scorn. The Parisian Surrealist group considered a
photograph of Benjamin Perét abusing a priest as something of a holy
relic (see Image 3.3). Another Parisian group, the Lettristes, cloaked
themselves as Dominican monks to disrupt the 1950 Easter Mass at Notre
Dame Cathedral, narrowly avoiding getting cut to pieces by the halberd-
wielding honour guard.

Just as significant are vanguardist tendencies outside the art world.
Liberation Theology comes to mind as an activist minority tendency that

IMAGE 3.3 Benjamin Perét abusing a priest

works both within and against institutional religion. Rooted in the prophetic tradition of evangelical missionary work, this activist trend began in the 1960s across Latin America. It was sparked, according to Leonardo and Clodovis Boff, by the failure of populist governments in Argentina, Brazil and Mexico to improve the lives of rural people and by the failure of established religion to hold those governments to their promises (1987). Rejecting the notion that theology is a mode of abstract reasoning and religion a consolation for suffering, Liberation Theologists like Gustavo Gutiérrez advocated theology as critical reflection on action (see Rhodes 1991). Gutiérrez asserted that 'to know God is to do justice' and that the church's mission is not just to save souls but 'at all times to

protest against injustice, to challenge what is inhuman, to side with the poor and the oppressed' (quoted in ibid.). The resistance of Liberation Theologists to institutionalized poverty, resistance that used violence on occasion, is premised on the idea that biblical scripture justifies the protection and advancement of the poor and that it can and should be read with 'a bias toward the poor' (ibid.).

But Liberation Theology is not just a reaction *against* the religious establishment; it was inspired in part by the Second Vatican Council (1962–65) which explicitly condemned the disparity between wealthy and poor nations. The simultaneously critical and affirmative nature of Liberation Theology vis-à-vis institutional religion can be seen in its most basic organizational method. As Guttiérez describes it, a central role in Liberation Theology praxis has been played by '"ecclesial base communities" [. . .] small, grassroots, lay groups of the poor or the ordinary people meeting to pray, conduct Bible studies, and wrestle concretely with social and political obligations in their setting' (quoted in ibid.). He notes that 'in most Latin American countries, the church's base communities are the only form of social action available to the poor' and that by 1980, 'there were as many as 100,000 base communities meeting in Latin America' (quoted in ibid.). That Pope Benedict XVI felt it necessary to publicly criticize the tendency during his 2007 visit to Brazil speaks to the continuing influence— and potent threat—that Liberation Theology poses to church hierarchy.

3. Religion as Cultural Practice

In addition to being an epistemology and a counter-institutional strategy, religion is also a *cultural practice*, a set of symbolic, dietary, aesthetic, hygienic principles and practices that enable social and symbolic continuity (the community of the faithful) but also maintain palpable boundaries between the sacred and the profane (the hierarchy of the faithful). Such boundaries make clear the differences between insiders and outsiders, between leaders and led, and, in artworld circles, the sophisticated and the 'philistine' (a term derived from the Old Testament). For true believers, a religion is much more than a way of thinking—it is a way of life. The influential Islamist theorist Maulana Maududi, for example, made his mark by advocating Islam as *al-Deen*, an all-encompassing system that links 'man's heart to the arena of sociopolitical relations [. . .] the mosque to the parliament [. . .] the home to the school and the economy [. . .] art, architecture, and science to law, state, and international relations' (quoted

in Marty and Appleby 1991: 828). Maududi's innovative understandings of Islam gave radical Muslims the tools to rethink the nature of political action in a fashion remarkably similar to the so-called bohemians of mid-nineteenth-century Paris. The question for Maududi as it was for the bohemian is not about belief but about a belief-infused *lifestyle*.

4. Religion as Embodiment

Religion gives metaphysics a *body*, too and this is the fourth concern I will explore. Every religion posits some kind of physical practice to tie together apparent and true reality: prayer posture, diet, rituals of respect surrounding religious authorities and so on. Louis Althusser memorably writes of the true believer, 'If he believes in God, he goes to Church to attend Mass, kneels, prays, confesses, does penance [. . .] ritual practices according to the correct principles. The believer must act according to his ideas [. . .] in the actions of his material practice. If he does not do so, that is wicked' (2001: 1501). Through such practices, religion functions as a *performative* force in the believer's life; the believer performs his or her distinction from the non-believing community, thus ensuring that the religion is a living, embodied experience within the vicissitudes of day-to-day life.

Established religion's manner of attaching itself in the most intimate ways to the bodies of worshippers prompted ex-Surrealist Artaud to imagine the possibility of a 'body without organs' to shake off the deeply embedded habits of Western metaphysical thought. 'So it is man whom we must now make up our minds to emasculate', he inveighed in the conclusion to his shattering 1947 radio performance *To Have Done with the Judgment of God*:

> Man is sick because he is badly constructed.
> We must make up our minds to strip him bare in order to scrape off
> that animiculate that itches him mortally,
> god,
> and with god
> his organs. [. . .]
> When you will have made him a body without organs,
> then you will have delivered him from all his automatic reactions and
> restored him to his true freedom (1976: 570–1).

Artaud's performance concluded a long career in which religious belief and body experience often collided, sometimes cataclysmically, taking him from the ranks of the Surrealists in Paris to the hills of Mexico to the

anguish of drug addiction and withdrawal and, perhaps most influentially, to a theory and practice of 'holy theater' (see Innes 1986). Artaud's career might be summarized as one long exploration of the energizing contradiction between art that addresses the sensibility of viewers in physical ways and an art that produces an experience which, '[i]n the anguished catastrophic period we live in, [. . .] events do not exceed, whose resonance is deep within us, dominating the instability of the times' (1958: 84).

For Artaud, the contradiction between the body as grounded, material entity and the body as transcendent, spiritual principle was best addressed by the experience of 'cruelty', which, in the theatre, would be achieved by 'attack[ing] the spectator's sensibility on all sides'. Artaud advocates the use of 'cries, groans, apparations, surprises, theatricalities of all kinds, [. . .] physical rhythm of movements whose crescendo and decrescendo will accord exactly with the pulsation of movements familiar to everyone'. As a result, 'all the lapses of mind and tongue, by which are revealed what might be called the impotences of speech, and in which is a prodigious wealth of expressions', will not fail to be produced. The result is that, 'departing from the sphere of analyzable passions [. . . cruelty can] cause the whole of nature to re-enter the theater in its restored form' (ibid.: 93, 95). Though Artaud's obsession with the body is shared by many of his fellow vanguardists, his unique take on the body politics of religion has proven singularly influential.

5. Religion as a Collection of Things

Finally, I use the term 'religion' throughout this chapter to refer to a varied group of symbolically charged *things*: robes, beads, shawls, hats (ah, the hats!), memorized verse, gestures, recipes and so on. As a way of investing objects with metaphysical significance, religion can be viewed as a *signifying practice* that intensifies, alters, or dislocates the significance of things. Artaud, for one, saw the theatre as a perfect place not only 'to create a kind of passionate equation between Man, Society, [and] Nature,' but also 'Objects' (ibid.: 90). Stewart Lee Allen has suggested a way of seeing the Last Supper as a congeries of objects 'manipulated [. . .] for political gain'. Allen argues, contrary to traditional views, that the supper was not a preparation for a political confrontation—efficacy in any direct way was never a consideration—but a confrontation in and of itself. Noting that Judas took as evidence to the Pharisees 'a gravy-soaked crust to prove that Christ was holding an illegal feast', Allen argues that it was in fact a fully

enacted *culinary* confrontation, a refusal to abide by the dietetic strictures of Jewish belief (2002: 89–90).This manipulation of things—in the case of these rebellious Jews, the stuff of board and cup—enabled a small, threatened community of believers to gain a concrete sense of historical and ritual solidity. The cênacle is always, ultimately, about sharing symbolically charged objects: bread and wine or, in the case of the modern literary cenacle, books, well-creased drafts of poems, cigarettes and cheap liquor.

Unlike Jesus' desacralization of Jewish practice through the manipulation of things in a private space, *fin-de-siècle* Parisian vanguardist Alfred Jarry's 'The Passion Considered as an Uphill Bicycle Race' invests a profane practice and object with sacred qualities and does so in front of a big crowd. 'There are 14 turns in the difficult Golgotha course,' Jarry writes after a lengthy consideration of 'the machine itself', an early-model bicycle 'generally called the right-angle or cross bicycle' upon which Jesus 'rode lying flat on his back in order to reduce his air resistance'. Jarry describes how the challenging turns can be negotiated by a bicycle that requires its user to be both rider and tires but still feels it a real disadvantage to the messiah, since his front tire was punctured by 'a bed of thorns' shortly after getting off 'in good form' following a 'stimulating', 'hygienic' 'massage' with the lashes of his Roman trainers (Jarry 1965: 123, 122).

The intentionally blasphemous comparison—which in passing characterizes Saints Matthew, Briget, Gregory of Tours and Irene as sports journalists—takes a curious turn as it moves to its conclusion: 'The deplorable accident familiar to us all took place at the twelfth turn. Jesus was in a dead heat at the time with the thieves. We know that he continued the race airborne—but that is another story' (ibid.: 124). Not unlike Jesus with his bread and wine or the literary cenaclists with their poetry, Jarry both desacralizes and re-sacralizes the objects of his interest. In 'Alfred Jarry: A Cyclist on the Wild Side', Jim McGurn notes that Jarry 'saw the bicycle as a liberator, a machine to extend the capabilities of the human being' (1989). The extension of human capability enabled by the bicycle mirrors for Jarry the crucifixion itself: at once testimony to the slapstick absurdity and glorious necessity of things.

RELIGION AS MEDIATOR

Having established these five areas of concern—metaphysics, institutions, culture, the body and things—it's just as well to flout all the conventions

of polite conversation and get into politics too. As I have discussed, Marx's characterization of religion as the 'opiate of the masses' has ruled the discourse and debates about the avant-garde—rendering the idea of a religious avant-garde an all but illegitimate topic, with notable exceptions such as Innes's *Holy Theatre: Ritual and the Avant-Garde* (1986). However, in general, scholars tend to denigrate, first, what I have called the metaphysics of effect and, second, the possibility of a politics pursued not in the conventional environs of parties, union halls and parliaments but in religious institutions, cultural practices, the body and things. Craig Calhoun has noted the disastrous effects this prejudice has had on the social sciences:

> Few eras have been shaped more profoundly by religious activism than the last fifteen years [1976–91]. But the *presumption of unbelief* is so basic to much of modern academe that it is hard for scholars to take religion altogether seriously [. . .] That an understanding of economic action is essential for sociologists and political scientists is all but unquestioned; that religion should be accorded similar centrality is all but unconsidered (quoted in Voll 1993: xii).

There is little doubt that religion has often been utilized to silence critique, bludgeon the opposition and defer the struggle for a better world to some far-off hereafter. But even in those cases, Dwight Billings argues, religion has spawned significant, long-lived and tendentiously critical trends and movements. As he puts it, 'Sectarian churches, defined by their rejection of the world, often function to integrate participants into the surrounding society', thus serving a mediating role in the expression of discontent and the waging of social conflict (1990: 2). There is no reason to assume that integration promotes quietude, though it often does. Consider the struggle during the 1950s and 60s between two arguably vanguard religious organizations in the US, the Southern Christian Leadership Conference of Martin Luther King Jr and the Ku Klux Klan. Both organizations viewed themselves as playing a vanguard role for their respective communities. Both were Christian organizations. For racist and anti-racist alike, Christianity afforded a common epistemology, vocabulary, eschatology, symbols, cultural practices (eating at diners, sitting in classrooms) and symbolic things (dark skin, white femininity, the burning cross, the preacher's pulpit) in the struggle to define the nature of state power, citizenship and legislative morality.

Thus, rather than viewing religion as purely quietistic, an opiate, even a dialectical opiate like that found in Marx's critique, we can follow

Dorothee Solle and think of religion in a more nuanced way, as having a 'double function', 'as apology and legitimation of the status quo and its culture of injustice, on the one hand, and as a means of protest, change, and liberation on the other hand' (quoted in ibid.: 3). Eugene Genovese, in *The Political Economy of Slavery: Studies in the Economy and the Society of the Slave South* (1965), seconds this, arguing that, for African American slaves, despite the church's 'history of submission to class stratification and the powers that be', there is a 'legacy of resistance that could appeal to certain parts of the New Testament and especially to the prophetic parts of the Old' (quoted in Billings 1990: 3). Thus, religion can and has served a complex mediating role in social struggle, supplying epistemologies, institutions, cultural practices, a sense of embodiment and significant objects to those in conflict with the governing order (earthly or otherwise).

ARGENTINA'S DIRTY WAR: THE HOLY *PICANA* AND THE SACRED VICTIM

That role is nowhere more clear—and nowhere more haunting—than in the 'Dirty War' that ravaged Argentina between 1976 and 1983, waged by Jorge Rafael Videla and his successors. Juntas such as Videla's are a potent form of radical praxis for modern military vanguards. Though supposedly a collective dictatorship premised on cooperation between military and government, the military, more often than not, undermines that collectivity, all the while exploiting the illusion of collectivity to progressively strengthen the military faction that brought the coalition into being in the first place. The concern for regime security cloaks the military's metaphysical beliefs about its status vis-à-vis the nation. In the case of the Videla Junta, the takeover was justified as a necessary means—an instrument—to bring to an end the intensifying barrage of terrorist attacks (from both Left and Right) suffered during the administrations of Juan Perón and his third wife, María Estela Isabel Martínez de Perón.

The 'Dirty War,' known officially as the Proceso de Reorganización Nacional (National Reorganization Process), was a War on Terror whose primary front was *within* Argentina, a war mapped across, in the regime's terms, 'ideological borders' threatened by 'exotic ideologies' (Graziano 1992: 19–20). It is infamous for the inhuman brutality with which it was waged. An estimated 30,000 people were 'disappeared' over the course of the war, redacted to secret detention centres where most were tortured and killed. Though it was justified as a War on Terror, perhaps only 20 per

cent of those abducted could be in any way considered armed terrorists—and none of those were provided any semblance of due process to prove the case. The majority were blue-collar workers, students and professionals whose only 'crimes' were minor or alleged infractions of speech, sympathy and action. (Percentages are provided by *Nunca Más* and cited in Graziano 1992: 29, 31.) This is epitomized by the 'Night of the Pencils', 16 September 1976, when a group of high-school students were rounded up for subversive activity, entered into a detention centre and tortured. Six were executed. Their 'subversive activity' had been a campaign for free bus passes for students.

What earns the Junta a place in a study of the avant-garde of religion is its metaphysics, how it imagined itself as an agent of Argentinean history, how it framed the use of violence, how it thought about the bodies that it trained, tortured and terrorized. As Frank Graziano demonstrates in *Divine Violence: Spectacle, Psychosexuality, and Radical Christianity in the Argentine 'Dirty War'* (1992), the conflict was dominated by 'medieval images, among them the Natural Order, the Antichrist, the depiction of society as a living organism, and the *corpus mysticum* adapted from ecclesiastical to political application' (ibid.: 12). Admiral Emilio E. Massera stated in 1979, 'God has decided that we should have the responsibility of designing the future' (quoted in ibid.). Lieutenant Colonel Hugo I. Pascarelli, in an address given on the occasion of the 150th anniversary of First Artillery Group, characterized the struggle as an offensive to preempt 'the brief reign of the Antichrist of Apocalypse' that demanded action that 'does not recognize moral or natural limits, that is realized beyond good and evil, that transcends the human level' (quoted in ibid.). His address met with the enthusiastic approval of President Videla, who sat in the audience, feeling, one imagines, rather good about the work he was doing for God. Torturers, too, justified their cruelty in theological terms. One of the Night of the Pencils' students was told by an interrogator, 'You are our best young people . . . valuable people, but . . . this is a holy war and you want to disrupt the natural order . . . you are the Antichrist . . . I'm not a torturer, I'm an inquisitor' (quoted in ibid.: 31). As Graziano describes it, 'The *desaparicidos* were construed as mythically guilty of having sinned against God—via the detour of having sinned against the Junta as vicars of Christ—and therefore become worthy recipients of the most horrific penal measures' (ibid.: 13).

Mediaeval metaphysics gave the Junta and its henchmen an effective, essentially magical logic for the use of torture. By torturing, Graziano

argues, the regime was able to physically manifest an essentially imaginary enemy, was able to conjure an avant-garde. By imagining itself as the sword of God and the very spirit of Argentina, it was able to obscure the fact that it was a minority faction, that it was in fact the avant-garde. Of course, every military dictatorship justifies itself as the manifestation of something larger than a minority interest. Every dictatorship is ratified in terms of some larger historical or 'moral' purpose. Graziano shows that the Dirty War was justified not just in the overtly expressed beliefs of the Junta leaders but also by torture itself. He explains that the Argentinean Junta functioned within a 'lived myth [. . .] structured on a hybrid literary model consolidating elements of romance and tragedy' and providing the 'military's mythopoetic self-perception as a holy order divinely guided in an eschatological mission' (ibid.: 119). Tapping into mythical archetypes of the Hero seeking out the Enemy to destroy him and, thereby, bring his community back to sacred order, the Junta was able to invest all levels of the war with sacred significance.

This was particularly true in the regime's torture chambers, where religion's ability to transform objects into sacred beings was apparent in the widespread use of the *picana eléctrica*, an electrified prod capable of administering graded levels of shock. As Graziano puts it, 'In the myth of the "Dirty War", the *picana* as used during torture fulfilled [the] role of the magical object', empowering 'the Hero', in this case the torturer, 'to *locate* the Enemy as well as destroy him' (ibid.: 142). Graziano describes torture in terms of this myth:

> Application of the magical object (*picana*) to the Victim-Donor's body first dismantled the Enemy's 'invisibility'—the victim became visibly, undeniably (and tautologically) the Enemy by virtue of having been abducted and tortured, and similarly the magical object in combination with 'interrogation' resulted in 'confessions' that made other 'subversives' visible (ibid.).

The specific way that religious epistemology and symbolic objects functioned in torture speaks to a particular problem that faced the Junta as it wreaked savagery across Argentina and, through collaboration with rogue militaries, across the world: its status as an avant-garde. The Junta's 'Christian' cosmology allowed it to deny that it was an avant-garde (we are not an isolated, self-aggrandizing, perverse minority but the very spirit of the people) while imposing the identity of avant-garde upon others (the

enemy is a minority, looking to seduce the masses into left-wing ideology and cultural degeneracy). The Junta pursued its minoritarian violence in a metaphysically air-tight, if completely fictional logic: the vanguard (the Junta) was the majority; the majority (the *desaparecidos*) was a vanguard. The myths provided the Junta the fructifying illusion that it was no special interest, no cadre pursuing the particular goals of a minority; rather, it was the very manifestation of a cosmic struggle of good over evil. The end result, ironically, was that the Argentinean people were in fact compelled to develop actual vanguards to challenge the Junta, adding further justification to their repression. That one of the most important vanguards was founded by the mothers, wives and sisters of the *desaparicidos* is a topic for Chapter 3.

HENRI DE SAINT-SIMON AND THE HIGH PRIESTS OF MODERNITY

It is presumed that the avant-garde is a distinctively modern tendency. There's little doubt that modernity has inspired avant-gardes to diverse, audacious religious flights, lofted by the most reticulated metaphysical systems, outrageous cultural practices, diversions of objects and the like. This is especially apparent in the sociopolitical revolutions that shook Western Europe and the Americas in the late eighteenth and early nineteenth centuries, a period that saw the emergence of great numbers of activist groups who understood themselves as specially empowered and privileged by their minority status and created innovative cultural practices to empower themselves and others in the absence of acceptable political process. Thus, when conservatives in the US insist on the primacy of the Judaeo-Christian tradition in the formation of the nation, they are not imposing prejudice on historical fact. Indeed, that tradition was ubiquitous. However, it was far from the only religious (or anti-religious) system in play.

In addition to the possible impact of aboriginal peoples—the Iroquois in the US, for example—the development of modern liberal society was driven by a volatile mixture of the rational and the passionate, the rigorously secular and the righteously religious, the conformist and the dissenting. The deist Voltaire, the Islamophilic British Romantics and the swooning mobs of the Great Awakening supplied word and attitude to the social, political and cultural events of the late eighteenth and early nineteenth centuries—and produced many vanguard organizations that thought

themselves knowledgeable enough to usher mankind (or at least part of mankind) through the crisis.

Saint-Simon is a perfect example. To recall Egbert again, when Saint-Simon first placed artists, scientists and industrialists on the cutting edge of social progress, his metaphysics of effect—his beliefs about causality—reflected the 'mechanistic philosophy of nature popularized in France during the Enlightenment under the influence of Newtonian thought' (1967: 340). He conceptualized the vanguard as an almost physical force capable of exerting a palpable, material influence on society through public actions, great works and the energizing manipulation of sentiment. This was a metaphysical model of a vanguard that understood it as being very good at very big projects. In that spirit, Saint-Simon visited Mexico to lobby for the construction of a trans-American canal. Barthélemy Enfantin, who led the movement after Saint-Simon's death, led the charge for a canal at Suez and, later, the Paris-Lyons-Méditerranée Railroad. Another Saint-Simonian, Michel Chevalier, promoted the building of a tunnel beneath the English Channel (and the company he founded eventually built it). It makes sense then that the earliest enthusiasts were military engineers at the École Polytechnique, right across the street from Saint-Simon's apartment cum salon. As Egbert shows, art played an essentially mechanistic role in this cosmology, serving as mere instrument, as a 'cog' (to recall Lenin's metaphor) in the great civil engineering feat of sociopolitical transformation. But here's the thing: despite the technocratic, ultra-rationalism of the Newtonian model, Saint-Simon still characterized the avant-garde as a 'priesthood', giving it a distinctly religious flavour. Perhaps this habit of mind was the consequence of the cloistered lifestyle of the engineers and their literary cheerleaders.

Nevertheless, I wonder what role this sense of priestly prerogative, this faith in the naturally ordained status and function of the technocratic avant-garde, had when Saint-Simon abandoned the Newtonian model late in his life. Egbert describes that shift in belief in some detail, reading in the late works a move from an epistemology based on mechanism (the Newtonian model of the universe as a grand clock) to one based on a vision of the cosmos 'as a kind of living organism' (ibid.: 341): 'According to this conception, each major form of society in history possesses a unique life of its own that makes it an organic totality differing from a machine in being more than merely the sum of its physical parts. Saint-Simon therefore increasingly emphasized the spiritual aspects of society' (ibid.). This

IMAGE 3.4 Reverend Billy's performance art, a priestly counter-offensive against the commercial takeover of popular neighbourhood. Photograph by Fred Askew.

'essentially Romantic idea of society', as Egbert puts it, provided Saint-Simon with the tools to map what he called *Le Nouveau Christianisme*, the title of the book he co-authored in 1825, shortly before his death. Saint-Simon's revised cosmological model downplayed technology and implied that the vanguard—particularly those that created art rather than bridges or chemical compounds—need not play a purely utilitarian function. In an organic whole where any change in a constituent element would impact all others, an avant-garde would inevitably effect change regardless of technique, strategy or location. Intriguingly, this epistemological shift catalyzed another shift: from things, machines and civil engineering to culture (and race, as I discuss in Chapter 1).

In place of canal and propaganda, Saint-Simon's second cosmological model emphasized the independent utopian community. The ideal avant-garde organization in this second model would be the 'small, closely knit, federated communities' similar to those advocated by Charles Fourier, communities 'more conducive to the personal development of their individual members' and whose impact would exert itself more indirectly but no less certainly than the technocrats (Egbert 1967: 344). As Egbert demonstrates, Saint-Simon's understanding of how the avant-garde could

achieve its goals shifted when his epistemology shifted its cosmological bases. And yet, despite the very different metaphysical assumptions of Saint-Simon's two theories—the very different 'metaphysics of effect'—his characterization of the vanguard itself stayed pretty consistent: the avant-garde was a sacred priesthood. For Saint-Simon, the artist, scientist and industrialist were never anything but a holy community, regardless of whether the universe was an enormous concatenation of gears and springs or a living, breathing, growing organism.

The consequence of Saint-Simon's religious thinking have been both humorous and dire. It's the foundational joke of performer Reverend Billy's performance-art counteroffensive against the commercial takeover of popular neighbourhoods (see Image 3.4). The Church of Stop Shopping is dedicated to 'unlocking the hypnotic power of Transnational capital'. The Reverend and the Stop Shopping Gospel Choir engage in innovative forms of anti-corporate activism, including information canvassing and creative shoplifting (such as, a ShopLIFT-a-lujah! at a San Francisco Victoria's Secret lingerie store), supporting union pickets with agitation-propaganda and blocking traffic. They have also mounted actions such as guided meditation sessions held in Disney stores, during which a leader asks the followers to 'look deeply into the eyes of the product before you, whether it be Goofy or Pluto or Donald Duck [. . .] That's right, look deeply into those fierce eyes. That's right. Return the product's stare, bond with it'.[2] If Saint-Simon had lived across the street from a drag queen bar rather than the École Polytechnique, something like Reverend Billy's church might have occurred to him, too.

The persistence of religious sensibility among intellectual elites has led in more dire directions, too. One of Saint-Simon's former disciples, the so-called Father of positivism, Auguste Comte, was thoroughly convinced that the radical intellectual and the revolutionary intellectual party had unchallengeable claims to truth. Against Saint-Simon's 'New Christianism', Comte advocated a 'New Catholicism, which, in contrast [. . .], ultimately helped to stimulate not radicalism but a Rightist movement in religion and politics, and, indirectly, a nostalgic Gothic revivalism in the arts' (ibid.: 341). James Billington has described has described how, in the 1850s and 60s, progressive Russian students 'substituted pictures of Rousseau for Orthodox medallions, wrote the words "liberty, equality, and fraternity" on crosses, and rhythmically sang out the slogan *"chelovek-cherviak"* (man is a worm) during theology lectures' (1960: 809). This substitution of objects—

which recalls Jesus' rejection of Jewish dietary law as well as Jarry's sacralization of cycling—suggests how persistent religious ways of thinking could be among those supposedly embracing the atheist rule of intellectual inquiry and hard-line science. This kind of religious/anti-religious 'mash-up' might strike us as humorous except for the fact that, as Billington notes, the word 'intelligentsia' 'acquired by the late 1860s the sense both of a group separated from ordinary humanity and of a suprapersonal force active in history' (ibid.: 812). Such a sacralization of intellectual work—and, with it, redemption from the petty insults suffered and endemic instability of the intellectual class—was partly responsible for the savagery of the mid-twentieth-century Soviet Union, savagery premised on belief in the infallibility of the Communist Party (ibid.: 808). Substitute Stalin for Rousseau on those medallions and one gets a pretty clear sense of the issue.

THE SEDITIOUS TRAIN

Saint-Simon, Comte and young Russian fanatics' contradictory attitudes toward religion were typical of their era (and, if the Church of Stop Shopping tells us anything, our own, too). The social, political, cultural and economic upheavals of the 1800s both spawned and were spawned by a veritable host of religious dissent. As Arthur Danto puts it in *Nietzsche as Philosopher* (1965),

> The nineteenth century, in its way, was as much an age of faith as was the twelfth century. Almost any European thinker of this epoch appears to us today as a kind of visionary, committed to one or another program of salvation, and to one or another simple way of achieving it. It was as though the needs and hopes which had found satisfaction in religion still perdured in an era when religion itself no longer could be credited, and something else—science, education, revolution, evolution, socialism, business enterprise, or, latterly, sex—must be seized upon to fill the place left empty and to discharge the office vacated by religious beliefs which could not now sustain (quoted in Leonard 1994: 20).

Because religion was, following Marx's critique, both affirmative and critical, it weathered the upheavals fairly well and continued to serve as an imaginative means to resolve the social, political and cultural crises of the times. Even after most feudal political and economic structures were torn down by liberal revolutions and most Western states instituted, if not the

kind of formal and legal separation of Church and State that we find in the US, at least an 'informal, *de facto* separation', religion continued to play a complex, contradictory role (N. J. Demerath and Rhys Williams, quoted in Demerath and Straight 1997). It has often been found playing that role in a variety of guises, including the epaulets and blood-and-shit-stained aprons worn by Argentine's Dirty Warriors.

Not unlike Videla and his lackeys, who saw vanguards lurking in every high school and bedroom in Argentina, the Reverend Bradshaw, in *A Scourge for the Dissenters; or, Non-Conformity Unmasked* (1790), saw in the British multiculture a profound threat to British civilization and advised the authorities of the modernizing British state to tread with caution on established religious authority. Written to sway the 1828–29 debate on the repeal of the Test and Corporation Acts—passed in 1673 to exclude Roman Catholics, Protestant Dissenters, Jews and atheists from civil and military office—*A Scourge* warns against a horde of metaphysical vanguards:

> the numberless multitude of Presbyterians, Independents, Anabaptists, Antinomians, Muggletonians, Swedenborgians, New-Light-Men, Sandemanians, and the various motley description of modern Schismatics aided by the Turks and Infidels of all names and nations, with Lord George Gordon at their head and Jewish priests sounding the horns of sedition in his train (quoted in Rix 2003: 163).

The tension between anti- and pro-religious sentiment in Bradshaw's polemic is typical in modernizing states, being both the spur to a multitude of grass roots and vanguards and the forces deployed against them.

One example is Guatemala. N. J. Demerath and Karen S. Straight point out that, while it was originally a Catholic state in which 'indigenous religious alternatives' were legally condemned and persecuted, it 'severed these state religious ties by the end of the nineteenth century. However, informal ties have persisted in varying forms' (1997). That persistence of Christian belief in the highest echelons of a supposedly secular state has, over the last few decades, nourished the hard line in its struggle against a hardy guerrilla opposition movement that is sustained by a widespread Maya religious revitalization among indigenous people, a resurgence I shall discuss below.

In China, a strong secular state (notwithstanding the deification of Mao and the Communist Party), there has been energetic debate about whether or not Marx was correct to claim that religion was the 'opiate of the masses'

(ibid.). This is a vital debate indeed, as China must contend with its Christian, Buddhist and Islamic religious communities—and the nascent vanguards who see no hope of change within the current political system. Many within India have also called to question the application of 'Western secular forms of government to an Eastern cultural reality that required a unique state response. [. . .] The very imposition of Western secularism has served perversely to fan the flames of religious politics by forcing religious advocates to adopt increasingly more extreme measures to make their case' (ibid.). Comparable examples can be found throughout the Middle East where secular-nationalist states found their legitimacy called into question by Islamist movements. This began in the 1960s—precisely the moment when the promises of modernization were first betrayed by authoritarian, anti-democratic regimes. Japan has seen the relation between religion and state in a state of intense flux since the 1860s—a flux so intense, apparently, that it more or less baffles systematic analysis by the sociology of religion (see ibid.). The 1995 attack on the Tokyo subway system by the radical Buddhist organization Aum Shinrikyo and the subsequent trial of its leader Asahara may have been a crystallizing moment. Demerath and Straight characterize the recent push to monitor religious movements in Japan as a 'sea change in state policy toward religious groups generally', essentially 'licensing the government to fish in deeper waters for its opposition prey' (ibid.). Ireland and Israel also come to mind as cases where the status and power of the state are inseparable from religious concerns and where this inseparability enables various kinds of pro- and anti-state movements.

More than a few advised right from the start that the whole mess just be tossed. Though neither an influence on the avant-garde nor a vanguardist himself, Thomas Paine has earned a solid reputation among atheists and the commendable status as the one 'Founding Father' most US conservatives would like to see trimmed from the family tree. Though properly considered a deist (believing in the divinity of creation but denying the continuing involvement of deity), his unstinting attacks on the overt and covert religiosity of authority, his abolitionism, anti-clericalism, anti-establishmentarianism and beliefs about property are hardly sympathetic to those who would like to view the US and its current economic structures as god-decreed. Paine's critique of religion and religiosity produced some deliciously barbed quotes: 'The Bible is a book that has been read more and examined less than any book that ever existed'; 'Priests and conjurors are of the same trade'; 'A people accustomed to believe that priests or any other

class of men can forgive sins [. . .] will have sins in abundance' (1845: 143, 173, 194).

Another patron saint of atheism, though like Paine a deist, Voltaire occupies an equally noteworthy position in avant-garde history. Voltaire's intransigent and pungent critiques of religious epistemology and establishment in the 1700s were part of a broader advocacy of freedom of speech, press, assembly and political representation that earned him the enmity of kings and clerics alike. Like Paine, he believed that no real sociopolitical change could occur unless metaphysical thought of all kinds was purged. Voltaire and Paine do not advocate any particular form of vanguardism in their works; however, their emphasis on the interrelationship of epistemology, institutions, cultural practices and the body provided the grounds for any number of subsequent avant-gardes, not least the Dadas of Zurich, who named their cabaret cum headquarters the Cabaret Voltaire.

With the possible exception of Marx, the most important atheist influence on the avant-garde was that bad boy of Western metaphysics, Nietzsche. Nietzsche mounted a thoroughgoing critique of Christianity in *On the Genealogy of Morals* (1887) and *Thus Spoke Zarathustra* (1883–85), arguing that it was a 'slave religion' premised solely on the need to restrain the more powerful, abrogate to a single authority all claims to creativity and judgement and denigrate earthly existence in favour of an afterlife. Beyond his critique of Christianity, Nietzsche attempted the more difficult project of thinking outside metaphysics altogether. His exploration of the Dionysian roots of Western culture's cult of reason, his relentless pursuit and defence of philosophical relativism and his efforts to imagine an ethics without recourse to metaphysical absolutes echoes in any number of subsequent vanguardists and vanguard movements, as well as more recent movements that have called into question the metaphysical presumptions of the avant-garde itself.

Nietzsche's influence on the art-world vanguard is as varied as it is ubiquitous. Playwright August Strindberg embraced Nietzsche enthusiastically—in fact, downright orgasmically. After reading *Beyond Good and Evil* (1886), he wrote, 'The uterus of my mental world has received a tremendous ejaculation of sperm [. . .] so that I feel like a bitch with a full belly. He's the man for me!' (quoted in Ewbank 1997: 340). The feeling was mutual, the philosopher finding the play *The Father* (1887) a solid effort to 'transvaluate all values' (barring, one presumes, the 'values' of

misogyny) (see Robinson 1998: xv). The German Expressionists also followed Nietzsche in his quest for primal experience, precision and rigour in the examination of psychology and ambivalence toward political activism (see Taylor 1990: 3). Georges Sorel, a follower of Nietzsche by no means ambivalent toward activism, formulated a theory of 'social myths' like the general strike, advocated violence and revolutionary syndicalism and asserted that cultural decadence could only be stopped by a strong leader—all the results of reading Nietzsche. Sorel's thought would, in turn, influence Marinetti and the Futurists, who were already interested in Nietzsche. Marinetti's *Mafarka il futurista* (1911; *Mafarka the Futurist: An African Novel*, 1998) has a Nietzsche-style superman as protagonist. Christopher E. Forth has traced the influence of the philosopher on the Cercle Proudhon, a monarchist, nationalistic organization founded by students at the École des Sciences Politiques in 1911 and devoted to revitalizing the nation according to the 'highest' standards of French culture. Forth makes a good case that the Cercle was the first true fascist organization, advocating the vitality of youth, the historical necessity of the overman and the hygiene of war (2001).

Renegade Surrealist Bataille was an insightful and dedicated reader of Nietzsche. In *On Nietzsche* (1945), Bataille explored the guilt he felt towards abandoning his blind father, his conversion to Catholicism and his efforts to define and experience a mysticism without god. Bataille passed on his resolutely leftist reading of Nietzsche to the intellectuals of the *Annales* journal, among them Foucault. This group would, in the 1960s and 70s, advocate a method of reading and writing history that rigorously refused metaphysics and the binary thinking that metaphysics promotes, placing new emphasis on the material practices of culture. Their efforts to disrupt traditional historiographical methods through the critical application of Nietzsche's genealogical method not only highlighted long-forgotten thinkers and social groups but also suggested to others new ways to think about and practice political, cultural, military and aesthetic activism; in other words, new ways to think about the avant-garde.

MYSTICISM, OCCULTISM AND THE AMBIGUITIES OF MODERNIST RATIONALITY

In addition to carrying on the work of undermining established religions, avant-gardes have also used metaphysical speculation and alternative

spiritual practices to carry out less explicitly confrontational missions: to reveal and cross experiential and epistemological borders; to explore other cultures' religious experiences; to go 'outside' conventional ways of thinking, institutions, cultural practices and body experiences. A number of such tendencies can be linked to one specific religious tradition: mysticism. Egbert notes that many European philosophers and writers were 'stimulated by oriental mysticism, especially that of India'. Though not necessarily avant-garde themselves, such writers exercised a profound influence on those who would claim the title: Herder, Schlegel, Schelling and Fichte in Germany (Schopenhauer, too, though Egbert overlooks him); Hugo, Leroux and Saint-Beuve in France (Egbert 1970: 184–5). Nobel Prize-recipient Romain Rolland comes to mind as a more explicitly avant-garde mystic. A former syndicalist and enthusiast of composer Wagner, non-combatant pacifist in the First World War, co-founder of the Association des Écrivains et Artistes Révolutionnaires in 1932, inspiration to radical theatre director Erwin Piscator and persistent refuser of Communist Party discipline (though an apologist for Stalin), Rolland studied the works of Tolstoy, wrote on Ramakrishna, Vivekananda and Gandhi and showed a life-long interest in Christian mysticism (see ibid.: 305–06). Rolland's interest in Eastern religions was shared by many Modernist poets who challenged literary convention, though not necessarily political convention, including T. S. Eliot, Ezra Pound and Wallace Stevens. Eliot, in fact, studied with the founders of Orientalist studies at Harvard and other Modernist poets incorporated Indic philosophy into their poetry and plays. Tom Gibbons has examined the influence of mysticism on W. B. Yeats, Havelock Ellis and Arthur Symons. Doing so, he challenges the conventional wisdom that the concept of the 'fourth dimension', an idea that one finds in the works of Picasso, Duchamp and other Modernist artists, was inspired by Einstein and his Theory of Relativity (2003). In fact, as John F. Moffitt makes clear, the term had been around since the 1890s thanks to German astronomer J. C. F. Zöllner's *Transcendental Physics* (1881), a book that attempted to explain the séances of American spiritualist Henry Slade in scientific terms (Moffitt, quoted in Gibbons 2003: 83). The patron saint of Modernist rationalism, architect Le Corbusier, reproduced a letter addressed to him from the theosophist J. Krishnamurti in his 1935 manifesto *La Ville radieuse*, though Krishnamurti's impact on Corbusier's design theory is difficult to detect. Mysticism played a role at another milestone of Modernist aesthetics, the

Bauhaus school of Weimar, Germany. Johannes Itten, the originator of the design course, was an Expressionist with 'strong "Mazdaznan", or near-Zoroastrian, leanings' (see Egbert 1970: 673). The individualistic, subjectivist nature of this leaning led the rationalist, group-oriented Bauhaus founder Walter Gropius to replace him in 1923 with László Moholy-Nagy, a hire that initiated the school's move towards a full-fledged (and arguably less politically inclined) Constructivism.

Occultism is a part of the story, too, though its role has been obscured by popular prejudice. In common parlance, 'occult' means 'satanic'. In fact, the term means simply 'hidden' and refers to a tradition of esoteric thought and magical practice that devotees trace to ancient Egypt and preclassical Greece. Though always outside the religious mainstream, occultism has not always been demonized like it is today: 'in the ancient world and until the end of the Renaissance, magic was seen not as superstition, but as a logical and coherent means of understanding the universe and controlling ones destiny' (Stavish 1997). However, after the Renaissance, esoterism was persecuted by authorities who disapproved of the way in which the esoterics subverted dogmatic readings of religious texts; granted to the laity the right to unmediated access of the godhead; and mixed science and religion. The improper use of sacred objects was at least partly responsible for the persecution of occultists. Given their tendency to 'use the same signs, symbols and literature as contemporary religions—Christianity, Judaism and Islam' (ibid.)—it is not surprising to find it the continual target of authorities intent on shoring up church power and dogma.

Combined with the inherently complex and difficult nature of the stuff, the risky thrills and inherent anti-authoritarianism of occultism proved attractive to many, leading during the seventeenth, eighteenth and nineteenth centuries to the founding of secret orders and societies across Europe and the Americas such as the Freemasons, Rosicrucians, Illuminati and Knights Templar. I shall leave it to the reader to wade through the vast body of literature on these organizations, a great deal of it simply loopy, but it is undeniable that occultism was an epistemological and practical principle for those who fought for change. Indeed, the notion of 'instruction in esoteric practices limited to a trusted few [. . .] through a process of slow, careful, symbolic rituals and cryptic teachings', to recall Stavish's description (ibid.), has been of interest not only to those who promote cataclysmic change in the social and political order but also

for those who, either by choice or force, have to keep their critical posi-
tions and intentions limited to a small group or who wish to secretly
explore ways of thinking and living that would otherwise draw the atten-
tion of the police. The avant-garde, in other words.

Occultism's implicit anti-authoritarianism and elitism complements
Saint-Simon's second, Romantic/organic notion of the avant-garde, the
one that sees imagination lead the way into the future in the hands of a
disciplined, sophisticated cadre of creative intellectuals working in secret,
assured of their ultimate influence on global culture. Paris had former
Catholic priest Alphonse Louis Constant, better known as Eliphas Levi,
who unleashed the occultist tide in 1856 with *Dogme et ritual de la haute
magie*. Gary Lachman writes that Levi not only supplied his fellow
Dissenters a fully built system to overturn the religious establishment
without overturning metaphysics but he also gave those Dissenters a way
to claim status equal to the scientists and technicians garlanded by the
propagandists of capitalist-imperialist 'progress' (2004). Occultism was
understood by Levi to be a science leading to the future. Saint-Simon, at
least the Saint-Simon who appeared during the last weeks of his life,
would applaud.

Another group that explored the boundarylands between science and
religion were the alchemists. Though, like mysticism and occultism, it is a
tradition far older than modernity and far broader than the geographical
boundaries of Europe, alchemy's efforts to rigorously understand the nat-
ural world without renouncing philosophy or spirituality was especially
attractive to those who struggled for a better world within European
modernity. Though most often associated with the fabled quest for the
'philosopher's stone', alchemists are properly credited with more utilitar-
ian discoveries, including the invention of gunpowder; methods to test
and refine mineral ores; the development of new inks, dyes and printing
processes; and a range of other distillation and purification processes still
in use today.

Strindberg is an especially intriguing figure in the alchemic history of
the avant-garde, for he was not only one of the most daring and innova-
tive playwrights of his day but also a cutting-edge chemist. In fact, during
an extended visit to Paris beginning in 1883, he stopped writing literature
altogether and spent serious time with his crucibles. The consequences
were more than just burned fingers and an unvanquishable stench: his
experiments were discussed in the leading French publications *La Science*

Français and *Le Figaro* and he was given permission to conduct further experiments at the Sorbonne. His work with sulphur drew the attention of an engineer at a chemical factory in Rouen who lauded it for explaining 'hitherto unexplained phenomena in the manufacture of sulfuric acid and sulfides' (quoted in ibid.). We shouldn't think that Strindberg's alchemical experiments had nothing to do with his art; indeed, there may be a direct influence. While attempting to produce gold in a zinc bath, he saw a 'landscape' formed by the evaporation of ferric salts, 'small hills covered with conifers . . . a river . . . the ruins of a castle' (quoted in ibid.). Both image and process should remind one of *A Dream Play* (1901), that masterwork of avant-garde drama, in which back alleys transmogrify into industrial wastelands which, in turn, sprout castle keeps.

Though it would be incorrect to characterize Surrealism as an occult movement, Rosemont reminds us that many of its members paid tribute to and were inspired by the counter-tradition of European religious thought 'exemplified by Giordano Bruno, the alchemists, and hermetists', a group that 'profoundly influenced the poetic underground in which the founders of Surrealism first recognized themselves: the work of Gérard de Nerval, the Comte de Lautréamont, Arthur Rimbaud, Saint-Pol-Roux and Jarry' (1998: 24). (For more on Surrealism and the Occult, see Choucha 1992.) Among those in this occult genealogy of Surrealism, we find the fascinating Afro-Caribbean American abolitionist and 'Sex Magick' worker Paschal Beverly Randolph, a leader of the nineteenth-century occultist movement admired by, among many others, Frederick Douglass. Hugh Urban notes his role as an intercultural mediator, a traditional role for the vanguardist:

> In the course of his wanderings in the Middle East, Randolph claimed to been initiated by a group of Fakirs in the area of Jerusalem, which may have been a branch of the mystical order of the Nusa'iri—a group long persecuted by orthodox Islam because of their alleged Gnostic sex rituals. Upon his return to the United States, Randolph began to teach a form of sexual magic that would have a profound impact on much of later Western esotericism (2003).

On both religious and sexual grounds, Randolph advocated equality between men and women.

Though abolitionists were not avant-garde per se, Randolph and the Surrealists remind us that there were significant vanguard tendencies

within the movement. This link is not altogether surprising once we delve into the history of occultist abolitionism in more detail. Douglass, for example, was a vocal critic of establishment religion for its explicit and tacit support of slavery and regularly attended séances. Nellie Colburn Maynard held sessions at the Lincoln White House and claimed, second-ed on this point by First Lady Mary Todd Lincoln, that the decision to emancipate the slaves was sparked by a spirit message to the wavering president. Douglass, William Lloyd Garrison (firebrand editor of the abolitionist paper *The Liberator*) and Wendell Phillips were all frequent guests of Amy and Isaac Post, themselves friends and collaborators of Kate Fox, perhaps the most celebrated medium of the day. In her biography of the Fox sisters Kate and Maggie, Barbara Weisberg notes that 'from its inception, spirit communication had attracted reformers who rejected the established order, whether in religion, politics, or social convention' (2004: 118–19). Such dissidence was persistently attacked by the Communist International and was the target of both Left and Right in the US too.

Randolph's efforts to synthesize occult speculation, social radicalism and sex is not unique, though the way he did it was. Religion, as I have noted, gives *body* to belief. Occult abolitionism is indicative of the kind of farsighted political vision that can be had when the body's relationship to authority is explored in spiritual terms but it is also a symptom of the cultural and political vulnerability of heretical religious movements to those who police the body. Kate Fox was a frequent target of sexual prudes who disapproved of the public, theatrical display of femininity as well as the intimate contact of hands and feet that were characteristic of séances. Advocacy of 'free love' by a small group of ultra-leftists earned the early feminist movement both publicity and disrepute, dampening its force and catalyzing a broader crackdown on freedom of expression and press. Molly McGarry has shown that the first national obscenity law in the US— the so-called Comstock Law of 1873—was initiated by popular outrage over the spiritualist, feminist and free-love advocate Victoria Woodhull. The law was passed specifically to stop the distribution of Woodhull and her sister Tennessee Claflin's newspaper, which published both occultist material and missives from Marx (McGarry 2000: 9). McGarry highlights an even deeper connection: Anthony Comstock, the namesake of the law, saw obscenity in essentially spiritualist terms, describing it as a host of 'vile phantoms' that 'haunt the mind' and challenge the boundaries between

the decadent public sphere and the sacred space of the bedroom (ibid.).
Obscenity, for Comstock, quite literally haunted the US, threatening the
body politic with strange sensations and threatening messages—very
much like the avant-garde, come to think of it.

EMANUEL SWEDENBORG, SYMBOLISM AND THE MATERIAL IDEAL

If sexuality and corporeality—the body—were the galvanizing issues bind-
ing occultists and the morality cops, the question of religion as institution,
as a basis for social organization, was the issue for perhaps the most influ-
ential mystical/occultist tendency in the avant-garde—Swedenborgism.
Though critical of institutionalized religion, Emanuel Swedenborg was not
an avant-gardist in the sense I use—a minority tendency engaging the core
problems and possibilities of political modernity. However, his interest in
the natural sciences and mathematics and his devotion to practical theolo-
gy excited many a tried-and-true vanguardist in the nineteenth century.
Swedenborg's theology begins with an essentially biblical concept (see
Balakian 1967): that the correspondence of material and idea, emblema-
tized by man's creation in the image of god, has been lost by modern man.
Our fall from grace, Swedenborg explains, occurred in both the material
and representational realms. Thus, the most important spiritual quest for
man is to find a way to restore 'every natural, physical vision [. . .] its
penumbra of spiritual recognition', thus strengthening 'communication
between the Divine being and man'. The goal of the quest was the true
symbol, a 'phenomena in the physical world that had a dual meaning, one
recognizable to the earthly perceptions of man, the other to his spiritual
ones' (ibid.: 13). This idea that there is a hidden 'correspondence' between
the material realm—the realm of objects, images and, especially, words—
and the spiritual inspired avant-gardes who attempted to walk the difficult
line between materialism and idealism during the 1800s.

Though not inherently avant-garde, the effort to find such a balance
could veer in that direction. Robert Rix has explored the blurred bound-
aries between mysticism and political radicalism in Swedenborg's thought,
particularly as it influenced the life and art of British Romantic poet and
visual artist William Blake (see Rix 2003). Inspired by Swedenborg's call
for a conference of those 'desirous of rejecting, and separating themselves
from, the Old Church, or the present Established Churches' (quoted in
ibid.: 158), William and his wife Catherine were among the 77 signatories

to a letter composed at the 1789 meeting proposing the terms for such separation. With this in mind, Rix takes issue with the tendency of scholarship to 'separate Blake's interest in occultism from his political radicalism' (ibid.: 159; a tendency, I note, also found in Yeats scholarship). Balakian would agree with Rix on this, arguing that Blake's rejection of established religion and his quest for the 'elimination of the distinction between body and mind' through an 'intensification of sensory acuteness' stems from a socially oriented radicalization of tendencies inherent to the aesthetic dimensions of Swedenborg's theology (Balakian 1967: 28). Though Swedenborg did not directly support any radical group or movement, his belief in individual illumination and 'True Religion' gave confidence to those chafing under the control of the establishment. This was particularly the case in England, where some were inspired to ask dangerous 'questions relating to modes of government, both ecclesiastical and civil', as one Anglican minister complained (quoted in Rix 2004: 161). Swedenborg, to play with the Reverend Bradford's metaphor a bit longer, was the head of a very long and accursed train.

Swedenborgism may have played a broader role in the political upheavals of the late eighteenth and early nineteenth centuries by way of the subversive Académie des Illumines Philosophes, founded in 1787 by Antoine-Joseph Pernety and Count Tadeusz Grabianka to replace the defunct Society at Avagnon, a Masonic organization active in the papal city in southeastern France since 1779. Though their role in and impact on the French Revolution cannot be firmly established, many conservatives of the time were perfectly sure about the matter and damned the organization and its radical religio-mystical politics for 'having played an active role in the Revolution, or being directly responsible for it' (quoted in ibid.: 165). Another hotbed of religious dissent and vanguardist plan-making were the Sunday morning gatherings of Londoner Jacob Duché, parties where 'the Masons' heady blend of mystical ideas and radical politics [. . .] trickled down to segments of the lower orders' (ibid.: 167). Speculation aside, Rix concludes, 'There is no denying that, for many Swedenborgians, spiritual and political regeneration were handmaidens' (ibid.: 170).

The Theosophical Society, founded in 1875 in New York by Helena Blavatsky, Henry S. Olcott and William Q. Judge, energetically propagandized Swedenborg's theories, promoting a spiritualist movement whose connections with radical reformist thought was well established. Though its founding document stipulated that members must 'be free from all

exacting obligations to society, politics, and family', it also obliged them to 'be ready to lay down his life [. . .] for the good of Humanity, and of a brother Fellow of whatever race, color, or ostensible creed' (see Blavatsky 1878). This combination of iconoclasm and humanitarianism attracted cultural activists uncomfortable with regular party membership. Egbert claims that this urge to move beyond dogma and materialism while still supporting the practical development of a Universal Brotherhood of Humanity led many Theosophists towards the radical side of socialism. This enabled those who were uncomfortable with Christian Socialism (for example) and its conservative social and cultural tendencies to retain in their own work both a metaphysical focus and an experimental aesthetic and organizational edge in the struggle for economic and social justice (Egbert 1970: 435).

Annie Besant is a case in point. Though not properly considered avant-garde, her work shows the urge to unify the various spheres of power that is characteristic of many modern vanguards. Member of the National Secular and Fabian societies, unstinting supporter of free speech, trade unions and women's reproductive rights, she found in Theosophy the all-inclusive philosophy that could address the need for transformation simultaneously in the personal, community, social and global orders. She would later promote the Theosophical Society in India through the Indian Home Rule League, an organization she co-founded with Gandhi in 1914 and for which she served as president two years later. The League would provide organizational, financial and propaganda support to the anti-British resistance movement and worked hard to improve Hindu–Muslim relations.

Theosophy's combination of exoteric (or public) and esoteric (or secret, cloistered) doctrines was especially attractive for those who understood the cultural, political and historical crises of modernity as both personal and systemic—and both as fundamentally spiritual. In this respect, the conceptual revolution of the feminist and civil rights movements in the US during the 1960s—premised on the shattering notion that the personal is political—can be understood as having deep roots. Though by no stretch 'feminist', the French artist group known as Les Nabis (The Prophets) was one of many vanguards that understood that linking the public and private spheres could inspire art and promote new and potent kinds of cultural activism. As a result of their study and discussion of the theories of colour, music and symbology published by the Theosophical Society—inspired by Gauguin's call to renounce the 'abominable error of naturalism'—they grew to view painting not as a pseudoscientific recording

of light on retina, as the Impressionists had trumpeted, but as an intensive, personal method for achieving spiritual experience.

This inner-directed exploration of colour and creation was complemented by their public role as activists. They collaborated with Félix Féneon, art critic for the anarchist magazine *Revue blanche*, providing both illustrations and publicity posters. Les Nabis also worked with Aurelian-Marie Lugné-Poë at the Théâtre de l'Oeuvre, generally considered (along with Andre Antoine's Théâtre Libre) the most radical Parisian avant-garde theatre of the time, admired for its staging of both experimental Symbolist works and the later, socially and spiritually radical plays of Henrik Ibsen. Russian composer Aleksandr Scriabin also took on the Theosophical quest for the unity of personal and public through creative activity. Maria Carlson describes Scriabin's compositional efforts as 'based [in the] theory that the creation of magic was a theurgic act, an act of magical, even divine creation, directly on Theosophical doctrine'. As a form of 'religious action', of 'synthesis of matter and thought', music was very much a medium that could synthesize private quest and public display (Carlson 2000).

If Les Nabis and Scriabin sought synthesis, the international Symbolist movement found in the experience of mystery a robust means for the construction of a transnational minoritarian identity that could weather the spiritual crises of modernity and resist the rise of mass media and mass man. Balakian writes, 'The Symbolists were [. . .] imbued with the notion that the foremost mission of the poet, particularly in a materialistic age, is to recapture the sense of the mystery of existence' (1967: 80). Their literary high priest Stéphane Mallarmé wrote, 'Whatever is sacred, whatever remains sacred, must be clothed in mystery' (quoted in ibid.). Like Gautier, Mallarmé 'felt that, in a society that made no official place for, nor gave any recognized rank to the poet, the poet did not need to concern himself with society. He had the right to withdraw from the circle of social action, to work in solitary or in sheltered surroundings' (quoted in ibid.: 80). Thus, the poetic, visual and theatrical exploration of mystery was not just a way to throw off philistines; it could also be the foundation for a radical community. The purposeful obscurity of Symbolist artwork was intended to give sympathetic readers a verifiable sense of belonging to a small, secret society whose members could appreciate certain subtleties of verse, who could effectively utilize the theoretical vocabulary underwriting it, who knew where to find the right magazines and could recognize them at a glance in a crowded cafe.

In this respect, 'mystery' should be understood not just as a way of knowing (an epistemology) but also a way of living (a cultural practice). A little magazine or the ability to speak to questions of 'poetic correspondence' were the material markers of community identity—the *fin-de-siècle* version of the fish drawn in the sand by early Christians (or glued to the back of a minivan, as many Christians do today). Yet all involved knew that such material markers were only paltry reminders of the beyond, access to which was persistently threatened both by the crass materialism of capitalism and the banal morality of mainstream socialism. Regardless, the idea here was that aesthetics and sociality were indistinguishable from larger historical tendencies—which is why the Symbolists more often referred to themselves as 'Decadents', an identity that promoted, in Calinescu's words, 'an aesthetic modernity that was, in spite of all of its ambiguities, radically opposed to the other, essentially bourgeois, modernity, with its promises of indefinite progress, democracy, generalized sharing of the "comforts of civilization", etc.' (1987: 162).

The notion that one could find in art that purposefully flouted clarity and certainty a 'convergence of a historical and mystical state', was an inspiration to many, not least to those who resisted the comforts of civilization' in Europe's colonial empire. This is evident in Yeats' work: his Byzantium poems, his interest in the Celtic myth of the poet Forgael and his belief in the radical power of theatrical performances designed for small, select audiences. In his short play *The Shadowy Waters* (1883), Yeats portrays Forgael using his harp to compel his crew and captives to sail to a realm beyond earthly memory and the foolish belief 'that gold and women taken in war / Are better than the woods where no love fades / From its first sighs and laughter' (Yeats 1900: 28). Intended for an intimate theatre—a cênacle in which the initiated could share a common experience of transcendence—Yeats' play aesthetically depends on and socially promotes an intertwining of mystical knowledge, social belonging, cultural practice and a performative unity of spirit and body.

More practically, as Innes has described it, plays such as *The Shadowy Waters* and *The King of the Great Clock Tower* (1935) use ritualized movement and silence to produce a 'gulf of distance' that allowed Yeats to ' "hold against a pushing world" and to de-emphasize the physical qualities of drama, allowing the restoration of "the ancient sovereignty of words" '(Innes 1981: 7). However, I disagree with Innes that this would disqualify Yeats as an avant-gardist. In fact, Yeats' refusal to 'merge audience

and action' or to 'induce trance states' that 'are active and tend toward convulsion' (ibid.), is the mark of a distinct—and distinctly religious— model of avant-garde dissidence that is particularly relevant when we juxtapose it with the nascent cultural nationalist movements that emerged in the early twentieth century to challenge European colonialism. Further, Innes doesn't map the connections between Yeats' theatrical strategies, his elitism and his fascism—a very different political perspective from anti-colonialism but no less relevant to the study of the avant-garde. George Orwell made no such mistake, writing of Yeats that, 'throughout most of his life, and long before Fascism was ever heard of, he had had the outlook of those who reach Fascism by the aristocratic route. He is a great hater of democracy, of the modern world, science, machinery, the concept of progress—above all, of the idea of human equality' (Orwell 1943). Rich soil for right-wing vanguardism.

Fascism was certainly not the rule among the Symbolists who were attempting to revitalize the correspondence between the material and the ideal. This effort, always understood by the Symbolists as an attack on capitalism (Mallarmé saw his poetry as a kind of 'general strike'), was complemented by efforts to promote international artistic coalition, at its most liveliest between Western and Eastern Europe but also with artists, critics and activists in Southeast Asia and Latin America. Mystery and obscurity, generally understood by historians as a way to retreat from reality and deny the materiality of artistic production, was, in fact, a conscious response to the intrusive materialism and bottom-line brutality of *fin-de-siècle* European hegemony—and an effective matrix for international, intercultural collaboration. Many Symbolists were ardent and active anarchists and, as such, critics of centralized authority and proponents of local autonomy in organizational matters. In other words, they were inherently hostile to the grand narratives of capitalism, colonialism, liberalism and socialism. Hardly a retreat into passivity, the spiritualist-influenced embrace of mystery, obscurity and *l'art pour l'art* can be understood as an effort to devise a language and practice of international cooperation in resistance to rapidly expanding capitalist-colonialist networks of transport and communication. We can argue the validity of such a position, no doubt, but that argument must account for the facts. Again, sometimes a private gathering of like-minded individuals can spark big changes.

The Swedenborgian correspondence of material and ideal helped promote globally oriented cultural-nationalist movements in India, Mexico and Ireland by suggesting new ways to act locally and think globally. In particular, they promoted the exploration and revaluation of older, indigenous cultural traditions that, according to Swedenborg, were more attuned to the universal correspondence of world and spirit. Symbolist critics and artists promoted the study of Celtic culture in Ireland and Brittany and Sanskrit and Bengali culture in the Asian subcontinent, abetting in both cases anti-colonialist struggle. Though this sort of primitivism should be approached with scepticism, its practical power is beyond doubt: Symbolism was able to cross national boundaries with ease, manifesting not only in France, Great Britain, Italy, Spain, Portugal, Ireland and other Western European nations but also in Greece, Poland, Russia, Romania, the Ukraine, Latvia, Lithuania and India.

THE JANUS FACE OF RELIGIOUS VANGUARDISM: BECKMANN, NOLDE, TOLLER

A more overtly political and directly materialist critique of established religion is apparent in German Expressionism. Expressionism's painterly roots can be traced to the work of Van Gogh, Ensor and Munch, all of whom used religious themes in their work, rejected the subdued palette of their times in favour of intense, almost hallucinatory primary hues and viewed painting itself as a visionary act. The movement found its way to just about everywhere alienated, artistically inclined youth gathered, which was basically all over the modernized world. It is characterized first and foremost by emotional intensity. Expressionists dwell in a world of 'revolt, distortion and boldness of innovation'; '[t]hey rebelled against propriety and "common sense", against authority and convention in art and in life' (Sokel 1963: ix). This rebellion was, for many Expressionists, grounded in the desire to renew spirituality in art and, by doing so, unify self, society and history. The form this unification might take was varied, as is apparent in Germany. The pioneering Die Brücke (The Bridge) group explored the spiritual potential of abstraction; Kandinsky sought 'to awaken [the] capacity for experiencing the spiritual in material and in abstract phenomena' (1977: 1). Unlike their abstractionist brothers, other Expressionists studied and emulated the indigenous folk traditions of Germany, particularly those of the medieval period and non-Western traditions such as West African wood carving.

Max Beckmann is typical of this second approach, and we see this in his appropriation of the triptych form, the large, three-panelled structure often used as an altar backdrop in Christian churches. His most notable work in this vein, *Departure* (see Image 3.5), was begun in 1932, a year that saw the Nazi party acquire its largest voting bloc. Some have seen the piece as an oblique comment on that situation and the brutarian role of religion in it but the evidence is not certain. The left and right panels depict scenes of striking violence: both display individuals bound and vulnerable to abuse and torture; the left with a man swinging a massive hammer, the right a man beating a drum. The centre panel depicts an overtly biblical scene and theme: three figures stand on a fishing boat, one wearing a crown, one holding an infant; a net in the lower right holds fish, echoing the notion of Jesus as 'fisher of men'.

Beckmann uses the triptych form to two ends. First, the three-panel structure enables him to heighten the contrast between violence and peace and the material and the spiritual in a manner fairly close to the traditional triptych style. In this respect, the antique form echoes the Modernist technique of montage or juxtaposition. Second, by using a genre generally associated with sacred spaces, Beckmann comments on both the degradation of spirit in the modern era and on the kind of role the artist must play in the battle against such degradation. The triptych speaks to the essential homelessness of art—it is never in the space for which it is designed—and to the growing irrelevance of art, always already an antique, like the triptych itself. The symbolism is similarly alienated. H. W. Janson notes that the fish, a biblical symbol that served early Christian communities as a passcode, serves Beckmann here as a symbol of male creative force and spirituality. Similarly, Jungian critic Armin Kesser believes that the symbol of the fish expresses not only fertility, lucky destiny, creativity, but at the same time the soul, Christ, and the redemption. *Departure* plays across all five aspects of religion as they concern the avant-garde—epistemology, institutionality, cultural practice, the body and things—utilizing them to both critique and affirm Christian belief as a way of expressing the alienation of the modern artist.

Ernst Toller's play *Man and the Masses* enjoyed a highly successful run with Jürgen Fehling's production at the Berlin Volksbühne in 1921. It uses traditional religious material to modern ends; specifically, the narrative structure of the medieval morality play. The 'strongly moral, essentially

IMAGE 3.5 Max Beckmann's *Departure* (1932). Courtesy: Corbis.

Christian belief in the possibility of man's regeneration and rebirth through love' that is typical of much Expressionism is clear in this play, whose 'alienated hero is in quest of salvation' (Dukore and Gerould 1976: 52–3). Sonia Irene L. (aka the Woman) is the charismatic leader of a workers' rebellion but finds herself torn between her ideals of social justice and the pragmatic realities of social, economic and political upheaval. As with Beckmann's *Departure*, montage is the rule here. Toller alternates scenes depicting the masses debating whether or not to embrace violence with 'visionary pictures' of corrupt capitalists advocating 'national brothels' and an equally corrupt judicial system that ultimately condemns Sonia to death.

Described this way, the play might seem to be little more than a simplistic transposition of agitation-propaganda techniques into the salvation drama genre—the working class as Everyman. However, Toller does more than this, focusing the conflict of the play not just on the struggle of the masses and the capitalists but also on the individual struggle of Irene. This complementary conflict is anchored in her relationship with a husband who has sworn loyalty to the state. Their first onstage meeting is charged with sexual heat, underlining the significance of desire—for sex, for children, for peace—to their salvation quests. Toller will ultimately displace the relationship of wife and husband to that of revolutionary and priest, as we see in the final scenes. On the eve of her execution, Irene intones, 'I live forever / From sphere to sphere / From change to change / Till some day I become / Clean / Guiltless / Mankind.' A priest enters, offering her a 'final consolation' she angrily rejects. 'By whose orders?' she asks. 'The State authorities directed me,' he replies. 'Where were you on the day of the trial?' she screams. 'Leave me!' He refuses and tries to convince her that the world is merely 'a constant changing of forms [. . .] Salvation rests in God'. She refuses again: 'I believe!!! I am cold [. . .] Leave me! Leave me!' Her affirmation of belief is not the priest's but the revolutionary masses', whom we see scrabbling for bread, a mirror and a silky cloth. One of the prisoners pauses and asks, 'Sister? Why did we do that?', 'breaks down,' and 'buries her head in her lap' (see Toller 1976). Thus, Toller's play abides by the antique structure of medieval morality plays such as *Everyman*, *The Castle of Perseverance* and *Mankind*, all of which depict in allegorical form the progress of a single character, representing all of mankind, through a world populated by personifications of virtue, vice, death, penance, mercy, patience and so on, and which, by and large, represent the world as irredeemably fallen. However, his play is shaped by a

distinctly modern concern with sex, dialectical materialism and mass-based social reform. Finally, it makes effective use of new theatre technologies, especially electric lighting, giving it an irredeemably modern character.

A similarly Janus-faced glance toward Jesus and Christianity can be found in the work of Emile Nolde, who painted a series of works depicting the life of Jesus as well as biblically themed pieces like *Dance Around the Golden Calf* (1910) and *Legend: Saint Mary of Egypt/Death in the Desert* (1912). *Dance* reflects a typically Expressionist ambivalence toward female sexuality. The harsh yellows of the dancing women in the foreground are repeated in the hillside in the upper right of the composition and the golden calf itself, anchoring the canvas in the upper centre and, consequently, communicating both fear and desire for the fecundity and hidden riches of the earth. *Crucifixion* (1912) shows Nolde's characteristic use of bold composition, vivid colour and purposefully crude brush technique, reflecting his interest in both non-Western art and German folk art, particularly of the medieval period. Not unlike Kandinsky's rejection of philosophical and cultural materialism through a technique that paradoxically focuses attention on the material stuff of paint and canvas, *Crucifixion* presents an apparently irresolveable conflict between an idealistic, confidently held religious sensibility and a cynical, angst-ridden sense that the world is in hopeless crisis. Nolde's own life reflects such ambivalence, too: an early and enthusiastic advocate of the Nazi Party, especially since the Nazis promised to promote a culturally rooted spirituality against materialistic movements like communism, he would find his paintings featured prominently alongside the works of the Bolsheviks and Jews he hated in the notorious 1937 *Degenerate Art* exhibition.

THE JANUS FACE OF RELIGION IN GUATEMALA, KOSOVO AND MOZAMBIQUE

The Janus-face of religion was a crushing paradox to Toller and Beckmann and a wellspring of fanaticism for Nolde, but looking simultaneously forward and backward through the eyes of religion does not necessarily have to lead to cynicism or extremism. On the contrary, it can inspire a nuanced sense of historical agency and provide powerful means of cultural recovery and unity to minoritarian movements denied a place in the official histories and power-sharing relationships of their societies. The recent resurgence of Maya cultural identity in Guatemala is one such case. A prominent feature of political uprisings in Guatemala during the

1980s, Maya identity politics is organized specifically around marginalized and outlawed religious practices. In the context of Guatemalan politics, those practices were

(1) 'magical', efficacious rituals

(2) a symbolic object of high regard in the historical consciousness of indigenous peoples

(3) a civil protest to promote Mayan ritual practice as a legal and integral part of Guatemalan national identity

(4) the cultural complement to an environmental movement literally reshaping the national landscape by restoring the sacred spaces of the Maya to the map.

The threat posed by Mayan vanguardism to state, military and educational authorities was perfectly clear to the establishment, and a small group of Maya catechists was deemed a priority target for military special operations, a corps trained by US Green Berets and generally considered to be one of the most ruthless counterinsurgency forces in Latin America. In a fashion all too familiar to historians of ethnic-based guerrilla warfare, the homelands of the ethnic group—in this case the Highland Indian communities—became an object of struggle between the government and the opposition. It was the guerrillas who got the popular support, despite horrendous violence.

As part of their effort to undermine popular support for the guerrillas, particularly among the indigenous labourers upon whom the economy of Guatemala depended, the government wreaked terror not only on the bodies and livelihoods of rural communities already the object of intensive exploitation but also on their culture, particularly those aspects that the government viewed as part of the Mayan resurgence and, by their logic, a threat to Guatemalan national identity. Ultimately, Richard Wilson argues, the military ended up transforming the catechists into an avant-garde: 'The catechist program and the civil war form the historical background for a new Indigenist movement' (1995: 205). This was more than simply a nostalgic, essentialist recovery of the past; it was also an invention of 'certain continuities in practice and belief [. . .] a fundamentally new way of apprehending the world that made it possible to imagine wider frames of reference such as class and the 'pan-Q'eqchí community' (ibid.). Wilson describes the effort within that community to use the Tzuultaq'as, or mountain spirits, as a bulwark against state repression,

concluding that the rituals perform a contemporary Maya identity that reflects the historical duration and geographical diversity of the Maya multiculture.

According to Wilson, Maya identity in this context was not understood as a monolithic, complete or unchanging sensibility (as so often happens with ethnicity movements) but was the object of contentious and often quite nuanced debate. In his review of Wilson's *Maya Resurgence in Guatemala*, Alex Taylor summarizes this debate:

> The resurgence of Maya culture and political activism in Guatemala [. . .] led to a growing polarization among the various Guatemalan Maya groups over what were the cultural, economic, and political factors that defined (and should define) 'Maya-ness'. In the particular case of the Q'eqchi, these developments also led to a growing competition, at both the inter and intra-communal levels, over the factors that defined and should define the Q'eqchi identity (quoted in ibid.).

Wilson shows that the flexible application of identity politics based in religious belief has allowed this avant-garde to look both backward to the pre-Conquest past and forward to a democratic Guatemala; both inward to an essentialist, insular identity and outward to a concept of pan-Q'eqchi community that enables and strengthens diverse forms of association beyond ethnicity and class.

The Guatemalan Mayas notwithstanding, it is nevertheless true that the Janus face of religion has often inspired avant-gardes to rally 'against the tide of modernity', to recall Michael Löwy and Robert Sayre's apt phrase, and isolate and essentialize their communities against the stresses of modernization (2001). Theology and theologically driven worldviews are often deployed to impose an antique interpretation on conflicts that are, at heart, neither antique nor religious but the consequences of industrial development, migration, economic crisis and sociopolitical transformation. The horrific ethnic conflicts in Kosovo during the 1990s show the dire effects of that kind of theological imposition. Samuel Huntington's 'Clash of Civilizations' thesis played a substantive, though certainly unintended, role in that conflict. His much-quoted 1993 essay asserts that 'the fundamental source of conflict' after the closing of the Soviet–US Cold War 'will not be primarily ideological or primarily economic. The great divisions among humankind and the dominating source of conflict will be cultural'. 'The

fault lines between civilizations', Huntington concludes, 'will be the battle lines of the future' (Huntington 1993). Those fault lines are characterized by Huntington in essentially religious terms. He divides the world into several 'civilizations', four of which are based on religion: Orthodox Christianity, Islam, Hinduism and Buddhism appearing on the same list as Latin America, the West and Sub-Saharan Africa. Though certainly neither the article nor the author's intention, Huntington's thesis proved remarkably useful for genocidal nationalists in the ruins of Yugoslavia to divert attention from the real history of conflict.

Julie A. Mertus has shown how Huntington's thesis attracted followers like Dušan Batović, a Serbian writer who promoted the idea that 'Muslim terrorists' were a threat against Serbian autonomy, propaganda that helped spark genocide. Batović warned his fellow Serbians in 1992 that the 'deep driving force of all the tectonic disturbances in Kosovo and Metohija emerged from layers beneath the deceptive communist reality [of the past] and the inheritance of a centuries-long conflict of different nations: a clash of two civilizations, the Christian and the Islamic' (Mertus 1999: 34). Mertus comments, 'This characterization of the conflict ignores the fact that Kosovo Albanians are both Muslim and Christian and that Kosovo Albanians have never identified themselves in terms of religious identity' (ibid.). The point is seconded by Kepel, who points out that, despite the presence in Kosovo of jihadists fresh from the camps of Pakistan and Afghanistan and despite their successful recruitment of some 4,000 Muslim Albanians, radical Islam failed to turn the conflict 'into a jihad in any meaningful way because the term struck no chord in the local Muslim population' (Kepel 2002: 239). Tragically, it struck precisely that chord in the non-Muslim Serbian community, not least in the offices, armories and holding cells of right-wing police officers, who used their authority and weapons to mobilize themselves as a vanguard. The result was the murder of perhaps 10,000 people, the injury and rape of many more, the forcible expulsion of a million and a half and the entry into our modern vocabulary of the term 'ethnic cleansing' (for statistics, see US State Department 1999).

The situation in Mozambique in the 1970s and 80s is distinct from that in Kosovo but shows a similarly cynical role played by religious avant-gardes and the tendency of religion to dominate and mutate debate, essentially closing out the possibility of other perspectives, particularly those of internationalist secular organizations. In 1976, the Resistência Nacional Moçambicana, or RENAMO, was founded by white Rhodesian

military officers to undermine the efforts by newly independent Mozambique to support guerrillas attempting to undermine the white Rhodesian government. RENAMO recruited alienated veterans of the Mozambique insurgency to subvert the Marxist government, led by the Frente de Libertação de Moçambique (FRELIMO). These fanatics found deep pockets in the government of apartheid-era South Africa and extreme right-wing organizations in the US who, in addition to supplying cash, provided valuable consultation on how to best achieve their ends. In that spirit, RENAMO disrupted the Mozambican economy, sabotaged its infrastructure and engaged in widespread murder, mutilation and rape, resulting in at least 100,000 dead and more than a million refugees.[3]

What sets RENAMO apart from similarly vicious right-wing vanguards such as the death squads that propped up regimes in Latin America during the 1960s and 70s is its metaphysics. K. B. Wilson has examined RENAMO's 'spiritual, magical, or cultic power', and its claim to be 'fighting a war of spirits' (a strategy they learned from their Zimbabwean trainers) (Wilson 1992: 528). He warns that the sacralization of violence by RENAMO—its use of formulaic torture, cannibalism, 'ritual allocation of women', (ibid.: 535) and the like—can and should be distinguished from other kinds of violence in the conflict due to its tendency to produce a sense of 'brotherhood' among the perpetrators as well as a sense that such ritual 'provides or imputes value or power into the activity' (ibid: 531). Though he unfortunately falls victim to the scholarly tendency to denigrate faith, Wilson convincingly argues that RENAMO's use of ritual was ultimately pragmatic, an effort to capitalize on widespread peasant distrust of and alienation from a secular government. Religion helped them to 'gain local legitimacy by engaging community spirits in their military program' and to exploit for strategic purposes the inherently terrifying nature of destruction, rape, mutilation and murder (ibid.: 541). Ultimately, the spectacle of violence was intended to

> symbolically banish the state, particularly from engagement in rural people's lives. In contrast [to the massive destruction of health and education services], property with religious association, such as churches, church buildings, religious fountains, and so on were generally left undamaged. This was part of RENAMO's active effort to capture religious legitimacy inside and outside Mozambique, and such churches were often used during their occupation (ibid.: 540).

RENAMO's exploitation of the epistemological, institutional, practical and material dimensions of religion was successful in convincing all concerned—RENAMO soldiers, FRELIMO soldiers and peasants alike—that their military successes were the result of 'spiritual and magical superiority' (ibid.: 547).

However, that success ultimately backfired. Mozambican journalist Gil Lauriciano has shown how the isolation of 'grassroots military and political structures [. . .] from national and ideological pressures [. . .] re-established communication with traditional structures and other cultural manifestations' (quoted in ibid.: 561), resulting in the disruption of RENAMO's mythos of invincibility. Consider the neotraditionalist Naprama movement led by Manuel Antonio, who claimed to have returned from the dead to 'declare a divine mission to rid the nation of war' and 'exploited the Achilles' heel of RENAMO by conquering the fear which RENAMO used to dominate the peasantry. And it did this through drawing on people's own resources in an innovative and powerful organizational framework' (quoted in ibid.). Of particular interest, there has been no evidence of tribal chauvinism in the Naprama movement, whose cultic beliefs are an intercultural matrix of traditions, not least of which being the modern tradition of 'vaccination', which is the literal translation of the word 'Naprama' (ibid.: 563). If the Janus face of religion allowed one vanguard to turn the tide against democracy and interculturalism in Mozambique, for another it was a wellspring and, to a degree, salvation.

THREE FUNDAMENTALIST AVANT-GARDES

Unlike the cynical manipulation of religious belief by Serbian ultra-nationalists and RENAMO, religious fundamentalism tends to be the province of true believers. That's certainly the case with the three fundamentalist avant-gardes I will now discuss. Another thing that sets apart these movements is that they do not accept theological modernism nor the institutions, communicative standards and political processes of modern liberal society. Thus, they must be distinguished from those whose faith is based in the idea of a 'golden age' of faith and communal living. Though religious fundamentalists are concerned with and often highly value the past, they are also knowledgeable about the present. In sum, the avant-garde fundamentalist movements I'll discuss here wear the Janus mask of religion, both cursing and embracing the social, political and cultural

transformations of modernity. Indeed, one hallmark of these movements is their embrace of technology. US Christian fundamentalism's dexterous use of radio and television; Gush Emunim's sacralization of rapid-response military technology; and Egyptian theologian Sayyid Qutb's scientific materialism are all examples of fundamentalism's Janus face. To recall Ferris' description of spirit photographers, these fundamentalists are emblematic of the 'anxiety and optimism in their times, while simultaneously altering, quite dramatically, received notions of representation and vision' (2003: 47).

Though their long-term fate is uncertain, these three vanguards should be understood as not only successful political movements but also some of the most successful examples of activism in the history of the avant-garde. The theories and strategies of minoritization they developed and implemented enabled their members to differentiate themselves from the majority and revitalized the function of their organic intellectuals, who were able to produce empowering and enthralling visions of human agency, devise new understandings of the role of culture and cultural production and invent and revise methods to wield and deflect power.

What do I mean by 'fundamentalism'? Because it is a phenomenon found in many societies and many religious traditions, we need to use the term with some care. Though grounded in premodern cultural practices and objects, especially sacred texts, and definitely a 'reaction against threatening features of the contemporary world,' fundamentalism is, in Bruce Lawrence's words, 'primarily a twentieth-century phenomenon with historical precedents, but no ideological precursors' (1989: 100–01). Martin E. Marty and R. Scott Appleby emphasize that 'it is difficult if not impossible to isolate for definitional purposes any pure form' of religious fundamentalism (1991: 817). That said, certain characteristics tend to be typical and are for the cases I describe here: religious idealism implemented as 'an irreducible basis for communal and personal identity'; a tendency to read historical events 'according to an uncanny calculation of time and space'; an obsession with crisis in all forms, whether personal, social, cultural, or historical; a 'comprehensive system emanating from religious principles'; a highly selective attitude toward the traditional and the modern; a 'shrewd exploitation of modern processes and instrumentalities' such as the mass media; and a tendency to rally around charismatic male leaders (ibid.: 817–27).

The three fundamentalist tendencies I discuss here have characteristics of special interest to avant-garde studies. First, we see each of them

actively cultivating a minoritarian identity, whether by choice (as is the case with the Protestant Christian movement, led and funded by wealthy white males and often the beneficiaries of political majority) or as compulsion (as in the case of Qutb, an activist imprisoned in a postcolonial nation). Second, their minoritarian identity is grounded in and empowered by a specific vision and model of community: the family, the settlement and the Hejira, respectively. Third, and a correlative of the first two tendencies, we find in each the troubling presence of one of the side effects of avant-garde theory as formulated by Saint-Simon and Comte: the sacred intellectual.

1. Christian Evangelism in the US

The term 'fundamentalism' is derived from the US Protestant Christian case, so it is best to start there. According to Nancy T. Ammerman, the word first appeared in 1910 in a 12-volume paperback series conceived and financed by Los Angeles oil millionaires Lyman and Milton Stewart. The Stewarts saw *The Fundamentals* as a good way 'to produce intellectually sound, popularly accessible defenses of the Christian faith' (over three million copies were distributed) (1991: 22). This was just one in a series of measures taken by the brothers to counter the 'dominance of historical-critical methods' in the training of pastors at institutions of higher education. As Ammerman tells it, institutions such as the Stewarts' Bible Institute, founded in 1908, 'emphasized practical evangelistic skills and techniques for uncovering the facts of Scripture', training that was a crucial step for those moving 'in the direction of a separate identity' (ibid.: 21). *The Fundamentals* expanded this minoritarian strategy beyond big educational organizations, providing non-experts, particularly pastors in small, out-of-the-way churches, with the intellectual tools to conceptualize and express their alienation from the mainstream. This trend was further extended to lay believers by Curtis Lee Laws, editor of the Northern Baptist newspaper *The Watchman Examiner*. In a series of scholarly essays that appeared between 1910 and 1915, Laws boiled out the key ideas of *The Fundamentals* for a popular readership. Titled, appropriately enough, 'The Fundamentals', the essays provided critical and polemical tools to 'do battle royal' for the fundamentals of the faith (Lee Laws, quoted in ibid.: 2).

In addition to these strategies, performance played a role in producing an enthusiastic and affirmative sense of minority status. The Christian revivalist performance style formulized by Charles G. Finney in the late

1800s emphasized individual soul-searching within emotionally intense group gatherings guided by a charismatic—and typically white and male—preacher (ibid.: 2, 18). (This style was refined for the electronic media by Charles E. Fuller, who will be discussed shortly.) In any case, the convergence of institutional independence, 'plain-speaking' theology distributed in easy-to-read form and group-based, affectively energizing revival performances enabled the Protestant Christian fundamentalist movement to spread their message quickly, particularly when modern electronic media such as radio and television became available.

Quite often, the most difficult challenge an avant-garde faces is to find the means to articulate its small-group message with the broader population. For Christian fundamentalists, the question of articulation was less one of vision, rhetoric or myth and more one of social formation. They had to figure out what kind of community would secure the strongest possible link between the elite intellectuals of the movement—the theologians at the Bible Institute—and the grass roots. To this end, they systematically mythologized and sentimentalized the heterosexual, monogamous, patriarchal family, thus cementing the traditional connections between God the Father and, well, Father the Father. By mythologizing and sentimentalizing the family, they also countered the threat of feminists, socialists, lawmakers seeking to prosecute violence and dissipation within the home, and demographic shifts toward urban life and multicultural community—all of which undermined the monogamous, heterosexual family as a site of unimpeachable patriarchal power.

Another advantage: the family myth fit perfectly the communications technologies available at the time. The 1920s saw explosive growth in radio stations and radio purchases. The year 1923, for example, saw 556 new stations, 400,000 homes purchasing ever-cheaper radio consoles (a 15 per cent rise from the previous year) and the mighty Sears Roebuck Company selling its first line of radios (see Lewis 1992). E. B. White suggests exactly how 'theological' this phenomenon was to the common person:

> I live in a strictly rural community, and people here speak of 'The Radio' in the large sense, with an over-meaning. When they say 'The Radio', they don't mean a cabinet, an electrical phenomenon, or a man in a studio, they refer to a pervading and somewhat godlike presence which has come into their lives and homes (quoted in ibid.).

This melding of the nuclear family (with its myths of patriarchal power) to the emerging electronic media was catalytic, as proved by the enormously

popular radio show *The Old-Fashioned Revival Hour*, hosted by Fuller begin-
ning in 1937 until the late 60s. Fuller's success depended on a paradox of
mass media: the ability to make isolated individuals or groups of individu-
als feel empowered and unified precisely because of their isolation. The
isolated, anxious family could easily imagine itself as being part of a vast
community, a community not of consumers buying the same paperbacks
and listening to the same radio programmes but of true believers in a
world of disbelief, sheep in a vast new pastureland with strange new threats
to their survival. Under the ministrations of preachers such as Fuller, radio
listeners could take that fantasy farther, imagining themselves not just as
part of a flock but as a kind of 'grass-roots vanguard'.

Not coincidentally, performance played a powerful role in the success
of Fuller's radio show. More than one commentator has described it as a
kind of virtual tent meeting, an apt description, since Fuller modelled his
show after the performance formula devised by Finney, the Presbyterian
and Congregationalist preacher sometimes known as 'The Father of
Modern Revivalism' and the lead inventor of the tent revival format.
However, the comparison ultimately falls short. The tent meetings that
Finney organized were based on a specific performative transaction between
the charismatic orator and the large, fervent crowd assembled under the
canvas. The power of the tent revival was the power of the assembled crowd,
both the true believers ready to testify their faith and those sitting in the
'anxious seats' and unsure of their commitments. Using a broadcast rather
than a theatrical space, Fuller's radio show had a very different performance
transaction, one in which the crowd and public space existed only in the vir-
tual sense. Further, this transition ocurred in the sitting room, not a tent,
among widely dispersed families grouped around their radios. And though
a talented tent revival speaker could make each spectator feel that she was
being directly addressed, Fuller could achieve this much more easily: even
made tinny by the low-grade speakers in most consoles, his voice still sound-
ed like it belonged to a guest in one's home, not a speaker in a crowded
meeting tent. Remarking on the enormous success the *Revival Hour*
enjoyed during its first year on the air, Fuller described letters he had
received from 'heart-broken, heart-hungry humanity, some contemplating
suicide, yet hundreds have come, cheery and full of thanksgiving that they
have received comfort and new hope and strength from hearing God's
Word again, and hearing the songs they used to sing back home with
Mother' (quoted in Ammerman 1991: 34). This feeling of togetherness

proved hardy; the model was seized upon by the ambitious young Jerry Falwell for his *Old Time Gospel Hour* television show, on the air since 1956 and nearly as big a success as his model.

Another, though later, factor in the rise of the Protestant Christian fundamentalist vanguard was institutional in nature; specifically, the rise of enormous, denominationally independent 'superchurches,' many of which had blossomed in response to radio and television shows and all of which catered to the mostly white families in their communities. Jerry Falwell, James Kennedy, Greg Dixon, Tim LaHaye and Charles Stanley used these churches to move hundreds of 'vanguard families' against gay rights, access to abortion, freedom of expression, feminism and laws designed to protect abused wives and children.

Yet another factor was the movement's merger with the nascent neo-conservative movement spearheaded by Young Americans for Freedom (YAF) in the 1960s. Many of YAF's members, according to Rebecca Klatch, 'grew up in devoutly religious homes, going to church regularly and attending parochial schools' (1999: 49). Richard Viguerie was one such individual. He brought to the table an extensive direct-mail network and a conviction that they could and should maintain a politically activist footing. Viguerie believed wholeheartedly in the old avant-garde idea that political battles are often best carried out on the terrain of culture; in this case, in the direct and indirect control of mass media and arts funding. In 1985, conservative groups, led by Viguerie and ultra-right-wing Senator Helms of North Carolina, attempted to take over the CBS television network, reflecting Viguerie's belief that 'in order to accomplish what we want politically, there is going to have to be a change in the media' (quoted in Edsall and Vise 1985: 1). It was on religious grounds that the so-called NEA Four was attacked in 1990. Though Karen Finley, Tim Miller, John Fleck and Holly Hughes ultimately won the legal battle, the cultural battle was lost, resulting in drastic cuts in arts funding whose impact is still being felt today in the US.

That said, perhaps the single most important factor in the rise of the Christian fundamentalist vanguard was its marriage of 'family values' and free market economics. The founding of the Moral Majority in 1979 was primarily justified in terms of the defence of the traditional family, characterized by them as 'the basic unit of society' but its scapegoat was the state, which the fundamentalists believed 'had grown far beyond its legitimate boundaries and must be brought down, like a tyrant, by its subjects'

(Ammerman 1991: 51). Though the Reagan administration of the 1980s was by no means guided by fundamentalist principles (the Reagans regularly consulted psychic Jeane L. Dixon and spiritualist Beatrice Anne Gehman and opened diplomatic relations with the Vatican), it was in many ways the child of this marriage. Reagan appealed to fundamentalists as a strong father figure, proclaimed sacred free-market economic policy, spoke often to right-wing religious groups, showed callous indifference to gays and homophobia during the early years of the AIDS pandemic, vociferously opposed abortion rights and initiated a two-decade-long trend among conservatives for installing a federal judiciary that reads the Constitution rather like fundamentalists read the Bible, as an inerrant document. Speaking before a right-wing Christian audience, he once stated that *they* couldn't endorse *him* (how times have changed!) but *he* could endorse *them*. Reagan opened a space for fundamentalist discourse at the highest echelons of government discourse. He characterized the faltering Soviet Union as an 'evil empire' and regularly commented on the situation of its religious dissidents, feeding the ardour of those in the US who felt that they too were passing through a dark night without end.

The administration of George W. Bush was the apotheosis of the trend. A born-again Christian who, according to Raney Anderson, cemented conservative Christian support for his father's faltering presidential campaign in 1988, he appointed like-minded believers in high posts (including his first Attorney General, John Ashcroft, quoted as saying that the US has 'no king but Jesus')[4] and instilled his presidency with, in the words of Commerce Secretary Don Evans, 'a desire to serve others and a very clear sense of what is good and what is evil' (quoted in Fineman 2003).This desire shaped the administration's views of international military, political and social policy; the role and use of science in domestic policy, particularly environmental and health research issues; and the relationship of Church and State. The power of the Protestant Christian fundamentalist movement in the US during the 1990s and early 2000s is best measured by the standard described by John Green, author of *Religion and the Culture Wars: Dispatches from the Front* (1996): 'The first stone in building the wall of re-election are evangelical Protestants' (see Anderson 2004). Elections are only one measure of such success: The Bush administration raised the minoritarian myth of Protestant Christian fundamentalism to the level of international diplomacy, viewing the rejection of their policies by other nations and international organizations as confirmation of their essential

and unchallengeable righteousness in a godless world. Though they were defeated in 2008, that defeat will surely strengthen their sense that they are an oppressed minority at odds with society—in other words, that they are the vanguard of morality in a fallen world.

2. Gush Emunim in Israel

Another vanguard fundamentalist movement that gained both widespread popularity and a dominant, though still oppositional, institutional and cultural presence in Israel is the Zionist Gush Emunim (or Bloc of the Faithful). Considering that it began among squatters, teenage study groups and *yeshivas* catering to active soldiers, Gush Emunim (or GE) has acquired a remarkable amount of political power and, given the necessary compromises attendant upon achieving hegemony, an equally remarkable degree of political independence from the state bureaucracy. Founded by Rabbi Zvi Yehuda in the wake of the demoralizing 1973 Yom Kippur War, Yehuda's organization can be credited with the physical and ideological redefinition of the Israeli state through the movements of 80,000 settlers, the founding of 100 outpost settlements and what might be called the 'biblicization of the territories'. The lattermost development is especially important; GE's belief that Israel has a religious imperative to own and settle the entire Land of Israel (including the West Bank) grew increasingly popular following the 1987 intifada, whose suicide bombers and anti-Semitic rhetoric put religious and strategic imperatives into uncomfortably close relationship. The biblicization of the Israeli/Palestinian conflict has altered the terrain of the Middle East peace process too, bringing intransigent Christian conservatives—so-called Christian Zionists—in the US into an already deeply muddled situation. Beyond its success at mythologizing Israel and its conflict with the Arab world, GE has gained a solid and widespread presence in the Israeli government while maintaining status as critical outsiders. GE leaders and supporters can be found at all levels 'as rabbis, teachers, students, soldiers, Interior and Defense Ministry officials, and even as functionaries of the Ministry of Religious Affairs' (Aran 1991: 283).

As is the case with Protestant Christian fundamentalism in the US, the GE's vanguardism can't be understood unless we take into account the way it cultivated a minoritarian identity through the construction of a sacred model of community whose members share ways of knowing, institutions, ritualized practices and sacred things. Gideon Aran has shown how GE constructed this kind of community. He traces its founding to two

very different historical crises: the demoralizing Yom Kippur War and the Six-Day War of June 1967. The latter is considered by GE 'the zero point of the movement's calendar, in which the national and religious reckoning begins with the birth of redemption' and whose 'significance lay not only in the fantastic, unexpected dimensions of the victory itself but also in the shock of moving, in the space of a few days, from the brink of national destruction to unprecedented heights of strategic achievement. It was in this dramatic reversal that the force of the event can be discovered, not least from a religious point of view'. Indeed, many of Yehuda's followers experienced the war as a 'profound mystical experience' (ibid.: 271).

The relationship of these events to the kind of sacred community constructed by GE is hinted at by David Rubinger's oft-reproduced photograph of paratroopers gazing reverently at the stones of the Western Wall, the remains of the venerated Second Temple of the ancient Hebrews (see Image 3.6). The photo's iconic linking of territorial expansion, the myth of sacred Israel, individual faith and rapid-response, proactive military strategy not only 'reconnected the State with the Land' but also signalled the 'emergence of religious motifs in contemporary Israel' (ibid.: 273). The photograph drew favourable attention to the Hesder yeshivas, schools created by special arrangement with the Israeli Defense Forces to allow soldiers to divide their time between active military duty and intensive, orthodox Torah study. Aran notes that students in the yeshivas 'maintained outstanding levels of both military and scholarly achievement' (ibid.: 274). The photo also confirmed a long-standing belief among some Israeli Jews that effective action need be neither mass-based nor follow the parliamentary route. Though it required some effort of imagination, the pietistic paratroopers, grimy and unshaven, supplied visceral evidence of the righteousness of the kinds of extra-parliamentary methods that are the bread and butter of vanguard political movements: mass rallies, the manipulation of public opinion and vigilante violence. Rubinger's photograph is symptomatic of a cultural-political-military ecosystem that allowed GE to quickly move into alliance with other radical minoritarian movements, including the Zionist youth movement Bnei Akava, Land of Israeli Loyalists (Aran: 'secular veterans of the right-wing undergrounds of the pre-State period [the Irgun Zevai Leumi and the Stern Group]'), and activists from the labour movement 'hailing from veteran cooperative settlements and kibbutzim, which inherited the legacy of

IMAGE 3.6 The iconic photograph of Israeli paratroopers at the Western Wall, by David Rubinger. Courtesy: Yedioth Aharonot.

the Palmach (the elite troops of the Hagana, the militia which became the core of the Israeli Defense Forces after independence)' (ibid.: 269).

If Rubinger's photo was a spark, the radical settler movement was the fire. Yehuda and his followers believe that 'settlement in Judea and Samaria is not only a restoration of the Zionist spirit but also *tikkun*—the kabbalistic concept of healing, repairing, and transforming the entire universe' (ibid.: 292).This belief isn't all that surprising. The origins of GE as a sociopolitical movement can be traced to a group of Torah scholars and their families who refused to leave an Arab-owned hotel in Hebron after a 1968 Passover Seder. 'That night,' Aran writes, 'they introduced, as they say, "new facts in the field" and changed the map of Israel' (ibid.: 268–9). More important in this process of acquiring and sacralizing space is Sebastia, at the time of its settlement an abandoned railroad station near the ruins of an ancient Israeli capital. Claimed by the organization as a way to heal the loss of territory in the Yom Kippur War, Sebastia was decisive to the movement's history. Aran writes, 'It is GE's counterpart to the storming of the Bastille in 1789 and Khomeini's landing at the airport of Meharabad in 1979: this place and event symbolized the movement's historical progress'. The Elon Moreh group at Sebastia has earned among many Israelis 'the role of supreme moral authority because its members mapped out GE's ideological, political and operative front with their own bodies'. Thus, 'at the same time, the settlements are both a bridgehead for assault and a model of an alternative lifestyle' best compared to the *kloiz*, the Yiddish term for 'small room', 'the Hasidic equivalent of a cloister' that, for one settler interviewed by Aran, perfectly captures the idea that the 'Israeli fundamentalist movement strives to combine all Jews and Zionists into a unified, dynamic body' (ibid.: 270, 304, 311). Settlements like those in Hebron and Sebastia were maintained in the face of enormous political pressures and violent opposition by Palestinians but enabled GE to knot together three tendencies in Zionist thought:

(1) historical and political justification for the existence of Israel (that is, defence of Jews against anti-Semites and institutionalized anti-Semitism)

(2) a chiliastic concept of messianic time inherent to *tikkun* (for example, a GE plot to blow up the mosque on Jerusalem's Temple Mount took into account the possibility that it might start a world war and open the door to the messiah).

And, despite its merger with Israeli bureaucracy and popular culture,

(3) maintenance of Israeli identity as a distinctively counter-cultural, if not minority, identity.

Abiding by these three principles, GE has pulled off the tough trick of being both an established institutional presence and an avant-garde.

The right to settlement has become a virtually unassailable *moral* position for many Israelis, not just the fundamentalists, and challenges to their legality levelled by international organizations must now contend with apparently impermeable religious faith. Even Prime Minister Ariel Sharon, a resolute secularist and a determined hawk on the issue of territory, had to confront this problem; the radicals who cheered the assassination of Yitzhak Rabin in 1995 turned their wrath toward Sharon for proposing the shutdown of a handful of Gaza settlements in 2004.

3. Sayyid Qutb and Islamism

Neither the Protestant Christian movement nor GE consciously modelled themselves on the avant-garde; their place in avant-garde history is the consequence of shared structural conditions and necessary responses to those conditions. They are, as Calinescu would put it, 'unconscious avant-gardes' (1987). This is not the case with the twentieth-century Islamic fundamentalist tendency known as 'Islamism'. Organizations and intellectuals within this tradition have taken on the vanguard mantle consciously; not least, Maududi of Pakistan, Qutb of Egypt and the Muslim Brotherhood, whose chapters are found throughout the Muslim world. The notion of a supposedly anti-Western movement embracing a supposedly Eurocentric term may strike some readers as absurd. I certainly found it so when I first came across it. However, on careful re-examination, the Arabic word *taliah* is nicely captured by the English 'vanguard', and an analysis of the history of Islamist activism reveals the widespread presence of explicitly vanguard models, particularly communist and fascist vanguards, movements carefully studied and occasionally emulated by Islamic activists.[5]

The instrumental efficacy of those vanguards is certainly one source of attraction. That was the case for Hassan al Banna, who modelled the original Muslim Brotherhood after the Russian Bolsheviks and the Spanish Falangists. However, for Maulana Maududi, the concept and vocabulary of vanguardism was more than instrumental: his use of the term depended on a story precious to Islamic culture: the Hejira, the exile to

Medina and subsequent insurgency of Muhammad and his Companions that brought them to power in Mecca. Kepel notes that, in a number of texts written in the 1930s and 40s, 'Maududi made explicit references to the "vanguard" of the earliest Muslims, who gathered around the Prophet in 622 during the Hejira, broke with the idolatrous people of Mecca, and departed to found the Islamic state of Medina. His own party [Jamaat-e-Islami] was intended to follow a similar course' (Kepel 2002: 34). Maududi was not the first to invoke the Hejira or characterize his society as comparable to that surrounding the Prophet, a society of disbelief or *jahiliyya*. However, his use of the term should be distinguished from earlier figures such as Jamal al-Din al-Afghani or Muhammad Abduh. Though they also called for a return to the example of the Companions, they viewed them as just that—an example—rather than a model of ethics and organization. Kepel continues, 'Maududi was the first twentieth-century Muslim thinker to build a political theory around the original break that led to the founding of Islam' (ibid.: 35). In other words, Maududi was the first to recognize that the Prophet was a homegrown Modernist—and that Islam was fundamentally a force to turn the tide of Western modernity. Maududi wedded the minoritarian myth of the Hejira to the organizational strategies of the Russian Bolshevik Party and the Spanish Falangists, 'transforming this break into a strategy for action' (ibid.). As Mumtaz Ahmad writes, 'Maududi came to the conclusion that the best way to transform a society was to create a small, informed, dedicated, and highly disciplined group which would work to assume social and political leadership'(Ahmad, quoted in Marty and Appleby 1991: 827). However, Maududi's vision of the avant-garde failed to fully carry through on the promise of that wedding. Though they called for a clean break with *jahiliyya* society, Maududi and the leadership of Jamaat-e-Islami never called for a break with the established political system of Pakistan and never advocated violence. Kepel notes, 'Maududi's holy war to build an Islamic state found expression through full participation in the political system of Pakistan, rather than radical opposition to it' (2002: 35).

A more literal and anti-state reading of the Companions as 'instruction to be translated into action', is found in the work of Egyptian theologian and radical martyr Qutb. A reader finds in those pages a far more thorough realization of the modernity of the Hejira story. In *Milestones*, Qutb follows Maududi in demanding that 'the callers to Islam in every country and in every period [to] give thought to one particular aspect of

the history of Islam and [. . .] ponder over it deeply'; specifically, 'the generation of the Companions of the Prophet, may God be pleased with them' (1981: 15). But Qutb implicitly criticizes Maududi for his willingness to play the game of parliamentary negotiation. He notes that Muhammad and his Companions broke off relations with Jewish merchants and priests in Medina and carried out guerrilla raids and assassinations against those who had satirized the Prophet or allied with Jews for trade or political ends. The true Muslim, Qutb writes, must make an absolute 'break' not only between his 'present and his past' but also with the '*jahiliyya* environment, its customs and traditions, its ideas and concepts, proceeded from the replacement of polytheism by the concept of the Oneness of God [. . .] and from absorption into the new Islamic community under a new leadership and dedication of all loyalties and commitments to this new society and new leadership' (ibid.: 20). Qutb compares the struggle of the Islamic vanguard to a journey or pilgrimage, whose milestones were not visible to the *takfir*. The vanguard, he writes, 'which sets out [. . .] and then keeps walking on the path [. . .] should keep itself somewhat aloof from this all-encompassing *jahiliyya*' (ibid.: 12). Though some ties with it will need to be maintained out of necessity, 'we will not change our own values and concepts either more or less to make a bargain with this *jahili* society. Never! We and it are on different roads, and if we take even one step in its company, we will lose our goal entirely and lose our way as well' (ibid.: 21). As John Voll notes, 'Before Qutb, the word *jahiliyya* simpy refered to the period before the time of the Prophet Muhammad or to those people at the time of Muhammad who did not know about him. However, Qutb used the term inclusively, extending it to all who rebelled willfully against God's rule' (Voll 1991: 371). This brings into play a very different kind of moral judgement from that advocated by, say, Maududi: Those who refused to break with such a society could themselves be deemed *takfir*. Those characterized as *takfir* are considered impure, no longer Muslim, no longer protected by law and their blood forfeit. Thus, the new vanguard of God is as justified in its use of violence as Muhammad and the Companions when they chose sword and knife to fight their way back to Mecca.

As was the case with Protestant Christians in the US and Zionist Israelis, Qutb sacralized an existing community form. For the Christians, this was the heterosexual, patriarchal family; for the Jews, the settlement. For Qutb, it was the men's prison. It was in the dungeons of the Gamel

Abdel Nasser regime that Qutb developed his final model of the *taliah*, one that emphasized the mortal threat faced by true Muslims in *jahili* society. Qutb's avant-garde theory could only have been written in an Egyptian prison. Musallam shows that it was in prison that Qutb and fellow inmate Muhammad Yusuf Hawwash 'concluded that the Islamic movement had reached a stage very similar to that which early Muslims experienced as a minority of believers in Mecca, that is in a stage of weakness. Therefore, they must prepare themselves by concentrating on translating the dogma and convictions into a concrete Islamic way of life led by a vanguard' (1998: 79). Voll develops this assertion further:

> The prisons became a new kind of educational center, in which the new recruits studied Qutb and Maududi and became persuaded that the society which produced the torturers and the prison camps was indeed worthy of being labeled *jahiliyya* [. . .] The debates among the prisoners in the period between 1965 and 1971 laid the ideological foundations for the different groups which emerged during the 1970s (1991: 374).

Subsequently, the prison has been joined by another all-male community characterized by absolute discipline and constant violence: the military training camp. Kepel views camps like those in Peshawar, Pakistan, as 'keys to the mystery' of the ability of the jihadist to 'conceal his true nature and to preserve his extreme convictions intact while exposing himself to Western culture down to its most intimate detail' (2002: 10).

Qutb's play on the Hejira myth suggests to me two distinct but equally provocative readings and two distinct ways to fit him and radical Islamism into the history of the avant-garde. The first reading is cynical: the Hejira rhetoric is a bald attempt by Qutb to festoon what is a blatantly Modernist, tendentiously Eurocentric concept of political change and intellectual labour with Islamic iconography. In addition to the convenience of not having to admit its European pedigree, the substitution of Hejira for avant-garde also lets Qutb sweep under the rug the influence on his thinking of the liberal-constitutional Wafd Party, which he damned as *jahiliya* upon his break with it in the late 1940s (see Ahmed 2004). It allows him to disingenuously revise the history of Islamist critique, too. The Hejira model is at the heart of his call in 1952 for the revision of Egyptian history books 'in order to correct the distortions [. . .] which failed to give an appropriate place to the Islamic renaissance as represented by the Wahhabiyah and the Mahdiyah movements' of the eighteenth and nine-

teenth centuries, movements that predated the major wave of European colonization and the dissemination of Western thought (Musallam 1998: 74–5). Qutb's culturally pure-bred fundamentalism proves, in this cynical reading, to be a cultural and historical mutt.

Qutb was a mutt, too. In his history of fundamentalism in the Sunni Arab world, Voll writes,

> It is clear that the Islamic resurgence is not primarily the accom-
> plishment of those with little experience with, or knowledge of, the
> modern West. Indeed, those who constitute the hard core of this
> broad-based Islamic revolution have had the greatest exposure to
> modern technologies, educational systems, political processes, cul-
> tural values, and lifestyles (1991: 346).

This was certainly true of Qutb, who was educated in a modern primary school rather than a traditional Quranic school (that is, a *kuttab*) and enjoyed making fun of those educated in such schools. He was a very good scholar of Romantic literature and an accomplished poet in the Romantic mode. Qutb was also drawn to other aspects of European modernity. According to Voll, Qutb was deeply influenced by the 'major rationalist modernists of the 1920s and 1930s' (ibid.: 369). By that time, Western modernity had long enjoyed a record of high regard and proven success in the Arab world, a record one can trace back to the reign of Muhammad Ali, who, inspired by the far-reaching social and political reforms instituted by Napoleon, 'began a program of rapid modernization of the Egyptian mil-itary, government, and economy using Western European advisers and models' (ibid.: 354). And though the Islamic Modernists were always chal-lenged by those who 'called for a return to the example of the pious ances-tors, the Companions of the Prophet', it is nevertheless true that 'Islamic modernism provided fundamentalism with a sophisticated modern vocab-ulary for the defense of Islam'; specifically, a 'focus on secularism and materialism as problems at the core of the modern experience' (ibid.: 356). Indeed, rather than viewing Qutb as simply anti-European and anti-American, as a raft of commentators recently have, it is more appropriate to follow Musallam's lead and consider him the result of 'conflicting forces of tradition and modernity in Egyptian society which were working to shape his personality and world view' (Musallam 1998: 65).

A second, less cynical and more compelling argument to make about Qutb's use of the Hejira myth puts the sleight of hand to the Europeans. There are two significant bodies of evidence that can be rallied to this

position: one, the impact of Islam on the development of Romanticism; two, the impact of Romanticism on the development of the avant-garde (recall that Qutb was a Romanticist). These links, individually, have been well established by historians; the connections between them have not. There is extensive and growing scholarship available on the relationship between Islam and Romanticism, an important corrective to the Westernized vision promulgated by the likes of M. H. Abrams and Harold Bloom.[6] Naji B. Ouejian notes,

> To the Romantics, the East was a model world of exoticism, and what helped popularize such an image of the East was a very old Western tradition which started way before politics and trade had forced the Orient on the attention of the Western peoples; it started with the Westerners' amazement that the East, and not the West, should have been the birthplace of almost all ancient civilizations and of heavenly religions, particularly Judaism, Christianity, and Islam (1998: 49).

One of the first substantive treatments of the avant-garde concept, Poggioli's *Theory of the Avant-Garde*, argues that it is only with full and critically minded restoration of Romanticism to the historical record that the avant-garde can be truly understood: 'Many historians and critics have affirmed the continuity of the ideological and historical line between romanticism and avant-gardism. But almost always this involves rightists, often polemicists, already hostile to romanticism, who attack the avant-garde as an extreme case of what they call the "disease of romanticism"' (1968: 46). However, though links between Islam and Romanticism are clear, as are those between Romanticism and the avant-garde, no scholar that I know of has traced them between Islam and the avant-garde. The right-wing polemicists have managed to dominate the conversation.

The avant-garde metaphor itself is part of the problem. Its military connotation obscures other models that are just as useful for imagining forms of cultural radicalism: the cenacle, the rhizome, the think tank, or, of most interest here, the mystical pilgrimage. Like the metaphor of the small group of elite soldiers leading the charge, the mystical pilgrimage is what Bakhtin would call a 'chronotope', a way of thinking and telling stories that imaginatively unifies space and time. Replacing the military group with the mystical pilgrimage doesn't mean we lose the usefully antagonistic connotations of 'avant-garde', since it is associated with the experience of exile and migration, random and intended threat, and purposive movement

through space. The mystical pilgrimage was a common chronotope for Romantic poets, as Oueijan makes clear:

> It is difficult to read extensively in the works of the Romantics without coming away with the feeling that there emanates from their writings a sense of determination to explore the mysteries of existing yet obscure realities. Their insistence on a voyage or a pilgrimage away from conventional civilization manifested itself in two forms: a physical (Byron's *Childe Harold's Pilgrimage*) and/or a mental (Coleridge's 'Rime of the Ancient Mariner') quest toward the exotic and mysterious (1998: 49).

Thus, it's not surprising that stories of the Hejira were so appealing to young, alienated poets.

Romanticism stands as one example of how, in Edward Said's words, 'popular orientalism during the late eighteenth century and the early nineteenth attained a vogue of considerable intensity' (quoted in ibid.). Though no doubt part of the larger, ultimately demeaning Orientalist fad, some Romantics studied Islam with real seriousness and respect, constructing a vision of Islam that was both seductive and effective in the instruction it gave to Europeans about how they might break with classical Western tradition and its industrial-capitalist parasites. Examples of Romantic literature in which Islam figures prominently are numerous, though basically overlooked by scholars like Bloom. Shelley, Byron, Goethe and William Beckford—just to cite the big names—all tried their hands at it. Scholar Dan White has drawn my attention to a particularly interesting one, Robert Southey's 'Mohammed: A Fragment', which portrays the Hejira as a mystical pilgrimage. Begun in 1799 by Southey, it languished for a few years until it was picked up again when Southey and Coleridge decided to give it another go. Only a fragment from what was to be the second book was completed but it's worth a look. It describes Ali's loyalty and assistance to his brother Muhammad during the flight from Mecca.

In the fragment, Ali disguises himself as his brother in order to deceive their enemies, enabling the Prophet to escape and hide in a warren of caves. Ali thus stands as a surrogate or duplicitous double of the displaced Muhammad. That disguise is cloaked in yet another: Ali is 'restless and full of fear, yet semblant of one that is sleeping'. Upon its discovery, the disguise causes further confusion. The substitution of one brother for another 'baffles' the enemies of Islam and goads them into a

panicky, disordered chase across Arabia and North Africa. The scene then shifts to a cave in which Muhammad and one of the Companions hide, passing 'expectant hours', their hope giving to 'the sound of the wind [. . .] its tone' and to the Prophet the promise that 'God will confound' the plots of his enemies. The fragment contains a cluster of tried-and-true vanguard themes: the self-imposed exile; the moralization of space and time; the sensory and intellectual sensitivity enabled by rebellion; the world-historical significance of contrarian attitudes and action and performance. It's hard not to read the thing as a commentary on avant-garde studies itself, scrambling in one direction while its object remains safely ensconced.

In the end, we must correct Bloom's insight that, 'though it is a displaced Protestantism, or a Protestantism astonishingly transformed by different kinds of humanism or naturalism, the poetry of the English Romantics is a kind of religious poetry, and the religion is in the Protestant line' (1961: xvii). In fact, the line is nowhere near as linear nor as Eurocentric as that—it takes a long, circuitous detour through the Middle East and Islam. The genealogical line that winds from Romantic Orientalism to the events of 9/11 leads me to the conclusion that, rather than the avant-garde being the disavowed European origin for radical Islam, exactly the opposite is the case: it is Islam that is the disavowed origin of the avant-garde. Saint-Simon and his Modernist ilk were latecomers to the game.

ZEN BUDDHISM AND THE INTRACTABLE IRONIES OF THE AVANT-GARDE OF RELIGION

Bradford's train of heretics and foreigners, the ecclesial base communities of Latin America, the Israeli soldiers at the weeping wall, the *picana*-wielding fanatics in Argentina's secret torture camps, the delightfully subversive séances of Fox, the flaming prophecies of free love declared by Randolph, the devastated villages of Mozambique and Kosovo, the devout Muslims in Nasser's prisons—these make clear that the avant-garde of religion is, at the very least, an important history, one that deserves far more attention than it has received. As institution, epistemology, material, body and practice, religion has afforded both conceptual structure and point of attack to diverse cultural activists and communities—even to those who gather in the spirit of scepticism, as Jill Dolan showed us in the case of queer performance in Austin.

But, given the ubiquity—if not the foundational role, if we're to take seriously the history of the *taliah*—of religion in the history of the avant-garde, a difficult question comes up for those who desire to critically engage the avant-garde in order to reveal its shortcomings and refine its possibilities: If the avant-garde is always already enmeshed in metaphysical concepts of time, space, identity and community, is the goal of constructing a general theory of the avant-garde ultimately a religious goal? Has the field marginalized the vanguards of religion because it is, in its heart of hearts, religious? We organize our subjects into the sacred and the profane. We dwell on things touched by the sacred makers, their paintings and interviews, and pore over the fragmentary documents validating their existence. We arrange events into true and false histories. We grant inordinate importance to things that most people don't know or care about. Even our critical methodologies are derived from methods developed for biblical exegesis.

This is one of the added virtues of Bürger's theory of the avant-garde—by avoiding religious questions, we can avoid falling into a logical conundrum. Derrida got into some very hot water when he dove into the debate about German philosopher Martin Heidegger's membership in the Nazi Party, but his argument is highly pertinent to our own. In *Of Spirit: Heidegger and the Question* (1987), Derrida argues that any effort to critique ideologies and political systems that are premised on metaphysical concepts of identity, community and history will ultimately prove 'abyssal'. That is to say, any such critique will find itself having to use the same kind of metaphysical reasoning that it attempts to refute. Any effort to reject matters of faith 'in the name of an axiomatic—for example, that of democracy or human rights,' Derrida writes, 'comes back to the metaphysics of *subjectivity*' (1991: 40).

But there is another possibility here. The inevitability of metaphysics—its capacity to justify good as well as evil actions, the most profound insights into power as well as its brutalizing application—has long been a concern for Zen Buddhists. The particular efforts of one group of Zen Buddhists and the avant-garde artists they influenced to find a way out of the paradox described by Derrida is a fitting subject to draw my discussion of religion and the avant-garde toward its conclusion.

Zen Buddhism is difficult to describe or summarize, for reasons that I'll try to explain, but one of its unique characteristics is that, in its struggle to liberate all sentient beings from suffering, it mounts a critique of religious discourse itself. Indeed, many have argued that Zen was deconstructing

metaphysics centuries before Derrida arrived on the scene and doing so for many of the same reasons; in particular, to undermine the tendency to think in terms of self and other, subject and object, action and inaction. (For a summary of the discussion of Zen and deconstruction, see Odin 1990.) Originating in China during the sixth century, it flourished in Japan during the twelfth century, attracting adherents with the anti-elitist notion that the essence of Buddhism can only be passed from master to student in direct, experiential ways and not through discourse or study under the supervision of licensed experts. This was not just a 'political' stance on the part of the Zen Buddhists, though the history of Zen is replete with institutional schisms, internecine warfare and courageous resistance to hidebound authority. Zen Buddhists hold that theological discourse and study are premised on relationships to being that interfere essentially with the becoming of Buddha-nature.

That said, there is a centuries-long debate within the Zen Buddhist community about whether one can simply dispense with discursive thought and ecclesiastical hierarchy. Regardless, it is a profoundly icono-clastic tradition, one that challenges the sanctity of virtually all of the conventions of religious life: holy texts and the literacy required to appreciate them, standardized rituals, sacred sites, adherence to doc-trine. One Buddha celebrated by Zen Buddhists gathered an enormous crowd who, expecting to hear words of wisdom and a long disquisition on enlightenment, were shocked to be presented with a mere flower and an interminable silence. According to the tale, only one member of that audience got the idea and, with a silent smile, was rewarded with the acknowledgement of one Buddha by another. Zen practice presumes that Buddha-nature—the potential to achieve enlightenment and recognize the inherent state of profound emptiness—is not developed by logic, common sense and discursive language. According to most schools of Zen, one must nevertheless study and diligently meditate, though atten-tiveness to the hazards of study and diligence must always be maintained.

However, one sect of Zen, Rinzai, has challenged even that assumption, asserting that enlightenment can be had spontaneously, in a moment of 'beginners mind' that can be catalyzed by all kinds of things; say, being tossed into the mud, having one's perfectly reasonable question turned into a philosophical paradox, or receiving in one's face the explosive shout of a teacher. The Rinzai tendency not only deconstructs the line between the intellectual and the anti-intellectual but also the sacred and profane; thus,

the Rinzai devotee spends as much time engaged in banal activities such as sweeping or making tea as they do in formal meditation and prayer.

However, though its anti-establishment posture and attentiveness to everyday life would seem to recommend Zen to the vanguardist, there is something distinctly un-avant-garde about an assertion one often hears from Zen Buddhists: Buddha-nature is not metaphysical, not something apart from ourselves. This presumed lack of differentiation—the idea that the lines we draw between self and other, sacred and profane, subject and object are mere illusions—runs against the grain of the avant-garde concept. The avant-garde is premised before all else on the idea of making a difference, of affecting a society through an act of communal and expressive self-differentiation. Vanguards make a clear and irrevocable break between past and present, the here and the there, us and them. That's not something a Zen Buddhist would consider worth doing. One noteworthy scholar and practitioner of Zen, the iconoclastic composer John Cage, once wrote that his intention was 'not to suggest improvements in creation but simply wake up to the very life we're living, which is so excellent' (quoted in Leonard 1994: 178). It's hard to imagine a less avant-garde statement. Around the same time he wrote that, Cage claimed, 'Nothing is accomplished by writing a piece of music / nothing is accomplished by hearing a piece of music / nothing is accomplished by playing a piece of music' (quoted in Nicholls 2002: 56). If there 'is nothing to realize', then what's the use of an avant-garde, which is, if nothing else, a *process of realization*, a process that gives material reality to the conceptual and representational crises of modernity?

In a spirit not unlike the Rinzai master turning a sincere question into a quandary, the historical record doesn't provide an easy answer to that question. Zen was something of a lingua franca among cultural activists in Europe and the US during the 1950s and 60s, activists who worked diligently and against tremendous odds to unseat the powers that be. It deeply influenced the Beat group around Jack Kerouac, Allen Ginsberg and Gary Snyder, suggesting literary themes, writing methods and radical cultural stances and affirming the righteousness of their 'bohemian' way of life. Zen inspired Ginsberg and Snyder's long dedication to public activism; Ginsberg in multiple anti-fascist actions in the 1960s, Snyder in the environmentalist movement.

Zen also influenced the pioneering performance and conceptual artists Yoko Ono, George Maciunas, Yves Klein, and the artists associated

with Japan's Gutai Group. Ono and Brecht called the little instruction cards they created 'performance haiku'. Typically printed on small two-by-three-inch cards, they described actions or observations for the reader to perform, such as 'Light a match and watch it till it goes out' (Ono, *Lighting Piece*, 1955) or 'ice water steam' (Brecht, *Three Aqueous Events*, 1961). Much like the poems of the Japanese haiku master and devout Zen practitioner Bashō, these cards allowed their readers to treat everyday events, observations and transformations as opportunities for self-disclosure. That such discoveries occurred outside of the conventional educational and gallery structures surrounding art was just as important.

Zen shaped the vanguard ceramics movement that emerged in the 1950s in the back-and-forth collaboration of Japanese and US artists. In his consideration of this group, Daniel Belgrad has written that, for potters like Mary Caroline Richards (translator of Artaud's *The Theater and Its Double*), Soetsu Yanagi, Bernard Leach and Shoji Hamada, the act of making a pot was a form of 'plastic dialogue' that underlined the 'inadequacies of verbal communication' and directed attention towards 'exploration of nuance and materiality' (1998: 167–8). Richards writes, 'There [is] something in the nature of the clay itself. You can do very many things with it, push this way and pull that, squeeze and roll and attach and pinch and hollow and pile. But you can't do everything with it. You can go only so far, and then the clay resists. To know ourselves by our resistances' (1962: 19). So, it's not quite right to characterize the Zen tendency of avant-garde art as quietistic. Cage's desire to 'accomplish nothing' is much more activist than it might first appear. The accomplishment of nothing can be a remarkable and implicitly political thing to do—particularly in an era that witnessed experimental art treated by the advertising industry as a research-and-development laboratory and by the US State Department as a propaganda tool in its war against global communism.[7]

Further complications emerge when we delve into the beliefs and practices of those who were most responsible for disseminating Zen among dissident artists in the US and Western Europe. Though it would be criminal not to acknowledge the essential contributions of Alan Watts and Yoko Ono, the lion's share of credit should be given to Daisetz Teitaro Suzuki. Though his reputation has plummeted during the last few decades, Suzuki was for half a century acknowledged as Europe and the Americas' foremost authority on Zen. Suzuki served as translator for the

groundbreaking World Parliament of Religions at the 1893 Columbian Exposition in Chicago, then for the publisher Open Court, for whom he made available the most important works on Taoism and the compassionate tendency of Buddhism known as Mahayana. In the 1950s, Suzuki hosted an influential series of lectures on Zen at Columbia University, lectures attended by then-students Kerouac and Ginsberg and the restive Cage. It was through these lectures—and their impact on a series of composition workshops led by Cage at the New School—that Zen achieved a kind of oneness with an emergent counter-culture.

But what exactly was the Zen that inspired that oneness? A point made by Suzuki's critics concerns his highly selective perspective on the Zen tradition. His disciple Masao Abe, for one, expresses concern that Suzuki was guilty of promoting exclusively the Rinzai tendency of Zen and 'neglecting the important stream of Soto Zen', the tradition that depends on diligent meditation and study of scripture. As George C. Leonard points out, 'That's no technicality. Soto disparages the idea of sudden *satori* [enlightenment], which Suzuki told the West was Zen's very heart' (1994: 148). Rinzai's emphasis on spontaneity and complete rejection of 'the formal discipline of Zen that generates and grounds this experience', was attractive to an incipient counter-culture negotiating for a place both in a highly complex and rapidly changing sociocultural situation as well as an increasingly competitive and elitist art market (Helen Tworkov, quoted in Leonard 1994: 162).

And they did this with real probity. When Ono asks us to light a match and watch it go out, or when Brecht asks us to contemplate the multiple physical states of water (solid, liquid, gas), we are in the presence of a Rinzai aesthetic, an aesthetic emphasizing sudden enlightenment grounded in the precious banalities of the everyday and in the absence of the historical traditions and conventional practices of art. Another performance-art pioneer, Allan Kaprow, incorporated Zen into the mixed-media art form he called a 'happening', a collage-like environment in which objects, sounds, textures, gestures and other aesthetic materials were arranged. In Kaprow's *Eighteen Happenings in Six Parts* (1959), for example, the audience was divided into four groups, each separated by polythene barriers and experiencing a distinct set of sensory stimuli, which might include a toy robot wobbling across the floor or a painter slowly rendering opaque a polythene wall. The spectators in such environments were more like 'audience-participants', another of Kaprow's

terms, actively involved in organizing the things they saw, heard, smelt and did rather than simply contemplating them, a stance that aligned with Kaprow's efforts to undermine concepts of artistic authority, habits of spectatorial passivity and the conventional routines of the artworld. Ono, Brecht and Kaprow, among others, blurred the conventionally distinct functions of artist and the audience, reminding one of similar efforts on the part of Zen Buddhists in respect to the roles of expert and novice. If the audience is an active presence in the work of art, then they are in part the artist, the maker of the work. Likewise, if there are consequences that are unplanned and untheorized by the artist, then she is in part an audience of those consequences.

Another concern of Suzuki's critics—one also relevant to his impact on avant-garde artists—is his promulgation of the 'Pure Land' tradition of Zen, which emphasizes adaptation to local circumstances and the making-accessible of religious practice to all people, not merely the monastic. On the face of it, this is an inarguably positive position, given that it promotes an anti-elitist, anti-bureaucratic, thoroughly localized awakening of Buddha-nature. As Kirita Kiyohide summarizes it,

> It is said that Zen Buddhism 'does not rely on words and letters; it is a separate tradition outside the teachings'. It has no fixed body of doctrine because the basis of Zen is experience, which is prior to doctrine. Zen experience always finds new modes of expressing itself depending on the time and social circumstances in which it takes place, just as its teaching is continually growing and developing through the lives and thinking of individual Zen Buddhists (1994: 69).

And this is exactly the spirit of the artists like Cage, Klein, the Gutai Group, Ono, Brecht and Kaprow, who utilized performance not just for its improvisatory qualities but also for its capacity to ground an inquiry into being in specific moments and places—neighbourhood coffee shops, the blooming aromas of baking bread, the timpani of leaky roof gutters and the like.

However, it has been argued that this tunnel-vision focus on the situational puts at risk both consciousness of history and of the valuable critique found only in the oral and scriptural tradition of Zen. In Kiyohide's words,

> The emphasis on the here-and-now [. . .] breaks the ties between before and after. It breaks with all value judgments and distinctions between good and evil. [. . .] The distinction is important, as is the fact that during [the Second World War] this idea in effect encour-

aged soldiers to push on and do battle without a thought, totally unconcerned with the historical and social circumstances (ibid.: 71).

We shouldn't forget that Suzuki's Pure Land Buddhism is rooted in the Mahayana tradition of absolute compassion. He wrote in 1945, 'The Zen understanding of human life is based on Mahayana Buddhism. Zen without this is not Zen. It isn't anything at all [. . .] To regard the foolhardy and senseless sacrifice of one's life as Zen is a mish-mash idea. Zen absolutely never teaches one to throw life away' (quoted in ibid.: 61). He goes to pains to remind his readers and students that his 'earnest desire is that Buddhists do not remain satisfied with personal peace and enlightenment but take it upon themselves to help society' (ibid.: 56). But the contradictions remain.

For instance, Suzuki was never able to close the gap between religion and politics. Though he wrote that his primary foes were 'ideologies that give absolute authority to the state [such as] state nationalism, state supremacy, and the idea of national polity,' (quoted in ibid.: 63) he never settled on a specific political programme. On the one hand he argued that 'in Zen experience itself there is no democracy, nor is there imperialism or hegemonism' (quoted in ibid.: 65); on the other he tended to portray Zen as a kind of 'enterprising spirit' and a practice of 'self-reliance', an individualistic practice that allowed him to 'keep his distance from the socialists' (ibid.: 56, 58). As Leonard points out, Suzuki's translation of the Zen term *ji-yu*, conventionally understood by Zen scholars as 'freedom', as 'self-reliance' 'casts over Zen a friendly Emersonian glow' (1994: 162). It also casts over it the glow of free-market liberalism, contradicting his claims of ideological neutrality. So, though Kiyohide concludes that 'Suzuki was first and foremost a realist,' he also admits that this does very little to clarify in any final way the necessary connection of Suzuki-style Zen to social justice (1994: 65). This is also true of the work of Cage and his colleagues. Though their works demand action and active, nuanced contemplation on the part of their audiences—indeed, they make clear that ethical concerns are integral to any aesthetic system—as I have argued in detail elsewhere, such 'activism' affords only an ironic solution to the ills of post-Second World War capitalism, even though that irony is premised on an acute consciousness of the structural conditions of those ills (see Sell 2005).

This lack of clarity is not Suzuki's and the artists' alone. The 'Kyoto School' of Zen Buddhism surrounding Nishida Kitarō has in recent years

become the object of a thorough critique, in part (as James W. Heisig and John C. Maraldo have explained) as a result of the recent debate about Heidegger's membership in the Nazi Party (Heisig and Maroldo 1994: vii). Though he isn't generally considered a true 'member' of the school, given his long absence from Japan and his somewhat distinct approach to metaphysics, Suzuki did play a role in its development with Nishitani Keiji, Hajime Tanabe, Takeuchi Yoshinori, Ueda Shizuteru and Masao Abe. Notable for their 'wide-eyed, open-minded approach to religious philosophy that seemed to answer the need for a serious encounter between East and West as few contemporary systems of thought have', (ibid.), the members of the Kyoto School attempted to restore religion to a philosophical debate that, after Kant and Hegel, essentially excluded religious questions. In some respects, the work of the school stands as one of the most provocative efforts to put into effect a philosophical practice that could avoid the pitfalls of conventional metaphysics while sustaining a concern with spirituality, and doing so by initiating a conversation between Zen Buddhism and the Western philosophical tradition. However, the Kyoto School also gave rise to a vicious right-wing tendency, as represented by the work of Suzuki Shigetaka, Kōsaka Masaaki, Kōyama Iwao and Hajime Tanabe. These promoted veneration of the Imperial family and sanctified military aggression, justifying their positions in the same terms that informed the critique of such positions by Suzuki and others.

I don't have the knowledge, authority or space to arbitrate the positions taken by historians and philosophers on the Kyoto School but it is clear that Zen Buddhism is an empowering mode of critique for those in the vanguard—regardless of their ideological perspective—due to its ability to call into question the metaphysical urge itself and restore attention to the 'facts as they are'. It served samurai and student-age conscripts on their way to sanctified death and destruction as well as it did the artists and audiences exploring the beauty of the smallest moments of daily life. It has been used to justify both Japanese imperialism and experimental compositional strategies. Many Zen practitioners have taken the courageous route of the Buddha Sakyamuni who, while eventually retiring in the face of the inevitable, placed himself three times in the line of an advancing army. Only someone fully conscious of the relationship between life and death can do such a thing. But such consciousness is not, in and of itself, the basis for moral decision-making. Sakyamuni's example has been emulated, too, by those who would halt the advance of forces that stand for justice, equality

and compassion. Those would be the ones aiming the water cannons and swinging the truncheons—a vanguard of violent repression.

RELIGION, POLITICS AND VIOLENCE

Andrew Hewitt, in *Fascist Modernism*, argues, following Walter Benjamin and Jürgen Habermas, that European fascism was prepared by the institutionalization in European civil society of a conceptual split between aesthetics and politics. This split opened between European art and political spheres when the new post-revolutionary states of the 1800s dismantled the centuries-old relationship between art, artists and their patrons in the church and among the aristocracy (Hewitt 1993). The consequence of this dismantling was not just a loss of financial security for artists but a crisis in the metaphysical and social assumptions that had supported art in Europe. *L'art pour l'art*—in which art is viewed as everything morality and utility is not—attempted to overcome this crisis by justifying art as valuable not for its service to authority and its mythologies but in and of itself. To recall Gautier again, art was valued by the formalists precisely to the degree that it could not be exploited by bourgeois moralists or left-wing materialists. But the consequence of this effort to make art and aesthetic perception a transcendent value was to introduce into European political discourse a way of conceptualizing politics itself that was dangerously similar to aesthetic formalism, a way of thinking about citizenship, the nation and geopolitics in which material differences in wealth and opportunity could be dismissed as, say, 'foreign inventions', or as transcended by concepts far beyond such 'petty' concerns, or displaced by tall tales of threatening others, cultural degeneration, or the special capacities of a chosen few. Though the attendees of a Symbolist perfume concert and a torchholder at a fascist rally would share little in terms of political beliefs, both viewed their societies in essentially aesthetic terms. What Benjamin has called 'the aestheticization of politics' empowered both communities to believe themselves to be key players in world history because of their unique sensitivities and to defend the righteousness of their actions by identifying and condemning the threatening 'other' on essentially aesthetic grounds. The Jews were burnt by an industrial proletariat that believed itself to be answering the call of destined whiteness. For the formalists, it was the philistine who threatened truth and light.

The split between aesthetics and politics is neither the only nor the dominant institutional and ideological catalyst for the violence unleashed from Europe during the nineteenth and twentieth centuries. Just as important, perhaps more so, was the divide between politics and religion. After all, it was not merely art that was set apart from politics after the great anti-aristocratic revolutions of the 1700s but religion, too. Indeed, it is difficult to imagine any of the examples I have explored in this chapter in the absence of such a separation. Further, the absence of religion in any discussion of 'aestheticized politics' will put us at a disadvantage when dealing with the vanguard movements that deployed such politics. This is clear in the case of fascist Germany. If, on the one hand, the German masses indulged essentially aesthetic fears of the ugly, degenerate brute (the Jew, the Roma, the black African), they also celebrated Hitler as a god and assented to his belief that his life be viewed as a modern version of Christ's passion. His bestselling autobiography *Mein Kampf* (1925–26) was an odyssey of redemption, an *imitatio Christi*, with Hitler taking the place of Jesus and *Mein Kampf* replacing the Gospels. Fascism was a 'civic religion'. Berghaus summarizes it well:

> Mussolini stated in 1923 that 'fascism is a religious phenomenon of vast historical proportions', and that it was 'a civic and political belief, but also a religion, a militia, a spiritual discipline which has had—like Christianity—its confessors, its testifying witnesses, its saints'. The Fascist party was often described as 'a new Church' [. . .] or as a 'religious and military order' (1996b: 53–4).

The events of 9/11 and after are sure proof that the institutionalized gap between religion and politics is as hazardous as the split between aesthetic and politics—and just as important a concern for the construction of a general theory and history of the avant-garde.

Just about every avant-garde is, at some level, a metaphysics in action, and all avant-garde theory is, tendentiously and paradoxically, a religious critique of religious systems of power. Every avant-garde must inquire into the conditions of causality and significance that enable them to pursue their world-changing campaigns. They must all find a point where a leap of faith is required to draw that inquiry to the point of decision, to a place and a moment where the spheres of religious belief and political practicalities intersect. Indeed, if the gap between the spheres of faith and politics is one of the motive engines of the avant-garde, the key question for

scholar and lawmaker alike would be: How can religion and politics be united without violence?

Notes

1 See Bonnie Marranca, who has recently drawn attention to this gap (1999: 15–16). See also Bonnie Marranca and Peter Sellars (2005: 44ff). For a discussion of anti-religious bias in literary studies, see Michael W. Kaufmann (2007) and the responses to it by Tracy Fessenden (2007) and Kevin Seidel (2007).

2 See 'The California Guided Meditation' on the website of Reverend Billy and the Church of Earthalujah. Available at: http://www.revbilly.com/participate/retail-interventions/the-california-guided-meditation (last accessed on 5 May 2006).

3 See 'Renamo Insurgency in Mozambique 1976-1992'. Available at: www.onwar.com/aced/data/romeo/renamo1976.htm (last accessed on 19 August 2004).

4 See John Ashcroft's speech, delivered at Bob Jones University, Greenville, South Carolina. Available at: www.spectacle.org/0201/ashcroft.html.

5 My thanks to Paul Berman for pointing out these connections. See Paul Berman (2003a and 2003b) and, for more extensive discussion on the connection, see Kepel (2002: 34–5). Thanks, too, to Abdel Soliman for his assistance in understanding the subtleties of the word *taliah*.

6 On the connection between Islam and Romanticism, see Conant (1908); Daniel (1962); Shaffer (1975); Smith (1977); Stevens (1984); Lowe (1991); Leask (1992); Sharafuddin (1994) and MacKenzie (1995).

7 For a discussion on the use of avant-garde art in advertising, see Thomas Frank (1997). On the use of avant-garde art by the US State Department, see Serge Guilbaut (1983).

war

RESTORING THE MILITARY TO THE METAPHOR

The term 'avant-garde' is originally a military term; the *Oxford English Dictionary* defines it as 'the foremost part of an army; the vanguard or van'.[1] For better *and* worse, the term, even in its most attenuated metaphorical sense, puts the political, social and artistic acts described in this book squarely in the terrain of state-on-state violence, the male chauvinist warrior ethos, the suffering of the refugee, the traumatic injury and post-traumatic stress syndrome of the wounded soldier and the global weapons industry. According to Calinescu, the earliest understandings of the vanguard artist were cloaked in 'such military or quasi-military notions as march, power, arms, victorious, decisive action, etc.' More specifically, he points out, the term reflects 'the central reality of war' of the modern era, particularly the era of 'revolutionary civil war'. Apparently, the first journal to bear the term 'avant-garde' in its title was a military broadside, *L'Avant-garde de l'armée des Pyrénées orientales*, published in 1794 amid the simmering French revolutionary crisis and intended to defend Jacobin ideals and communicate them beyond the ranks of soldiers to a wider circle of patriots (Calinescu 1987: 100–01, 104).

These historical and linguistic legacies should give any user of the term 'avant-garde' cause to pause. These associations cannot be dismissed or defended easily. Baudelaire found the popularity of the term to be

characteristic of his society's 'predilection . . . for military metaphors' and a sure 'sign of natures that are not themselves militarist, but are made for discipline' (1950: 188–9). Paul Mann, in a similar vein, characterizes the recent turn in the humanities towards 'war studies' as a self-serving, self-congratulatory compensation for the marginalization of the humanities in the modern university (Mann 1999: 91, 114). On the other hand, there are certain qualities of this military association that are well worth keeping around despite Baudelaire and Mann's sneers: loyalty (especially to one's brothers and sisters in rank), discipline, commitment to the challenges of revolutionary struggle and the philosophical problems of just war, among others. I am more than a little hesitant to abandon those.

Regardless, avant-garde studies would do quite well without its key term, dedicating itself to other models, other chronotopes of revolutionary time and space not associated with war. There are plenty of them, to be sure: the cenacle (described in Chapter 2), the utopian commune, the theatre collective, the groupuscule, the matrix organization, the specialist enclave. We don't need the metaphor to keep hold of the tendency. But I suspect that the metaphor will last, as it is too embedded, too much a part of our thinking, to throw away. It's a term people recognize, one that still has the titillating *caché* of Frenchness.

And *caché* aside, at this point in the history of avant-garde studies, rather than shake off the militaristic connotations of our key term, scholars, historians and critics need to give the military-historical dimensions of avant-gardism their full attention. After all, as Watten points out, the prototypical model of the avant-gardist is the male artist refusing 'to participate in normative culture after the traumatic rupture of total war' (2003: 154). In addition, military vanguards have played an enormously influential role in recent history—count the coups, putsches, juntas and purges. Two of the most influential theories of the avant-garde, those of Lenin and Mao, applied in reverse Prussian military scientist Carl von Clausewitz's principle that war is politics carried on by other means. (The actual quote is 'War is a mere continuation of policy by other means', which means something slightly different [see Clausewitz 1999].) War being unavoidable, Lenin and Mao developed specific leadership structures to manage their respective civil wars in such a way that, once it was attained on the battlefield, the march to victory might continue on the labyrinthine fronts of bureaucracy. Their reversal of Clausewitz's axiom was the de facto philosophy of the state apparati of the Soviet Union and

IMAGE 4.1 US Special Forces soldier celebrating victory in Buzkashi, Northern Afghanishtan, December 2001. Photograph courtesy Associated Press.

the People's Republic of China. Even if we only include these two individuals, it is obvious that the modern era has been deeply impacted by a specifically militarist conception of vanguardism. So while avant-garde studies should not consider its key term sacred, it is hardly the time to abandon the term—or stay within disciplinary confines that disable a general theory of the avant-garde.

This became especially clear to me when photographs of US Special Forces soldiers from Operational Detachment Alpha (ODA) 595 were published by the Associated Press in December 2001 (see Image 4.1). Sent to

Northern Afghanistan to rally the region's notoriously unruly tribesmen against the Taliban, the soldiers of ODA 595 participated in a traditional horseback tug-of-war with the tribesmen, earning their respect and support (big bags of money and promises of future power helped too). Though only one of many special force units deployed there, these soldiers typified the kind of dexterous negotiation of the old and the new required of any avant-garde that is aware of the uneven, dynamic relationship of culture and technology and hopes to exploit it for social, political or economic change. Relying on horses, local food, long-lived ethnic bonds, rivalries and cultural practices but also utilizing the latest global positioning technology, laser targeting devices and electronic networking, they provided key tactical force to the US offensive, ensuring the rapid taking of Kandahar and the destruction of the Taliban regime.

Special forces, uncapitalized and broadly defined, are simply an elite unit within an existing military force—thus, falling in line with the original definition of 'avant-garde'. Such units feature in virtually every national military force in existence today and is the working model for the private military corps owned by big-time gangsters, coup-dreaming generals and private suppliers of elite soldiers and guards such as Xe Services LLC. Military historians generally consider the Second World War to be the first moment that special forces were used on a significant scale. According to *The Oxford Companion to Military History*, the first were created by the Germans during the Second World War after careful study of the use of guerrilla tactics by Allied forces in the First World War (2001: 865–6). The 'Brandenburgers', named after the city in which they were formed, were 'highly trained men capable of carrying out long-range, deep-penetration missions' (ibid.: 866). Great Britain's Special Operations Executive was formed in 1940, an elite force primarily concerned with deep penetration reconnaissance, demolitions and assassinations. The SOE trained early members of the US Office of Strategic Services, which provided personnel and guidance for operations in the Middle East, North Africa, Burma, Siam (now Thailand), China, Australia and Western Europe (not least, Normandy, in preparation for D-Day).

The function of special forces changed during the Cold War era, shifting 'from insurgency to counterinsurgency', as Edward Luttwak and Stuart Koehl put it, with units deployed to recruit and train indigenous warriors in struggles across the developing world (1991: 552). But there was more to it than just a shift in strategic purpose. As Chalmers Archer Jr, one of

the original Green Berets, makes clear, special forces at that time began considering *culture* as a critical feature of all theatres of military operation and began seeing themselves as more than just 'highly trained men'. In fact, they began to envision themselves as a force for economic development, utilizing 'environmental improvements', 'population and resource control' and medical education to not only demonstrate their commitment to those indigenous groups but to also provide them an entry into global capitalism (Archer Jr 2001: 62). (I shall discuss in detail these shifts in perception and function later.)

Special forces, without a doubt, ought to figure prominently in any general history and theory of the avant-garde, not least due to the increasingly important role they will play in the near future. According to a February 2006 *Wall Street Journal* report,

> [W]ith nearly three years remaining in his tenure [. . . Secretary of Defense Donald] Rumsfeld is intent on laying a foundation for future administrations to use the military's elite commandos more expansively. The current plan would increase the number of Special Operations troops by 14,000 to about 64,000—the largest number since the Vietnam War. Defense officials say the number represents the most the military can currently maintain without lowering standards (Jaffe 2006).

This audacious expansion would, as the Secretary envisioned it, provide not only quicker response to regional military situations but also give to the US Defense Department 'broader latitude to both work with indigenous forces and take action in countries where the US is technically not at war' (ibid.); which is another way of saying that the Department could use diplomatic and military resources outside the scope of international law and treaties, a point raised by Linda Robinson (see Priest 2003: 97–111). This is, to say the least, a worrisome tendency, particularly given the fact that—as I will argue in more detail in the conclusion to this chapter—the world is experiencing what might be called a *generalization of special forces*; a generalization, to put it another way, of the avant-garde of war. Though Rumsfeld's plan has been rejected, his belief in the special utility of Special Operations, both militarily and politically, remains strong throughout the US military establishment (see Shanker 2008).

THE GUERRILLA AND THE LIMITS OF MILITARY THEORY

Oddly enough, the 'hurrah' that Rumsfeld and his colleagues sounded for special forces is mostly unprecedented. Indeed, irregular fighters such as special forces—and those they combat—have long suffered disregard, disrespect and underestimation by politicians, policy-makers, military leaders and cultural historians. Consider the guerrilla, a classic avant-garde by my definition: part of a minority movement seeking a shift in political power through the use of illegal, subversive or alternative methods, particularly those that utilize culture. The guerrilla has long been disdained by military strategists and historians. Walter Lacquer describes the difficulty Julius Caesar had combatting Vercingetorix, King of the Arveni, who rallied an army of the poor in what is now Lyons, France, to repulse the invaders. Not only did Caesar have to contend with Vercingetorix's hit-and-run tactics but he also had to deal with their impact at home. As Lacquer describes it, Caesar spent an inordinate amount of time contending with 'the impatience and foolishness of his own countrymen, who time and again forced him to commit errors against his better judgement: Insisting on his giving battle, for instance, or retreating after a battle into a prepared fortress' (Lacquer 1976: 7). Like Caesar's fellow citizens, Napoleon Bonaparte held guerrillas in absolute contempt, though they provided him some of the most persistent difficulties of his military life and one of the most humiliating defeats of his career (in fact, the term 'guerrilla' was coined during the Spanish campaign of 1808–14). Ironically, those same guerrillas were despised by their own countrymen. Francisco Espoz y Mina and El Empecinado, the two most important guerrilla leaders, were considered by Spanish regulars to be 'mere peasants, lacking military training, experience and discipline—little better than brigands. The guerrillas for their part, hardened in countless skirmishes, made short shift of such criticism. [. . .] The guerrillas had little respect for the personal courage of the regular army officers whose records against the French had not been impressive' (ibid.: 39).

Intriguingly, precisely because of the industrialization and rationalization of war in the nineteenth and early twentieth centuries and the development of modern military science and officer education schools, irregular warfare became a more viable strategy. Lacquer believes that the development of military conscription and enormous standing armies; the invention of new forms of firepower, transportation and organizational

structures (general staffs and the like); and the development of a common discourse of military science across Europe (aided by the development of military schools) led to a 'grim unanimity, a universal recognition that the coming war would be a war of masses, with the outcome hinging on which side could get fastest with the greatest quantity of men and material to the particular area of operation' (ibid.: 50). He finds the situation more than a little curious considering that, between 1815 and 1914, 'there were only a very few major wars but a great many guerilla campaigns' (ibid.: 51). Even those few big wars—the American Civil War (1861–65) and Franco-Prussian War (1870–71) coming to mind—saw the use of guerrilla warfare strategy by both sides. But smaller conflicts such as the Polish insurrection, the Italian and Greek wars of independence, the Spanish civil wars, the resistance of the Caucasians against the Russians and of Ad el-Kadar against the French in North Africa can be properly considered guerrilla wars. Ultimately, Lacquer argues,

> One does not have to look far for the reasons for such blindness. There was, to begin with, instinctive resistance to the employment of forces that could not be fitted into the framework of organized and disciplined armies. Guerrilla warfare was erratic, unprofessional, unpredictable; it violated all established rules. It might dovetail neatly with right- or left-wing anarchist thinking, but it was altogether alien to the make-up of the military mind (ibid.).

The combination of bigger-is-better thinking and bureaucratic military science has often been a rich soil for irregulars of all sorts ever since, particularly the small-scale, elite kinds of units that are the emblem of the avant-garde of war.

It does not help matters that irregulars have a reputation for hanging out with the wrong kind of people. Lacquer quotes a British diplomat who, upon returning from a visit to the Shensi Province of Northern China in 1917, warned his superiors that the province was in the hands of 'organized troops of brigands of a semi-political character'; in the words of the diplomat, 'robbers one day, rebels the next, and perhaps successful revolutionaries the next' (ibid.: 93). During the guerrilla phase of its revolutionary struggle against Chinese national forces in the 1930s and 40s, Mao's Red Army depended on these semi-political types to augment its forces— a case of one vanguard minority, faltering on the military side of things, depending on another minority, advanced in terms of military practice and economic subversion but with virtually no sense of politics. Mao at one

point had to defend the alliance against those who worried that the anti-
authoritarianism of the irregulars would demoralize the entire Red Army.
As Lacquer summarizes it, 'Mao declared it was not true to say [. . .] that all
the soldiers were *éléments déclassés* [*yumin*], meaning deserters, robbers, beg-
gars, and prostitutes but he admitted that the majority consisted of such
men and women' . The problem was, according to Mao, that these '*éléments
declasses* [. . .] were especially good fighters, they were courageous, and
under the right leadership they could become a revolutionary force'. Mao
pointed out that '[i]t was surely no mere accident that the Communist
guerrillas appeared precisely in those parts of China such as the Hua Yin
region in which banditry on a mass scale had been endemic for a long
time'. Thus, rather than attempt to quarantine these bad types, it was nec-
essary to intensify political education efforts, in Mao's words, 'so as to effect
a qualitative change in these elements' (ibid.: 96).

More than a few avant-gardes have depended on (or were them-
selves!) such 'bad types'. Anarchist Mikhail Bakunin put great store by the
bandit, characterizing him as the 'genuine and sole revolutionary—a rev-
olutionary without fine phrases, without learned rhetoric, irreconcilable,
indefatigable and indomitable, a popular and social revolutionary' (quot-
ed in ibid.: 94). This was also the case for Huey Newton, one of the
founders of the Black Panther Party for Self-Defense, in the mid-1960s. As
Judson L. Jeffries has described it, Newton's childhood in a poor, black-
dominated ghetto was a contributing factor to his rejection of the tradi-
tional Marxist rejection of the so-called lumpenproletariat, that class of
individuals who cannot or will not find regular work and who, generally,
seem to resist organized revolutionary movements. Inspired by his own
experiences and by readings of Fanon (who also saw the lumpen as a pow-
erful force for revolutionary spontaneity), Newton would write of the
'brothers off the block' that, '[i]f you didn't relate to these cats, the power
structure would organize these cats against you' (quoted in Cleaver and
Katsiaficas 2001: 29).

MILITARY STRATEGY AND FUTURIST AESTHETICS

Emphasis on practical military questions has been a common feature of
vanguards not connected with armies; for example, the Situationist
International tendency of the Cold War era led by Guy Debord. Debord
was a devotee of Clausewitz and a designer of a compelling military-

strategy board game.[2] And there are the Italian Futurists, who advocated
—obnoxiously, incessantly—war as cultural 'hygiene'. The comparison of
war to hygiene was well-worn by the time Marinetti and his gang picked it
up, something of a Modernist antique. (On war and hygiene, see Pick
1993: 75–110.) Other dimensions of Futurist militarism come to light
when we examine Futurist performance strategies. The Futurists devised
artistic methods that could palpably 'move' their audiences into a state of
'body madness' (*fisicofollia*). The itching powder, glue and double-booked
seats called for by Marinetti in his 'Manifesto of the Variety Theatre'
(1913) are a kind of transposition of military strategy into public relations.
Not just strategy—the Futurists also embraced the everyday bluster of
cocksure soldiers, perfectly willing to punch someone in the nose for an
ideological error. 'Don't forget it,' Marinetti writes, 'We Futurists are
YOUNG ARTILLERYMEN ON A TOOT' (2005b: 38). In sum, the Futurists articu-
lated a two-pronged strategy. First, a kind of sociocultural projectile war-
fare, with crowds as the targeter, the Futurists the aim of rhetorical force.
Second, a more quotidian aggressiveness, familiar to anyone who's had to
tolerate a cocky military presence in their neighbourhood.

One irony of Marinetti's Futurist proclamation is that it cites a mili-
tary corps that had reached maturity three quarters of a century earlier
and was already in decline—yet another Modernist antique prized by
these propagandists of innovation. The artilleryman was, during the early
nineteenth century, the very model of modernity. Christopher Coker
writes, 'the origins of the industrialization of war can be traced back to the
last years of the Napoleonic Wars' (2004: 15). A key part of this industri-
alization was the rise of modern artillery, which demanded great techni-
cal expertise on the part of both the worker who built the big guns and
the soldier who shot them at others.

> Napoleon began his career as a captain of artillery [and] put great
> emphasis on that arm. In claiming that 'missile weapons have now
> become the principal ones', he echoed Turpin de Crisse's statement
> that 'it's by fire, not by shock, that battles today are decided [and] it is
> with artillery that war is made'. Battering at the enemy's line often for
> hours, the sheer quantity of fire concentrated was unprecedented for
> this era of warfare. A battery of only 40 guns, occupying a front of
> about 600 yards, might throw a thousand rounds an hour into an
> enemy position and still increase their rate of fire minutes before an
> attack (ibid.:16–17).

The artilleryman was the prototypical technocrat, the cocky expert who disdained politics except to bully his neighbour. However, the artilleryman was losing his claim to the cutting edge at the time of Marinetti's belligerent metaphorizing.

The airplane came of age in the First World War, unseating artillery from the prime seat of military glamour. Oddly enough, Marinetti's invocation of the artilleryman as the very model of modernity came a year *after* he first sang the praises of aerial travel. Marinetti writes in the 'Technical Manifesto of Futurist Literature' of 1912,

> Profound intuitions of life linked together one by one, word by word, according to their illogical surge—these will give us the general outlines for an *intuitive psychology of matter*. That is what was revealed to me from the heights of the airplane. Looking at objects from a new vantage point, no longer head on or from behind, but straight down, foreshortened, I was able to break apart the old shackles of logic and the plumb lines of the old form of comprehension (2005a: 18).

From the bird's-eye view of the airplane, the artilleryman looks pretty passé. That being so, I wonder if the artilleryman-on-the-toot bit might have been intended in a minor key, even though it is in ALL CAPS. Regardless, the swagger described by the Futurists is downright *passeist* ['past-ist'], to recall a Futurist term of contempt.

As a brief but pertinent aside relating both to the relationship of Futurism and war and to the study of military vanguardism more generally, we might recall that it was RoseLee Goldberg who ensconced the Italians as the founding fathers of modern performance art. In *Performance Art: From Futurism to the Present*, she writes, 'In tracing an untold story, this first history inevitably works itself free of its material, because that material continues to raise questions about the very nature of art' (1988: 9). One question that we might raise concerns the originality of the Italians and the shortfalls of a performance history defined solely in terms of 'art'. As Attanasio di Felice notes, Renaissance performance spectacles such as Gian Lorenzo Bernini's *L'Inondazione* of 1638 (which caused a house to collapse) or his *Allestimento di una Girandola* (1659, which partly melted the cupola of St Peter's in Rome) can be rightly considered 'prototypical' performance actions, particularly interesting ones, given their use of military technologies to celebrate military triumphs (1984: 3). But the mantle of 'most significant prototype' would have to go,

IMAGE 4.2 Russian Suprematist El Lissitzky deploys a military strategy for propagandistic ends in *Beat the White with the Red Wedge* (1919).

in my opinion, to the proponents of 'propaganda by deed'. However, this requires, as I argued in the Introduction, a willingness to consider cultural events that are not strictly 'artistic' in nature.

Anarchists such as Peter Kropotkin and Enrico Malatesta considered the symbolic violence of individuals as capable of inspiring action by others. As Kropotkin put it, 'A single deed is better propaganda than a thousand pamphlets' (quoted in Manning 2004: 226). One such mythic deed of this kind is the ignition of explosives in a crowd. The urban bomber can be considered the prototype of the artist who hopes to capitalize on what Paul Wood calls the 'sheer power of the symbolic in social life' (Wood 1999). So, though I wouldn't deny the literally explosive nature of their sound and fury, it is *through* the Futurists—not *starting* from them—that one traces a line of aggressive, ideologically charged symbolic actions to performance art. This line moves from the anarchists both to the suicide bombers of Tel Aviv and 9/11 and the provocative body art of Chris Burden and Marina Abromović.

Questions of priority aside, from a purely belletristic perspective, digging into military history augments our reading of familiar works of art. For example, a particular kind of military strategy is embedded in Russian Suprematist El Lissitzky's *Beat the White with the Red Wedge* (1919) (see Image 4.2). The classic, though highly dangerous manoeuvre of divide-and-conquer is the principle here, with the Bolshevik avant-garde, the red wedge, plunging deeply into the Menshevik white ranks, thus splitting

and weakening them. The modernity of El Lissitzky's composition is to be found not only in its geometric simplicity and bold use of colours but also in its representational mediation of the military and the cultural. It is, if you will, a piece of aestheticized militarism, of abstract, paint-coated strategic theory.

THREE WAYS TO THINK ABOUT WAR

As these few examples make clear, thinking about culture, politics and economics as varieties of warfare is not only a perennial tendency in avant-garde history but of the modern era more generally. As Calinescu reminds us, the imagination and experience of war—as action, as social organization, as technical application—is as central to our collective sense of modernity as it is to the vanguards in our midst (1987: 100). Daniel Pick's *War Machine: The Rationalisation of Slaughter in the Modern Age* (1996) makes this thoroughly clear. He examines an eclectic range of Modernists alized warfare (Pick 1996). The modern era is, obviously, the era of modern war. Indeed, we might go so far as to say that, rather than war experiencing the effects of industrialization (what Coker calls 'the disenchantment of war' [2004]), it is industry—the small-scale, semi-artisanal operations that peppered Europe in the age of Napoleon—that experienced the effect of continental, then intercontinental warfare. So, clearly, war should be at the forefront of any study of the avant-garde—and as more than metaphor.

What I intend to do in the pages that follow is examine a number of moments, movements and issues to be found in the shared history of war and the avant-garde. As I explore and describe these, I will use a set of terms that allow me to discuss together the military and aesthetic dimensions of avant-garde warfare while not erasing significant distinctions between them. In *The Future of War: The Re-Enchantment of War in the Twenty-First Century* (2004), Christopher Coker describes three dimensions of the military experience. They are a useful place for us to begin:

(1) *The instrumental*: 'The ways in which force is applied by the state, the way in which it is used to impose one state's will upon another' (ibid.: 6). In other words, war as a collection of technologies and ways of thinking. War has proven to be a wellspring of invention, giving us everything from food preservation to foot care to rocket travel to the Internet. It has

also catalyzed innovations in the way we think about subjectivity; for example, post-traumatic stress syndrome was first theorized by Freud when he worked in a clinic caring for those with war-induced neuroses. The instrumental is *techne*, the craft or art of war, and is the aspect of military experience that provides the best perspective on the impact of both technology and military science.

(2) *The existential*: The experience of war itself. Coker focuses on the warriors, their experiences in the field; however, we should also keep in mind non-combatants, too, whether civilians in theatres of war, the families of warriors, draft dodgers (that is, the Dadas, hippies, etc.), or those who are not allowed to participate in a direct fashion but whose labour is a necessity for sustaining the war project (that is, women, resident aliens, etc.).

(3) *The metaphysical*: The mode of thinking that 'translates death into sacrifice . . . invests death with a meaning' (ibid.) or fails to do so. Coker writes that 'it is the metaphysical dimension which is the most important of all precisely because it persuades societies of the need for sacrifice. It is sacrifice which makes war qualitatively different from every other act of violence' (ibid.). Providing the means by which to transcend death—and, by extension, the fear of death—metaphysical beliefs about war have long provided the means to glamorize war, as well as the means to ensure that war remains the object of intensive ethical debate and institutional struggle.

In any given war situation, the instrumental, the existential and the metaphysical are in play. This is not to say that each is equally significant or that they play well together. As often as not, they are in contradiction, as was the case for many African American soldiers during the Vietnam conflict, who experienced a profound disparity between the existential and the metaphysical. Their experiences at home and in the ranks of the US military were scarred by the most profound kinds of racism, while the metaphysical justification of the war in which they fought was that it was a defence of human progress and liberal democracy against godless communism. No surprise that insubordination, drug use and poor morale were rife among black troops.

Each of the three dimensions of war has a distinct history. There is a history of the gun that is independent of the history of, say, Horace's

dictum, '*Dulce et decorum est pro patria mori*' ('It is sweet and proper to die for the fatherland'). But there are sites where these dimensions and histories coalesce—for example, in the mythic status of the electrified prod, the *picana eléctrica*, in the torture theatres of Argentina's Dirty War, a subject I discussed in chapter 2 and will return to shortly. This is what makes war such an eminently valuable concern for avant-gardists beyond the specific usefulness of violence. A shift in the metaphysical significance of war, for example, can affect the acceptable limits of instrumental efficiency (say, in discussions of acceptable 'collateral damage'). This, in turn, can transform the phenomenological experience of fighting itself. Understanding the multidimensionality of war in Coker's terms can provide a way not only to assess the specific nature of this or that vanguard of war but also to better comprehend its efficacies, its failures and its symbolic purchase on the imaginations of those it affects. Let me offer two examples to which we can apply Coker's themes and their interrelationship, one of which is literary, the other cultural.

1. Melvin Tolson's 'The Bard of Addis Ababa' and a Fourth Way to Think About War

Melvin Tolson's poem 'The Bard of Addis Ababa' is a fascinating, obtuse response to the end of the Italian occupation of Ethiopia (1936–41). A kind of High Modernist obliquity addressing the final moments of the conflict between colonizers and colonized, the poem is structured in three parts. The first section introduces the Bard himself, the soul of Ethiopia, its cultural wellspring and griot. He follows behind a 'massive yellow' junkyard dog. The Bard and the dog live on a 'trash alps', the result of the centuries-long residence of the Ethiopians and the Italians' breakneck modernization of the Ethiopian infrastructure. This initial section spends most of its lines describing the appearance and significance of this wild man who wears both a Chinese dagger and British pistols and is at once 'emblem of justice' and dweller in garbage, a 'hero of *grazmatch* and vendor, / of *hakim* and beggar and wag'. The second section of the poem shifts its approach. Here, we get the Bard's song, a rousing, though poetically traditional call to arms. Significantly, the song calls not only for the end of the 'Fascist jackals' but also to the 'days of masters' more generally: 'And a *ras*, a *dedjazmatch*, a king—yoho!— / Each father's son shall be!' Thus, the final call is not the nationalist knee-jerk we might expect but a call for rejection of oppression in all forms. The third section returns to the descriptive mode of the first

though the setting this time is not a trash heap but a triumphal march. The Ethiopian army, led by Haile Selassie, 'giant Galla captain, / Khaki-clad, nerveless, and straight', returns to the capital amid clattering shields, daggers and swelling 'patriot's pride', while the fascist 'Black shirts slump on the camels, / Haggard and granite-eyed'. Two odd bits about this final section. First, the fascists are characterized as 'gypsying Caesars'. This 'blackening' of the Italian forces by comparison to 'gypsies' (see Chapter 2 for more on this) complements the vision of triumph, which places both griot and nation in a similar, hybrid status. On one hand, the Bard wears both Chinese and British weapons and a lion's-mane busby, which is not an African icon but a 'London-born gift'. On the other, the national triumph ends '[o]n the steps of St. George's Cathedral', while 'eucalyptus cloisters / Echo with festive bands' (Tolson 1944: 83–7).

This moment of triumphal syncretism is followed by two stanzas, each briefly describing the sovereign powers of the post-war moment. This is the second odd bit: the first stanza describes a static image, a 'pyramid' of 'Princes and bishops and scholars' crowned by Selasse, his head capped by a 'Diadem of Light'. The second stanza in a sense overrides this image of glory by describing what appears to be the ultimate sovereign, the Bard, whose face 'shines with a glory / No crown, no *lumot*, can shed'. What's particularly odd here, beyond the ascendance of the bard over the emperor, is the invocation of the 'Imperial Highway', one of the many projects of the force-fed modernization, the so-called de-Ethiopianization project, initiated by the fascist invaders. The highway 'discovers / A great dog and a graybeard *ahead*. / "O Bard of Addis Ababa!" / Cry the heroes to wake up the dead' (my emphasis).

There's a weird temporal loop here that concludes the poem, putting what introduced the poem, the Bard and his dog, at the *end* of modernity's project. Thus, if we were to approach this poem as a metaphorical representation of an avant-garde—the Bard on the trash heap is a classically romantic figure, marginal yet central—is set against another, the imminent presence of the song, memory and unity of the African nation achieved through modernization. Tolson's poem is, in the final analysis, a tangled knot of oppositions: formal irony vs agitation-propaganda; nationalist vs cosmopolitan/hybrid; a momentous, forward-moving account of war vs a circular return.

This is where Coker's terms can help us. Consider first the instrumental dimensions of the poem—its representation of the tools and

technologies of war. There is the yellow dog, the dog being a long-time companion of warriors. However, it's not entirely clear that the Bard is master of this dog, so to deem the dog purely instrumental would be a stretch. Among the other instruments in the poem are the pistols and dagger, traditional instruments of war, though these are never used in the poem, remaining in some sense souvenirs, trusted tools and potent threat. There are the shields and knives of Selassie's triumph, though these, too, are no longer in action and are basically stage decor. There is the donkey ridden by the Emperor, the camels by the fascists (objects now, 'slumped' and 'granite-eyed') and the road. Transportation is always a vital infrastructure of war and the instruments of transport are especially important. But the fascists no longer move and Selassie is set like a jewel atop a pyramid. It is the Bard—and the Bard only—who travels the road. In sum, the instrumental elements of Tolson's poem are weirdly non-instrumental.

In terms of the existential dimensions of war—the representation of violent struggle—there is a kind of vacuum in 'The Bard of Addis Ababa'. There is no great storm of violence, only its wind-up (the rousing song of Part II) and its monumentalization (the dazzling, pyramidal triumph of Selassie). This is rather striking. There were great heroes in the struggle that might have been portrayed in action: Abune Petros, for example, executed by the fascists for his efforts as Bishop of the Ethiopian Orthodox Church to protect his flock. There were epic battles, too; some 30,000 soldiers from both sides died in the initial invasion. Perhaps the existential vacuum in the poem is the consequence of a rather awkward fact: the defeat of the Italians came with the heavy assistance of British troops. However, this supposition is problematic for a couple of reasons. First, Tolson often wrote about such ambiguities, notably in his opus *Libretto for the Republic of Liberia* (1953). Second, the Bard wears his British pistols proudly and his hat is a virtual proclamation of Anglophilia. Regardless, on the existential level, there is no representation of war itself to be found in the poem. Has such art been consigned to the trash heap? Or is it a trauma we are dealing with here, something just beyond the reach of language?

Which brings us to the metaphysical dimensions of Tolson's war poem. The existential emptiness of the poem may have something to do with the way *time* is shaped in its lines. Appeal to 'time's ripening' is, as many have noted, the pillar of any hawkish metaphysics of war: present violence allows future benefits to happen. Glory, history, progress, hygiene, self-betterment—these were the talking points of the most successful 'propaganda of

modern life' ever mouthed by Marinetti and his gang. Tolson's poem, troublingly, seems to second that emotion. The martial beat of the second section is linked to a decisive future action: the throwing down of the fascists by way of an act of insurgent violence. That future-oriented threat is complemented by another, directed to all those who would deny any Ethiopian citizen their sovereignty. And the future involves a superhighway. But against this activist, future-oriented movement, we have the static images of the defeated fascists, Ethiopia (a jewel-encrusted pyramid) and the Bard himself, a creature of past, present and future. Understood within the poem's ambivalently Modernist construction of time, war is both futurological potential and monumentalized memory. The metaphysical dimensions of Tolson's poem are decidedly in flux.

Coker's terms are useful for getting a grip on the nuances of 'The Bard of Addis Ababa'. However, Tolson's poem exposes the limits of those terms as well—and of Coker's analysis of war more generally. Arguably, the most powerful kinds of war-thinking and war-waging occur when the instrumental, the existential and the metaphysical are tightly welded together. That kind of unity is made possible by a fourth dimension of war:

(4) *The aesthetic/representational.* War is trauma, propaganda, information, dramatic backdrop and many other representations. Of no small importance is the way that such material is structured, communicated, mediated, made touching or enraging, told as story or slogan or painting. Art's place in war itself—as entertainment for the troops, as critical opposition, as hypocritical evasion, as stirring tale of human endeavour—is varied and significant.

Returning to Tolson's poem with an eye towards its aesthetic qualities, we notice an intriguing tension—indeed, contradiction—on the level of genre. The poem is both a piece of agit-prop and art for art's sake, both a rousing call to battle and an oblique, difficult meditation on form. Why this tension and how does it relate to the tensions in the poem's instrumental, existential and metaphysical dimensions that I have addressed?

What I think we've got here is one poet's effort to describe a moment in Afro-diasporic history when the instrumentalism of revolution, the traditional instrumentalities of culture (that is, the griot as historian, maintainer of the oral tradition, conserver of social behaviour and the like) and the modernity of European capitalist imperialism collided, producing a

cataclysmic spray of 'modernities' and, as a consequence, decentering the dominant notion of the 'modern' generally operative in European capitals after the First World War. Simon Gikandi has noted that any theory of African postcoloniality must address the 'African subject's difficult location and dislocation in the symbolic economy of European modernity, and the models developed to explain institutions and practices that always seem to be both inside and outside the metaphysics of modern reason' (2000: 142). The paradoxical representation of time in the poem, propped up by that icon of modernization, the newly constructed highway, reflects this inside/outside tension. Likewise, the ironic intertwining of agitational and formalist *poesis* may be symptomatic of Tolson's deeply ambivalent feelings about future-oriented ideologies based in violence.

Without discussion of aesthetics, our understanding of war and the avant-garde—even those avant-gardes that do not appear to be 'artworld' vanguards—will fall short. This can be illustrated by moving beyond the rarefied climes of Modernist poetry to the streets and plazas of Buenos Aires during one of the most horrific moments in the history of the avant-garde.

2. Las Madres de Plaza de Mayo: Motherhood, War and Technology

If Coker's book doesn't account for the aesthetic dimensions of war, it also falls short on questions of agency. His representation of war and its 're-enchantment' in the twenty-first century concerns only those who carry weapons and wage military campaigns with them, soldiers. However, war is neither only about soldiers nor only about the kind of military campaigns described in, say, Tolson's poem. It's about mothers, too, such as the 14 who gathered in Buenos Aires' Plaza de Mayo in the early autumn of 1977 to demand information from the government about their missing children. Their children were just a handful of the estimated 30,000 *desaparecidos* (literally, 'disappeared') abducted, tortured and murdered during the Proceso de Reorganización Nacional (National Reorganization Process) carried out by the Junta of General Videla and its successors between 1976 and 83. The regime justified the violence—though paradoxically never admitting to the abductions—as the necessary means to combat internal political subversion. It was a War on Terror whose primary front was *inside* Argentina, waged, in the regime's terms, along 'ideological borders' threatened by 'exotic ideologies', especially communism (Graziano 1992: 19–20). Las Madres de Plaza de Mayo, as they came to be known, exercised the most profound courage and love to challenge

vicious power. Given their small numbers, given that they fought against a totalitarian system in which the state waged a war against its own people and, given their unconventional, culturally grounded strategies, they belong in any history of the avant-garde but especially any history that hopes to address the avant-garde's relationship to war. In addition, as with Tolson's poem, Las Madres show us how important it is to comprehend war of all kinds as a complex tangle of existential, metaphysical, instrumental and representational issues.

Risking the most vile consequences in a war named for its vileness (the *sucia* in 'Guerra Sucia' is better translated as 'vile' or 'disgusting' rather than just 'dirty'), the mothers began their campaign quite simply, by gathering on Thursday afternoons in a public space of great significance to Argentina, the Plaza de Mayo, 'the seat of power in the country, flanked not only by the presidential palace but also by the cathedral and the most important banks' (Bouvard 1994: 2). The Plaza has long been a symbolic space for the country, the site of its declaration of independence from Spain and countless public demonstrations and memorial gatherings. However, the Junta declared such demonstrations both illegal and dangerous, rightly recognizing that any gathering of citizens was a challenge to its hegemony. Exploiting a loophole in the assembly law—gatherings were banned but not walks—Las Madres would stroll in a slow counter-clockwise perambulation around the Plaza for a half hour or so, sharing their experiences, anger and grief with each other and with passers-by, embarrassing public officials with their requests for information and personal responsibility (ibid.: 12). Eight months into their campaign, 12 members, including leader Azucena Villaflor were disappeared. Villaflor and two others were later seen, all three brutally tortured (their bodies were not recovered until 2005). Despite this blow and the constant threats and abuse they and their families faced, Las Madres continued to walk and organize, inspiring similar groups across the country, developing a range of innovative protest tactics and eventually constituting themselves formally as a human rights organization in 1979.

To properly understand the existential, metaphysical, instrumental and representational dimensions of Las Madres, we must first make some sense of the Junta and the Dirty War within which Las Madres fought as an avant-garde. That war is notorious for the inhuman brutality with which it was waged. Though it was justified as a War on Terror, few of those abducted were likely to be armed terrorists, and the majority of abductees were

young, most under 25 years of age. Thus, the Dirty War was not only an attack on youth but on mothers and fathers too. As Diana Taylor sums it up, 'The nocturnal raids on homes, the abduction of family members, and the practice of raping and torturing loved ones in front of each other revealed the armed forces' uneasiness with the family as a separate space and organizational unit' (1997: 85). Discomfort with autonomy was characteristic of the Junta as a whole, which, like other fascist governments, systematically erased the legal, moral and geographical boundaries separating the military, the civil and the domestic spheres of Argentinean society, enabling power to flow savagely from the public realm to the private realm, from state to home. However, by fully incorporating the civil and domestic spheres into its so-called War on Terror, the Junta inadvertently enabled the methods that would help its eventual collapse. As Marguerite Bouvard writes, 'The first institution to buckle under the violence of the terror was the family. In Argentine society, home and family form the pivot of a woman's life. [. . . Las Madres] did not rebel against this' (1994: 66).

Aside from its scale, arbitrariness and brutality, the Dirty War was unusual in two other ways, both relating to the exploitation of the existential and metaphysical experiences of privacy and maternality within a theatre of war and both fundamental to strategies that would be developed by Las Madres. First, as Graziano describes it, 'disappearances' occurred in highly spectacular fashion, yet were subsequently cloaked in absolute secrecy. Typically, whole neighbourhoods would have their power cut and traffic interrupted while heavily armed *grupos de tarea*, dressed as civilians, roared towards the target home in their Ford Falcons, helicopters throbbing overhead. Entrance into residences would be carried out with the maximum possible violence: doors smashed, furniture overturned, valuables frequently stolen. Abductees were immediately denigrated and abused, often in view of family, friends and neighbours (themselves often abused as part of the operation). However, despite the fury and violence of the abductions, there was systematic denial by authorities, both 'officially by the Junta (and the high command), which disclaimed responsibility for the "disappearances" and sought to annul the reality of their occurrence, and unofficially by low-ranking personnel who came into direct contact with the relatives of the *desaparecidos*' (Graziano 1992: 41).

The effect of this paradoxical 'theatre of secrecy' was to shape the Argentinean people into a peculiar kind of military instrument. Heleen F. P. Ietswaart describes that instrumentality: 'They are approving witnesses

to the events, they cooperate by informing the security forces about 'suspect happenings' and generally assisting them, and they serve as the audience for a moral and political lecture about "subversion" and their role in the struggle against it' (quoted in ibid: 255n62). Thus, they were, in Graziano's words, 'neither actor nor bystander'; they were, at once, a passive witness to atrocity and a 'function integral to the efficacy of the spectacle by which power is being generated' (ibid.: 76). Las Madres' decision to assemble on the Plaza and call for the bodies and voices of their children reflected, therefore, the particular, peculiar situation of 'passive agency' characteristic of the Argentinean people as a whole and the absurd commitment of those who would not accept the disappearance of their families, despite the manifest impossibility of ever recovering them.

Second, the Dirty War was a war on women. Taylor describes the spectacular masculinity of the Junta: 'The military represented itself as a disciplined masculine body, aggressively visible, all surface, identifiable by its uniforms, ubiquitous, on parade for all the world to see' (1997: 183). Further, the Junta figured the nation itself as a woman in need of protection: '[T]he Junta made explicit that the maternal image of the Patria or Motherland justified the civil violence', requiring 'her' defence against being 'raped', 'penetrated' and 'infiltrated' (ibid.: 184). This symbology was applied to victims, as well. In the camp known as Olimpo (Olympus), women were tortured in front of an image of the Virgin Mary. Rape was standard operating procedure, as was application of the *picana* to vagina, breast and mouth. Given the fact that the war was fought in part on the terrain of gender, a certain concept and enactment of femininity had significant instrumental value to Las Madres, defining them simultaneously as both outside power and central to it. Taylor argues that Las Madres 'attempted to manipulate the maternal image that was already rigorously controlled by the State. They claimed that it was precisely their maternal responsibilities as "good" mothers that took them to the Plaza in search of their children' (ibid.: 185).

Las Madres neatly reversed the existential, metaphysical, instrumental and representational strategies of the Junta. First and foremost, Las Madres waged a *representational* struggle. This struggle was based on an insistence that both criminals and victims be brought into view and their stories told, an insistence that the people of Argentina had the right to assemble and associate—in short, on the importance of what might be called 'the politics of presence', an especially powerful politics given the Junta's foreclosure of

IMAGE 4.3 The *pañuelo*, the iconic white head scarf of Las Madres, was chosen early on for a variety of reasons. Courtesy: Anil Kanji.

the right of *habeas corpus*. Indeed, as it has often been described, to encounter one of the mothers is to encounter the story of that mother and her family, the story of the disappeared child, a story that invokes through gesture, narrative and tears the physically absent *desaparecido*.

In addition to storytelling, Las Madres' representational struggle with the Junta was also carried out on the level of public assembly. Taylor points out that, early on, the women 'realized that only by being visible could they be politically effective. Only by being visible could they stay alive in a society in which all opposition was annihilated by the military' (ibid.). The Junta represented itself publicly in the display of an erect and isolated leader fronted by tight files of gun-wielding soldiers, and privately in the sweating, clustered bodies of torturers wielding the sizzling *picana eléctrica* around the bound victim. Las Madres' Thursday afternoon marches strike one as disorderly, as a kind of mercurial magnetic centre that, by gathering onlookers, brings an Argentine public into its own kind of presence. Thus, the instrumental passivity of the Argentinean people (the audience of atrocity) was brought into direct contact with the putative passivity of mothers—the

consequence being a sudden recognition of agency through 'a suspension of governmental authority' (Bouvard 1994: 14). Las Madres 'claimed the geography of dissent' precisely because 'they were not admitted to the chambers of governmental power' (ibid.: 60).

Las Madres also exploited the myths of passivity and domesticity at the heart of the Junta's intensely gendered concept of power. The *pañuelo*, the iconic white head scarf of Las Madres, was chosen early on for a variety of reasons (see Image 4.3). First, it was a simple visual tool to distinguish the women from other people in the Plaza. Secondly, it was a symbol, standing both for a baby's diaper and for humble domesticity. Lastly, it served as a kind of spiritual medium, providing an existential link to their children (in the words of one mother, 'It will make us feel closer to our children'; quoted in ibid.). Bouvard writes, 'In adopting the baby shawls as their insignia, the Mothers embarked on the use of powerful symbols that would not only identify them but that would also represent a reality in stark contrast to the brutality of the military regime. The shawls symbolized peace, life and maternal ties, and they represented the claim of family bonds and ethical values in the public arena' (ibid.: 75). We might go even further. The *pañuelos* communicate a soft, engulfing darkness, a hole surrounded by whiteness, the emptiness of the icon echoing with the singularity of a mother's sorrow. *A*, not *the*. The headscarf provides group identity, yet also frames an incommunicable, abysmal and individual sadness.

All this established, it should be duly noted that there is a fairly extensive body of incisive, if friendly critique concerning Las Madres. In that spirit, I would like to raise a few questions concerning the instrumental dimensions of their protest. In *The Spatiality of Collective Action: Flexible Networks and Symbolic Performances Among the Madres de Plaza de Mayo in Argentina* (2002), Fernando J. Bosco explores the network of activists and supporters built by Las Madres, not only the hundreds of members of their own organization spread across at least 20 cities in Argentina (some groups as small as two or three members) but also the dozens of supporting organizations across Europe and North America. Bosco is particularly interested in how Las Madres' 'identification with particular symbolic places, their territorial expansion across Argentina and the formation of a trans-local network of activists, and their movement across the country to gather in specific places are integrally related to their capacity to effectively sustain activism for over two decades' (2002: 10–11).

An especially intriguing aspect of Bosco's analysis concerns Las Madres' instrumental use of their bodies as a medium to invoke their disappeared family members. As Bosco notes, the two current organizations of Las Madres have distinct strategies to bring the *desaparecidos* into presence. The Asociación Madres de Plaza de Mayo 'has found a way to come to the plazas to claim for the disappeared as a group (without having to carry individual pictures and without calling them by their individual names) and to represent them as being alive'. They do so, by claiming that the abductions 'have made them *perpetually pregnant*. In effect, Las Madres claim that their sons and daughters still live inside their bodies, in their wombs, and give Las Madres energy to keep their activism alive' (ibid.: 216). In contrast, the women from Las Madres de Plaza de Mayo-Línea Fundadora 'carry pictures of the disappeared to make the disappeared visible, because for these Madres, the "disappearances" mean the displacement of a person from his/her regular social and spatial location to become a "nobody" located "nowhere" [. . .] Thus, they want to make the disappeared visible again' (ibid.: 217). Unlike the 'pregnant' Madres, these make clear a strict boundary between themselves and the *desaparecidos*. Regardless, 'despite the differences between the two groups, the body has become the medium through which both groups of Madres inscribe and represent their competing politics in the plazas' (ibid.: 218).

It is this instrumental dependence on the body, on the impact of emotional encounter and the social embeddedness of Las Madres that I wish to question. Some background is in order. My interest in Las Madres was sparked a few years ago by an intriguing paper written by theatre historian Jean Graham-Jones that called to task a certain tendency concerning the representation of the *desaparicidos* in Argentinean theatre:

> From the first explicit representations of the disappeared (e.g. Carlos Somigliana's 1982 *Oficial primero*, where the stage ended up buried in bodies) throughout the 1980s and early 1990s, embodiment was emphasized, indeed it seemed a prerequisite for any play on the subject. Bodies abounded: there were mute corpses, victims yanked under tables, loudly furious Antigones, lamenting Eurydices, and Evita phantasms; even when the individual was split into two, the body separated from the voice, the physical cadaver dominated staging and reception. The disappeared were embodied on the Argentinean stage in such a way that it became nearly impossible to think of their representation as anything other than corporeal ghosting (2005: 5).

The issues for Graham-Jones are, intriguingly, the same that caused Las Madres to split in 1986: representational methods and the institutionalization of memory after the end of the Dirty War. She continues,

> However, what had made dramatic sense in early re-democratized Argentina—when it was urgently necessary to unearth and give human form to all that the military regime had covered up—dangerously neared fetishism ten years later. The more realistic of Buenos Aires theatrical productions insisted on incorporating the disappeared into the historical pantheon through the most literal of embodied performances, while many experimental performances of the late 1990s avoided overt theatrical engagement with their country's recent history (ibid.).

While this is certainly an important issue, for my present purposes, I find another aspect of Graham-Jones' critique more so. Specifically, in her efforts to define an alternative to the visually based, embodied manifestation of the disappeared, she turns to the experimental work of La Pista 4. By comparing and contrasting this work with the strategies of Las Madres—and by situating both within the broader military-cultural context that enabled the Dirty War—we can accomplish three goals. First, we can situate Las Madres within a broader history of the avant-garde (including the aesthetic or artworld vanguard). Secondly, we can better understand the challenges facing minoritized groups such as Las Madres that would use aesthetic-representational means to challenge the brute instrumental power of military authority. Third, the case of Las Madres vis-à-vis what might be described as 'political embodiment' enables us to further refine the sense and application of Coker's terms.

Graham-Jones provides a detailed description of a La Pista 4 performance. In 1998, Luis Ziembroski, Gabriel Correa, Luis Herrera and guest artist María Inés Aldaburu produced an experimental performance work titled *Cadáveres*. The piece began with three of the artists winding through the performance space playing trombone, trumpet and bass drum. The opening four-note dirge mutated into Brazilian carnival tune and then into a march reminiscent of the days of Juan Perón, former President of Argentina (1946–55 and 1973–74). The musicians then accompanied Aldaburu, who recited the poetry of Argentinean poet/anthropologist Néstor Perlongher, before moving to individual microphones set on a table covered by a black cloth. There Correa,

Herrera and Ziembroski improvised and experimented amplification devices and a pre-recorded sound track. The performance ended with confetti falling over four pairs of legs (two male pairs wearing fishnet stockings), the only parts of the performers' bodies made visible below the table, as the performers together recited the evening's final poem. As Graham-Jones elaborates on her description, the performers worked 'against the . . . merciless litany [of Perlongher's poems about the Dirty War] and, interacting with Edgardo Cardozo's ornate soundtrack, the performers constantly changed sonic directions' by distorting voices and shifting genres (from soccer play-by-play to tango crooner, etc.) (ibid.: 2). The programme described the event as a 'structure of tempi and chance mathematical combinations [. . .] to create a score on top of which the poem was mounted. *Cadáveres* should be listened to as a radio-play, like the ones we will never get to hear on FM' (quoted in ibid.: 2–3).

Seizing upon this, Graham-Jones brings into play the work of Joe Milutis and Allen Weiss, two theorists of radiophonics, arguing that, 'by "staging" a radio-play, La Pista 4 achieved a goal shared by body- and radio-artists [. . .] that of dematerializ[ing] the art object into performing present' (ibid.: 2–3). Moreover, as Milutis contends, radiophonic performance such as this one 'break[s] down ontological borders, a process which is very similar to certain forms of psychosis' (quoted in ibid.: 8). As Graham-Jones summarizes it, 'This spatiotemporal shift . . . held an important consequence for Argentinean cultural production: through disrupting sign and referent in a stage (not broadcast) performance, *Cadáveres* freed the word from literary visual representation as it freed the performing body from mimesis' (ibid.). By mimetically representing neither the *desaparecidos* nor Perlongher's 'now-disappeared body' (he died in 1992 of AIDS), '*Cadáveres* managed to recuperate multiple explicitly Argentinean referents without mimetically reproducing their "deaths"' (ibid.).

Milutis and Weiss argue that the radio is fundamentally about the body. Not a body with discrete, bounded borders, a body here and now, computer in lap, coffee nearby; rather, a body encountering words transmitted from multiple locations, a body encountering the same words as many other bodies dispersed across the listening zone. Weiss writes, 'In radio, not only is the voice separated from the body, and not only does it return to the speaker as a disembodied presence—it is, furthermore, thrust into the public arena to mix its sonic destiny with that of other voices' (quoted in ibid.). According to Graham-Jones, La Pista 4 'effectively disrupted body-voice

identification', (ibid.) enabling not only a different relationship to absence—and a different style of mourning—but also a way of addressing the body that did not depend on notions of truth and presence exemplified by the 30-year-old photographs carried by Las Madres.

This is more than simply a question of aesthetic style; as a rule, medium and representational strategy are central to any consideration of vanguard activism, and this is particularly true of the Dirty War. In the case of *Cadáveres*, we find raised not only issues of representational strategy in the post-Dirty War era but also an instrumental dimension of the Dirty War itself, one that directly implicates Las Madres and the network of activists and support groups that they built within Argentina and across Europe and North America during and after the war. To wit, it can be tempting to consider the Junta an isolated, aberrant event—indeed, one wishes it were so. However, the War on Terror in Argentina was only one part of a larger struggle across South America known as Operation Condor. A joint project initiated in 1975 by the intelligence and security organizations of Argentina, Bolivia, Brazil, Chile, Paraguay and Uruguay—all led by right-wing military governments—Operation Condor was possible only through the advice and assistance provided by France, Portugal, Spain, Italy and the United States. The lattermost provided something more than mere advice; the operation would not have been possible if not for an American communications installation in the Panama Canal Zone that provided integrated communications across the Southern Cone (see Schemo 2001 and 2002). According to John Dinges, information exchanged via this network included torture techniques as well as the locations of suspected leftists who had fled persecution in their home countries (Dinges 2004). Thus, the Dirty War was not an 'Argentinean' war; rather, it was part of a larger operation involving governments on three continents and cutting-edge telecommunications, including telephone, teletype, coding and decoding technologies and shortwave radio.

Given this broader 'instrumental environment' of the Dirty War, it is appropriate to reconsider the existential, representational and instrumental strategies of Las Madres' struggle. A few questions that might be asked in this spirit (though not answered, due to limits of space): Do Las Madres' strategies, both past and present, effectively integrate or counter the cultural, political and strategic effects of electronic networks such as the international military-surveillance systems of Operation Condor or popular mutations of those systems, such as the World Wide Web (which plays a

significant role in Las Madres' work today)? How do the abstraction, distance and mediation that are inevitable aspects of electronic communications affect the existential impact of a victim describing the violence of a war? What impact does such distance have on efforts to mobilize against war? Along these lines, can the kinds of emotional and symbolic ties and social embeddedness described by Bosco be produced through electronic means, given the attenuation of the existential dimensions of experience within current electronic media? Lastly, how viable is the emphasis on the body, whether symbolically (in the case of Las Madres, maternality) or legally in terms of *habeas corpus*, as a strategy to contain wars, such as Operation Condor, that are electronically mediated? Finally, is there a way to fuse the representational and instrumental dimensions of Las Madres' protests, both past and present, with the kinds of techniques found in La Pista 4's *Cadáveres*, a way to fuse the existential impact of the live and present with the self-reflexive technology of the national or international broadcast? How might, for example, the Asociación's radio broadcast be altered in such a way as to open up the profound representational and ethical questions raised by La Pista 4's work? These are not questions I can answer here, but I hope that they suggest the value of approaching the avant-garde of war within a framework that combines the instrumental, the existential, the metaphysical and the aesthetic/representational.

RESTORING HISTORY TO THE METAPHOR

Tolson's poem and Las Madres de Plaza de Mayo exemplify the kinds of analytic insights and implications that come when we situate avant-gardes within Coker's cultural model of war, modified to give aesthetics its proper due. However, as the reader might have noticed, as I applied that model, I never lost sight of *history*, whether history as shaped by Tolson in his poem or history as a framework for better understanding the actions of Las Madres. In that spirit, I will now turn to some other case moments in order to provide further perspectives on avant-garde history, both history as it has been told by artists and scholars and history as a critical framework to recast the stories we find in the history books.

To start, we can turn to one of the first known figurative uses of the term 'avant-garde', found in Etienne Pasquier's *Recherches de la France*, published in 1560. Pasquier, a lawyer and historian, writes of a 'glorious war [. . .] waged against ignorance' by some of the poets of his time, 'who

constituted the avant-garde' (quoted in Calinescu 1987: 98). Calinescu, who unearthed this surprisingly early use of the term, speculates, based on the comfort with which Pasquier uses it, that we are already in the presence of a cliché from an 'age-old codified symbolism of war' (ibid.: 100). Calinescu has two points to make with this. First, the figurative use of the military term is far older than historians of the avant-garde have generally realized; by extension, so is the dynamic of modernity that we have tended to associate mostly with the nineteenth and twentieth centuries. Second, Calinescu notes that, in the effort to 'chronicle the growth' of culture in his country, Pasquier invoked 'certain notions of the language of history [. . .] a language directly connected with the central reality of war, from which it derives much of its narrative structure and dramatic quality' (ibid.). These are both important points, allowing us to not only historicize Pasquier's remarks but to also comprehend the specific vision of history motivating his use of the term 'avant-garde'.

However, in his effort to situate vanguard modernity in a longer historical line, Calinescu's analysis is oddly ahistorical. Pasquier's 'war against ignorance' is not an abstract concept, regardless of how cliched it might be; it is rooted in real acts in real time, in the concrete history of warfare, most obviously the Wars of Religion that wracked Western Europe from 1562 to 1598. Pasquier wrote about that war at length, arguing that it represented a profound threat to European culture if not the very possibility of a humanized history.[3] The upshot of this is that, if the poets Pierre de Ronsard and Joachim du Bellay (who Pasquier celebrates in his essay) are characterized as 'entering a battle', they do so quite differently from the Futurist artillerymen on a toot in 1913 or the boxcutter-wielding fanatic in the tight aisles of a jumbo jet in 2001. If we pay attention to military history, then we might conjecture that the van for Pasquier is in the chivalric mode, perhaps reminiscent of Francis I at the head of the French cavalry during the Battle of Marignan. Or perhaps Pasquier is thinking of something closer to the ground, an infantry armed with pikes and primitive rifles, a van that was common at the time (and invariably shot and cut to pieces). Or perhaps, presaging the Futurists, he has in mind something more like the artillerymen who made the day at Marignan in 1515 and thus became indispensable to any truly 'modern' army. Each of these metaphorical vehicles communicates a very different sort of avant-garde.

Calinescu discusses other moments in the history of the avant-garde metaphor, notably Balzac's *Les Comédiens sans le savoir* (1846), a book he

believes is among the earliest evidence of a rising fashion of the figure among literary and artistic types in mid-nineteenth-century France. The vehicle of Balzac's metaphor is much clearer than Pasquier's:

> Everything is conspiring to help us. Thus, all those who pity the people and brawl over the question of the proletariat and salaries or interest themselves in the amelioration of anything whatsoever— Communists, Humanitarianists, philanthropists [. . .] you understand—all these men are our avant-garde. While we lay in the powder, they are braiding the fuse, and the spark of circumstance will set fire to it (quoted in Calinescu 1987: 109).

Again, Calinescu leaves military history out of the picture. But if we read the passage with an eye to military science, we note that the image used is not a charismatic leader in charge, a belaboured infantry soldier or a long-range technocrat. Rather, we find here the *sapper*. Known in French by the term *génie*—the same word for 'genius' also favoured by artists—the sapper was responsible for a variety of tasks in combat conditions. Probably the most enjoyable, if most supremely hazardous, was exploding enemy fortifications and 'creatively destroying' roads, bridges and mountain passes to impede enemy pursuit. The sapper, in other words, is both an avant- and an arrière- (or rear) garde. The *Oxford Companion to Military History* informs us that the sapper enjoyed genuine vanguard status during the nineteenth century, at least at the instrumental level: 'In the British army, a standard cry was to "follow the sapper".' This strategy worked particularly well during the Indian Mutiny campaign, which saw the Indian Bengal Sappers and Miners, under the command of British engineers, blow to bits the heavily fortified Kashmir Gate during the siege of Delhi in 1857 (Holmes 2003: 286).

Focusing on the historical vehicle of Balzac's metaphor brings to light a number of issues of broader significance to our understanding of the avant-garde. First, Balzac's use of the figure is more than just evidence of an upswing in vanguard thinking, which is Calinescu's point. It is evidence of a shift in the instrumental aspects of European warfare that were bringing the combat engineer to new prominence, a shift based on the availability of new kinds of explosive charges, new kinds of defensive architecture and new kinds of technical knowledge—all the result of the spread of gunpowder and other explosive technologies throughout European military forces. In this respect, we can agree with Clausewitz who asserts that

such advances were troublingly independent of those occurring in the civil and intellectual quarters of European society. He complains that 'the invention of gunpowder, the constant progress of improvements in the construction of firearms, are sufficient proofs that the tendency to destroy the adversary which lies at the bottom of the conception of War is in no way changed or modified through the progress of civilization' (2008: 29). In other words, the technical advances of warfare were changing the world without reference to civil society or lifeworld.

If new kinds of explosives and explosive delivery systems were slow to be absorbed into law and philosophy, they were very quickly finding their way into the language of social visionaries. In the case of Balzac's frustrated painter Publicola Masson, the sapper provided a new chronotope—to recall Bakhtin again, a unifying figure of time and space—with which to think about violence, social conflict and the role of the intellectual. Balzac's representation is grounded in very specific instrumental terms, in an action of braiding that leads from the explosives (under the barricade, around the gate) to the broader social scene, which is where the spark is generated. There is, therefore, recognition on Balzac's part of the social and political significance of both the grass roots and the 'punch point' of social dissent, the two brought together—for the first time, conceivable together—in an instrumental metaphor suggested by the changing role and status of the industrial-era combat engineer. The sapper suggested to Balzac that, for artists such as the fictional Masson, history is a swirling, chaotic, sublimity that can be brought to bear on a single point in space and time through a carefully planned act of subversion, a well-placed, decidedly explosive act, 'propaganda by deed'.

The strategic usefulness of subversive engineering gives us another good reason to return to the Dadas of the Cabaret Voltaire and its raucous crowd of socialists, Expressionists, anarchists and other diverse malingerers. Though it's common knowledge that Dada was inspired by the industrialized madness of the First World War (many of the group's members were dodging their respective countries' drafts), Zurich Dada has yet to be adequately situated in terms of its place in the history of military theory. I'd suggest that that place is close to Publicola Masson and the Indian Bengal Sappers and Miners. The operative term here is 'revolutionary defeatism', summarized by Don LaCoss:

> As espoused in the waning years of the First World War by Lenin, Trotsky, and Rosa Luxemburg, revolutionary defeatists believed it

was their duty to criticize and resist anything having to do with a capitalist society's national defense, the use of patriotism as a rhetorical device in that national defense, or any other form of martial posturing. In the event of a possible war between capitalist powers, revolutionary defeatists would do everything possible to turn the climate of crisis into an incitement to proletarian revolution by encouraging mutinies, desertions, and other acts of sedition against the ruling government as it tried to mobilize the nation for war (2000: 3–4).

In a Europe covered by a fog of war comprised of equal parts gun smoke and propaganda, acts of profound nonsense like Ball's recital of the sound-poem 'Karawane' in a rainbow-coloured lobster suit can be understood as an act of subversion on par with the much more overtly 'political' *Prussian Archangel* that hung from the ceiling at the First International Dada Fair at Galerie Otto Burchard in Berlin in the summer of 1920, an assemblage composed of a German officer's uniform, butcher offal and pro-communist propaganda (see Image 4.4).

IMAGE 4.4 John Heartfield and Rudolf Schlichter's *Prussian Archangel* (1920), hanging from the ceiling at the First International Dada Fair at Galerie Otto Burchard, Berlin.

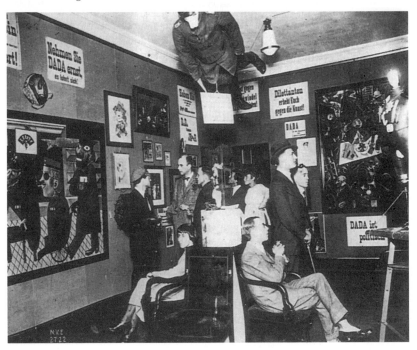

Understood in the context of revolutionary defeatism, a number of scholarly 'problems' concerning the politics of the Cabaret Voltaire start to evaporate. For example, the contributions of singer, dancer and passport-forger Emmy Hennings have often struck scholars as, at least on the level of political critique, strangely disengaged, even in comparison to the often highly oblique anti-war positions found in the work of her fellow Zurich Dadas. As Renée Riese Hubert puts it, Hennings neither 'made strong theoretical or ideological statements' nor 'articulated a philosophically or politically grounded program to which other Dadaists might adhere' (1998: 517, 519). However, given the general mobilization of culture across Europe, Hennings' electrifying, boyish, growling recitation of folktales and traditional love songs and her dogged consumption of morphine and absinthe might be considered actions as radical as forging passports for draft dodgers (for which she spent time in jail)—but only if we comprehend the political implications of 'escapism' in a situation of total war. We can argue about the efficacy of Hennings' work but only if we understand it as an 'engaged disengagement' from the absorption of all expressive acts into the global war machine. Hennings was a revolutionary defeatist and a sister to Masson and the Indian engineers who took down the Kashmir Gate.

Dada's revolutionary defeatism is one of the more important, if under-appreciated, contributions it has provided the avant-garde concept more generally, a legacy proudly, if inconsistently, carried by the Surrealist movement. As LaCoss has shown in his incisive description of Breton's group in occupied France, passive-aggressive subversion was a basic strategy, though, given their general commitment to revolutionary optimism, not one it consistently sustained. One moment when it became central to their vanguard strategy was in 1940. Oscar Dominguez, Hélène Lam, Jacqueline Breton, André Breton, Victor Brauner, André Masson, Pierre Mabille and others stayed for part of that year at a semi-secret safe house in Marseille, attempting to evade the German Occupation force and its French collaborators. One of their pastimes was to design and play with a deck of cards that paid tribute to the great pioneers of cultural insurgency and 'black humor' such as Vaché, Freud and the scandalous Portuguese nun Marianna Alcoforado (see Image 4.5). As LaCoss argues, the *Jeu de Marseille* and the more general refusal of the Surrealists to participate in the Resistance was not a gesture of quietism but one of the many 'meaningless activities' that provided the group a way to contribute absolutely nothing to the war effort, earning them

IMAGE 4.5 Cards from the *Jeu de Marseille* deck, created by Surrealists.

the scorn of at least one of the relief workers attending the refugees at the villa Air-Bel.

Revolutionary defeatism for the Surrealists was both a tactical response to a particular time and place of disempowerment but also a strategic decision in response to a recent tendency in France of using avant-garde art to sustain the French war machine. This tendency has been described at length by Kenneth E. Silver in *Esprit de Corps: The Art of the Parisian Avant-Garde and the First World War, 1914–1925* (1989). As Silver explains, the first issue of *La Révolution Surréaliste*, published in December 1924, was an explicit challenge to widespread French propaganda proclaiming the national virtues of 'reason and clarity'. He argues that the effort by Surrealists to reclaim

> internationalism and cosmopolitanism, with the concomitant interest in the so-called primitive nations and non-Western cultures; revolutionary sentiment, both specifically in Marxist terms and more generally in a desire to disturb, upset, and overturn the status quo; the anti-hierarchical aesthetic attitudes that valued above all the disenfranchised, the common, and the ephemeral, [. . .] challenged in the most direct and vocal way the widespread capitulation of the Parisian avant-garde to the forces of 'order' and reaction (ibid.: 396–7).

LaCoss views the Surrealists, finally, as part of a long tradition of radical defeatism that assumes as primary the 'duty to criticize and resist anything having to do with a capitalist society's national defense, the use of patriotism as a rhetorical device in that national defense, or any other form of martial posturing' (2000: 3). Indeed, Breton remarked in a 1951 interview, 'It appeared to me as if the task of intellectuals was to not let this purely military defeat [. . .] stop at just being purely military. Instead, we needed to attempt to turn it into a debacle of the mind' (quoted in ibid.: 6).

In addition to its metaphorical and instrumental suggestiveness, the sapper as a military strategy is well worth considering. The sapper, as I have pointed out, is a variety of military engineer, and it is beneficial to examine that corps more generally to comprehend the specific relevance of the sapper to the cultural history of vanguard warfare. The military engineer's duties are described by the *Oxford Companion to Military History* as any kind of 'civil engineering undertaken in a military environment', whether that be combat or not (in the latter case, the construction of barracks and other camp buildings). The military engineer has always been, at the very least, an instrumental vanguard for the military—recall the Anglo-Indian force that brought down the Kashmir Gate. However, the military engineer also played a broader role in European modernity. As the *Companion* describes it, 'With the advent of gunpowder, the mathematical and scientific knowledge needed by engineers for fortification and siegecraft became increasingly important and most modern military academies trace their descent from schools for engineers and artillery established during the eighteenth century' (Holmes 2003: 286).

We recall that Saint-Simon lived for a short while in 1799 across the street from one of those schools, the École Polytechnique, and found many of the earliest converts to his utopian programme among the military engineers who studied there. Egbert describes the school as 'almost the first of the great engineering schools, founded five years earlier as a product of the French Revolution' (1970: 119). Regarding Saint-Simon: 'There he took courses, and there such disciples as Enfantin, official leader of the Saint-Simonians after the master's death, and Auguste Comte, Saint-Simon's one-time secretary, were trained as engineers . . .' (ibid.). Thus, the military engineer can be understood as a faithful companion to the development of utopian socialism, especially the tendency grounded in technocratic visions of social harmony.

Other engineers provided the infrastructure for another kind of utopian vision: the so-called Manifest Destiny proclaimed by US patriots. From 1819 to 1879, US Army Engineers surveyed the roads, laid out the forts and drew the maps of western North America that enabled the US, in J. W. Morris' terms, 'to bind this huge new country to the old, to increase the public's understanding of the West, and to develop critical networks of communication and transportation' (2005). In addition, as Frank N. Schubert demonstrates, these engineers 'provided the necessary link between the first explorations of the mountainmen—those rude, brawling beaver trappers who first probed beyond the frontier and were no less than walking storehouses of geographical knowledge—and the civilian scientific specialists who understood a rigorous study of western natural resources after the Civil War,' thus providing an 'extension and codification' of that knowledge into 'the groundwork for scholarly analysis' (Schubert 2005). In sum, military engineers played a foundational role in the intellectual and technological trends that led, a century later, to the Cold War between the Soviet Union (the apotheosis of technocratic socialism, Global Communism) and the US (the apotheosis of spiritualized capitalism, Manifest Destiny).

Intriguingly, some of the nations and political movements caught between those two warring systems—those seeking a way beyond the binary clash of US and the Soviet Union—would not only develop a so-called Third Way between capitalism and communism but also develop and exploit a third and distinct variety of combat engineer, an engineer that was both an instrumental and symbolic force and who provided a distinct chronotope of vanguard action. As recognized by Balzac in *Les Comédiens sans le savoir*, the sapper decisively shifted the instrumental, existential and symbolic register of military engineering. But the full maturation of the sapper would have to wait until the 1960s, a period that witnessed significant challenges to the ideological and technological dominance of the West. Which brings us to Vietnam. Pitted against two economically and technologically superior nations—first the French (1945–54), then the US (1965–73)—the communist Viet Minh, led by the legendary Ho Chi Minh and General Vo Nguyen Giap, worked out a strategy that perfectly counteracted that superiority. An important part of that strategy, one that fit perfectly the instrumental, existential and representational contours of the struggle, was the sapper.

The notion of an elite demolitions unit was not a new idea; however, as David E. Spencer points out, 'It was the Viet Minh and, later, the North

Vietnamese that developed the concept to its full expression and gave it its unique characteristics' (1996: 2). Spencer writes that earlier, similar units, such as the storm trooper battalions of the Nazis or the elite demolitions units deployed by the Soviets in Poland and Spain, 'were very skilled with demolitions, and not as skilled at infiltration. The Vietnamese turned this around. They concentrated heavily on infiltration and were less skilled with the demolitions. Essentially, they integrated principles from the German storm troopers and the Soviet demolition units with advanced infiltration techniques' (ibid.). The priority placed on infiltration techniques is what set the Vietnamese apart. Spencer describes the difference in useful ways:

> Most infiltration techniques taught in conventional special forces schools emphasize finding where the enemy is not and crossing his lines at these points. However, few special forces schools teach techniques of infiltrating into an enemy position by moving directly under their guns without being detected. This was the unique characteristic developed by the North Vietnamese (ibid.).

These vanguard troops pulled off remarkable, almost magical moves, such as crossing triple-strand concertina perimeters and spot-lit minefields without being spotted, sometimes moving so close to an enemy gun emplacement that they could reach out and touch the soldiers stationed there. The consequences of these techniques were devastating attacks against American and South Vietnamese army and air-force bases, attacks that were almost always signalled by explosions *within* the fortifications under attack rather than from outside. It's hard to imagine a more frightening and demoralizing signal.

There are three dimensions of the Vietnamese sappers and their techniques that are relevant to a general history and theory of the avant-garde. First, there is their strategic and tactical unification of the political and the military dimensions of the struggle, or, another way of thinking it, of the representational and the instrumental. In this respect, we can turn to El Salvador, where a 12-year civil war (1980–92) that claimed some 75,000 lives was shaped by the sappers of the Farabundo Martí National Liberation Front (FMLN). As Spencer points out, for both philosophical and strategic reasons, insurgents such as the FMLN had to consider every military action as a political gesture. First, as Marxists, the rebels couldn't abide by the distinction between the military and the civil that is typical of

liberal democracies, a distinction one never finds in the work of, say, Lenin and Mao. Second, as Spencer writes, 'To the Salvadoran guerrillas, the potential political impact of an operation was regarded to be equally placed on the role that special forces could play by enhancing the psychological, and thus political impact of a guerrilla attack or operation' (ibid.: 5). In this respect, the sappers provided an effective means to achieve the interlocking goals of all insurgencies: 'First, strip legitimacy from the regime and, second, seize it themselves' (Metz 1995: 3). Guillermo M. Ungo, speaking for the El Salvadoran revolutionaries, saw the issue of legitimacy as 'the primary strategic problem in El Salvador' (quoted in Manwaring and Prisk 1990: 5). Thus, in a war where propaganda played a key role (President José Napoleón remarked in 1987 that, due to the 'avalanche of international press coverage [. . .] FMLN propaganda almost defeated us by itself'; quoted in ibid.), any military action was inevitably symbolic.

The second dimension of the Vietnamese sappers of interest to a general history and theory of the avant-garde concerns how it was understood and evaluated by the enemy. In the case of the sapper in Vietnam, as Spencer notes, most US military studies dismissed them, given that the bombers inflicted far less infrastructural damage and casualties than North Vietnamese artillery and rockets. However, the Vietnamese didn't see it that way, 'as they continued to train and teach these tactics after 1975' (Spencer 1996: 2). Neither did the communist and Warsaw Pact countries; among their analysts, '[t]he Vietnamese special forces had a reputation for being the best in the world' (ibid.). The El Salvadoran rebels were well aware of how the gap in understanding would increase their chances of military and political success. As Spencer shows, if, '[e]ssentially, the special forces being proposed by the FPL [Fuerzas Populares de Liberación, the largest of the groups within the FMLN] in their documents was a proposal for the transposition of the special forces techniques used by the North Vietnamese to El Salvador', then, given that the US was training the Salvadoran army, good success with these techniques could be just about guaranteed (ibid.). And, indeed, '[t]he majority of the spectacular blows suffered by the Salvadoran government forces would be at the hands of the guerrilla special forces using Vietnamese techniques' (ibid.).

The third dimension of the Vietnamese sappers and their techniques that is relevant to a general history and theory of the avant-garde is related to the second: what might be called the 'instrumental interculturalism'

of the sapper. 'Interculturalism' is a term generally used to describe the process of transaction and transformation that can occur in situations where two or more cultural groups interact; interculturalism is the process by which such groups encounter each other and translate, negotiate, and mediate affinity and difference within a dynamic of exchange and inclusion, as such processes have been described in another context (see Meredith 1999). The term is most common in anthropology and performance Studies. Ariane Mnouchkine's Kabuki-style productions of Shakespeare plays or her use of movement and musical elements from Indian Kathakali in her cycle of Greek tragedies are excellent examples of this process as it functions within the world of art. Not merely an exotic element to add spice to the tried-and-true within the Western tradition, Mnouchkine's use of Japanese and Indian forms provides a combination of theatricality, spectacle and sacred distance she believes no longer possible in Western theatre and, in Adrian Kiernander's words, 'an image of a formalized, theatricalized, and Orientalized Europe', thus turning the tables on a culture that has traditionally done that to everyone else (1996: 2). At its most empowering, interculturalism is a process that unifies while at the same time providing critical perspectives not only on the cultural groups and traditions coming together in the exchange but also on the nature of the exchange itself.

Though intercultural theory has addressed the 'exchange or reciprocal influence' (Pavis 1996: 2) of culture in various social, personal and aesthetic situations; along various gradations of power, especially in colonial and neocolonial situations; and in terms of identity, community, politics and so on, there has been no discussion in the humanities, as far as I know, of intercultural practice occurring along solely instrumental lines (though McKenzie's *Perform or Else* [2001] provides much to consider). This makes a certain kind of sense—after all, the instrumental dimensions of culture are often considered precisely what does *not* enable critical consciousness, human collaboration and creativity. For similar reasons, I suspect, one finds a general disdain among humanists for forms of human expression that are overly didactic or propagandistic. However, it is along instrumental lines that some of the most significant intercultural practices occur, as is recognized in the vast body of work in the field of business management and among the marketers of international sport.

The kind of techniques developed by the Vietnamese in their war against a technologically and economically superior enemy made perfect

sense to El Salvadoran revolutionaries going up against a US-backed regime. But recognizing the instrumental 'fit' of the sapper model doesn't explain why such strong links were developed between the El Salvadorans and the Vietnamese. After all, for those needing to link insurgent military and cultural action, there were plenty of styles to choose from, with Maoist 'people's war' and the Cuban *foco* strategy being perhaps the closest to hand. But there was an aspect of the El Salvadoran situation that gave it a special kind of *simpatico* with the bombers of Southeast Asia. This sympathetic combination of the instrumental and cultural is emblematized in the sartorial and strategic stylings of Cayetano Carpio, alias Marcial, founder of the FPL.

> It was no accident that Vietnamese concepts like those of the sapper special forces should show up first in the ranks of the FPL [. . .] The press often called [Carpio] the Ho Chi Minh of El Salvador because of his affectation of a scraggly goatee, and his admiration for all things Vietnamese when it came to revolution. Carpio established direct ties with the Vietnamese, and the ties between the Vietnamese and the FPL would remain strong through the end of the Salvadoran conflict. Carpio was obsessed with Vietnamese methods and modeled his own forces and war plan on the lessons learned from Vietnam. He rejected the Cuban concept of a *foco* or small group of guerrillas causing revolution from the distant hinterland, and the idea of quick insurrection as advocated by urban guerrillas. His strategy was modeled on Ho Chi Minh's adaptation of Mao Zedong's concept of prolonged popular war (Spencer 1996: 3).

It is not clear when the FPL got hold of Vietnamese military engineering concepts and techniques, but there was already in place a real desire for them, one rooted, we might suppose, in the existential, metaphysical and representational dimensions of anti-capitalist, anti-imperialist insurgency.

One thing is for sure: such *simpatico* baffled the enemy. Not unlike American officials tallying damage to bases and batallions in Vietnam in the assumption that mere numbers were enough to win the war, the Salvadoran security organizations and their US advisers spent a great deal of time, money and personnel trying to quantify the struggle they were fighting, trying to find a '"smoking gun" that would clearly and legally implicate' Vietnam and other communist nations 'in the support of the Salvadoran guerrillas' (Manwaring and Prisk 1990: 10). However, according to

Manwaring and Prisk, one of the signal failures of the counter-revolution was its fetishization of material evidence retrieval at the cost of military and psychological action that could 'counter and interdict the flow of support' on the level of culture (ibid.). As has been recognized by performance studies scholars, interculturalism cannot be comprehended solely in terms of objects; it is a *process*, a *performance* that involves the *use* of objects, conversation, imitation, revision and the sharing of techniques and insights—all of this stemming from what Schechner calls the 'deep structural level' of culture (1996: 44). Thus, any effort to find a 'smoking gun' understood as somehow distinct from general or local cultural practices must ultimately fail. Instead, there must be an effort to recognize the broader issues and specific, local practices that enable the transport of techniques (an issue recognized by the US Marine Corps in their recently revised *Small Wars Manual*, which I will discuss in the conclusion to this chapter.)

It is believed that Vietnamese sapper techniques arrived in El Salvador between 1975 and 1979; however, the groundwork for that exchange (and, presumably, Marcial's whiskers) was established some time earlier in Cuba during a series of cultural exchanges designed to strengthen the existential and metaphysical links among those Fanon called 'the wretched of the earth' (2005). According to Spencer, the Cubans and Vietnamese had enjoyed strong ties since the Tricontinental Conference of the Peoples of Africa, Asia and Latin America held in Havana in January, 1966. As Robert J. C. Young astutely comments, the significance of this conference was, in part, 'that it gathered together representatives from the entire non-western world, the three continents'. Even more significantly, the conference represented 'the formal initiation of a space of international resistance of which the field of postcolonial theory would be a product' (Young 2001: 213). Chile's Salvador Allende characterized the results of the conference as 'of the greatest historical importance, representing as they do the consolidation of our common struggle against imperialism and old and new colonialism' (quoted in ibid.). Amilcar Cabral, five years into his struggle against Portuguese imperialism, characterized this consolidation as 'one of the most far-reaching—if not the greatest—defeats that the peoples who struggle for their national liberation have inflicted upon imperialism', adding to this that the 'task is now to carry out the resolutions in practice and strengthen the struggle' (quoted in ibid.). Che Guevara's seminal address to the 1967 meeting, 'Create One, Two, Three, Many Vietnams', can, therefore, be understood

as the consequence of a moment of intense sharing of existential, instrumental, cultural and metaphysical knowledge and experience.

The sense of shared experience and agency enabled by this and subsequent Tricontinental conferences culminated in, among other things, the rise of what might be called a sapper interculture. Around the time of the first Tricontinental, Cubans began sending their personnel to Vietnam and the North Vietnamese sent theirs to Cuba for mutual training and information exchange. Thus, the seemingly banal fact that many of the sapper techniques described in FMLN manuals carried the prefix 'Vietnamese' (such as the Vietnamese crawl) is actually the mark of a much deeper cultural dynamic. Transported by various vectors of the radical, the Vietnamese sappers not only provided an effective technique for a geographically dispersed but similar struggle of poor against rich and low-tech vs high-tech but also a shared 'language' or 'performance ontology' for revolutionaries from distant lands, a common *esprit de corps*, and a way to think about the deep, mutual penetration of the military-strategic and the ideological. Evidence of the robust power of sapper culture as the basis for a common sense of historical destiny can be found today among the Puerto Rican Fuerzas Armadas Liberación Nacional Puertoriquena Macheteros, the Colombian M-19 and the Zapatistas of Mexico, all of whom include the Vietnamese Crawl in their violent repertoires (see Spencer 1996: 138–9, 139–40, 143). In addition, there are strong similarities to actions taken by the Tamil Tigers of Sri Lanka and by insurgents in Somalia (ibid.: 143). Marcial's beard, it seems, has deep roots.

INTERCULTURALISM AND COUNTERINSURGENCY

As the case of the Vietnamese sapper demonstrates, intercultural exchange and transformation, even when based in instrumental concerns, can empower the military vanguards who wage insurgencies. This is not always the case. While intercultural exchange definitely empowered vanguards in Vietnam, El Salvador and other anti-colonial situations, those same sorts of exchanges have been deployed *against* vanguards in other places. One kind of anti-vanguard action is counterinsurgency, the destruction of an avant-garde for the preservation of status quo order. Before I move to one such case, I should clarify what I mean by 'insurgency' and explain why insurgencies and counterinsurgencies are useful to consider when we study the avant-garde.

Insurgency can be defined as any organized rebellion that utilizes so-called irregular tactics such as bombings, kidnappings, hijackings, assassinations and other 'illegal' forms of violence to destabilize the legitimacy of a force in power and hamper the capacity of that force to rule. If we are going to discuss the avant-garde of war, then we certainly need to discuss insurgency. Charles Townshend characterizes it as 'perhaps the key military issue of the later twentieth century', and it is reasonable to extend that characterization into the twenty-first, judging from the ongoing situations in Israel/Palestine, Colombia, East Africa, Iraq, Afghanistan, India, Pakistan and so on (2003). One of the reasons for this is that insurgency is more than a military problem; it is a conceptual problem rooted in the challenges of one culture understanding another. 'Historically,' Townshend explains, 'the core problem in devising appropriate countermeasures [to insurgency] has been the difficulty of clarifying or specifying the nature of the threat. [. . .] Largely because insurgency, if it is at all effective, operates beyond the margins of conventional political and military action' (ibid.). It is by no means coincidental that most counterinsurgencies have failed.

Insurgency (and any effort to combat it) is always situational, always linked to local conditions. It is a complex military strategy that intertwines political, psychological and military factors, thus requiring the most subtle manoeuvering from both insurgents and their enemies. It is a form of social warfare; insurgent forces depend on the support (either freely given or compelled) of the masses—as do counterinsurgency forces. It is in regards to that lattermost issue—the support of the masses—that we see the most significant practical and theoretical challenge of insurgency as it pertains to avant-garde studies. Though there are exceptions to the rule—the Cuban *foco* strategy which overthrew the corrupt Batista regime in the 1950s being perhaps the most notable—any vanguard waging an insurgency depends on the people. Such vanguards, therefore, must, to a greater or lesser degree, *instrumentalize* culture; that is to say, must transform folkways, dialects, cuisine, religious beliefs, clothing and the like into materiel for military struggle. Culture is the most volatile weapon in an insurgency. 'The people are like water and the army is like fish,' Mao wrote in 1948 apropos of the insurgency he was waging against Japanese imperialist forces. To extend Mao's metaphor, one of the lessons of insurgency and counterinsurgency is exactly how fluid and contentious the boundaries can be between the water and the

fish, particularly in situations in which culture and cultural boundaries are themselves the objects of struggle.

There are many reasons why counterinsurgencies have generally failed but among them should be counted the inability or refusal by authorities to recognize their dependence on the masses as well as the porosity of cultural boundaries. Again, insurgency is not only a daunting strategic challenge to those waging war against it but also a conceptual problem, especially as it concerns the dynamics of culture and intercultural exchange. Indeed, it was not until after the Second World War that the military scientists and strategists developing counterinsurgency strategies to contend with the many anti-colonial struggles blossoming across the Third World began to comprehend the dynamic relationship of insurgency and culture—likewise, the potential that such a relationship could give (or take) from the vanguards involved in the conflict. Intriguingly, among the first to recognize this connection and among the first to theorize the best ways to instrumentalize culture and interculturalism as part of counterinsurgency strategy were the military forces of two European nations that had the deepest and most chauvinist commitment to culture as part of their national self-image. Not by accident, those nations also had the most impressive track records for using culture as a tool of international diplomacy and imperialism: namely, France and the UK. I will discuss the case of the French *guerre révolutionnaire* tendency further on. The British case is where I will turn next.

One of the few successful counterinsurgency operations occurred in Malaya, where the communists were defeated by the British in 1960 after 12 years of bitter struggle. The strategies developed by Generals Harold Briggs and Gerald Templer remain to this day a viable, if limited, model, one often consulted by experts, though unfortunately not by US military leaders when they prepared for the actions in Afghanistan and Iraq. One who did study Malaya, US Army Chief of Staff General Harold K. Johnson, writes in his Foreword to Richard L. Clutterbuck's classic account of the Malayan Emergency, *The Long, Long War: Counterinsurgency in Malaya and Vietnam* (1966), that the unique characteristic of such warfare is its totalizing nature:

> The insurgencies in Malaya and Vietnam are very sophisticated wars. Every conceivable facet of human life and endeavor and every function and agency of government have been taken under attack by every available means. Those wars are a blend of intense political,

economic, socio-psychological, and military activities—a blend conceived, practiced, and finally put into operation by experts. The result is a total war, war more total in its effect on people than any ever fought before (1966: viii).

It was in response to the failure to comprehend the totalizing nature of insurgency conflict that Templer coined one of the most important phrases in modern warfare, a phrase intended to highlight the limits of a purely military answer to the avant-garde of war: 'The answer lies not in pouring more troops into the jungle, but in the hearts and minds of the people' (quoted in ibid.). Recognizing the necessity of fighting the war on the cultural front—on the front of hearts and minds—the British set to work on what is perhaps the most significant, if difficult, aspect of counterinsurgency: breaking down traditional boundaries between the army, the government and the people. According to Edgar O'Ballance, Templer 'stressed the need for Malays, Chinese, Indians, and Europeans to sink their differences and build up a truly "Malayan way of life"'. To that end, 'Templer was soon openly criticizing certain sections of the European community for their detached "golf and cocktail" attitude, and for not associating themselves more closely with the people and the interests of the country' (O 'Ballance 1966: 118–19). In addition, he pushed for major changes in the racialized politics of the country, granting full citizenship in September 1952 to all aliens born in Malaya, which included some 1.2 million Chinese (the primary focus of communist propaganda efforts) and the 180,000 indigenous people marginalized by both the Chinese insurgents and the Malayan establishment (ibid.: 119). (Templer tried a similar unification effort in the country's military forces, too, though this would result in the 'main disappointment' of his management of the emergency, as he failed to create 'a truly multi-racial Federation Army'; ibid.: 142, 125).

In addition to these large-scale measures, there was also endless, tightly focused, small-scale work to be done across these same cultural boundaries. As Clutterbuck puts it,

> Our best commanders in Malaya were the ones who set themselves the task of managing the war in such a way that their small patrols came face to face with the guerrillas on favorable terms; in other words, with good intelligence. This meant long hours of tactful discussions with police officers, administrators, rubber planters, tin miners, and local community leaders, getting them to cooperate with

the soldiers and to promote the flow of information to them. Such commanders would regularly accompany their patrols, often placing themselves under the platoon commanders, so that they really understood the war and knew what was needed to win it (1966: 52).

Clutterbuck never claims to have beeen a fast learner:

It took us some time to learn the obvious lesson that psychological warfare *must* be directed by a local man. [. . .] The really able Europeans [. . .] realized that their function was to provide good organization and enough supervision to insure against corruption and treachery, and to leave the intellectual contacts with Chinese guerrillas and villagers—both in the police Special Branch and psychological warfare—to other Chinese (ibid.: 106).

To put this in terms more familiar to avant-garde studies, the British managed, over the 12 years of the Malayan Emergency, to take control of that most delicate moment of the vanguard process: the transition from minority/elite to popular movement. Briggs, Templer, local police officials, scores of bureaucrats and the hundreds of British soldiers who managed the relocation of over 400,000 Chinese squatters transformed the British forces both instrumentally and symbolically from a colonialist vanguard—a tiny minority attempting to transform a society after its own image—to a popular movement, while isolating the communists, not allowing them to become anything more than the mere semblance of a vanguard, incapable of transforming itself into the will—or the spearpoint—of the people.

MAO AND THE CULTURAL ISOLATION OF THE AVANT-GARDE

According to O 'Ballance, British success in Malaya was due in large part to Templer's way of understanding the conflict, an understanding built on 'a leaf from Mao Zedong's handbook . . .' (1966: 15). It was from Mao that the British learned how to get a grip on the complexity of cultural warfare, particularly the long, deliberate, moment-to-moment work that helps to ensure successful communication, inspiration and action between insurgent vanguards and the people they putatively serve—or, alternately, between counterinsurgents and the people they putatively protect. Of course, Mao was on the side of the insurgents but, like the British and French, the Chinese Communist Party (CCP) in the early 1940s was faced

with its own task of staggering scope and complexity, a task that concerned the same transformational moment in the vanguard story as the British encountered in Malaya.

To get a grip on the challenges of this transformational moment for the CCP and the Red Army, it is helpful to consult the series of talks Mao delivered in 1942 at the Yenan Forum on Literature and Art. The time and place of these talks tell us much about the problems and opportunities presented to the CCP and its military forces—particularly as they impacted the Party's self-definition as a revolutionary vanguard. In 1942, the communists had already spent seven years in the isolated Yenan province after being nearly destroyed by Chiang Kai-shek's nationalist Kuomintang army and the subsequent 'Long March' that forced them to retreat some 4,000 miles to the lonely and unforgiving terrain of Yenan. Isolated, with both army and Party membership decimated, the CCP was forced to reconsider its position and the necessities they were facing. As many commentators have pointed out, Yenan gave Mao and the Party an opportunity to assess and refine their revolutionary and military strategies; indeed, it was in Yenan that Mao and the CCP confronted on both the theoretical and practical level the political and military challenges to come. The notion of cultural struggle—captured by the figure of 'People's War'—was one fruit, perhaps the most important, of this theoretical, political and military reassessment.

People's war is often simplistically equated with insurgency, given its tendency to avoid major battles, draw the enemy deep into controlled territories and prolong the war in order to demoralize the enemy. In addition, as Steven Metz points out, the Maoist model emphasizes more than just 'the typical People's War strategy, which would likely focus on primacy of political organization over military operation, the development of extensive political undergrounds and common fronts of "progressive" organizations and movements, [. . .] and emphasis on rural areas' (1995: 4). What the Maoist model adds to the equation is culture. And that is what makes the Yenan period such a significant moment in the history of the avant-garde of war—and such an illustrative moment in the broader history of avant-garde activism.

Though the notion of culture per se was fundamental to the revitalization of the Chinese communist revolution, of greater significance was the recognition by the CCP *that it was itself a culture*. In other words, the Chinese communists came to the realization that it is not enough to consider the

culture of others when charting vanguard strategy; one must also consider one's own culture, the culture of the avant-garde. Thus, the reassessment of 1942 marks a shift in the *ontological status* of the avant-garde, a shift that affected the military strategy of the Chinese communist vanguard. The Yenan years rendered defunct the romantic (and largely Eurocentric) myth of the avant-garde as the 'spirit of the people', disabled also the myth that the vanguard group was an intrinsic part of the 'organic totality', a myth that had motivated activist minorities and elites since it was invented by the Saint-Simonians around the time of their master's death. In Yenan, the communists came to recognize that the avant-garde must *make itself* the spirit of the people, must *construct* the organic totality.

In the process, the CCP was able to translate the cultural struggle into distinctly *ethical* terms—in other words, translate cultural into *inter*cultural struggle. As an illustration, we can turn to one of the key discoveries of the Yenan phase: the loyalty of the Chinese peasantry. Such loyalty, it was recognized, could only be acquired through determined and dedicated work for and among the peasants, work guided by very strict rules of behaviour. These rules are exemplified by the 'Three Points of Discipline' and 'Eight Points of Attention' issued by the Party in 1928. The 'Three Points of Discipline' require of all soldiers and Party members absolute obedience to Party orders, ban taking peasant property and demand immediate delivery of all materials confiscated from non-peasants to Party authorities for proper distribution. The 'Eight Points of Attention' describe more general rules of behaviour, such as closing doors when leaving a house, cleaning up sleeping quarters, behaving with the utmost courtesy and politeness, returning borrowed goods, conducting all transactions honestly, paying adequately for all purchases and sustaining a high degree of sanitation, particularly in regards to the construction of latrines (see Uhalley 1985).

The positive impact of these 11 rules on the communist struggle cannot be overestimated. They proved to the peasantry that there really was a difference between the communists and their two enemies, the nationalists and the imperialists. This is not difficult to figure out. In any military situation, recognition of cultural difference leads either to victimization—you are different and, therefore, do not deserve humane treatment—or ethical care—you are different, therefore require of me careful consideration of my assumptions about you and the treatment I assume is required to 'manage' you. Mao and the CCP took the latter path. Recognizing that the Party and the army were not 'the people' but recognizing that the people were

the water to the Party's fish, they repositioned the revolutionary struggle onto ethical grounds.

The pertinence of these rules extends far beyond Yenan. Chalmers Archer Jr, a founding member of the US Army's Green Berets, recalls assiduously studying 'the British experience in Malaysia [sic] and elsewhere, the French experience in Algeria and Vietnam [sic], and anything else pertinent to putting down insurgencies' (2001: 31). Though these lessons were yet to be learned when the Green Berets began their initial training as a corps in 1953, there was already recognition that the Chinese communists had developed 'a new and shrewd brand of warfare' that would demand equally innovative and clever responses from those who would fight their revolutionary progeny (ibid.: 6). As Archer Jr puts it, 'The writings of Mao were always handy' (ibid.). 'In particular,' he writes, 'we discussed Mao's metaphor of the "fish and the sea" [. . .] We reviewed with renewed interest Edgar Snow's book *Red Star over China* [1968; an account of the retreat to Yenan] . . . That book gave us a firsthand account of the emphasis that both Mao Zedong and other experts placed upon good discipline and trooper behavior as means of gaining popular support for a struggling revolutionary army' (ibid.: 31). In fact, so important were these rules—boiled down to six for the Green Berets—so 'magical', that they were set to song, providing a kind of ethical soundtrack to counterinsurgency operations.

Another keystone of the Green Beret's approach was knowledge of culture. Archer Jr writes, 'From the beginning, we were intended to perform more as political scientists and trainers than as soldiers. Our credentials equaled the accreditation of US military attachés' (ibid.: ix). Linda Robinson views the emphasis on culture as the defining feature of special forces such as the Green Berets: 'Because the special forces are the only unit in the military required to learn foreign languages and gain regional expertise, members also have an unmatched ability to discover and understand what is happening in remote hotspots' (2004: xii). Emphasizing that such forces are not designed for rapid deployment, she characterizes the process by which they prepare for action: 'The men studied the area they were assigned as thoroughly as any PhD student. They sucked up every available open-source and classified assessment of the demographics, tribal clans, local politics, religious leaders and schisms, history, terrain, infrastructure, road maps, power grids, water supplies, crops, and local economy. They planned, debated, and rehearsed both

combat and follow-on operations' (ibid.: 9). Further highlighting the close relationship of soldier and community, Robinson describes the practice of leaving 'anchors' in a region that is otherwise pacified. Such anchors

> provide a formidable store of institutional knowledge that fed the group's regional expertise. They develop a breadth and depth of understanding rivaled by few officials in the government, because they work out in the field and not behind embassy walls or in air-conditioned cars. In El Salvador, the special forces studied the local health, economic, legal, educational and security needs in the province where they were assigned. A counterinsurgency effort cannot succeed unless it addresses every facet of peoples' lives. To extend the Clausewitzian metaphor, politics and social work and land reform is war by other means, when it is recognized that the battlefield is human, not territorial (ibid.: 56).

In Panama, where a US military presence has been in place since the construction of the canal, ties were 'deep, historical, and even familial', with quite a few Special Forces soldiers marrying Panamanian women with brothers in the Panamanian Defence Force (ibid.: 48). It is fitting that the Green Beret sleeve insignia is in the shape of an arrowhead, a shape that, according to Archer Jr, 'connects the Special Forces to its Native American heritage'. Indeed, one of the lessons ratified for the Green Berets by the CCP's years in Yenan was the need to 'be the Apache'.

In the talk he gave on 23 May 1942, Mao makes clear that any assessment of 'people's culture' must attend to the diversity of that culture and the differences between that culture and the culture of the avant-garde that would claim to lead the struggle:

> Who, then, are the masses of the people? The broadest sections of the people, constituting more than ninety per cent of our total population, are the workers, peasants, soldiers and urban petty bourgeoisie. Therefore, our literature and art are first for the workers, the class that leads the revolution. Secondly, they are for the peasants, the most numerous and most steadfast of our allies in the revolution. Thirdly, they are for the armed workers and peasants, namely, the Eighth Route and New Fourth Armies and the other armed units of the people, which are the main forces of the revolutionary war. Fourthly, they are for the laboring masses of the urban petty bourgeoisie and for the petty-bourgeois intellectuals, both of

whom are also our allies in the revolution and capable of long-term
co-operation with us (1967: 78).

Mao concludes that, to maintain its legitimacy as vanguard, the CCP would
not only have to contend with a military-political situation in which the
lines between ally and enemy were often blurry and with a tradition of rev-
olutionary art and literature that was not entirely adequate to their needs
but also with a population that was, to put it mildly, diverse. Emphasis on
cultural diversity and the requirements to work across such diversity pro-
vided critical 'glue' to bind together the political and military dimensions
of struggle, the Party to the people and the people to themselves.

Mao applauds the willingness of writers and artists to travel the ardu-
ous road to Yenan and other anti-Japanese base areas but reminds his lis-
teners that merely 'being there' does not accomplish anything: '[I]t does
not necessarily follow that, having come to the base areas, they have
already integrated themselves completely with the masses of people here',
masses that, as I've already pointed out, are themselves in need of inte-
gration (ibid: 71). Moreover, this issue is not only relevant to the new-
comers: 'Even among comrades who have been to the front and worked
for a number of years in our base areas and in the Eighth Route and New
Fourth Armies, many have not completely solved this problem [of snob-
bishness in attitude and aesthetic taste]. It requires a long period of time,
at least eight or ten years, to solve it thoroughly' (ibid.: 79). Thus, given
the necessity of unifying artist, Party and people and of developing the
proper forms of art to achieve such unification, Mao defines the key issues
as 'the class stand of the writers and artists, their attitude, their audience,
their work, and their study' (ibid.: 71). These key issues introduce a set of
subsidiary concerns, including whether art should 'extol or expose', the
target audience for revolutionary art, the proper form and content of rev-
olutionary art and, as mentioned, the attitudes and tastes of all involved.
To address all this, Mao urges his audience to go intercultural:

> Many comrades like to talk about 'a mass style'. But what does it real-
> ly mean? It means that the thoughts and feelings of our writers and
> artists should be fused with those of the masses of workers, peasants
> and soldiers. To achieve this fusion, they should conscientiously
> learn the language of the masses. [. . .] If you want the masses to
> understand you, if you want to be one with the masses, you must
> make up your mind to undergo a long and even painful process of
> tempering (ibid.: 73–4).

Though Mao's focus in these talks is the status of the artist, he does not view the artist as the main problem. Rather, what is needed is proper education of the people and its teachers. The fruit of this shift towards ethics and pedagogy was that the 'cultural army' of the CCP 'reduced the domain of China's feudal culture and of the comprador culture which serves aggression and weakened their influence' (ibid.: 70). As a result, Chiang Kai-shek's army could do no more than 'pit quantity against quality' (ibid.). As with so many other counterinsurgencies that have failed to build an 'organic totality' with the masses, they lost.

AMILCAR CABRAL AND CULTURAL REVOLUTION IN GUINEA-BISSAU

This kind of synthesis, obliterating the borders among the political, the cultural and the military both in theory and practice, is a common characteristic of many civil and anti-colonial wars that have occurred over the last half century (Metz 1995). It was certainly characteristic of the anti-colonial war waged in Guinea-Bissau, on the west coast of Africa, from 1962 to 1974, in which the Partido Africano da Independência da Guiné e Cabo Verde (PAIGC) was the vanguard in the fight against colonialist, fascist Portugal. On the evidence of the military fight alone, the PAIGC's management of the war is a remarkable story of successful vanguardism. A tiny country of about 600,000 people—mostly illiterate—defeated a modern European military force that was proportionally larger than that deployed by the US in Vietnam; further, Portugal enjoyed the support of the North Atlantic Treaty Organization (NATO), the most powerful military alliance in the world (see Cohen 1998). As Patrick Chabal sums it up, the PAIGC 'was the most successful nationalist movement in Black Africa and the first to achieve independence through armed struggle. It did so by mobilizing the villagers of Guinea into a political and military force capable of challenging Portuguese colonial rule; and it went some way towards establishing a new social and political order in the areas which it wrested from Portuguese control' (1983: 2). The founder and leader of the PAIGC, Cabral was, as one historian puts it, 'the most original political and revolutionary thinker Africa has produced in modern times' (see Cohen 1998). His influence is widespread; indeed, the popularity of the notion of 'cultural warfare' among avant-gardes in the 1960s and 70s (the BAM, especially) should be credited as much to Cabral as to Mao.

Cabral opens his widely read tract *National Liberation and Culture* (1970) with an anecdote about Hitler's propaganda minister Joseph Goebbels who, when asked about the importance of culture, flashed his service pistol. Cabral spins Goebbels' gesture in a distinctly anti-colonial fashion, praising the gesture for its 'clear idea of the value of culture as a factor of resistance to foreign domination' (Cabral 1970: 3). This was an interpretation that made perfect sense in his home country, where the Portuguese—the only self-proclaimed fascist nation in existence at the time—systematically repressed and co-opted cultural practices to deny the colonized their history and exacerbate the differences among ethnic groups. Reflecting the totalitarian regime into which he was born and the totalizing rebellion that he then came to understand as the only way out of it, Cabral defines culture as

> the life of a society (open or closed), the more or less conscious result
> of the economic and political activities of that society, the more or
> less dynamic expression of the kinds of relationships which prevail in
> that society, on the one hand between man (considered individually
> or collectively) and nature, and, on the other had, among individu-
> als, groups of individuals, social strata, or classes (ibid.: 4).

How did the PAIGC's understanding of culture shape its military practices? How did it shape their self-conception as a military vanguard?

For Cabral, the key is the relationship between the vanguard and the masses. He asserts that it is vital for any liberation movement to 'embody the mass character, the popular character of the culture—which is not and never could be the privilege of one or of some sectors of the society' (ibid.: 6). Qualifying this assertion somewhat, he adds that, 'while the culture has a mass character, it is not uniform, it is not equally developed in all sectors of society' (ibid.). This dynamic relationship between mass and local character must shape all aspects of the struggle. This would seem to be perfectly in line with the concept of vanguard—mass relationships addressed in Mao's Yenan speeches. However, there is a subtle but meaningful difference between them. Though Mao put culture at the forefront of any revolutionary action, characterized culture as heterogeneous and without any 'natural' hierarchies and situated the problem of culture squarely at the centre of any theory of a communist vanguard, he ultimately refrains from asserting that the political and military struggle is essentially—not *also* but *essentially*—a cultural process. For Mao, culture is always an instrumental dimension of the struggle.

In contrast, Cabral asks his readers to

[c]onsider these features inherent in an armed liberation struggle: the practice of democracy, of criticism and self-criticism, the increasing responsibility of populations for the direction of their lives, literacy work, creation of schools and health services, training of cadres from peasant and worker backgrounds—and many other achievements. When we consider these features, we see that the armed liberation struggle is not only a product of culture but also *a determinant of culture*. This is without doubt for the people the prime recompense for the efforts and sacrifices which war demands. In this perspective, it behooves the liberation movement to define clearly the objectives of cultural resistance as an integral and determining part of the struggle (ibid.: 14).

In this spirit, Cabral's writings and the on-the-ground practices of the PAIGC consistently emphasized the *process* of revolutionary work, a process that was guided by the recognition, as with Mao's CCP, that the vanguard party was always and inevitably a culture unto itself. However, and this sets the PAIGC apart from virtually every other revolutionary party of the era, including the CCP, there is also recognition that, regardless of how conscious it may be about its autonomy as a cultural body, the Party would always trend dangerously towards anti-democratic behaviour in matters of political decision-making and the deployment of violence (in ibid: 63). How they avoided that fate—how Cabral and his comrades guaranteed, if you will, the 'death of the avant-garde'—is worth a closer look.

The PAIGC managed to avoid the authoritarianism of the Soviet Union, China and many postcolonial nations by firstly, training all involved in the practices and ideals of democracy and secondly, designing a training process that can be best characterized as 'transformative pedagogy'. By training the leadership core of the PAIGC with care, consistency and rigor during 1959–60, Cabral was able to institute group practices to ensure that the Party would not become autonomous (as it did in the Soviet Union and China) and, just as importantly, empower it to exercise absolute control over the military wing of the Party. That control was not gained easily. Friction had been building between the politicians and the soldiers for years, coming to a head at the Cassaca Congress of 1964. At the Congress, abuses of power, ethnic prejudice and 'localist' insubordination by PAIGC cadres were brought to a decisive conclusion; those

responsible banished, jailed or killed, depending on the severity of their actions. This combination of strict party discipline and subjugation of the military was designed to ensure that the non-democratic organizational and decision-making necessities of war would not shape the post-revolutionary society.

But just as crucial to ensuring the 'death of the avant-garde' in Guinea-Bissau was the PAIGC's refusal to treat the masses as an instrument. Jock McColloch, for one, sees as fundamental to the PAIGC's success their adherence to Cabral's principle that 'victory in a national liberation struggle is the result of human forces and only secondly of material resources' (quoted in McColloch 1983: 31). In order for victory to be achieved and for the creation of a properly democratic relationship of party, people, civil bureaucracy and military, the fight had to 'depend first and foremost upon the determination of the people of Guinea and Cape Verde to throw off the colonial yoke' (ibid.). Sylvester Cohen argues that this was possible because political education was a priority in the struggle: 'For Cabral and his comrades realized that the peasants would have to undergo political mobilization before armed struggle could be conducted successfully' (1998).

The success of this mobilization effort was at least partly due to the lessons Cabral had learned during the agricultural census he had managed for the Portuguese authorities in 1953–54. No survey of the kind had been done before. The survey provided Cabral and his staff (including his first wife Iva, also an agronomist) the opportunity to travel to all ends of the country and, most importantly, talk to people. Chabal writes, 'It gave him an intimate knowledge of the socio-economic conditions in the country which later proved invaluable. He was [. . .] presented with a unique chance to acquaint himself with and to understand the reality of life [. . .] under colonial rule' (1983: 48). Also, as Iva later noted, the census gave him an invaluable fund of contacts with village and urban elites.

But just as important as the education Cabral and his colleagues received about their country's multiculture was their discovery that 'the rural population had a natural suspicion of foreign ideas and were not easily convinced by them' (ibid.: 49). Along those lines, Cabral discovered that, as a representative of the state—and quite simply as an educated member of a specific ethnic group—he was 'in an ambiguous position. He was a Portuguese civil servant of whom the villagers had an automatic and immediate distrust' (ibid.). Thus, at the same time that Cabral and his

associates were collecting 'specialized and detailed knowledge' of the folk-ways, languages and experiences of their fellow countrymen, they were also learning that none of them were representative of the people, a lesson as formative to Cabral's understanding of the avant-garde as it was to Mao and the Red Army in Yenan.

Cabral and his fellow intellectuals were not the only revolutionaries in Guinea-Bissau walking the fine line between insider and outsider. In a seminar he led in Trevilio, Milan, in the spring of 1964, Cabral spent some time discussing an odd group of young men who were playing a sur-prisingly successful role in the development of the revolutionary struggle. Before getting to the details, we should recall, first of all, that Cabral's theory of cultural warfare was premised on the prior mobilization and education of the people, a process that requires a thorough understanding of the specific situation of each cultural group in the country. Cabral asserted that the party must carefully define 'to what extent and in what way does each group depend on the colonial regime', 'what position they adopt toward the national liberation struggle' and 'their nationalist and, [. . .] envisaging the post-independence period, their revolutionary capacity' (Cabral 1969: 59). In the case of this strange group of young men, though, he could not pull off the trick. Their cultural position was too ambiguous, their revolutionary capacity unprecedented. Cabral admits that he is tempted to characterize them as a kind of lumpenproletariat, given their dedicated lack of concern with employment and their lack of commitment to good behaviour but he's not entirely happy with the characterization, noting that, as a class, they are 'not really made up of *déclassé* people'. He feels some relief that he's not alone in his befuddlement. The PAIGC more generally 'have not yet found the exact term for it; it is a group to which we have paid a lot of attention and it has proved to be extremely important in the national liberation struggle' (ibid).

These young men regularly showed up at PAIGC recruitment meet-ings and seemed especially eager to help out. They had all recently arrived from the countryside—which would seem to indicate that they were of the rural peasantry—but they had family connections with urban petty bourgeois and working-class families; specifically, uncles obligated by custom to care for their nephews. They were generally unemployed and not particularly interested in employment, and hence were in some sense 'classless'. And they had a unique perspective on Guinea-Bissau's multiculture. Unlike the true lumpen, Cabral explained to his audience,

the particular group [. . .] for which we have not yet found any pre-cise classification [. . .] gradually [came] to make a comparison between the standard of living of their own families and that of the Portuguese; they [began] to understand the sacrifices being borne by the Africans. They [. . .] proved extremely dynamic in the struggle. Many of these people joined the struggle right from the beginning and it is among this group that we found many of the cadres whom we have since trained' (ibid.: 62).

This is where the question of teaching and transformative pedagogy comes into play. To recall, Chabal argues that the 'ultimate success of the PAIGC can be partly (although not entirely) explained by the training and preparation which these young militants received' during 1959–61. These years marked a crucial transitional period for the Party, as it transformed itself from a legal, urban-based trade union into an illegal, rural guerrilla movement (1983: 61). For Chabal, the make-or-break factor here was Cabral's charisma: his ability to communicate his vision in a compelling, heart-grabbing way. Without denying either the force of Cabral's person-ality or his personal power as a teacher, I'd argue that the most important part of this process was the *pedagogical practice* of the PAIGC, practice developed in order to provide the best educational approach and the broadest appeal to students like those odd young men and provide a bridge between the 'foreigners' in the Party and the locals in the country-side. Though I cannot be entirely sure, given the evidence I have uncov-ered, that the intensive educational work of the PAIGC was a mutually transformative practice, there is enough evidence available to strongly suggest that it was a practice similar to the student-centred, process-ori-ented approaches developed by progressive education and writing theo-rists in the the Americas during the 1970s and 80s.

For those theorists, student writing practices, standards of judge-ment and perspectives are not only taken seriously but are understood as requiring a revision of pedagogical practice itself. Such revision may implicate larger entities such as syllabi, curricula and (most important) the status of the teacher herself. It is significant, in this respect, that in 1975, Education and Culture Commissioner Mario Cabral (Amilcar's brother) invited educational activist Paolo Freire and his staff to visit the country and guide it in the development of its post-revolutionary educa-tional system. Cabral imagined schools that would not only educate individuals but reconstruct a culture devastated by colonialism and in

desperate need of modernization. This would enable not only the full institutionalization of the socialist agenda but also overcome the endemic illiteracy of the adult population. Freire's well-known critique of the teacher as a 'bank of knowledge' and the student as mere 'receptacle' for that knowledge surely struck Mario Cabral and others as just the right thing for Guinea-Bissau—just the thing to enable the unification and mutual transformation of avant-garde and masses. (For perspectives on Freire's work in Guinea-Bissau, see Freire 1978.) Having learned so much from those country kids living off their city uncles' wages, they knew that much more could be accomplished, much more to create a truly democratic nation. (And if today's Guinea-Bissau is little more than a vicious shade of Cabral's vision, it does not besmirch that vision one bit.)

'Class suicide', therefore, can be understood as a pedagogical theory. As Tom Miesenhelder defines it, 'Class suicide by the revolutionary petty-bourgeois leadership amounts to listening to its own revolutionary consciousness and the culture of revolution rather than acting on its immediate material interests as a social class. It must sacrifice its class position, privileges and power through identification with the working masses' (1993). Cabral and the PAIGC recognized early on that the distinctive history and culture of the revolutionary class had to be taken into full account when waging the anti-colonial war. No communication with, let alone indoctrination of that class, was possible without such understanding. Miesenhelder points out that, in Guinea-Bissau, the educated urban working classes were a tiny minority and one not easily swayed by revolutionary rhetoric of their neighbours. Further, they tended to be pro-Portuguese, not surprising given that, in most respects, they were a comprador class. Cabral and his comrades had no hope for them, yet at the same time they had only tenuous relations with the rural peasantry. They came to the conclusion that 'there was no single agent capable of successful revolution' in their country. Therefore, the revolutionary petty bourgeoisie—Cabral's own class—was in a contradictory position, at once responsible for leading the revolution as well as for ensuring its own death—'avant-garde suicide', if you will. Rather than assuming some natural, spontaneous or inevitable 'withering away' of the revolutionary Party, Cabral and the PAIGC devised specific institutional and pedagogical practices to ensure the dissolution of the Party's original class base.

The dissolution of identity through revolutionary social struggle was not just a concern of the Party as a bureaucratic entity, it was also characteristic of one of Cabral's favourite teaching activities: educational theatre. Theatre can be a remarkably effective teaching tool, as it can put both knowledge and the knowledgeable into a state of structured instability, allow audiences to see and feel what it's like to live in crisis and survive and thrive to tell the tale. Theatre can transform both subjects and their situations. Cabral had good practice with theatre. As a child, he organized the other children in his neighbourhood to put up plays. The love never faded. Chabal writes, 'One of Cabral's favorite training techniques was that of the theatre. After having studied the social characteristics, traditions and religion of a particular ethnic group, trainees were made to "act" their political arguments' (2002: 64). A Party member who experienced this training described it as follows:

> Cabral made us play a game. One by one, we had to pretend, in front of him, that we were going into a village to talk to the *homen grande*. Everybody else would watch. If it was not right, if there was anything wrong about it, Cabral would make us start all over until we found exactly the right openings and the right arguments. We would start over and over again until it came out right (quoted in ibid.).

These theatre games weren't just about transforming raw recruits into robotic ideologues: 'In preparing the trainees, Cabral also made use of the knowledge which some of these young people still had of their ethnic groups. In many instances, they had only just arrived in the cities and were still familiar with the social and political customs of the region from which they came' (ibid.). The diverse dialects, experiences and cultural practices brought by these youth and by the 'grand men' of the villages were visible and audible resources for communicative acts whose object was a fundamental rethinking of personal and community identity. The use of theatre games surely contributed to 'the relatively high quality of the party elite whom Cabral trained, and the flexibility and adaptability of the party structures which, during the early years, were developed and changed to facilitate political work inside Guinea' (ibid.: 65). Though the post-independence history of Guinea-Bissau has not lived up to the promise of Cabral's vision, that vision is still worth considering. It is further evidence of the value of military history to our understanding of the avant-garde. More importantly, perhaps, Cabral's revolution, along with Mao and the sapper

diaspora, is evidence of the many ways culture and interculturalism can be instrumentalized as a tool of warfare.

ALGERIA AND THE REVOLT OF THE COLONELS

One of the most surprising discoveries during my research was how often I found myself returning to North Africa. Qutb's vanguardist theology took us to Egypt, the Rif uprising that inspired the French Surrealist section's turn to anti-colonial activism took us to Morocco. Algeria in particular has long been a hotbed of vanguard activism, a superheated node in the transnational circulation system that gave rise to the European avant-garde. We have seen the role played in Algeria by the French medical corps, including Fanon, a French-educated medical man who helped set the charges that collapsed the French empire. Of the many figures who shaped that most venerable myth of the bohemian, we remember the actor, raconteur and professional 'rude boy' Richepin, an Algerian by birth. Another child of Algeria, Derrida appears from time to time in these pages. North Africa is a veritable crossroads of the avant-garde. So, it should not come as too much of a surprise to see the questions of culture and war that I have pursued leading us back to this tumultuous and beautiful land.

The eight-year war that concluded in 1962 with Algerian independence from France and anywhere between 800,000 to a million dead was a fruitful, if blood-drenched soil for vanguard theory and practice. During the conflict, multiple self-styled vanguard parties fought for independence and ideological position across the hillsides, alleyways and market centres of Algeria and France, each attempting to finesse the transition from elite to popular force. Among the most important were the Front de Libération Nationale (FLN) and its military wing, the Armé de Libération Nationale (ALN) but they were hardly alone. The Mouvement National Algérien (MNA), for one, fought the 'cafe wars' with the FLN in the coffee shops of Paris, resulting in over 5,000 deaths. Highly influential theories of the avant-garde came out of the insurgency, notably Fanon's critique of the avant-garde. Knocking the legs out from under the Communist Party's avant-garde theory, he argued that any vanguard formation must develop from *within* the struggle, not advise it from afar, and develop party and institutional structures grounded in a critical relationship with tradition and modernity.

One more chapter to add to the story of the avant-garde in Algeria is the French officer corps. These men nearly toppled the government of France and had a fair chance of taking it over if they had tried a *coup d' etat*. It was in the Corps that three currents of avant-garde military history collided in the late 1950s, producing a singular theory and practice that would guide subsequent military vanguards, including Argentina's Dirty War Junta (On the influence of French *guerre révolutinnaire* theory in Argentina and Brazil, see Filho 2004.) One current can be traced back to the premodern era when the term 'avant-garde' communicated a metaphysical sense of aristocratic elitism, élan and the ancient military values of loyalty and discipline. Another current comes to us from across Asia to the rugged climes of Yenan and the prison camps of Indochina, where potent theories of people's war and psychological warfare were developed. The third and last current flows from the tradition of secret conspiracy— the vanguard as spectre—inaugurated by François-Noël 'Gracchus' Babeuf and the 'Conspiracy of Equals' (1797). It was in the French officer corps in Algeria—especially the French Foreign Legion and the Paratroopers—that the currents converged to produce the doctrine known as *guerre révolutionnaire*.

Peter Paret describes *guerre révolutionnaire* as an 'effort to make colonial experiences applicable to all violent and nonviolent international conflicts' and justify unprecedented, extraconstitutional involvement of military leaders in the political life of their country' (1964: 4–5). When one takes a look at the history of the officer corps, it's not surprising that they chose the path of the avant-garde in the 1950s and 60s. The existential status of the officer corps and its metaphysical beliefs (rooted in Church and School) made the vanguard strategy especially attractive to them. As vanguard, they molded France's internal affairs to their own image, permanently shifting the balance between the civil state and the military not just in France but in liberal democracies around the world. Challenging the conventional relationship between state and military in a fashion not unlike Mao and Lenin, the theorists of *guerre révolutionnaire* inverted Clausewitz, making state policy the extension of war, rather than vice versa.

The comparison to Mao is not incidental; the theorists of *guerre révolutionnaire* were students of Mao's work, which they pored over to understand the enemy they faced in Indochina (later known as Vietnam). The commander of the French air campaign against the Viet Minh from 1951 to 1954, General Lionel-Max Chassin, published *La conquête de la Chine par*

Mao Tsé-Toung (1945–1949) in 1952. Colonel Charles Lacheroy, who became something of a poster boy for the Algerian conflict, held a staff post in the Indochina campaign and was an open admirer of the Viet Minh soldier's capacity to apply in equal parts violence, coercion, propaganda and education. Large numbers of junior officers served in Indochina, either in the field or as directors of intelligence, civil affairs or propaganda operations. And all of them—their most salient commonality—experienced first hand the sting of defeat in a people's war (see Paret 1964: 6–7). Though Paret would argue that the officers' understanding of communist cultural warfare was superficial, there is no denying that, as he puts it, 'A decisive spur to the growth of the French doctrine was a willingness to learn from the enemy that went far beyond the usual adjustment to new or special situations' (ibid.: 101).

Some details are in order. On 29 May 1958, France narrowly avoided the launch of Operation Resurrection, a military plot to take over France. The crisis was the consequence of widespread discontent among army commanders in Algeria, who viewed the persistent political instability and perennial cabinet crises of the Fourth Republic (1946–58) as strengthening the possibility of a military debacle in North Africa every bit as awful as the one that had happened in French Indochina four years earlier at Dien Bien Phu. General Henri de Navarre expressed the opinion of many officers and French citizens that 'uncertainty over political goals [was] the real reason why we were prevented from a continuous and coherent military policy in Indochina [. . .] The divorce between policy and strategy dominated the whole Indochina war' (quoted in Kelly 1965: 55). It was shortly after Dien Bien Phu that Colonel Paul Vanuxem, later a chief of the terrorist Organisation Armé Secréte (OAS), captured the feelings of his generation: 'It would be gratifying to be on the winning side now and then' (quoted in Planchais 1962).

Operation Resurrection was organized on several fronts. Algerian Governor-General Jacques Soustelle provided the broadest backing, galvanizing a group of dissident army officers, *pied noir* (or 'black feet', the European-descended residents of Algeria) and sympathizers of the presidential ambitions of Charles de Gaulle. This organizational drive was supported by Lacheroy's Service d'Action Psychologique et d'Information, which launched an intensive agitation-propaganda campaign. On 13 May, all of them threw their weight behind a Junta led by General Jacques Massu, who took control of the Algerian capital and handed it to the

newly formed Committee of Public Safety led by General Raoul Salan. Having steeled itself as a force in civil affairs, the Committee sent its demands to Paris, insisting that De Gaulle be pronounced head of government and be granted the power to enforce a strict policy of non-abandonment for the Algerian department. To the surprise of many on the Left, the demand was met with widespread support across France, not least among students. Preparation for Operation Resurrection continued in the meantime, with the understanding that it was to be implemented on any of three conditions: the failure to name De Gaulle head of government; a request by De Gaulle himself; or in the event of takeover attempt by the communists, the sworn enemy of the predominantly Catholic, aristocratic leaders of the French military establishment.

Only 15 hours before the scheduled launch of the operation, De Gaulle was promoted by the French Parliament and Operation Resurrection was shelved. The political lobbying by the officers, backed up by potent threat, shifted the relationship of civil and military authority in France, tilting it decisively in favour of the latter. And it confirmed the officers' belief that they were the key to the future of a unified France, the very spirit of its people. However, De Gaulle would ultimately prove unfaithful, as he harboured deep doubts about the possibility of a French victory in Algeria. A year and a half later, he intoned the fatal words 'self-determination', backing them up with a referendum that would, if approved, provide majority rule in Algeria. This was received by the army as a most despicable betrayal. Four months later, in January 1960, an insurrection was launched in Algiers to remove the pro-de Gaulle authorities. The insurrection was quickly shut down, primarily due to the refusal of soldiers to fire on other soldiers, but it catalyzed the development of multiple independent vigilante groups which terrorized Muslims and pro-autonomy *pied noir* alike. Among them were the vestiges of the military vanguard that planned Operation Resurrection, now working as an underground terrorist organization, Salan's OAS. The vanguard faction in the officer corps was fairly large. According to Paret, who bases his estimate on a discussion with a senior French officer, perhaps 20 per cent of Army officers in 1961 'wholly accepted the views of *guerre révolutionnaire* on modern war' (1964: 143n11).

This raises a question: How did a minority within the French military, a military that had suffered profound kinds of social, political and military humiliation for 60 years, come to imagine itself the avant-garde not only of France but of the so-called Free World? To answer this question, we must

first understand the peculiar sociopolitical situation of the French officer corps. George Armstrong Kelly sees the French officer corps in Algeria as 'a unique, peculiar, and powerful instance of the long French tradition of extra-parliamentary protest'. Its especially pronounced role in the 1950s was a clear symptom of the French people's growing dislike of corporate rule (councils, conferences, unions, protest movements, technocratic think tanks, elite power groups, etc.), a red-tape state in which 'major political battles [were] scarcely any longer decided by parliamentary debate' (1965: 5). 'While a genuine pluralism has grown up, much richer and more complex than any mere class or occupational pluralism, this variety of aim and interest has found neither representation nor satisfaction within the political structure. It has approached consensus only in horrified reflex to political dilapidation' (ibid.).

Formerly known as '*la grande muette*' (the great silent one), the French military class has generally been 'abstemious of politics' and 'contemptuous of the governing class' (ibid.: 13). Its vow of silence was strengthened by a self-image as a subculture that has, 'most often, lived to itself and by its own peculiar values in enclaves half cut off from the temptations and bewilderments of the wider world', a subculture that has 'paradoxically, in time of danger [. . .] been called upon to lead the defense of an order which its training has caused it to distrust and to understand very imperfectly' (ibid.). However, this self-marginalization from the affairs of the civil state was not possible in the era of anti-colonial insurgency. Commandant Jacques Hogard wrote extensively about Lenin's notion of 'the security of the rear', concluding that '[t]he rear areas of [the insurgent's] opponent are of two kinds. Those that one might call "Zone of the Interior" (for example, metropolitan France during the Indochinese War or during the [war in Algeria]). To reduce them, he can call on numerous open supporters [. . .] and on all those whom his mystique of double-dealing has deceived of his true nature. Experience has shown that he can create trust in many' (quoted in Paret 1964: 17–18). For Hogard, a long-lived distrust of democratic pluralism meshed perfectly with the cultural warfare necessitated by insurgency and counterinsurgency.

The need to unify military and cultural strategies in those kinds of conflicts inspired the officer corps to re-envision the role of the military, to imagine it as something more than a mere instrument of the state. Quite the contrary, the state itself was to be modelled after the metaphysical and representational traditions of France's military culture. (One

French general asserted, 'There is no true war other than religious war'; quoted in ibid.: 611.) To this end, as Paret summarizes it, 'The nature of operational methods constituted only one of the problem areas' for the corps: 'Equally incompatible was the need to impose onto the various regimes a policy of full support for the war; the Army had to enter politics on a grand scale' (ibid.). If, as Hogard would claim in 1958, '[I]t is time to realize that the democratic ideology has become powerless in the world today,' then it follows that, in its place, one might put a 'combative system of values strong enough to unite and stimulate national energies' (quoted in ibid.: 28). Thus, '[i]n the eyes of the theorists and adherents of *guerre révolutionnaire*, the war in Algeria became part of a greater crusade for the spiritual and national future of France' (ibid.).

Jean Planchais has written that, while the paranoid perfection of *guerre révolutionnaire* was in part the consequence of the army's experience in French Indochina in the 1950s, 'its primary origin lies in the traditionally Rightist tendencies of the officer corps' (1962). Of course, this is true of most militaries but in France, 'officers form a particularly tight-knit social class' and never tighter than in the late 1950s. This was a matter of family, Planchais explains: 'Traditional military families are often descendants of the old conservative provincial aristocracy. This group has been deprived of high political office since the end of the nineteenth century and is still embittered over being a ruling class no longer' (ibid.). This sense of class distinctiveness was further strengthened at Saint-Cyr, the French equivalent of West Point, where the percentage of students who were the sons of soldiers rose to almost 44 per cent even as young men of other backgrounds turned to other professions at mid-century (ibid.).

Equally important to this class' self-imagination was the peculiar strategic status of France in the Cold War between the US and the Soviet Union. Kelly raises an interesting point concerning the situation of a French military that was not yet a member of the 'nuclear club', yet had a very real strategic significance. Kelly views the radical French officer corps in reaction to the rise of technocratic, 'remote-control' warfare methods dominated by nuclear détente strategy:

> There were [. . .] precise psychological conditions that made [*guerre révolutionnaire*] highly compatible with French national needs of morale and prestige. It defied the vast impersonality of nuclear war, in which France had then no capability, and it seemed to justify the formulation of strategies de-emphasizing the technical perfection of new

weapons and statistical measures of power. [. . .] In *la guerre révolution-naire*, the judgment of leadership and the resourcefulness of small units became paramount, and this tendency seemed to restore morale by 'reglamorizing' war (1965: 9–10).

Recalling the chivalric code of the premodern military vanguards, *guerre révolutionnaire* was, to recall the terms I used in Chapter 2, a unified vision of war as an instrumental, existential and metaphysical action and provided the French officers with a sense of real historical agency. The avant-garde was the cure for the existential malaise caused by the defeat in Indochina.

This very old-fashioned notion of the avant-garde was affirmed by the militantly anti-communist, anti-democratic vanguard political-religious organization Cité Catholique, which played a big role in the development of *guerre révolutionnaire*. Its clandestine study and activism cells—more than 100 in Algeria, according to *Le Monde* in 1959 (see Paret 1964: 108)— spread, in Paret's view, a 'classically counterrevolutionary' message: 'It proclaimed the Revolution of 1789 was the root of all present evil.' From this it followed that it was necessary 'to fight against everything that sprang from the Revolution, against its "sons" who are the liberals, the radicals, the socialists, and Communists, and naturally the FLN [. . .] loyalty to the nation has its roots in religious faith, and nowhere else' (ibid.: 109). The Cité kept alive the vision of the first Resident-General of Morocco, Louis Hubert Gonzalve Lyautey. Like Lyautey, the Cité's members could be characterized as feeling both 'dissatisfaction with democratic society and parliamentary government' and the need for a 'regenerative elite', specifically the army's officer corps, whose 'concept of the common good was superior to that of the state' (ibid.: 111). What is perhaps most radical about the Cité's role in the Algerian conflict was the way it systematically collapsed the boundaries separating the metaphysical, the instrumental, the existential and the representational dimensions of warfare. This collapse is perhaps best exemplified by Salan's OAS, which felt perfectly justified 'murdering opponents, intimidating with plastic bombs, and seeking to "intoxicate" the non-Muslim masses of Algeria and the excitable and romantic elements among French university students' (Sulzberger 1962: 20).

The doctrine of *guerre révolutionnaire* guided the development of an instrumentalized theory of culture. The need for psychological warfare services was recognized by the French as early as the late 1940s, leading to the Defense Reorganization Decree of 1 April 1950, which created the Section d'Action Psychologique et d'Information (Psychological and

Informational Action Service or SAPI), a bureau 'made up of a small group of civilians who had the duty of publicizing and selling government policy to the public', an especially important function given French Communist Party campaigns against NATO and the presence of US military forces on French soil (see Paret 1964: 53). Because of the need to coordinate the information programmes of a great many governmental ministries, the SAPI grew in size and power rapidly. Ironically, given their subsequent embrace of psychological warfare as central to their doctrine, French military officers were initially sceptical. However, when they saw it at work for the Viet Minh, when they experienced how it had transformed those who had been captured by the Viet Minh and how it had handcuffed the military, psychological warfare become the newest, best weapon.

Psychological warfare was organized along three fronts. In 1955, the Section Administrative Spécialisée (Special Administration Section, or SAS) was founded. The SAS' mission was to construct lasting relations with the Algerian Muslim population, dampen Algerian nationalist enthusiasm by promoting a sense of French 'presence' and recruit and train *harkis*, Arab soldiers loyal to the state. Simultaneously, the Bureaux Psychologizes was set up in Algeria, intended to educate French soldiers newly arrived from France about the political situation they were facing. In April 1956, the SAPI was formed with Lacherory at its head. It was this organization that spearheaded psychological warfare in France itself, becoming 'a powerful agency for spreading the doctrine of *guerre révolutionnaire*'. The end result of this was the formation of the 5es Bureaux of the General Staff of National Defence in July 1958. As Paret sums it up, 'In eight years, the psychological services of the government had increased enormously in size and in operational and political importance. They had changed from an advisory board on the periphery of power into an executive organ, which disposed of such sizable allocations of money and personnel that it began to be called the seventh arm of the service.' Of significance to the avant-garde: 'With little or no exception, its key positions were occupied by proponents of the doctrine of *guerre révolutionnaire*' (ibid.: 56).

The 5es Bureaux had its fingers in a lot of pots, including high-level military decision-making, resettlement of villages and the coordination of lecture series in France. As Paret notes, 'The scope of *action psychologique* [is] difficult to delimit. If the 5es Bureaux took literally the mission assigned to them of "assuring the cohesion of the whole of the nation and developing the will to fight in everyone", they could hardly keep from

becoming actively involved in the political life of France' (ibid.: 57). This model is familiar to readers in the US—it looks a lot like the coordination of media by the Bush administration after the election of 2000. The Bureaux enjoyed almost complete autonomy:

> Between 1957 and the settlers' insurrection of January, 1960, the 5es Bureaux were almost entirely free of control from Paris. They could develop their own methods of psychological action and psychological warfare; they were also able to assume a growing share in the formulation of the ideology and the political program these methods were to advance. [. . .] Since they held that the clash between revolution and counterrevolution demanded total unity of the counterrevolutionary base and its armed forces, they extended their activities to Metropolitan France: Not only were the services to be trained to fight a revolutionary war, but French society itself had to be cleansed and reoriented (ibid.: 76–7).

The significance of Algeria—and Vietnam, Malaya, Yenan, Cambodia and Guinea-Bissau—for a general theory and history of the avant-garde requires much more exploration than this, without doubt. For the present, we can conclude that both culture and the people are valuable resources— valuable and transformative. While inevitably instrumentalized by the vanguard, they also shape those vanguards. The most successful avant-gardes, it appears, have understood that their position on the front lines is inconceivable and impossible without the masses and the folkways that tie them to soil, tradition, language and myth.

THE PUBLIC SPHERE, THE GENERALIZATION OF SPECIAL FORCES AND THE MILITARIZATION OF THE LIBERAL ARTS

Looking back over the cases and questions I have considered in these pages, what are some of the general lessons that might be learned from the avant-garde of war? To my mind, there are three interrelated concerns of particular importance. The first concerns the military's function in respect to the creation and maintenance of a democratic or, more cynically, *faux*-democratic 'public sphere'. Second is the generalization of the special forces model in response to the complex demands of global geopolitical and economic relations, especially in the face of underfunded, underdeveloped diplomatic and cultural institutions. The third concerns the increasingly important role of the liberal arts in that generalization, a role that portends

either a strengthening of higher education as a critical force in a public sphere increasingly dominated by the military or its full instrumentalization and pacification in a never-ending war on terror.

1. War and the public sphere

Like Bürger and Hewitt, I am of the opinion that Habermas' analysis of the development of modernity is among the most compelling for a general history and theory of the avant-garde. To review briefly, the most significant aspects of that history and theory are

(1) the fundamental importance to the history of liberalism of the separation into distinct 'spheres' of the formerly unified discourses and institutions of religion, politics and aesthetics in eighteenth- and early-nineteenth-century Europe;

(2) the rise of a bourgeois 'public sphere', again in Europe, as the consequence of new kinds of conversational standards and new conversational spaces, notably coffeehouses, literary circles, salons, and theatres of the late 1700s and early 1800s; and

(3) the role played in European social and political history by the 'lifeworld', the realm of experience associated with everyday life, domesticity and the like, which provides significant critical perspectives on the various 'spheres' and the languages operative in them.

As insightful as Habermas has proven to avant-garde studies, the limits of his thinking is palpable when situated within military history—*military* history, not the history of war. Habermas' work is a systematic and engaged response to the ubiquity of war in the modern period, an effort to imagine civil institutions that might provide some kind of progressive alternative to violence. However, Habermas takes no account of the military as a public sphere in its own right. The French officer corps is not unique; most militaries are a distinct community in their nations, a community with its own specific interests, embedded in cultural traditions, equipped with specific kinds of instrumental potential that has unique standards of discussion and debate and that preserves and promotes existential experiences that mark it as a realm of citizenship as important as the church, the civil state and the market (Habermas' favoured spheres). In his work on modernity and the public sphere, Habermas appears to consider the military as nothing more than a mere instrument, an extension of state policy, to recall Clausewitz's maxim. In Habermas' groundbreaking

Strukturwandel der Öffentlichkeit: *Untersuchungen zu einer Kategorie der bürger-lichen Gesellschaft* (1962; *The Structural Transformation of the Public Sphere*: *An Inquiry into a Category of Bourgeois Society*,1989), one finds no mention of the military barracks or the military college as sites of convivial and committed conversation at par with the coffeehouses and reading groups out of which supposedly came the conversational and critical standards that gave rise to the bourgeois public sphere. But it's hard to imagine the conspiracies of the French officer corps in Algeria or the anti-Semitic machinations surrounding Dreyfus without a sense of the military as a site of active and pertinent debate and dissent. As we have seen repeatedly, the existential dimensions of war provide highly effective language and critical perspectives to debates in other spheres. Military cultures shape the political, social and economic history of their societies, occasionally becoming the pre-eminent force within a society.

Any discussion of the blurring of the lines between art and life (key to Bürger's *Theory of the Avant-Garde*) or the violent collapsing of aesthetics and politics that catalyzes fascism (as Hewitt discusses it in *Fascist Modernism*) must account for the role of infrastructural and civil development—*development*, not destruction—that has been part and parcel of vanguard (and anti-vanguard) warfare since the Second World War. The military has often had its hands in the construction of the public sphere's material infrastructure—the creation of roads that allow people to meet each other, the securing of buildings for parliamentary meetings, the provision of security to politicians and so on. According to Metz, it is precisely this dimension of warfare that has proven vital to the battle against insurgent vanguards. He notes that, since the 1940s, insurgency has been more than just a military and political factor in the developing world. It has directly addressed shortfalls in political representation. A sensible argument, as Metz explains. First, there is often 'limited or ineffective control' of governments 'over parts of their nations' due to 'rugged terrain, poor infrastructure, government inefficiency, and tradition'. So, this has compelled marginalized groups toward non- or anti-parliamentary forms of dissent. Second, there is the 'electronic and transportation revolutions of the twentieth century,' which 'paved the way for revolutionary insurgency by allowing people in remote regions to develop an accurate sense of their predicaments'. Last, there are the various kinds of international support networks for insurgency efforts, whether state-sponsored (and in those cases, whether official or secret), formed at international gatherings such as the

Tricontinental conferences, or, more recently, constructed in *ad hoc* fashion like the decentralized electronic information networks and 'matrix organizations' that provide communications and funding for terrorist operations (Metz 1995: 2). For Metz, a basic impetus behind insurgency—and the reason for the primacy of Maoist People's War in many of those insurgencies— has been the 'very real, local grievances' of people, especially those in rural areas, grievances that are not merely addressed by the insurgents but provided 'holistic, integrated, and synchronized' expression through insurgency (ibid.: 4). In essence, and this is a point that cannot be stressed enough, People's War functions as a public sphere for the marginalized and silenced. This was an explicit goal of Cabral's PAIGC, which viewed the establishment of new social and political structures in combat areas not simply as a goal of the struggle but the very foundation, the enabling condition, of the military struggle.

In a discussion of a pilot operation executed in 1957–58, one French commander in Algeria claimed 'that the opening of a road created *ipso facto* significant progress in pacification' (quoted in Paret 1964: 90). This was not simply due to the fact that troops and materiel could therefore be more efficiently transported to the region in question, an essentially instrumental benefit; it also provided a means to integrate the region into the overall strategic and political system. This is an example of what might be termed a *'faux*-public sphere', as the complex give-and-take of democratic interaction was never the intention and never a possibility. As with so much else concerning counterinsurgency, it was in Malaya that the potential benefits of infrastructural development were discovered. As the British commanders discovered, one could defeat military vanguards by improving the political situation.

An illustration: Meeting significant resistance among the Chinese and Indian immigrant populations who were their most strategic constituency, the communist Malayan Races Liberation Army turned to the Sakai, an indigenous ethnic group that occupied the mountainous interior of the country. O'Ballance writes, 'As a counter, the Security Forces established a number of jungle posts, or "forts", in Sakai country, supplied by the air, to combat insurgent activities. The government provided some elementary medical care for the aborigines and made other attempts to educate and improve their standard of living' (1966: 137).

Infrastructure is the foundation for winning hearts and minds. Archer Jr would agree with the British on this point, noting that, in Laos, the

Green Beret's 'environmental improvements and population and resource control [were] some of the greatest tactics in the world to maintain or restore internal order' against insurgency (2001: 62). Contrary to many who thought the best method was to 'bomb them back to the stone age', Archer Jr and his fellow special forces soldiers understood 'that any real chances for success in Laos (and Vietnam and elsewhere) would depend upon the counterinsurgents' ability to strike at the roots of the population's dissatisafaction' (ibid.: 119). Argument alone was useless without significant improvement in the everyday lives of the people—including their ability to have their voices heard. In this respect, recent insurgency and counterinsurgency seem to hail back to the original vision of the avant-garde promulgated by Saint-Simon and the engineers at the École Polytechnique.

2. The Generalization of Special Forces

Though there is no doubt that the development or expansion of the public sphere is a commendable and significant achievement wherever it might occur, there are significant concerns that need to be addressed regarding what I would call the 'generalization of special forces', my second concluding concern. As I have mentioned at the beginning of this chapter, there has been a push recently among American military leaders to radically expand special operations. Dana Priest describes the origins of this development in *The Mission: Waging War and Keeping Peace with America's Military* (2003):

> Long before September 11, the US government had grown increasingly dependent on its military to carry out its foreign affairs. The shift was incremental, little noticed, de facto. It did not even qualify as an 'approach'. The military simply filled a vacuum left by an indecisive White House, an atrophied State Department, and a distracted Congress. After September 11 [. . .] US-sponsored political reform abroad is being eclipsed by new military pacts focusing on anti-terrorism and intelligence-sharing (2003: 14).

Soon after the end of the Cold War, special forces cadres were saddled with an ever-growing number of assignments spread across 125 countries (ibid.: 17). Indeed, 'special forces were often the tool of default when US policymakers abandoned more difficult alternatives, such as long-term economic development or political reform won through creative diplomatic sticks and carrots' (ibid.).

It was during the Bill Clinton administration (1993–2001) that the principle of building 'political partnerships' through the sharing of irregular techniques began (ibid.: 29). On Clinton's watch, 'the military slowly, without public scrutiny or debate, came to surpass its civilian leaders in resources and influence around the world' (ibid.: 42). In large part, this was simply a gap-filling measure, a response to the systematic slashing of the State Department budget, reduced by 20 per cent in the 1970s and 80s, with more than 30 embassies and consulates closed, and over a fifth of employees cut from the payroll (ibid.: 45). In other words, in the absence of a robust, effective international public sphere, the military has become the default mediator of international political and cultural relations. Priest comments,

> Instead of righting the imbalance [between military and diplomacy], Washington came to rely ever more on the regional [Commanders in Chief] to fill a diplomatic void. They asked infantry and artillery officers and soldiers to help build pluralistic civil societies in countries that had never had them. They required secretive special forces to make friends with the nastiest elements in foreign militaries and turn them into professionals respectful of civilian authority (ibid.).

Clinton's Secretary of Defense William James Perry steered this development; he was 'the first to see that the military could be used to "shape" the world in peacetime by using military-to-military relations to seduce countries into the US sphere of ideas and geopolitical interests' (ibid.: 97).

An equally impactful player has been General Anthony Zinni, one of those Commanders in Chief mentioned by Priest—specifically, of United States Central Command from 1997 to 2000. During the Vietnam War, Zinni familiarized himself with irregular warfare during his assignment to a Marine advisory unit that, according to Priest, was 'modeled after units in the French counterinsurgency campaign in Indochina'. During his training at Fort Bragg in preparation for this work, Zinni studied 'guerrilla tactics, psychological operations and the ideology of revolution' (ibid.: 61). After the defeat of the US in Vietnam, Zinni was left with a tangled knot of questions:

> How had the Americans misread the cultural context of the war? How did culture define politics? Why had the Vietnamese turned to the communists in the first place? And what made them so loyal in adversity? He believed his military's future would be determined by

what the United States forgot, rather than what it understood, about the root causes of other nations' troubles (ibid.: 65).

These questions would arise again when he was assigned to collaborate with Kurds in Northern Iraq in 1991 as part of Operation Provide Comfort. Zinni was absolutely flustered by the assignment until he spoke to 'a Kurdish-speaking Turkish-American intelligence officer, Nilgun Nesbett,' who advised Zinni to alter the layout of the camps designed for the refugees. With the help of a Kurdish schoolteacher, 'Zinni identified a different group of men to contact—the real leaders. He also ordered his troops to completely rebuild the villages. The neat rows of tents became circles of tents. Each circle had a tent for the male head of a family. The other tents were occupied by his wives and children. That did the trick. The Kurds came down from the mountains' (Robinson 2004: 65–6). The questions raised by Vietnam had been answered for Zinni—what was needed was a military organization that could not only deliver enormous amounts of violence but was capable of handling complex cultural interactions in highly unstable sociopolitical situations.

Prior to 9/11, while Secretary of Defense Rumsfeld et al. were 'embrac[ing] the technological possibilities of the dot-com boom' (Priest 2003: 32–3), Zinni and Special Forces Command were assessing what makes US special forces unique. Contrary to Rumsfeld's pie-in-the-sky vision of special forces, Robinson reminds us that special forces are 'not a rapid deployment force; the secret is intensive preparation. The men studied the area they were assigned as thoroughly as any PhD student. They sucked up every available open-source and classified assessment of the demographics, tribal clans, local politics, religious leaders and schisms, history, terrain, infrastructure, road maps, power grids, water supplies, crops, and local economy' (2004: 9). Zinni and other Commanders in Chief deployed special forces—joint Delta Force, Army Green Berets, Navy SEALs, Air Force Special Tactics and Combat Controllers—all over the world to exploit the old-fashioned, low-tech stuff of training exercise and fireside chat. As Priest puts it, while the top-rankers in the US military were buying up all the technology they could, special forces were having first encounters 'in obscure places: in cities such as Tashkent, Astana, Ashgabat and Bishkek; in African nations once off-limits for political reasons, such as Nigeria, Swaziland, and Rwanda, and the Persian Gulf region' (2003: 32–3). The sappers of Vietnam and El

Salvador may have been the first but they're no longer the only military interculture on the block.

While I don't wish to dismiss glibly the potentially progressive function of such intercultural exchange and the very real impact it may be having on the construction and implementation of international standards for the training and use of the most dangerous kinds of military elites (all the more important given the increasing privatization of military forces), there is no doubt that such exchanges have roots in some of the most troubling chapters of military history and often exploit loopholes left by international treaties and law. It was in El Salvador during the 1980s that US special forces, both the official corps sustained by each of the four military branches and clandestine Special Missions Units, began their phoenix-like rise from the ashes, to recall Metz's metaphor. Success in El Salvador was enabled by long familiarity between US soldiers and local paramilitary forces. It is likely that US personnel were working with groups as early as 1963, helping to modernize surveillance systems; provide strategic, tactical and technical training; and share information.

Such assistance is always problematic—funded by secret budgets, beyond public scrutiny—but in El Salvador there are especially troubling issues; not least, that special forces likely trained the first 'death squad' in that country, the Organización Democratica Nacionalista of General José Alberto Medrano (See Kirsch 1990). This kind of training continued over the next three decades. As David Kirsch tells it, 'In spite of the official suspension of police assistance between 1974 and 1985, CIA and other US officials worked with Salvadoran security forces throughout the restricted period to centralize and modernize surveillance, to continue training, and to fund key players in the death squad network' (ibid.). This work occurred during the same period in which the US provided advice and technology to Operation Condor, the communications operation that sustained authoritarian governments throughout the Americas, including Argentina's Dirty War Junta. Such squads have been conclusively linked to atrocities such as the infamous rape and murder of three American nuns and a lay worker in December 1980. How deeply rooted is this particularly vile vanguard sensibility within the US military establishment? In 2005, Michael Hirsh of *Newsweek* magazine reported that the Pentagon was considering what it called 'the Salvador option' to gut the Iraqi insurgency (2005: 8). Special Forces, like the avant-garde concept in general, is a blade that twists in the hand, cutting in all ideological directions.

3. War and the Liberal Arts

Finally, in addition to the issues I have raised about war's role in the construction of the public sphere and the generalization of the special forces model, there is the increasingly important role of higher education, particularly the humanities, social sciences and fine arts, in the War on Terror. If there is one lesson to be learned from the avant-garde of war, it is that culture plays a big role in military conflicts and that those who understand this tend to have an advantage over those who don't. We have seen how often the refusal or inability to recognize the cultural dimensions of conflict has led to disaster. On the other hand, Las Madres de Plaza de Mayo, in the face of an absolute disparity of power, astutely recognized their cultural power and exploited certain key components of the Dirty War's representation of gender, nation and morality to significantly weaken the fascist regime. Mao and the Chinese Communist Party stole the initiative from the nationalists by fighting a war on the basis of everyday interaction with peasants and rank-and-file soldiers. Cabral and the PAIGC put culture, education and theatre at the forefront of their struggle against the Portuguese. *Guerre révolutionnaire* stemmed from the peculiar class, religious and existential conditions of the French military. Teaching has also played a significant part in the history of avant-garde war. It is the basic premise—training exercises and exchanges of information—of the first encounters taking place among special forces worldwide. And we have seen how significant teaching was for the Chinese communists while they remained holed up in Yenan, for the PAIGC as it attempted to unify a divided Guinea-Bissau, and for the international sapper culture that has posed such an insistent threat to the dominant nation-states since the 1960s.

Recently, the US military has, to an extent, come to recognize the importance of culture and teaching in war, particularly wars in which vanguards play a role. This is evident in the draft revision of the Marine Corps' *Small Wars Manual*, available on the internet for public review until it was pulled sometime in mid-2005. While it is important to recognize distinctions among the various armed forces—and between the US military and other armed forces around the world—the Marines' take on the role of culture in counterinsurgency warfare illustrate aspects of the War on Terror that are of broad concern, particularly for educators and artists. The new manual provides rare insight into how the most important lessons of special forces are being disseminated into the military as a whole, directly impacting the performance of every single member.

The very fact that a revision was put into the works is significant—it indicates that the Marine Corps had come to the clear recognition that it could no longer approach warfare in conventional fashion, that it had to model itself after the threat it would most often face in the post-Cold War era. Indeed, the *Manual* begins by noting that, for the Corps, the new era of warfare did not begin with 9/11 but 18 years earlier, in the autumn of 1983, when 241 sailors, soldiers and Marines were killed in Beirut, Lebanon, by a suicide bomber. 'In retrospect,' the *Manual* reads, 'the Beirut bombing was a seminal event, heavily influencing subsequent Marine Corps organization and culture and ushering in the kind of profound change that seldom takes place in large organizations without the stimulus of a significant emotional event' (US Marine Corps n.d.: 1) This is a manual that puts high value on conserving the past. Towards the end of the *Manual*, the reader is reminded that, even though it describes a new kind of response, the Marines have always had a 'culture of adaptability' that relied on 'a climate of open-mindedness, mentoring, and on-the-job training rather than upon strict doctrinal conformity' (ibid.: 66). Yet, despite the commitment to spontaneous, interactive, experiential learning, the nature of contemporary warfare—'short-term, small-scale, and episodic'—has negatively impacted the Corps's ability to sustain that tradition. And it is more important than ever. The authors of the new *Manual* give credit to the older for making clear that '[i]t is the political/diplomatic *context* in which the war is fought that determines whether it is a "small war" and not the size and scope of resources expended, or the specific tactics employed'. Moreover, they agree that 'the political/diplomatic *context* determines the conflict's characteristics far more than the theoretical or actual capabilities of the participants' (ibid.: 4–5).

It is the complex contextual dynamics of the small war that requires a different kind of thinking—and this different kind of thinking is palpable in both the form and content of the new *Manual*. The first things one notices about it is that it is both much shorter (82 pages vs almost 500) and far more theoretical than its predecessor. In contrast to the original version's emphasis on the nitty-gritty details of counterinsurgency—including such things as feeding troops, maintaining pack animals, organizing patrols, types of reconnaissance aircraft and so on—the revised *Manual* is focused on paradigms and perspectives. It begins with a question: 'What's a small war?' and follows with another: 'What's new about small wars?' It then moves into strategic, operational and tactical perspectives before

concluding with recommendations for preparing for the challenges ahead. In sum, the new manual is concerned less with *information* than with *knowledge*. In a 1997 Marine Corps Doctrinal Publication, Major Emile Sander insisted that Corps intelligence must move decisively into ways of thinking that provide the grounds for sound and effective intellectual judgement (1997). Thus, to utilize Sander's illustration, while it is important to know the current weather conditions—what he would call 'information'—it is of little use if it does not provide the means to make a weather forecast. By Sander's estimate, intelligence doctrine in 1997 not only 'fails to clearly articulate how intelligence supports warfighting' but tends to 'focu[s] on equipment, structure, and organization instead of the intelligence process' (ibid.). What Sander is calling for can be summed up in two words: critical thinking.

The new *Small Wars Manual* fully responds to Sander's recommendations but extends them farther, justifying the move away from mules and into more abstract kinds of questions not just because of the need to make better military decisions but because of the peculiar nature of anti-vanguard warfare. Small wars are no longer best understood in terms of the nation-state; rather, they are cross-national or regional conflicts, often ignited by marginalized elites affiliated across national borders (US Marine Corps n.d.: 12, 18). In addition, 'advances in international telecommunications, rapid computation, and weapons of mass destruction' have radically expanded what was formerly 'a small class of potential adversaries' (ibid.: 8). Lastly, as opposed to the traditional insurgency organizations of the classic era of guerrilla war, today's insurgencies are best understood in terms of a business concept, the 'matrix organization':

> In response to the complex business environment, many companies have established what is described in business jargon as 'matrix organizations'. In this case, a matrix is an organizational structure in which two or more lines of command, responsibility, or communication may run through the same individual. Most often this means that a functionally organized company establishes project teams composed of individuals from throughout the organization and possibly even drawn from sources external to the company, to accomplish a specific task or project. In addition to providing 'just-in-time' support without unnecessary idle time for specialists, this corporate approach allows companies to share unique expertise to multiple projects concurrently (ibid.: 13).

Al-Qaeda is an exemplary matrix threat (recall that its name means nothing more than 'database'). The 'interfacing matrix groups may not know the identity or location of one another' and the organization 'will look different for every objective and at any given place in time' (ibid.: 14). Thus, a particular objective might bring together a handful of groups. 'In this arrangement, one group could provide explosive training, another would supply the explosives, yet another would provide intelligence on actual targets, and so forth' (ibid.: 15). As a consequence, a successful counteroffensive 'will have to be able to detect and respond to [the adversary's] changes even faster in order to control the tempo of the competition or conflict' (ibid.). In order to achieve the level of manoeuverability demanded by today's small wars, the Marine Corps will have to think critically but also in terms of context; specifically, 'focus with greater resolution on such factors as cultural, ethnic, religious, societal, and economic microclimates that comprise the nation, region, or organization' (ibid.: 12). Indeed, unlike conventional state-on-state wars, small wars are much more about the 'human element' as opposed to 'technical aspects', the latter of which dominates 'much contemporary military writing' (ibid.: 29).

Thus, culture comes to the fore but in very specific ways, framed by particular metaphors and historical beliefs. In the 'Strategic Perspectives' section of the manual, culture is placed squarely in 'the most important part' of the planning process: cultural orientation, which is defined 'as the repository of our genetic heritage, cultural tradition, and previous experiences' (ibid.). The manual defines culture as comprised of science and attitudes towards it, language, history (understood as both the conditioning elements of the past and the stories told about it), religion, art, and myth (that is, the most 'deeply held cultural beliefs' that shapes perception and judgement) (ibid.: 30). And this precedes a discussion of the differences between 'Western culture', which according to the manual prefers 'tangible, [. . .] quantifiable [. . .] neat and discrete' answers and 'Non-Western cultures', which don't. 'Especially in a world of small wars, the palette is shades of gray and not the more categorical black or white' (ibid.: 34). As I have discussed in Chapter 1, when the politics of culture intensify, understandings of culture can easily take on shades of race—and cultural studies can become the science of racism. That seems to be happening in the manual. Regardless, culture is understood in remarkably complex ways, particularly when we understand that the ultimate point is to provide strategic and tactical advantage in a theatre of war.

I don't want to overlook the fact that the military has been listening, at least a little, to scholars and critics in the humanities, fine arts and social sciences. This is not all that surprising, considering that a great many officers have spent at least some time in our classrooms and seated in front of our books and articles. However, what is most interesting about the manual's foregrounding of culture is less its queasy references to race 'science' than its ultimate purpose. For those fighting small wars, there is an absolute necessity for the coordination of military and diplomatic efforts on the macro-scale but also—and this is the key point here—extensive knowledge of political objectives at the lowest levels of operation, that is, the soldier on the ground. Recalling the most decorated soldier in Marine Corps history, the *Manual* notes that Chesty Puller (surely the best name a marine ever had) 'never had to worry that his activities in Nicaragua could precipitate a Weapons of Mass Destruction attack on Washington' (ibid.: 20). That is no longer the case. And this is where higher education—especially the liberal arts—comes into play. The revised *Manual* recommends that the best approach to educating the soldier—the capacity to comprehend the deep interrelationship of strategic and tactical objectives to the history, culture, geography, economy and demographics of the conflicted area—is to get him or her into college.

In order to prepare for the double challenge of creating a new kind of soldier to fight a new kind of war, the *Manual* makes overt references to liberal arts education: 'Without a solid educational foundation, Marines will be ill-equipped to deal with the numerous institutional and human cultures with which they will be confronted' (ibid.: 68). An entire section of the *Manual*, 'Preparing for the Challenges Ahead', is dedicated to education, defining it as 'a critical component for successfully understanding and coping with the wide variety of actors in small wars' (ibid.: 67). Now, it is certainly true that the military has long had a relationship to higher education in the US. The Morrill Land-Grant Colleges Act of 1862 established 106 colleges with the stipulation that they teach, in addition to engineering and agriculture, military tactics. The Reserve Officers' Training Corps (ROTC) was thus established. Until the 1960s, many universities mandated ROTC for all male students. Though no longer mandatory, ROTC produces today 60 per cent of all armed forces' officers, and 75 per cent of Army officers (many of whom attend liberal arts universities and colleges).[4] Moreover, enrollment in ROTC programmes has increased significantly since 9/11, despite the difficulties the military has had recruiting enlisted

personnel (See Carlisle 2005). For regular enlistees, the Marines, typical of all the US armed forces, offers education as a fringe benefit, providing tuition assistance for enlistees and defining itself as an opportunity 'to sharpen your mental abilities': '[F]or sharp minds make sharp Marines'. In addition, they provide training and opportunities for successful college entrance and General Educational Development (GED) exams and educational counselling. Finally, universities have long played a role as a research-and-development resource for the military, providing, for example, the high-altitude infrared surveillance equipment that helped track down Che Guevara in Bolivia, leading to him being killed in 1967.

However, the challenges posed by the contemporary small war require a different kind of role for higher education—and necessitate a rapprochement between the military and disciplines in places that have, at least since the 1960s, been a home base for the military's most committed critics: literary studies, art history, sociology, performance studies and so on. This level of intimacy led Senator J. William Fulbright to speak out against it, calling the relationship 'the military-industrial-academic complex'. The ideal Marine described in the *Manual* is the dream child of that complex. He or she combines 'experience, character, common sense, flexibility, creativity, and cultural awareness' (n.d.: 68), enabling a high degree of flexibility in terms of gathering, assessing and applying knowledge. He or she is someone who can make sense of and make connections among science, religion, language, history and myth—and understand their role in different places and moments. The ideal Marine is someone who has practice in critical thinking and understands the benefits of mentoring. This Marine sounds a lot like the ideal college student described in the catalogues, websites and mission statements of virtually every university and college in the country. In a sense, the ideal Marine is, to coin a phrase, a 'liberal-arts warrior'.

This raises a question for teachers, critics, scholars and artists: What is our role in the War on Terror? But before we answer that question, there's another: How have the conditions of the War on Terror strengthened what William Fulbright called, in 1967, the 'military-industrial-academic complex'?

Colleges and universities are already providing the education called for by the *Manual*, whether their faculties like it or not. And, as I have discussed in the Introduction, in the case of disciplines such as anthropology there has long been a direct relationship between academic work and

military operations. So, to suggest that academics are shaping modern military culture is not a matter of ego-stroking fantasy (see Mann 1999); it's a matter of pedagogy and demographics. More students are enlisting in the military reserves, there are thousands of students returning from military service with their G.I. Bill checks in hand and there are many, many children of these soldiers passing through the classrooms and corridors of the American higher educational system. Each of these groups— in addition to the officers produced by way of ROTC—can and will play a role in the development, approval, execution and appraisal of military operations, whether within military ranks or as informed citizens. A few among them will enter the elite ranks of the special forces and, in all likelihood, serve as unofficial diplomats and technical trainers with other military elites around the world or as up-close-and-personal combatants in insurgency situations. All will inevitably be a part of combat theatres in which cultural questions will be essentially indistinguishable from military questions. All will share certain experiences—what might be called, playing a bit with Habermas' phrase, 'military life world experiences'—that may significantly impact their communities.

Without denying the complexity of the issue here—which concerns not just the structure and focus of curricula and who is in the classrooms or studios but who is recruiting on campus, providing money for programming, advertising in the campus newspaper, funding the new optical physics laboratory and so on—I will raise a few questions of relevance to teachers, scholars and practitioners in the humanities, social sciences and fine arts. The ultimate concern here is higher education's function vis-à-vis the military—and the possibility, however small, however pragmatic, of university-level teachers providing educational experiences that would cultivate critical consciousness among enlisted soldiers and officers in theatres of operation like those described in the Marine Corps' *Manual*, especially those 0in which they must play complex peacekeeping and infrastructural development and defence roles.

If cultural studies is to be the pre-eminent mode for comprehending the total military-diplomatic situation in a given theatre of war, then can there be a function for the kind of self-reflexive, mutually transformative, rigorously critical forms of cultural studies that have been explored by scholars, critics and artists for the last 40 years? This is more than a question of critical style, position or method—of theory, in other words. And it's more than just a matter of individual character, though it doesn't

exclude it. What forms of mentorship, for example, might teachers provide future combat officers to foster personal growth, emotional strength and philosophical rigor for the young men and women under their lead? What kinds of pedagogical strategies do we have at our disposal to acknowledge and integrate the experiences and perspectives of veterans into classrooms whose primary concerns are culture and critical thinking?

I don't envision any revolutionary transformation of the military as a consequence of a critical, as opposed to merely instrumental, engagement with the humanities, social sciences and fine arts. However, I do think that such an engagement demands consideration—as does the de facto segregation of military faculty on most university and college campuses in the US. Coker puts it like this:

> We have a choice. There is an instrumentalist vision in the way many Americans look at war, one which has a long history—the 'technicization' of the life world (including war) through instrumental reason. There is another vision we associate with the suicide bomber and postmodern terrorist: the sacralization of war, the privileging of the spirit (and the attendant triumph of the will) over the body. Both are extremes, and [. . .] we should fear a world in which either has won out. We should aim instead to position ourselves in between—to make war valuable morally is to make it sacred in terms of sacrifice, the willingness to die for a cause in which one believes. To take out sacrifice would be to disenchant it once again. To surrender responsibility to computers [. . .] who would feel no guilt and no remorse for their actions or to autonomous weapons systems with no concept of loss, would be to compromise the human dimension of war (2004: 142).

Coker's book provides a valuable perspective on a moment when the War on Terror portends the total instrumentalization of culture and education. On the other hand, it is a book thoroughly Eurocentric in its perspective and references, one that fails dismally to explore other ways of thinking of technology, other ways of thinking of the lines between the sacred and the profane, of experiencing the body, of making sacrifice meaningful, of considering the world in any other way than in the neat binaries of conventional thinking. These other ways are the specialty of many within higher education and academic scholarship and criticism, not least those in the humanities, fine arts and social sciences. The slow crawl of the Vietnamese

sapper; the courageous perambulations of Las Madres; the multiple tem-
poralities of Tolson's 'Bard of Addis Ababa'; those strange, slacker youths
who excited Cabral and his commanders; the builders of friendship and
hospitals among Archer Jr's Green Berets—these and other vanguards of
war provide useful object lessons for academics in a world war in which
there are seemingly nothing but avant-gardes. The ultimate question is:
Who will take the lead?

Notes

1 See 'Avant-Garde' in *Oxford English Dictionary*. Available at: www.oed.com
 (last accessed on 8 October 2004).

2 For Guy Debord's 'The Game of War' and a commentary on it, see Len
 Bracken (1997). Thanks to Don LaCoss for reminding me of Debord's
 game.

3 See, for example, Pasquier's letter to Monsieur de Fonssomme in 1562:
 'All one talks about now is war [. . . and] there is nothing to be more
 feared in a state than civil war [. . .] particularly when a king, due to his
 minority, does not have the power to command absolutely. [. . .] If it was
 permitted to me to assess these events, I would tell you that it was the
 beginning of a tragedy' (quoted in Holt 1995: 50). Pasquier's rumina-
 tions are discussed by Mack P. Holt, who notes that Pasquier understood
 the wars as exacerbating social tensions and placing at risk both French
 culture and the elites who defended it.

4 See website of National ROTC Alumni Association. Available at:
 http://www.naraa-pn.org/?page_id=118&active=0 (last accessed on 17
 May 2006).

bibliography

AHMED, Ishtiaq. 2004. 'Revolution: Western and Islamic'. *Daily Times*, 13 August 2004. Available at www.dailytimes.com.pk/default.asp?-page=story_13-8-2004_pg3_2 (last accessed on 3 September 2004).

ALLEN, Stewart Lee. 2002. *In the Devil's Garden: A Sinful History of Forbidden Food.* New York: Ballantine Books.

ALTHUSSER. Louis. 2001. 'Ideology and Ideological State Apparatuses' in Vincent B. Leitch (ed.), *The Norton Anthology of Theory and Criticism.* New York: W. W. Norton.

ALTSHULER, Bruce. 1994. *The Avant-Garde in Exhibition: New Art in the 20th Century.* New York: Harry N. Abrams.

AMMERMAN, Nancy T. 1991. 'North American Protestant Fundamentalism' in Martin E. Marty and R. Scott Appleby (eds), *Fundamentalisms Observed.* Chicago: University of Chicago Press, pp. 1–65.

ANDERSON, Raney. 2004. 'The Jesus Factor'. *Frontline.* Available at www.pbs.org/wgbh/pages/frontline/shows/jesus (last accessed on 19 August 2004).

APPADURAI, Arjun. 1996. *Modernity at Large: Cultural Dimensions of Globalization.* Minneapolis: University of Minnesota Press.

APTER, Emily. 2004. 'Weaponized Thought: Ethical Militance and the Group-Subject'. *Grey Room* 14(Winter): 6–25.

ARAN, Gideon. 1991. 'Jewish Zionist Fundamentalism: The Bloc of the Faithful in Israel (Gush Emunim)' in Martin E. Marty and R. Scott Appleby (eds), *Fundamentalisms Observed.* Chicago: University of Chicago Press, pp. 265–344.

ARCHER JR, Chalmers. 2001. *Green Berets in the Vanguard: Inside Special Forces, 1953–1963.* Annapolis, MD: Naval Institute Press.

ARTAUD, Antonin. 1958. *The Theater and Its Double* (M. C. Richards trans.). New York: Grove Press.

————. 1976. 'To Have Done with the Judgement of God' in *Antonin Artaud: Selected Writings* (Susan Sontag ed., Helen Weaver trans.). New York: Farrar, Straus and Giroux.

————. 1994. 'Preface' in *The Theater and Its Double* (M. C. Richards trans.). New York: Grove Press, pp. 7–14.

ATTALI, Jacques. 1992. *Noise: The Political Economy of Music* (Brian Massumi trans.). Minneapolis: University of Minnesota Press.

BAKHTIN, Mikhail M. 1981. *The Dialogic Imagination: Four Essays* (Caryl Emerson and Michael Holquist trans). Austin: University of Texas Press.

BALAKIAN, Anna. 1947. *The Literary Origins of Surrealism: A New Mysticism in French Poetry*. New York: New York University Press.

————. 1967. *The Symbolist Movement: A Critical Reappraisal*. New York: Random House.

BANES, Sally. 2000. 'Institutionalizing Avant-Garde Performance: A Hidden History of University Patronage in the United States' in James M. Harding (ed.), *Contours of the Theatrical Avant-Garde, Performance and Textuality*. Ann Arbor: University of Michigan Press, pp. 217–38.

BARAKA, Amiri. 1968. 'Communications Project'. *The Drama Review* 12(4): 53–7.

BARRON, Stephanie (ed.). 1991. '*Degenerate Art*': *The Fate of the Avant-Garde in Nazi Germany*. New York: Harry N. Abrams.

BASS, Jack. 1978. *Widening the Mainstream of American Culture: A Ford Foundation Report on Ethnic Studies*. New York: Ford Foundation.

BAUDELAIRE, Charles. 1950. *My Heart Laid Bare and Other Prose Writings*. (Peter Quennell ed., Norman Cameron trans.). London: Weidenfeld and Nicholson.

BAUDRILLARD, Jean. 2002. 'L'Esprit du Terrorisme' (Michael Valentin trans.). *The South Atlantic Quarterly* 101(2)(Spring): 403–15.

BECKETT, Samuel. 1954. *Waiting for Godot*. New York: Grove Press.

BELGRAD, Daniel. 1998. *The Culture of Spontaneity: Improvisation and the Arts in Postwar America*. Chicago: University of Chicago Press.

BELL, Terry and Dumisa Buhle Ntsebeza. 2003. *Unfinished Business: South Africa, Apartheid, and Truth*. London: Verso.

BENJAMIN, Walter. 1968. 'The Work of Art in the Age of Mechanical Reproduction' in *Illuminations* (Kurt Wolff trans.). New York: Harcourt Brace Jovanovich.

————. 1985. 'Surrealism: The Last Snapshot of the European Intelligentsia' in *One Way Street and Other Writings* (Edmund Jephcott and Kingsley Shorter trans). London: Verso.

BENSTON, Kimberly. 2000. *Performing Blackness: Enactments of African-American Modernism*. New York and London: Routledge.

BERGHAUS, Günter. 1996a. *Futurism and Politics: Between Anarchist Rebellion and Fascist Reaction, 1909–1944*. Providence, RI: Berghahn Books.

————. 1996b. 'The Ritual Core of Fascist Theatre: An Anthropological Perspective' in Günter Berghaus (ed.), *Fascism and Theatre: Comparative Studies on the Aesthetics and Politics of Performance in Europe, 1925–1945*. Providence, RI: Berghahn Books, pp. 39–71.

BERMAN, Paul. 2003a. *Terror and Liberalism*. New York: W.W. Norton.

————. 2003b. 'The Philosopher of Islamic Terrorism'. *The New York Times Magazine*. 23 March 2003, pp. 24–67.

BHARUCHA, Rustom. 2000. *The Politics of Cultural Practice: Thinking Through Theatre in an Age of Globalization*. Middletown, CT: Wesleyan University Press.

BILLINGS, Dwight. 1990. 'Religion as Opposition: A Gramscian Analysis'. *American Journal of Sociology* 96(1)(July): 1–31.

BILLINGTON, James H. 1960. 'The Intelligentsia and the Religion of Humanity'. *The American Historical Review* 65(4)(July): 807–21.

BLAVATSKY, H. P. 1878. 'The Theosophical Society: Its Origins, Plan, and Aims'. Theosophical University Press Online. Available at www.theosociety.org/pasadena/bcw/b78-5-3.htm (last accessed on 16 August 2004).

BLOOM, Harold. 1961. *The Visionary Company: A Reading of English Romantic Poetry*. Garden City, NY: Doubleday and Co.

BOCCIONI, Umberto. 2001. 'Genius and Culture' in Bert Cardullo and Robert Knopf (eds), *Theater of the Avant-Garde, 1890–1950: A Critical Anthology*. New Haven: Yale University Press, pp. 195–7.

BOFF, Leonard and Clodovis Boff. 1987. *Introducing Liberation Theology* (Paul Burns trans.). Maryknoll, NY: Orbis Books.

BOSCO, Fernando J. 2002. 'The Spatiality of Collective Action: Flexible Networks and Symbolic Performances Among the Madres de Plaza de Mayo in Argentina'. PhD dissertation, Ohio State University, Columbus.

BOUVARD, Marguerite Guzman. 1994. *Revolutionizing Motherhood: The Mothers of the Plaza de Mayo*. Wilmington, DE: Scholarly Resources.

BRACKEN, Len. 1997. *Guy Debord: Revolutionary*. Venice, CA: Feral House.

BRETON, André. 1972. 'Surrealist Situation of the Object' in *Manifestoes of Surrealism* (Richard Seaver and Helen R. Lane trans). Ann Arbor: University of Michigan Press.

———. 1978. 'Legitimate Defence' (Richard Howard trans.) in Franklin Rosemont (ed.), *What Is Surrealism?: Selected Writings*. New York: Monad.

BROWN, Marilyn R. 1985. *Gypsies and Other Bohemians: The Myth of the Artist in Nineteenth-Century France*. Ann Arbor: University of Michigan Press.

BULLINS, Ed. 2006. 'The So-Called Western Avant-Garde' in Mike Sell (ed.), *Ed Bullins: Twelve Plays and Selected Writings*. Ann Arbor: University of Michigan Press, pp. 284–7.

BÜRGER, Peter. 1984. *Theory of the Avant-Garde* (Michael Shaw trans.). Minneapolis: University of Minnesota Press.

CABRAL, Amilcar. 1969. 'Brief Analysis of the Social Stucture in Guinea' in *Revolution in Guinea: Selected Texts by Amilcar Cabral* (Richard Handyside ed. and trans.). New York: Monthly Review Press, pp. 56–75.

———. 1970. *National Liberation and Culture*. (Maureen Webster trans.). Syracuse, NY: Syracuse University Program of Eastern African Studies, Maxwell School of Citizenship and Public Affairs.

CALINESCU, Matei. 1987. *Five Faces of Modernity: Modernism, Avant-Garde, Decadence, Kitsch, Postmodernism*. Durham, NC: Duke University Press.

CARLISLE, Nate. 2005. 'Call to Arms'. *Columbia Daily Tribune*, 10 April 2005. Available at http://archive.columbiatribune.com/2005/apr/20050410-show001.asp (last accessed on 18 May 2007).

CARLSON, Maria. 2000. 'Fashionable Occultism: The World of Russian composer Aleksandr Scriabin'. *The Journal of the International Institute* 7(3)(Summer). Available at http://quod.lib.umich.edu/j/jii/4750978.-0007.301?rgn=main;view=fulltext (last accessed on 31 August 2004).

CASTRONOVO, Russ. 2000. 'Within the Veil of Interdisciplinary Knowledge?: Jefferson, DuBois, and the Negation of Politics'. *New Literary History* 4: 781–804.

CÉSAIRE, Suzanne. 1996. '1943: Surrealism and Us' in Michael Richardson (ed.), *Refusal of the Shadow: Surrealism and the Caribbean* (Michael Richardson and Krzysztof Fijałkowski trans). New York and London: Verso, pp. 123–6.

CHABAL, Patrick. 2002. *Amilcar Cabral: Revolutionary Leadership and People's War*. London: C. Hurst and Co.

CHAPMAN, Roger (ed.). 2010. *Culture Wars: An Encyclopedia of Issues, Viewpoints, and Voices*. Armonk, NY: M. E. Sharpe.

CHARNON-DEUTSCH, Lou. 2002. 'Travels of the Imaginary Spanish Gypsy' in Jo Labanyi (ed.), *Constructing Identity in Contemporary Spain: Theoretical Debates and Cultural Practice*. Oxford: Oxford University Press, pp. 22–40.

CHICAGO SURREALIST GROUP. 1998. 'Introduction'. *Race Traitor* 9(Summer): 3.

CHOUCHA, Nadia. 1992. *Surrealism and the Occult: Shamanism, Magic, Alchemy, and the Birth of an Artistic Movement*. Rochester, VT: Destiny Books.

CLAUSEWITZ, Carl Von. 2008. *On War*. Radford, VA: Wilder Publications.

CLEAVER, Kathleen and George N Katsiaficas (eds). 2001. *Liberation, Imagination and the Black Panther Party: A New Look at the Black Panthers and their Legacy*. New York and London: Routledge.

CLIFFORD, James. 1984. 'Histories of the Tribal and the Modern' in Jack Flam and Miriam Deutch (eds), *Primitivism and Twentieth-Century Art: A Documentary History*. Berkeley: University of California Press, pp 351–68.

COHEN-CRUZ, Jan. 1998. *Radical Street Performance: An International Anthology*. London: Routledge.

COHEN, Sylvester. 1998. 'Amilcar Cabral: An Extraction from the Literature'. *Monthly Review* 50(7)(December). Available at http://www.highbeam.-com/doc/1G1-53590417.html (last accessed on 24 March 2006).

COKER, Christopher. 2004. *The Future of War: The Re-Enchantment of War in the Twenty-First Century*. London: Blackwell Publishing.

COLE, Catherine. 2010. 'Justice in Transition: South Africa's Political Trials of 1956–1964' in *Performing South Africa's Truth Commission: Stages of Transition (African Expressive Cultures)*. Bloomington, IN: Indiana University Press, pp. 28–62.

COLLINS, Lisa Gail and Margo Natalie Crawford (eds). 2006. *New Thoughts on the Black Arts Movement*. New Brunswick, NJ: Rutgers University Press.

CONANT, Martha Pike. 1908. *The Oriental Tale in England in the Eighteenth Century*. New York: Columbia University Press.

CONQUERGOOD, Dwight. 1988. 'Health Theatre in a Hmong Refugee Camp: Performance, Communication, and Culture'. *The Drama Review* 32(3)(Autumn): 174–208.

———. 1989. 'Poetics, Play, Process, and Power in the Performative Turn in Anthropology'. *Text and Performance Quarterly* 1: 82–95.

COOKE, Paul. 2005. 'The Paris of René Crevel'. *The Modern Language Review* July: 621–31.

CRANE, Diana. 1987. *The Transformation of the Avant-Garde*: *The New York Art World, 1940–1985*. Chicago: University of Chicago Press.

CREVEL, René. 1996[1934]. 'The Negress in the Brothel' (Samuel Beckett trans.) in Nancy Cunard (ed.), *Negro*: *An Anthology*. New York: The Continuum Publishing Group, pp. 354–6.

CROW, Thomas. 1983. 'Modernism and Mass Culture in the Visual Arts' in Benjamin H. D. Buchloh, Serge Guilbaut and David H. Solkin (eds), *Modernism and Modernity*. Nova Scotia: Nova Scotia College of Art and Design Press, pp. 215–47.

CUNNINGHAM, David. 2006. 'Making an Example of Duchamp: History, Theory, and the Question of the Avant-Garde' in Dafydd Jones (ed.), *Dada Culture*: *Critical Texts on the Avant-Garde*. New York: Editions Rodopi BV, pp. 254–86.

DANIEL, Norman. 1962. *Islam and the West*: *The Making of an Image*. Edinburgh: Edinburgh University Press.

DANTO, Arthur. 1997. *After the End of Art*: *Contemporary Art and the Pale of History*. Princeton, NJ: Princeton University Press.

DEMERATH, N. J. and Karen S. Straight. 1997. 'Religion, Politics, and the State: Cross-Cultural Observations'. *CrossCurrents* 47(1)(Spring). Available at www.crosscurrents.org/Demerath.htm (last accessed on 15 August 2004).

DERRIDA, Jacques. 1991. *Of Spirit*: *Heidegger and the Question* (Geoffrey Bennington and Rachel Bowlby trans). Chicago: University of Chicago Press.

DEUTSCH, Jan-Georg, Peter Probst and Heike Schmidt (eds). 2002. *African Modernities*: *Entangled Meaning in Current Debate*. Portsmouth, NH: Heineman.

DI FELICE, Attanasio. 1984. 'Renaissance Performance: Notes on Prototypical Artistic Actions in the Age of the Platonic Princes' in Gregory Battcock and Robert Nickas (eds), *The Art of performance*: *A Critical Anthology*. New York: E. P. Dutton, pp. 3–23.

DINGES, John 2004. *The Condor Years*: *How Pinochet and His Allies Brought Terrorism to Three Continents*. New York: The New Press.

DOLAN, Jill. 2001. 'Performance, Utopia, and the "Utopian Performative"'. *Theatre Journal* 53(3)(October): 455–79.

DUBOW, Saul. 1992. 'Afrikaner Nationalism, Apartheid, and the Conceptualization of "Race"'. *The Journal of African History* 33(2): 209–37.

DUKORE Bernard F. and Daniel C. Gerould. 1976. 'Introduction to *Man and the Masses*, by Ernst Toller' in Bernard F. Dukore and Daniel C. Gerould

(eds), *Avant-Garde Drama*: *A Casebook 1918–1939*. New York: Thomas Y. Crowell, pp. 43–4.

DUNA, William A. 1985. 'Gypsies: A Persecuted Race'. Available at www.chgs-.umn.edu/histories/victims/romaSinti/gypsies.html (last accessed on 18 September 2007).

EBAN, Katherine. 2007. 'Rorschach and Awe'. 17 July. Available at www.vanityfair.com/politics/features/2007/07/torture200707?printable=true¤tPage=all (last accessed on 28 November 2007).

EDELMAN, Lee. 1994. *Homographesis*: *Essays in Gay Literary and Cultural Theory*. New York: Routledge.

EDSALL, Thomas B. and David A. Vise. 1985. 'CBS Fight a Litmus Test for Conservatives: Helms Group Faces Legal Hurdles in Ideological Takeover Bid'. *Washington Post*, 31 March 1985.

EDWARDS, Brent Hayes. 1999. 'The Ethnics of Surrealism'. *Transition* 78: 84–135.

EGBERT, Donald Drew. 1967. 'The Idea of "Avant-Garde" in Art and Politics'. *The Amerian Historical Review* 173(2)(December): 339–66.

———. 1970. *Social Radicalism in the Arts, Western Europe*: *A Cultural History from the French Revolution to 1968*. New York: Alfred Knopf.

ELAM JR, Harry. 2006. 'The *TDR* Black Theatre Issue: Refiguring the Avant-Garde' in James Harding and John Rouse (eds), *Not the Other Avant-Garde*: *The Transnational Foundations of Avant-Garde Performance*. Ann Arbor: University of Michigan Press, pp. 41–66.

ENWEZOR, Okwui. 1999. *Reading the Contemporary*: *African Art from Theory to the Marketplace*. Cambridge, MA: MIT Press.

ENGELS, Friedrich. 1945. *Socialism*: *Utopian and Scientific*. New York: International Publishers.

ENZENSBERGER, Hans Magnus. 1973[1962]. 'The Aporias of the Avant-Garde' in Gregory T Polletta (ed.), *Issues in Contemporary Literary Criticism*. Boston: Little, Brown, and Co., pp. 734–49.

EWBANK, Inga-Stina. 1997. 'Shakespeare and Strindberg: Influence as Insemination' in John Batchelor, Tom Cain and Claire Lamond (eds), *Shakespearean Continuities*: *Essays in Honour of E. A. J. Honnigmann*. London: Macmillan, pp. 335–47.

FADIMAN, Anne. 1997. *The Spirit Catches You and You Fall Down*. New York: Farrar, Straus and Giroux.

FANON, Frantz. 1967a. 'Medicine and Colonialism' in *A Dying Colonialism* (Haakon Chevalier trans.). New York: Grove Press.

——. 1967b. *Toward the African Revolution* (Haakon Chevalier trans.). New York: Grove Press.

——. 1994. *Black Skin, White Masks* (Constance Farrington trans.). New York: Grove Press.

——. 2005. *The Wretched of the Earth* (Richard Philcox trans.). New York: Grove Press.

FERRIS, Alison. 2003. 'Disembodied Spirits: Spirit Photography and Rachel Whiteread's *Ghost*'. *Art Journal* 62(3)(Fall): 44–55.

FESSENDEN, Tracy. 2007. '"The Secular" as Opposed to What?'. *New Literary History* 38(4)(Autumn): 631–6.

FILEWOD, Alan. 2006. 'Vanguard Aesthetics in Working Class Theatre'. Seminar paper. American Society for Theatre Research, Chicago. 17 November.

FILHO, João Roberto Martins. 2004. 'The Education of the Brazilian *Golpistas*: Military Culture, French Influence, and the 1964 Coup'. Paper presented at The Nathan and Jeanette Miller Center for Historical Studies, University of Maryland, College Park, Maryland. Available at www.history.umd.edu/History-Center/-2004-05/conf/Brazil64/papers/jmartinseng.pdf (last accessed on 2 April 2006).

FINEMAN, Howard. 2003. 'Bush and God', *Newsweek*, 10 March, pp. 22–31.

FLAM, Jack and Miriam Deutch (eds). 2003. *Primitivism and Twentieth-Century Art: A Documentary History*. Berkeley: University of California Press.

FORTH, Christopher E. 2001. *Zarathustra in Paris: The Nietzsche Vogue in France, 1891–1918*. DeKalb, IL: Northern Illinois University Press.

FOSTER, Hal. 1985. 'The "Primitive" Unconscious of Modern Art' in Jack Flam and Miriam Deutch (eds), *Primitivism and Twentieth-Century Art: A Documentary History*. Berkeley: University of California Press, pp. 384–95.

FOUCAULT, Michel. 1984[1971]. 'Nietzsche, Genealogy, History' (Donald F. Bouchard and Sherry Simon trans) in Paul Rabinow (ed.), *The Foucault Reader*. New York: Pantheon, pp. 76–100.

——. 1990. *The History of Sexuality, Volume 1: An Introduction* (R. Hurley trans.). New York: Vintage.

——. 1995. *Discipline and Punish: The Birth of the Prison* (Alan Sheridan trans.). New York: Vintage.

FRANK, Thomas. 1997. *The Conquest of Cool: Business Culture, Counterculture, and the Rise of Hip Consumerism*. Chicago: University of Chicago Press.

FREDERICKSON, George M. 2002. *Racism: A Short History*. Princeton: Princeton University Press.

FREIRE, Paulo. 1978. *Pedagogy In Process: The Letters to Guinea Bissau* (Carman St John Hunter trans.). New York: The Seabury Press.

FUSCO, Coco. 1995. 'The Other History of Intercultural Performance' in *English Is Broken Here: Notes on Cultural Fusion in the Americas*. New York: The New Press, pp. 37–64.

GABORIK, Patricia. 2007. 'La Donna Mobile: Massimo Bonempelli's *Nostra Dea* as Fascist Modernism'. *Modern Drama* 50(2)(Summer): 210–32.

—— and Andrea Harris. 2011. 'From Italy and Russia to France and the U. S.: "Fascist" Futurism and Balanchine's "American" Ballet' in Mike Sell (ed.), *Avant-Garde Performance and Material Exchange: Vectors of the Radical*. London: Palgrave Macmillan.

GARNER, Stanton B. 2000. 'Physiologies of the Modern: Zola, Experimental Medicine, and the Naturalist Stage'. *Modern Drama* 43(Winter): 529–42.

GATES JR, Henry Louis. 1987. *Figures in Black: Words, Signs, and the 'Racial' Self*. New York: Oxford University Press.

——. 1988. *The Signifying Monkey: A Theory of Afro-American Literary Criticism*. New York: Oxford University Press.

——. 1994. 'Black Creativity: On the Cutting Edge'. *Time*. 10 October, pp. 74–5.

GAUTIER, Théophile. 2001. 'Preface to *Mademoiselle de Maupin*', in Vincent B. Leitch (ed.), *The Norton Anthology of Theory and Criticism*. New York: W.W. Norton, pp. 753–9.

GENTILE, Emilio. 2003. *The Struggle for Modernity: Nationalism, Futurism, and Fascism*. Westport, CT: Praeger.

GIBBONS, Tom. 2003. 'The Occult and Early Modernism', review of *Alchemist of the Avant-Garde: The Case of Marcel Duchamp* by John F. Moffit. *Quadrant* November: 82–4.

GIKANDI, Simon. 2002. 'Reason, Modernity, and the African Crisis' in Jan-Georg Deutsch, Heike Schmidt and Peter Probst (eds), *African Modernities: Entangled Meanings in Current Debate*. Portsmouth, NH: Heinemann, pp. 135–57.

GLUCK, Mary. 2000. 'Theorizing the Cultural Roots of the Bohemian Artist'. *Modernism/Modernity* 7(3): 351–78.

GOLDBERG, RoseLee. 1988. *Performance Art: From Futurism to the Present*. New York: Harry N. Abrams.

GOLDSTEIN, Warren S. 2006. *Marx, Critical Theory, and Religion: A Critique of Rational Choice*. Boston: Brill Academic Publishers.

GONZÁLEZ, Roberto J. 2007. 'Towards Mercenary Anthropology?'. *Anthropology Today* 23(3)(June): 14–19.

GRAHAM-JONES, Jean. 2005. 'Aural Textuality: La Pista 4 Breaks Down the Material Word and World'. Paper presented at American Society for Theatre Research Conference, Toronto.

GRAÑA, Cesar. 1964. *Bohemian Versus Bourgeois: French Society and the French Man of Letters in the Nineteenth Century*. New York: Basic Books.

GRAZIANO, Frank. 1992. *Divine Violence: Spectacle, Psychosexuality, and Radical Christianity in the Argentine 'Dirty War'*. Boulder, San Francisco and Oxford: Westview Press.

GREENBERG, Clement. 1961. *Art and Culture: Critical Essays*. Boston: Beacon Press.

GUILBAUT, Serge. 1983. *How New York Stole the Idea of Modern Art: Abstract Expressionism, Freedom, and the Cold War* (Arthur Goldhammer trans.). Chicago: University of Chicago Press.

HABERMAS, Jürgen. 1989. *The Structural Transformation of the Public Sphere: An Inquiry into a Category of Bourgeois Society* (Thomas Burger trans.). Cambridge, MA: MIT Press.

HANCOCK, Ian. 1998 .'The Struggle for the Control of Identity'. *Transitions: Changes in Post-Communist Societies* 4(4): 36–53. Available at http://www.radoc.net/radoc.php?doc=art_d_identity&lang=en&articles=true (last accessed on 18 September 2007).

HANSBERRY, Lorraine. 1994. *Les Blancs, The Collected Last Plays: The Drinking Gourd/What Use Are Flowers?* (Robert Nemiroff ed.). New York: Vintage.

HARDING, James M. 2000. 'Introduction' in James M. Harding (ed.), *Contours of the Theatrical Avant-Garde: Performance and Textuality*. Ann Arbor: University of Michigan Press, pp. 1–13.

———. 2006. 'From Cutting Edge to Rough Edges: On the Transnational Foundations of Avant-Garde Performance' in James Harding and John Rouse (eds), *Not the Other Avant-Garde: The Transnational Foundations of Avant-Garde Performance*. Ann Arbor: University of Michigan Press, pp. 18–40.

———. 2010. *Cutting Performances: Collage Events, Feminist Artists, and the American Avant-Garde*. Ann Arbor: University of Michigan Press.

——— and John Rouse (eds), 2006. 'Introduction' in *Not the Other Avant-Garde: The Transnational Foundations of Avant-Garde Performance*. Ann Arbor: University of Michigan Press, pp. 1–17.

HAY, Jonathan. 2001. 'Toward a Disjunctive Diachronics of Chinese Art History'. *Anthropology and Aesthetics* 40(Autumn): 101–11.

HEBDIGE, Dick. 1989. *Hiding in the Light*: *On Images and Things*. New York and London: Routledge.

HEISIG, James W. and John C. Maraldo. 1994. 'Editor's Introduction' in James W. Heisig and John C. Maraldo (eds), *Rude Awakenings: Zen, the Kyoto School, and the Question of Nationalism*. Honolulu: University of Hawaii Press, pp. vii–x.

HERNANDEZ, Rod. 2006. 'Latin Soul: Cross-Cultural Connections between the Black Arts Movement and Pocho-Che' in Lisa Gail Collins and Margo Natalie Crawford (eds), *New Thoughts on the Black Arts Movement*. New Brunswick, NJ: Rutgers University Press, pp. 333–48.

HEWITT, Andrew. 1993. *Fascist Modernism: Aesthetics, Politics, and the Avant-Garde*. Palo Alto, CA: Stanford University Press.

HIRSH, Michael. 2005. 'Iraq: New War, Old Tactics?' *Newsweek*, 19 January 2005, p. 8.

HOFFMAN, Crystal Jean. 2010. 'Religion in Flux: Hugo Ball and Emmy Hennings; Dada Prophets of the Word'. MA Thesis, Indiana University of Pennsylvania.

HOLMES, Richard. 2003. *The Oxford Companion to Military History*. New York and Oxford: Oxford University Press.

HOLT, Mack P. 1995. *The French Wars of Religion, 1562–1629*. Cambridge: Cambridge University Press.

HUBERT, Renée Riese. 1998. 'Zürich Dada and Its Artist Couples' in Naomi Sawelson-Gorse (ed.), *Women in Dada*: *Essays on Sex, Gender, and Identity*. Cambridge, MA: MIT Press.

HUNG, Wu. 2004. *Between Past and Future*: *New Photography and Video from China*. Chicago: University of Chicago Press.

HUNTINGTON, Samuel P. 1993. 'The Clash of Civilizations?'. *Foreign Affairs* 72(3)(Summer): 22–50.

INNES, Christopher. 1986. *Holy Theatre*: *Ritual and the Avant-Garde*. Cambridge: Cambridge University Press.

——. 1993. *Avant-Garde Theatre: 1892–1992*. New York and London: Routledge.

JAFFE, Greg. 2006. 'Rumsfeld Aims to Elevate Role of Special Forces'. *Wall Street Journal*, 18 February 2006, p. A1.

JAMESON, Fredric. 1989. 'Periodizing the 60s' in *The Ideologies of Theory*: *Essays 1971–1986, Volume 2, Syntax of History*. Minneapolis: University of Minnesota Press, pp. 178–208.

——. 1991. *Postmodernism, or, the Cultural Logic of Late Capitalism*. Durham, NC: Duke University Press.

———. 2002. 'The Dialectics of Disaster'. *The South Atlantic Quarterly* 101(2)(Spring): 297–304.

JANNARONE, Kimberly. 2010. *Artaud and His Doubles*. Ann Arbor: University of Michigan Press.

JARRY, Alfred. 1965. 'The Passion Considered as an Uphill Bicycle Race' in Roger Shattuck and Simon Watson-Taylor (eds), *Selected Works of Alfred Jarry*. New York: Grove Press, pp. 122–4.

JEANNÉE, Pascale. 2001. 'Wochenklausur' in Wolfgang Zinggl (ed.), *Wochenklausur: Sociopolitical Activism in Art* (C. Barber trans.). New York: Springer.

JOHNSON, E. Patrick. 2003. *Appropriating Blackness: Performance and the Politics of Authenticity*. Durham, NC: Duke University Press.

JOHNSON, Harold K. 1966. 'Foreword' in Richard L. Clutterbuck, *The Long, Long War: Counterinsurgency in Malaya and Vietnam*. New York: Praeger, pp. vii–x.

JOSEPH, Peniel (ed.). 2006a. *Black Power: Rethinking the Civil Rights/Black Power Era*. New York and London: Routledge.

———. 2006b. *Waiting 'til the Midnight Hour: A Narrative History of Black Power in America*. New York: Henry Holt and Co.

KALAIDJIAN, Walter. 1993. *American Culture Between the Wars: Revisionary Modernism and Postmodern Critique*. New York: Columbia University Press.

KANDINSKY, Wassily. 1977. *Concerning the Spiritual in Art*. New York: Dover.

KAPUR, Geeta, 2000. *When Was Modernism?: Essays on Contemporary Cultural Practice in India*. New Delhi: Tulika Books.

KAUFMANN, Michael W. 2007. 'The Religious, the Secular, and Literary Studies: Rethinking the Secularization Narrative in Histories of the Profession'. *New Literary History* 38(4)(Autumn): 607–28.

KELLEY, Robin D. G. 2002. *Freedom Dreams: The Black Radical Imagination*. Boston: Beacon Press.

KELLY, George Armstrong. 1965. *Lost Soldiers: The French Army and Empire in Crisis 1947–1962*. Cambridge, MA: MIT Press.

KEPEL, Gilles. 2002. *Jihad: The Trail of Political Islam* (Anthony F. Roberts trans.). Cambridge, MA: Harvard University Press.

KIERNANDER, Adrian. 1996. Introduction to 'The Theatre is Oriental' by Ariane Mnouchkine in Patrice Pavis (ed.), *The Intercultural Performance Reader*. New York and London: Routledge, pp. 93–4.

KIRSCH, David. 1990. 'Death Squads in El Salvador: A Pattern of US Complicity.' *Covert Action Information Bulletin* 34(Summer): 51–3.

KIYOHIDE, Kirita. 1994. 'D. T. Suzuki on Society and the State' in James W. Heisig and John C. Maraldo (eds), *Rude Awakenings: Zen, the Kyoto School, and the Question of Nationalism*. Honolulu: University of Hawaii Press, pp. 52–74.

KLATCH, Rebecca. 1999. *A Generation Divided: The New Left, the New Right, and the 1960s*. Berkeley: University of California Press.

KRAUSS, Rosalind. 1985. *The Originality of the Avant-Garde and Other Modernist Myths*. Cambridge, MA: MIT Press.

KROEBER, A. L. and Clyde Kluckhorn. 1952. *Culture: A Critical Review of Concepts and Definitions*. New York: Vintage.

LACHMAN, Gary. 2004. 'Absinthe and Alchemy'. *Fortean Times*. Available at www.forteantimes.com/articles/180_strindberg1.shtml (last accessed on 1 September 2004).

LaCOSS, Don. 2000. 'Black Humor, Revolutionary Defeatism, and the Surrealist *Jeu de Marseille*'. Paper presented at the conference 'Rethinking the Avant-Garde: Between Politics and Aesthetics', Center for Continuing Education, Univeristy of Notre Dame, Notre Dame, Indiana.

LACQUER, Walter. 1976. *Guerrilla: A Historical and Critical Study*. Boston: Little, Brown and Co.

LAWRENCE, Bruce B. 1989. *Defenders of God: The Fundamentalist Revolt Against the Modern Age*. San Francisco: Harper and Row.

LEASK, Nigel. 1992. *British Romantic Writers and the East*. New York: Cambridge University Press.

LEMON, Alaina. 1996. 'Hot Blood and Black Pearls: Socialism, Society, and Authenticity at the Moscow Teatr Romen'. *Theatre Journal* 48: 479–94.

LENTRICCHIA, Frank and Jody McAuliffe. 2002. 'Groundzeroland'. *The South Atlantic Quarterly* 101(2)(Spring): 349–59.

———. and Thomas McLaughlin (eds). 1995. *Critical Terms for Literary Study*. Chicago: University of Chicago Press.

LEONARD, George J. 1994. *Into the Light of Things: The Art of the Commonplace from Wordsworth to John Cage*. Chicago: University of Chicago Press.

LEPECKI, André. 2007. 'Choreography as Apparatus of Capture'. *The Drama Review* 51(2)(Summer): 120–3.

LEWIS, Tom. 1992. '"A Godlike Presence": The Impact of Radio on the 1920s and 1930s'. *OAH Magazine of History* 6(Spring): 26–33.

LIPPARD, Lucy (ed.). 1970. *Surrealists on Art*. Englewood Cliffs, NJ: Prentice-Hall.

——. 1971. *Dadas on Art: Tzara, Arp, Duchamp, and Others*. Mineola, NY: Dover Publications.

LONSDALE, John. 1992. 'The Moral Economy of Mau Mau: Wealth, Poverty, and Civic Virtue in Kikuyu Political Thought' in Bruce Berman and John Lonsdale (eds), *Unhappy Valley: Conflict in Kenya and Africa*. Athens, OH: Ohio University Press, pp. 315–468.

LORCIN, Patricia M. E. 1999. 'Imperialism, Colonial Identity, and Race in Algeria, 1830–1870: The Role of the French Medical Corps'. *Isis* 90(4)(December): 653–79.

LOWE, Lisa. 1991. *Critical Terrains: French and British Orientalism*. London: Cornell University Press.

LÖWY, Michael and Robert Sayre. 2001. *Romanticism Against the Tide of Modernity* (Catherine Porter trans.). Durham, NC: Duke University Press.

LUTTWAK, Edward and Stuart Koehl. 1991. *The Dictionary of Modern War: A Guide to the Ideas, Institutions and Weapons of the Modern Military Power Vocabulary*. New York: Harper Collins.

LYOTARD, Jean-François. 1984. *The Postmodern Condition* (G. Bennington and B. Massumi trans). Manchester: Manchester University Press.

MABILLE, Pierre. 1996. 'The Jungle' in *Refusal of the Shadow: Surrealism and the Caribbean* (Michael Richardson and Krzysztof Fijałkowski trans). New York and London: Verso, pp. 199–212.

MACEY, David. 2000. *Frantz Fanon: A Biography*. New York: Picador.

MACKENZIE, John M. 1995. *Orientalism: History, Theory and the Arts*. Manchester: Manchester University Press.

MANN, Paul. 1991. *The Theory-death of the Avant-garde*. Bloomington: Indiana University Press.

——. 1999. 'The Nine Grounds of Intellectual Warfare' in *Masocriticism*. Albany: SUNY Press, pp. 91–126.

MANNING, Martin J. and Herbert Romerstein. 2004. *Historical Dictionary of American Propaganda*. Westport, CT: Greenwood Publishing Group.

MANWARING, Max G. and Court Prisk. 1990. 'A Strategic View of Insurgencies: Insights from El Salvador'. Carlisle, PA: Strategic Studies Institute, US Army War College.

MARINETTI, Filippo Tommaso. 1989. *The Futurist Cookbook* (Lesley Chamberlain ed. and Suzanne Brill trans.). San Francisco: Bedford Arts Publishers.

——. 1992. 'The Foundation and Manifesto of Futurism' in Charles Harrison and Paul Wood (eds), *Art in Theory, 1900–1990: An Anthology of Changing Ideas*. Oxford, UK, and Cambridge, MA: Blackwell, pp. 145–9.

——. 2005a. 'Technical Manifesto of Futurist Literature' in Lawrence Rainey (ed.), *Modernism: An Anthology*. Oxford: Blackwell, pp. 15–19.

——. 2005b. 'The Variety Theater', in Lawrence Rainey (ed.), *Modernism: An Anthology*. Oxford: Blackwell, pp. 34–8.

MARRANCA, Bonnie. 1999. 'Bodies of Action, Bodies of Thought: Performance and its Critics'. *Performing Arts Journal* 21(1): 11–23.

—— and Peter Sellars. 2005. 'Performance and Ethics: Questions for the 21st Century'. *Performing Arts Journal* 27(1): 36–54.

MARTER, Joan (ed.). 1999. *Off Limits: Rutgers University and the Avant-Garde, 1957–1963*. Rutgers, NJ: Rutgers University Press.

MARTINOT, Steve and Jared Sexton. 2003. 'The Avant-Garde of White Supremacy'. *Social Identities* 9(2): 169–81.

MARTY Martin E. and R. Scott Appleby. 1991. 'Conclusion: An Interim Report on a Hypothetical Family' in Martin E. Marty and R. Scott Appleby (eds), *Fundamentalisms Observed*. Chicago: University of Chicago Press, pp. 814–42.

MARX, Karl. 1963. *The Eighteenth Brumaire of Louis Bonaparte*. New York: International Publishers.

——. 1970. *Critique of Hegel's 'Philosophy of Right'* (J. O'Malley ed.). Cambridge: Cambridge University Press.

MATTHEWS, J. H. 1965. *An Introduction to Surrealism*. Philadelphia: Pennsylvania State University Press.

——. 1966. *Surrealism and the Novel*. Ann Arbor: University of Michigan Press.

McCOLLOCH, Jock. 1983. *In the Twilight of Revolution: The Political Theory of Amilcar Cabral*. Boston: Routledge and Kegan Paul.

McGARRY, Molly. 2000. 'Spectral Sexualities: Nineteenth-Century Spiritualism, Moral Panics, and the Making of US Obscenity Law,' *Journal of Women's History* 12(2)(Summer): 8–29.

McGURN, Jim. 1989. 'Alfred Jarry: A Cyclist on the Wild Side'. Available at http://www.bikereader.com/contributors/mcgurn/jarry.html (last accessed on 19 July 2004).

McKENZIE, Jon. 2001. *Perform or Else: From Discipline to Performance*. London: Taylor and Francis.

MEISENHELDER, Tom. 1993. 'Amilcar Cabral's Theory of Class Suicide and Revolutionary Socialism'. *Monthly Review* 45(6)(November). Available at http://libcom.org/library/amilcar-cabrals-theory-class-suicide-and-revolutionary-socialism-tom-meisenhelder (last accessed on 24 March 2006).

MÉNIL, René. 1996. '1978 Introduction to *Légitime défense*' in *Refusal of the Shadow: Surrealism and the Caribbean* (Michael Richardson and Krzysztof Fijałkowski trans). New York and London: Verso, pp. 37–40.

MEREDITH, Paul. 1999. 'Hybridity in the Third Space: Rethinking Bi-cultural Politics in Aotearoa/New Zealand' in Te P. Hauora (ed.), *Proceedings of te ora rangahau. Maori: Research and Development Conference. Te P'utahi-a-Toi. School of Maori Studies, Massey University, 7–9 July 1998*. Palmerston North: School of Maori Studies, pp. 305–09.

MERTUS, Julie A. 1999. *Kosovo: How Myths and Truths Started a War*. Berkeley: University of California Press.

METZ, Steven. 1995. 'Counterinsurgency: Strategy and the Phoenix of American Capability'. Carlisle, PA: Strategic Studies Institute, US Army War College

MOORE, Alan. 2004. 'General Introduction to Collectivity in Modern Art'. *The Journal of Aesthetics and Protest* 1(3)(March). Available at www.journalofaestheticsandprotest.org/1/amoore/1.html (last accessed on 30 November 2007).

MORRIS, J. W. 1980. 'Foreword' in Frank N. Schubert, *Vanguard of Expansion: Army Engineers in the Trans-Mississippi West, 1819–1879*. Washington, DC: Office of the Chief Engineers. Available at www.cr.nps.gov/history/online_books/Shubert/foreword.htm (last accessed on 17 March 2005).

MORRISON, Toni. 1989. 'Unspeakable Things Unspoken: The Afro-American Presence in American Literature'. *Michigan Quarterly Review* 28: 1–34.

MOSSE, George L. 1992. 'Max Nordau, Liberalism, and the New Jew'. *Journal of Contemporary History* 27(4)(October): 565–81.

MOTEN, Fred. 2003. *In the Break: The Aesthetics of the Black Radical Tradition*. Minneapolis: University of Minnesota Press.

MOTHERWELL, Robert. 1951. *The Dada Painters and Poets*. New York: Wittenborn.

MURCH, Donna. 2003. *The Urban Promise of Black Power: African-American Political Mobilization in Oakland and East Bay, 1961–1977*. PhD dissertation. University of California, Berkeley.

MURGER, Henri. 1903. *The Latin Quarter* (Ellen Marriage and John Selwyn trans). London: Grant Richards.

MUSALLAM, Adnan. 1998. 'Sayyid Qutb's View of Islam, Society, and Militancy'. *Journal of South Asian and Middle Eastern Societies* 22(1)(Fall): 64–87.

———. 2001. 'Prelude to Islamic Commitment: Sayyid Qutb's Literary and Spiritual Orientation, 1932–1938'. *Muslim World* 80: 176–89.

NADEAU, Maurice. 1965. *The History of Surrealism* (Richard Howard trans.). New York: Macmillan.

New York Times. 2001. 'Bin Laden's Statement:"The Sword Fell"'. 8 October, p. B7.

NICHOLLS, David (ed.). 2002. *The Cambridge Companion to John Cage*. Cambridge: Cambridge University Press.

NORDAU, Max. 1968. *Degeneration*. Lincoln: University of Nebraska Press.

O'BALLANCE, 1966. Edgar. *Malaya: The Communist Insurgent War, 1948–60*. Hamden, CT: Archon Books.

O'MEARA, Dan. 1977. 'The Afrikaner Broederbond 1927–1948: Class Vanguard of Afrikaner Nationalism'. *Journal of Southern African Studies* 3(2)(April): 156–86.

ODIN, Steve. 1990. 'Derrida and the Decentered Universe of Chan/Zen Buddhism'. *Journal of Chinese Philosophy* 17(1): 61–86.

OGBAR, Jeffery O. G. 2005. *Black Power: Radical Politics and African-American Identity*. Baltimore: Johns Hopkins University Press.

ORTON, Fred and Griselda Pollock. 1981. 'Avant-Gardes and Partisans Reviewed'. *Art History* 4(3)(September): 305–27.

ORWELL, George. 1943. 'W. B. Yeats'. *Horizon* 7(37)(January): 67–71.

OSBORNE, Michael A. 2004. Review of *Labelling People: French Scholars on Society, Race, and Empire, 1815–1848* by Martin S. Staum. H-France Review 4(59)(May). Available at http://www.h-france.net/vol4reviews/-vol4no59Osborne.pdf (last accessed on 20 January 2007).

OUEIJAN, Naji B. 1998. 'Orientalism: The Romantics' Added Dimension; or, Edward Said Refuted' in Virgil Nemoianu (ed.), *Romanticism in its Modern Aspects: Review of National Literatures and World Report*. Wilmington, DW: Council on National Literatures.

PAINE, Thomas. 1845. *The Theological Works of Thomas Paine*. Boston: J. P. Mendum.

PARET, Peter. 1964. *French Revolutionary Warfare from Indochina to Algeria: The Analysis of a Political and Military Doctrine*. New York: Praeger.

PAVIS, Patrice. 1996. 'Towards a Theory of Interculturalism in Theatre?' in Patrice Pavis (ed.), *The Intercultural Performance Reader*. New York and London: Routledge, pp. 1–21.

PERLOFF, Marjorie. 2003. *The Futurist Moment: Avant-Garde, Avant-Guerre, and the Language of Rupture*. Chicago: University of Chicago Press.

PHELAN, Peggy. 1993. *Unmarked: The Politics of Performance*. New York: Routledge.

PICK, Daniel. 1996. *War Machine: The Rationalisation of Slaughter in the Modern Age*. New Haven and London: Yale University Press.

PLANCHAIS, Jean. 1962. 'The French Army: A Close-up'. *New York Times*, 18 February 1962, p. SM9.

POGGI, Christine. 2002. '*Folla/Follia*: Futurism and the Crowd'. *Critical Inquiry* 28(3)(Spring): 709–48.

POGGIOLI, Renato. 1968. *The Theory of the Avant-Garde* (Gerald Fitzgerald trans.). Cambridge, MA: Harvard University Press.

POUILLADE, Frédéric. 2007. '*Scéne* and Contemporaneity' (Noémie Solomon trans.). *The Drama Review* 51(2)(Summer): 124–35.

POZORSKI, Aimee L. 2005. 'Eugenicist Mistress and Ethnic Mother: Mina Loy and Futurism, 1913–1917'. *Melus* 30(3)(September): 41–70.

PRICE, David H. 1998. 'Gregory Bateson and the OSS: World War II and Bateson's Assessment of Applied Anthropology'. *Human Organization* 57(4)(Winter): 379–84.

———. 2007. 'Buying a Piece of Anthropology, Part I: Human Ecology and Unwitting Anthropological Research for the CIA'. *Anthropology Today* 23(3)(June): 8–13.

PRIEST, Dana. 2003. *The Mission: Waging War and Keeping Peace with America's Military*. New York: W.W. Norton.

QUTB, Sayyid. 1981[1964]. *Milestones*. Cairo: Kazi Publications.

REDDING, Sean. 2006. *Sorcery and Sovereignty: Taxation, Power, and Rebellion in South Africa, 1880–1963*. Athens, OH: Ohio University Press.

RHODES, Ron. 1991. 'Christian Revolution in Latin America: The Changing Face of Liberation Theology'. *Christian Research Journal* Winter: 8

RICHARDS, Mary Caroline. 1962. *Centering: In Pottery, Poetry, and the Person*. Hanover, NH: Wesleyan University Press.

RICHARDSON, Michael. 1996. 'Introduction' in *Refusal of the Shadow: Surrealism and the Caribbean* (Michael Richardson and Krzysztof Fijałkowski trans). New York and London: Verso, pp. 1–33.

RIX, Robert. 2007. *William Blake and the Cultures of Radical Christianity*. Hampshire and Burlington, VT: Ashgate.

ROBINSON, Cedric J. 1983. *Black Marxism: The Making of the Black Radical Tradition*. Chapel Hill, NC: University of North Carolina Press.

ROBINSON, Linda. 2004. *Masters of Chaos: The Secret History of the Special Forces*. New York: PublicAffairs.

ROBINSON, Michael. 1998. 'Introduction' in August Srindberg, *Miss Julie and Other Plays*. Oxford: Oxford University Press, pp. vii–xxxvi.

ROCHESTER, Myrna Bell. 1998. 'René Crevel: Surrealist Critic of White Patriarchy'. *Race Traitor* 9(Summer): 55–60.

ROSEMONT, Franklin. 1998. 'Notes on Surrealism as a Revolution Against Whiteness'. *Race Traitor* 9(Summer): 19–29.

ROSENBERG, Fernando J. 2006. *The Avant-Garde and Geopolitics in Latin America*. Pittsburgh: University of Pittsburgh Press.

RUBIN, William (ed). 1984. *'Primitivism' in 20th Century Art*. New York: Museum of Modern Art.

SALAAM, Kalamu Ya. 1997. 'Black Arts Movement' in William L. Andrews, Frances Smith Foster and Trudier Harris (eds), *The Oxford Companion to African American Literature*. New York: Oxford University Press, pp. 70–4.

SANDER, Major Emile. 1997. 'Marine Corps Intelligence and Security Doctrine'. Presentation at Federation of American Scientists Intelligence Resource Program, Washington DC. Available at www.fas.org/irp/dod-dir/usmc/index.html (last accessed on 17 May 2006).

SAVRAN, David. 2000. 'The Haunted Houses of Modernity'. *Modern Drama* 43(Winter): 583–94.

SCHECHNER, Richard. 1996. 'Interculturalism and the Culture of Choice' in Patrice Pavis (ed.), *The Intercultural Performance Reader*. New York, Routledge, pp. 41–50.

———. 2002a. 'The Five Avant-Gardes or . . . or None?' in Michael Huxley and Noel Witts (eds), *The Twentieth-Century Performance Reader* (2nd edn). New York and London: Routledge, pp. 342–58.

———. 2002b. *Performance Studies: An Introduction*. New York: Routledge.

SCHEMO, Diana Jean. 2001. 'New Files Tie US to Deaths of Latin Leftists in 1970s'. *New York Times*, 6 March 2001, p. A7.

———. 2002. 'Latin Death Squads and the US: A New Disclosure'. *New York Times*, 23 October 2002, p. A6.

SCHUBERT, Frank N. 1980. *Vanguard of Expansion: Army Engineers in the Trans-Mississippi West, 1819–1879*. Washington, DC: Office of the Chief Engineers.

SCOTT, Anna. 1997. 'It's All in the Timing: The Latest Moves, James Brown's Grooves, and the Seventies Race-Consciousness Movement in Salvador, Bahia-Brazil' in Richard Green and Monique Gillory (eds), *Soul: Black Power, Politics, and Pleasure*. New York: New York University Press, pp. 9–22.

SEIDEL, Kevin. 2007. 'Beyond the Religious and the Secular in the History of the Novel'. *New Literary History* 38(4)(Autumn): 637–47.

SELL, Mike. 2001. 'The Black Arts Movement: Performance, Neo-Orality, & the Destruction of the "White Thing"' in Harry Elam Jr and David Krasner (eds), *African American Performance and Theatre History: A Critical Reader*. New York: Oxford University Press, pp. 56–80.

———. 2005. *Avant-Garde Performance and the Limits of Criticism: Approaching the Living Theatre, Happenings/Fluxus, and the Black Arts Movement*. Ann Arbor: University of Michigan Press.

———. (ed.). 2011. *Avant-Garde Performance and Material Exchange: Vectors of the Radical*. London: Palgrave Macmillan.

SHAFFER, E. S. 1975. *'Kubla Khan' and 'The Fall of Jerusalem': The Mythological School in Biblical Criticism and Secular Literature, 1770–1880*. Cambridge: Cambridge University Press.

SHANKER, Thom. 2008. 'Wider Antiterror Role for Elite Forces Rejected'. *The New York Times*, 21 May 2008, p. 21.

SHARAFUDDIN, Mohammed. 1994. *Islam and Romantic Orientalism*. London: I. B. Tauris Publishers.

SHATTUCK, Roger. 1968. *The Banquet Years*. New York: Vintage.

SILVER, Kenneth E. 1989. *Esprit de Corps: The Art of the Parisian Avant-Garde and the First World War, 1914–1925*. Princeton, NJ: Princeton University Press.

SMETHURST, James B. 2005. *The Black Arts Movement: Literary Nationalism in the 1960s and 1970s*. Chapel Hill, NC: University of North Carolina Press.

SMITH, Byron Porter. 1977. *Islam in English Literature*. New York: Caravan Books.

SMITH, Cherise. 2006. 'Moneta Sleet, Jr. as Active Participant: The Selma March and the Black Arts Movement' in Lisa Gail Collins and Margo Natalie Crawford (eds), *New Thoughts on the Black Arts Movement*. New Brunswick, NJ: Rutgers University Press, pp. 210–26.

SMITH, David Lionel. 1991. 'The Black Arts Movement and Its Critics'. *American Literary History* 3(1)(Spring): 93–110.

SMITH, Lorrie. 2006. 'Black Arts to Def Jam: Performing Black "Spirit Work" Across Generations' in Lisa Gail Collins and Margo Natalie Crawford (eds), *New Thoughts on the Black Arts Movement*. Rutgers University Press, pp. 349–68.

SOJA, Edward W. 1989. *Postmodern Geographies: The Reassertion of Space in Critical Social Theory*. New York: Verso.

SOKEL, Walter H. 1963. Introduction to *Anthology of German Expressionist Drama*. Ithaca, NY: Cornell University Press.

SPENCER, David E. 1996. *From Vietnam to El Salvador: The Saga of the FMLN and Other Guerrilla Special Forces in Latin America*. Westport, CN: Praeger.

SPITERI, Raymond. 2003. 'Surrealism and the Political Physiognomy of the Marvellous' in Raymond Spiteri and Donald LaCoss (eds), *Surrealism, Politics, and Culture*. New York: Ashgate, pp. 52–72.

STANSELL, Amanda. 2003. 'Surrealist Racial Politics at the Borders of "Reason": Whiteness, Primitivism, and Négritude' in Raymond Spiteri and Donald LaCoss (eds), *Surrealism, Politics, and Culture*. New York: Ashgate, pp. 111–26.

STAUM, Martin S. 2000. 'Paris Ethnology and the Perfectibility of "Races"'. *Canadian Journal of History* 35(December): 453–72.

———. 2003. *Labeling People: French Scholars on Society, Race, and Empire, 1815–1848*. Montreal: McGill-Queen's University Press.

STAVISH, Mark. 1997. 'Alchemy, It's Not Just for the Middle Ages Anymore'. *Atlantis Rising*. Available at http://hermetic.com/stavish/alchemy/alchemy-middle.html (last accessed on 29 August 2004).

STEVENS, Mary Anne (ed.). 1984. *The Orientalists, Delacroix to Matisse: The Allure of North Africa and the Near East*. London: Weidenfeld and Nicolson.

STILES, Kristine. 2000. 'Never Enough Is Something Else: Feminist Performance Art, Avant-Gardes, and Probity' in James M. Harding (ed.), *Contours of the Theatrical Avant-Garde: Performance and Textuality*. Ann Arbor: University of Michigan Press, pp. 239–90.

SULZBERGER, C. L. 1962. 'Can Revolutionary War Go Wrong?'. *New York Times*, 4 March 1962, p. 20.

SVEJENOVA, Silviya, Carmelo Mazza and Marcel Planellas. 2007. 'Cooking up Change in Haute Cuisine: Ferran Adrià as an Institutional Entrepreneur'. *Journal of Organizational Behavior* 28(5)(July): 539–61.

TAFURI, Manfredo. 1992. *Architecture and Utopia: Design and Capitalist Development* (Barbara Luigia La Penta trans.). Cambridge, MA: MIT Press.

TAYLOR, Diana. 1997. 'Making a Spectacle: The Mothers of the Plaza de Mayo' in Alexis Jetter, Annelise Orleck and Diana Taylor (eds), *The Politics of Motherhood: Activist Voices from Left to Right*. Hanover and London: University Press of New England, pp. 182–97.

———. 2003. *The Archive and the Repertoire: Performing Cultural Memory in the Americas*. Durham, NC: Duke University.

TAYLOR, Seth. 1990. *Left-Wing Nietzscheans*. Berlin: Walter de Gruyter.

THOMAS, Lorenzo. 2000. 'Roots of the Black Arts Movement: New York in the 1960s' in *Extraordinary Measures: Afrocentric Modernism and Twentieth-Century American Poetry*. Tuscaloosa and London: University of Alabama Press, pp. 118–43.

THORNTON, Patricia H., Candace Jones and Kenneth Kury. 2005. 'Institutional Logics and Institutional Change in Organizations: Transformation in Accounting, Architecture, and Publishing'. *Research in the Sociology of Organizations* 23: 125–70.

TOLLER, Ernst. 1976. *Man and the Masses* (Louis Untermeyer trans.), in Bernard F. Dukore and Daniel C. Gerould (eds), *Avant-Garde Drama: A Casebook 1918–1939*. New York: Thomas Y. Crowell, pp. 105–7.

TOLSON, Melvin B. 1994. 'The Bard of Addis Ababa' in Raymond Nelson (ed.), *'Harlem Gallery' and Other Poems of Melvin B. Tolson*. Charlotte, VA: University of Virginia Press.

TOWNSHEND, Charles. 2003. 'Counter Insurgency' in Richard Holmes (ed.), *The Oxford Companion to Military History*. New York and Oxford: Oxford University Press, p. 230.

UHALLEY, Stephen. 1985. *Mao Tse-tung: A Critical Biography*. New York: New Viewpoints Publishing.

ULMER, Gregory L. 1985. *Applied Grammatology: Post(e)-Pedagogy from Jacques Derrida to Joseph Beuys*. Baltimore: John Hopkins University Press.

URBAN, Hugh. 2003. 'Unleashing the Beast: Aleister Crowley, Tantra and Sex Magic in Late Victorian England'. *Esoterica* 5: 138–92.

US Department of State. 1999. Ethnic Cleansing in Kosovo: An Accounting. Washington DC: Department of State. Available at h t t p : / / w w w . s t a t e . - gov/www/global/human_rights/kosovoii/homepage.html (last accessed on 19 August 2004).

US Marine Corps. n.d. *Small Wars Manual (Draft Revision)*. Available at www.smallwars.quantico.usmc.mil/index.asp (last accessed on 20 February 2005; site discontinued.)

VERGÈS, Françoise. 1996. 'To Cure and to Free: The Fanonian Project of 'Decolonized Psychiatry' in Lewis R. Gordon, T. Denean Sharpley-Whiting, Renée T. White (eds), *Fanon: A Critical Reader*. New York and London: Blackwell, pp. 86–7.

VOLL, John O. 1991. 'Fundamentalism in the Sunni Arab World: Egypt and Sudan', in Marty and Appleby (ed.). *Fundamentalisms Observed*. Chicago: University of Chicago Press, pp. 345–402.

———. 1993. 'Foreword' in Richard P. Mitchell, *The Society of Muslim Brothers*. New York: Oxford University Press, pp. vii–xxii.

WAKIN, Eric. 1992. *Anthropology Goes to War: Professional Ethics and Counterinsurgency in Thailand*. Madison: Center for Southeast Asian Studies, University of Wisconsin.

WATTEN, Barret. 2003. *The Constructivist Moment: From Material Text to Cultural Poetics*. Middletown, CT: Wesleyan University Press.

WEISBERG, Barbara. 2004. *Talking to the Dead: Kate and Maggie Fox and the Rise of Spiritualism*. New York: Harper.

WESTBROOK, John. 2008. 'Seductive Theories: Roger Caillois, Inquisitions, and the Performative Intellectual' in Fabio Durão and Dominic Williams (eds), *Modernist Group Dynamics: The Politics and Poetics of Friendship*. Newcastle: Cambridge Scholars Publishing, pp. 145–71.

WHITE, Graham. 2011. 'Punk Attitude: The Influence of the Avant-Garde and the Case of Ian Stuart Donaldson' in Mike Sell (ed.), *Avant-Garde Performance and Material Exchange: Vectors of the Radical*. London: Palgrave Macmillan, pp. 188–206.

WHITE, Hayden. 1975. *Metahistory: The Historical Imagination in Nineteenth-Century Europe*. Baltimore: Johns Hopkins University Press.

WHITE, Michael. 2001. 'Johannes Baader's *Plastic-Dio-Dada-Drama*: The Mysticism of the Mass Media'. *Modernism/Modernity* 8(4): 583–602.

WILKINS, Fanon Che. 2001. 'In the Belly of the Beast': Black Power, Anti-Imperialism, and the African Liberation Solidarity Movement, 1968–1975'. PhD dissertation. New York University, New York.

WILLIAMS, Raymond. 1976. *Keywords: A Vocabulary of Culture and Society*. Oxford: Oxford University Press.

———. 1982. *Sociology of Culture*. New York: Schocken.

WILSON, K. B. 1992. 'Cults of Violence and Counter-Violence in Mozambique'. *Journal of Southern African Studies* 18(3)(September): 527–82.

WILSON, Richard. 1995. *Maya Resurgence in Guatemala: Q'eqchí Experiences*. Norman, OK: University of Oklahoma Press.

WINKIEL, Laura. 2006. 'The Rhetoric of Violence: Avant-Garde Manifestoes and the Myths of Racial Community' in Sascha Bru and Gunther Martens (eds), *The Invention of Politics in the European Avant-Garde (1906-1940)*. Amsterdam and New York: Rodopi.

WISTRICH, Robert S. 1995. 'Radical Antisemitism in France and Germany (1840-1880)'. *Modern Judaism* 15(2)(May): 109–35.

WOOD, Paul. 1999. 'The Avant-Garde and the Paris Commune' in Paul Wood (ed.), *The Challenge of the Avant-Garde*. New Haven and London: Yale University Press, pp. 112–36.

YATES, Frances. 2001. *The Art of Memory*. Chicago: University of Chicago Press.

YEATS, William Butler. 1900. *The Shadowy Waters*. London: Hodder and Stoughton.

YOUNG, Robert J. C. 2001. *Postcolonialism: An Historical Introduction*. London: Blackwell.

ZEDONG, Mao. 1967. 'Talks at the Yenan Forum on Literature and Art' in *Selected Works of Mao Tse-Tung*, VOL. 3. Beijing: Foreign Languages Press, pp. 69–98.

ZINGGL, Wolfgang. 2001. 'From the Object to the Concrete Intervention' in Wolfgang Zinggl (ed.), *Wochenklausur: Sociopolitical Activism in Art* (C. Barber trans.). New York: Springer, pp. 11–17.

ŽIŽEK, Slavoj. 2002. 'Welcome to the Desert of the Real!'. *The South Atlantic Quarterly* 101(2)(Spring): 385–9.

index